*Chrysalis*

"In this spellbinding biography, Todd interweaves the life of Maria Sibylla Merian, a German artist and naturalist who became famous in the seventeenth century for her engravings of caterpillars, with the intellectual and scientific history of metamorphosis." —*The New Yorker*

"Todd's book is a portrait of the metamorphosis of an age, a society, and a woman whose passion to see the world through the metaphor of moths and butterflies would not abate. The illustrations reproduced in this fine biography affirm Merian's vision; the range of Todd's research and the eloquence of her writing give that vision voice." —*Bookforum*

"Kim Todd writes lucidly, and with historic and scientific accuracy, about the life of Maria Merian who, as an explorer and natural scientist, preceded Darwin, Humboldt and Audubon." —*The Times* (London)

"If Maria Sibylla Merian were alive today, she'd be on *Oprah*. A teen bride, she later left her husband and joined an obscure cult, supported herself by selling her paintings, and studied nature in the South American jungle at the age of 52. The kicker? She did all this in the 17th century. Merian was one of the first to study insects in their habitats,

and *Chrysalis* puts her pioneering life in historical perspective…. [Merian's] obsession with metamorphosis led her to a book of stunning paintings and huge strides for the fledgling field of entomology." —*Bust* magazine

"Accounts of voyages and expeditions of discovery hold a special place in travel literature, especially when the destinations are exotic and the travelers are out of the ordinary. *Chrysalis* has both." —*The Courier-Journal* (Louisville, KY)

"Todd weaves an excellent tale to at last do justice to this prodigious, exceptional, forgotten woman and the extraordinary time in which she managed to flourish."
—*The Explorers Journal*

"Drawing on Merian's work and personal documents, Todd sheds new light on the history and contributions of this absolutely amazing woman…. Todd's writing itself is lush, almost poetic, whether she is describing the science of metamorphosis or Merian's own personal metamorphoses throughout her life. Highly recommended for all public and research libraries." —*Library Journal* (starred review)

"Todd emulates Merian's richly contextual approach in her vivid descriptions of every facet of her subject's vibrant world as she insightfully chronicles Merian's extraordinary life…. Todd's discerning analysis and deep appreciation resurrect Merian and reclaim her still vital achievements."
—*Booklist* (starred review)

"An extraordinary portrait of an artist and amateur naturalist who explored the teeming life of the Amazon and helped

lay the groundwork for our present-day understanding of ecology... Todd's long overdue re-examination of Merian's work shows the extent of her scientific contributions and reminds us how much of our early understanding of biology depended on the keen eye of the amateur. This bold, wide-ranging text also considers the theological view of meta-morphosis, the controversy over spontaneous generation, Merian's connection to other accomplished women of her day, her opposition to slavery in Surinam and her reliance on Amerindians to bring her specimens. A breathtaking ex-ample of scholarship and storytelling, enriched by ample il-lustrations of Merian's work."

—*Kirkus Reviews* (starred review)

"Todd fleshes out her biography with colorful descriptions of Merian's world and the people she knew, emphasizing that she was as exceptional in her art as in her life.... Todd's vivid account should do much to further the renewed inter-est in this unusual woman and her pioneering approach to insect illustration."                                    —*Publishers Weekly*

"In this revolutionary biography of Maria Merian, Kim Todd has rewritten history to include this woman of courage, dedication and genius, and in doing so has turned an old notion or two on its head. This is an earth-shaking book."
— Janisse Ray, author of *Ecology of a Cracker Childhood*

"Kim Todd gives wings to the life of the artist/naturalist Maria Merian. A lovely and exhilarating book."
—Deirdre McNamer, author of *My Russian*

*Chrysalis*

ALSO BY KIM TODD

*Tinkering with Eden*

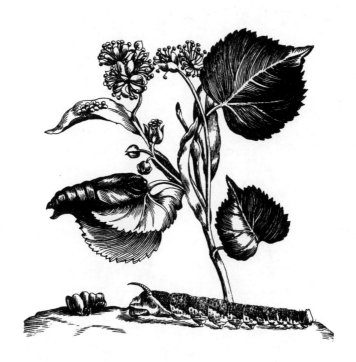

# KIM TODD

# Chrysalis

## MARIA SIBYLLA MERIAN
### and the Secrets of Metamorphosis

A HARVEST BOOK
HARCOURT, INC.
*Orlando   Austin   New York   San Diego   London*

Illustrations are from *Erucarum Ortus, Alimentum et Paradoxa
Metamorphosis*, a compilation of three of Maria Sibylla Merian's books
published in 1718 and are courtesy of Dover Publications.

www.HarcourtBooks.com

The Library of Congress
has cataloged the hardcover edition as follows:
Todd, Kim, 1970–
Chrysalis: Maria Sibylla Merian and the secrets of
metamorphosis/Kim Todd. — 1st ed.
p.    cm.
Includes bibliographical references and index.
1. Merian, Maria Sibylla, 1647–1717.   2. Naturalists — Germany —
Biography.    3. Artists — Germany — Biography.    I. Title.
QH31.M4516T63    2007
508.092 — dc22       2006015367
[B]
ISBN 978-0-15-101108-7
ISBN 978-0-15-603299-5 (pbk.)

Text set in Cochin
Designed by Linda Lockowitz

Printed in the United States of America
First Harvest edition 2007

A C E G I K J H F D B

*For Ben and Peregrine*

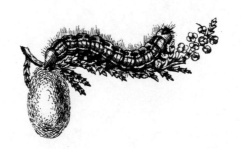

# CONTENTS

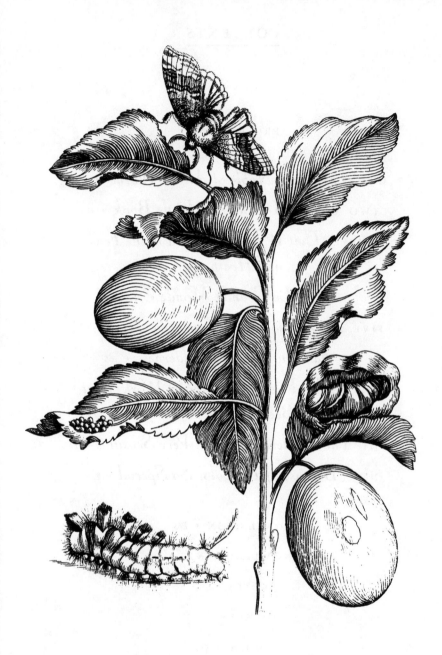

# Chrysalis

# PROLOGUE

In the fields, cassava plants grew fiercely green, fed by the June rains that raked the plantation. Underground, their roots swelled with poison. When ripe, they would be grated, their juice extracted and boiled to leech out the toxins, their flesh baked into bread. Above ground, glossy leaves like seven-fingered hands soaked up the sun. The heat was unyielding, gripping temples and lungs like a meaty fist.

A small caterpillar with brown stripes inched along the plant, chewing its way across the leaf. Tufts of hair sprouted from each segment down its back. As the furry body carved a methodical, voracious path, a sharp-eyed woman stood in the field and watched its progress. She hadn't seen one like it before, that nut color, those stripes, and was curious what it would become.

She had traveled here to Surinam, this sugar-fueled Dutch colony in the South American rain forest, to document metamorphosis, the progression of change that revealed new talents, new aspects of personality, new body parts—antennae, sexual organs, wings. She wanted to observe and paint each stage, capturing the shifts in color and form.

Not long before, she had been living in Amsterdam, peering at the dead butterflies in cedar-scented natural history cabinets of collectors. Conches, plump beetles, limp birds with eyes shuttered closed lay in the wood drawers, a background blank as a sheet of paper. She wanted to fill in that background, to see what plants the animals fed on, how they moved. Which caterpillar turned into each glossy moth? How long did it take from spinning a cocoon to hatching? How might the lives of these insects of New World forests be different from the ones she found in Old World flower beds?

Now, here she was, miles up this tropical river, far from the sophisticated streets of Europe, in a dangerous and undocumented place. Smells of boiling cane juice, swamp mud, and split guava replaced Amsterdam's city air. Fevers paced the coast. Diseases plagued the entire country from dock to dense jungle — leprosy, yaws, guinea worms, worms that crawled under the ankles, worms of the stomach and intestines, dry gripes, the bilious putrid fever of the West Indies. It was frightening to breathe.

The insects themselves were bold and untamable. They didn't respect human authority. Mosquitoes claimed stretches of forest and swamp by the ocean, forbidding trespassers with their dense swarms. Wasps circled her as she painted, building a mud nest nearby. Biting wood ants rained from the trees. When the mood struck, the ants swarmed through houses, carpeting the floor, papering the walls, leaving them shining and bare, ravaging any insect specimens she left unprotected.

In its box, her captive caterpillar consumed leaf after leaf, choosing flesh closest to the middle vein. Holes gaped in its wake. Then, one afternoon, it spun a silk button, disappeared into a pupa anchored to the silk, and dangled

there like a small, unripe fruit. At this stage, she called them "date pits." Like seeds, they were hard kernels of potential. She'd witnessed the transformation thousands of times, but each new pupa was wrapped in suspense.

Of all the shapes, wing patterns, color splotches, what will it become? Nothing as spectacular as the golden emperor moth, a hand span across, or the emerald-colored beetle with ruby-red eyes whose larva she found in her potato patch, surely, but a workable model. Maybe it was one of the small white-winged moths she'd seen in fluttering clouds over the cassava crops.

Days passed without movement. Thunderstorms came and went, pelting the earth with heavy drops then rising up as steam. She worked on other projects, hunted other caterpillars, sketched and took notes, but kept her eye on the date pits. Often they broke open and pesky flies crawled out rather than the butterfly she waited for. That, or the pupa dried up and died, never moving to the next stage. "Patience is a very beneficial little herb," she later wrote to a patron. It's an herb she cultivated.

She watched for the moment of hatching, ready to heat a darning needle, and, careful not to damage the wings, pierce the furry body. Some of her discoveries — snakes, iguanas, a gecko — could be preserved in glass jars of brandy, but butterflies and moths were too delicate. They died quickly, still perfect. She placed them in a box and rubbed turpentine oil over the edges to ward off wood ants.

She painted her finds on leftover chips of parchment — larva, pupa, adult with wings open, adult with wings closed, a quick sketch just to get down the details. She wielded her brush with a casual skill, knowing more about her insect subjects than perhaps any painter in Europe. Then she pasted them in the study book she'd carried with her for

years, creating a blue-paper frame, sticking it to the page with beeswax, and sliding the watercolor in. On the opposite page, she noted when and where she found the insects, recording how they behaved and what they ate.

This particular picture will be a strong addition to the book opening in her imagination. She'll capture all the colors of the cassava, from greens sliding toward brown to greens sliding toward blue, and the leaves will reach to every corner of the page. Close up, each cassava is a miniature jungle, and her rendering will draw the viewer into the thicket. Maybe to add interest, she'll include an azure and black lizard, gripping the plant's red stems. Its curling tail can fill out the bottom, tongue flicking at an ant on the stalk.

For the moment, though, the pupa ripened, turned transparent. Caterpillars rustled in the box. Her notebook was filled with blank pages. The plantation owner tallied up his harvest. They were all on the edge of change.

Before Darwin, before Humboldt, before Audubon, Maria Sibylla Merian sailed from Europe to the New World on a voyage of scientific discovery. An artist turned naturalist, Merian studied insects for most of her life. She started in the gardens and forests near her home in Germany, but in 1699, her fascination with the bizarre and stunning specimens carried from South America on trade ships pushed her farther. Over the course of two years, she stalked the sweltering rain forests of Surinam, flipping over leaves and peering down the throats of flowers, looking for the caterpillars that were her passion. Braving pounding heat, drenching rain storms, tarantulas and piranhas, with only her younger daughter for company, Merian searched out and sketched a record of her finds. Merian invested heavily in her experimental journey: she sold years worth of her

paintings to pay for the trip, abandoned her husband, and rejected expectations of what a seventeenth-century woman should be and do.

In 1701, Merian returned to Amsterdam and wrote a book called *Metamorphosis of the Insects of Surinam,* covering species from iridescent blue morpho butterflies to giant flying cockroaches. In her beautiful and scientifically accurate drawings and detailed field notes, she documented the lives of South American beetles and moths, recording life histories and behaviors previously unknown to western science. Her careful observations made her one of the first to describe metamorphosis, the unsettling process by which a species, in the middle of its life, swaps one body form for another. These transformations had long been the source of speculation and intrigue because the dramatic shape shifting seemed to hold the key to the unidentified origins of life.

While many of her naturalist contemporaries like Jan Swammerdam, Marcello Malpighi, and Robert Hooke used sharp dissecting knives and finely ground lenses to look deeper under a creature's skin than had ever been possible before, Merian investigated animals in their natural habitat, observed the plants they fed on, and charted the stages of their development. Many artists of the time drew colorful butterflies, pinned and preserved, growing dusty on collectors' shelves. Impatient with this limited view, she put exploration to the service of science and pioneered some of the first field studies. Her focus on direct observation, field work, the entire life cycle, and the interrelationships between plants and animals helped lay the groundwork for modern-day biological science, particularly ecology.

I have been fascinated with Merian ever since a box of notecards decorated with meticulously painted moths caught my eye. The insects were lovely, wings rippling with

bark and lavender scallops. A delicacy in the lines captured the fragile nature of the subject, but the images had obviously been executed with a scientific as well as an artistic sense. Many butterfly and moth pictures show only the pretty adults, but not these. An ungainly cocoon bulged along the stalk and the leaves were tattered with holes. A caterpillar crept up the branch and the artist didn't shy from including its bristles and the wicked edge of its jaw. There was an empirical coldness in the details combined with a lush, almost sensual feeling for color. To look at the picture was to brush against a unique mind at work.

I flipped the card over. The back read "Maria Merian, German, 1647–1717," followed by a citation of a book about the metamorphosis of insects from Surinam housed in the collection of the American Museum of Natural History. The time period seemed so at odds with these few facts. When she was born, Shakespeare had been dead only thirty years. Galileo stood trial a mere thirteen years before for suggesting the earth moved around the sun. My image of an eighteenth- or nineteenth-century naturalist/explorer was a wealthy, university-educated young man seeking adventure or a ship's surgeon picking shells off the beach in between treating cases of scurvy. If I had a picture of a naturalist/explorer earlier than that, which I didn't, it surely wasn't a fifty-two-year-old German woman with little formal education. What was Merian doing drawing insects in South America three hundred years ago, I wondered. How did she get there? What did she hope to find?

This book started as an effort to answer some of these questions, to delve deeper into the life of a woman whose actions would be exceptional today, much less in 1699. Starting with the few clues on the back of the notecard, gradually pieces of her biography came together.

Speculation, though, is necessary. She left two wills, a lawsuit, scattered watercolors, four books about insect metamorphosis and one about flowers, a study book with pictures and notes about hundreds of creatures from moths to snails to frogs, and seventeen letters. The letters, preserved by chance, were not the ones we might choose. Those to her close friend Dorothea Auer and to her brother when he lived with a pietist religious sect are lost. Instead we have those she wrote to the naturalist and collector James Petiver because his papers wound up in the British Museum. We have those she wrote to her pupil Clara Regine Imhoff, a girl from an influential Nuremberg family, whose letters ended up in the Imhoff archive. They are heavy on business negotiations and instructions for mixing varnish and light on personal detail. But that's all there is. We know nothing about what she felt for her husband. Or her daughters. Or her God. Her interior life is as remote as the innermost whorl of a snail shell on the ocean floor.

But on the other hand, how can we complain? Her passion was charted as diligently as anyone's could be. We know day by day what she saw when she looked at insects: the seasons of their hatching, the alteration of colors, how they respond when touched, the weight of their cocoons. She left in-depth reports throughout her life, recording what she saw and did. Her voice, mute on marriage and motherhood, tells instead of caterpillars in a quince tree which, when given only the slightest prod, "bang their head several times in any direction as if angry." Of another insect, she says: "they eat so much every day that they get so fat they soon start to roll and then fall off the trees." And of a particularly pretty metamorphosis: "they became such snow white moths and had a shimmer like a mother of pearl."

At the time of Merian's work, science was in its infancy, still struggling to balance the developing scientific method with a belief in magic, trying to reconcile theories of matter with the creation as described in Genesis. Direct observation was replacing reliance on words of authority passed down from Aristotle and Pliny, but slowly. Galileo took the risk of saying, "I think that in the discussion of natural problems, we ought not to begin at the authority of places of Scripture, but at sensible experiments and necessary demonstrations." Francis Bacon, contrary to tradition and contrary to Descartes, who wanted to move knowledge forward by thought alone, suggested in his "On Natural and Experimental History," the need for a science rooted in experimentation. Since, to that point, experiments were often the province of alchemists and other purveyors of the "mechanical arts," he warned this might require embracing things out of the scope of most university-educated men, including things "most ordinary," things "mean, illiberal, filthy," and things "trifling and childish." For instance, though every cook knows crabs change color when boiled, he wrote, the humble pot might not be a bad place to study the nature of redness.

This created opportunities for those like Merian who, limited in her position as a woman and a craftsperson rather than an aristocrat, could still make notes about and drawings of what she saw, starting close to home with finds in the roots of vegetables and the walls of her house, and eventually moving on to palms on the banks of the Surinam River. At this time, the boundaries between certain kinds of art and science were fluid, since the nascent discipline of biology was all about documentation of the ever expanding natural world. Many breakthroughs involved new ways of seeing: the telescope, the microscope, the camera obscura.

Observational skills developed during Merian's training as an artist made her a stronger naturalist, and her artwork turned from its starting place — designs for needlepoint — to records of animals most of her peers would never see.

In the late seventeenth century, the Netherlands, where Merian moved in the 1690s and launched her most serious work, was a center of metamorphosis investigations. In Delft, Leeuwenhoek perfected his microscope, allowing intimate views of a drop of pond water, the legs of a bee. Natural historians like Swammerdam used these tools and others to understand how insects developed, drawing links between creatures that, at least visually, seemed completely unconnected.

Amsterdam, in particular, was a nexus of science, arts, and commerce. The city pulled in painters like Rembrandt with its rich resources of talent and funds for patronage and drew naturalists and doctors to look at its flourishing botanical gardens. Natural philosophers and the curious public ventured into the cabinet of Dr. Frederik Ruysch to view a branching vein and the interior of a lung, preserved and on display. Dutch trading ships raided the globe, bringing back exotic seashells, plants promising cures for all sorts of ailments, preserved hummingbirds and crocodiles. The streets and shops filled with the new scents of chocolate and coffee. The city teetered at the pinnacle of its Golden Age, brimming with wealth and creativity.

If Amsterdam drew artists and merchants with its prosperity, Surinam called to adventurers and pirates, big dreamers and get-rich-quick schemers. On its northwest border, according to some accounts, lay the mythical El Dorado, a city with gold so plentiful that goldsmiths lined the streets, furniture was fashioned of gold, and citizens traded golden

shields in exchange for rare iron. Many explorers, including Sir Walter Ralegh, who lost his son in the search, staked their reputations on finding the glittering metropolis on the banks of Lake Parima, led by stories from the Amerindians who couldn't have told a more enticing tale if they'd tapped straight into European fantasies.

At the time of Merian's visit, Surinam was a country fed by sugar rather than gold, energetic and impatient, often with a nasty temper. While to European eyes, it represented a source of ready cash and an endless font of biological wonders that dazzled viewers with the strange riches of the newly expanded world, as much as 90 percent of the residents were slaves, imported to work the sugar fields. They were brought over by the English, and after the colony was swapped to the Dutch for Manhattan in 1667, they were brought over by the Dutch. Many escaped from the brutal treatment on the coastal plantations, described by Aphra Behn in her 1688 book *Oroonoko,* to form "maroon" communities in the interior. By the time Merian arrived, thousands of maroons staked their independence in the dense jungle.

What she found in this conflicted place is the subject of her book, *Metamorphosis of the Insects of Surinam,* whose large plates displaying slices of insect and animal life brought the tropics vividly to Europe. One of the first to study the rain forest, Merian inspired a century of scientists, both those who traveled to South America to conduct their own research and those who stayed closer to home and tried to make sense of the information flooding in from the New World. In books and articles, they cited "Madame Merian" over and over again. Her portraits and descriptions of Surinamese insects were so definitive that Linnaeus, in compil-

ing his systemization of natural life, used her drawings rather than actual specimens. Her visual catalog of a country's natural history was a precursor to books like John James Audubon's *Birds of America*.

During the nineteenth century, though, both a campaign to discredit her and the few bastardized and mistranslated copies of her books still in circulation undermined her reputation, and Merian's work sunk into obscurity. But still, the pictures themselves retained their stirring, unsettling power. As a boy, Vladimir Nabokov discovered a collection of insect books in the attic of his family's country home in Vyra. He flipped through Merian's Surinam work along with other colorful volumes, and they helped inspire his own lifelong passion for Lepidoptera.

As I researched Merian, I became more interested in the history of metamorphosis—its importance both as a scientific discovery and an evolutionary breakthrough. The questions shifted: How did metamorphosis alter the way people thought about animals and their potential for change? Did the natural world appear more threatening as its shapes were revealed to be unstable or did it seem filled with hope, more ripe with possibility?

Metamorphosis has a strong grip on our psyche, from Ovid's vivid descriptions of arms spreading to branches, throats turning to stone, to Kafka's Gregor waking to find himself a beetle. One of the first ways children understand nature and how it functions (a cocoon in a jam jar is a staple of elementary school classrooms), metamorphosis has metaphorical potential that is strong and easy to grasp. It is a process integral to the way we perceive ourselves and our ability to change our lives.

To some, it appears so complex, so unexplainable, that it must be miraculous. Creationists use it as a prop for intelligent design, claiming that no one has explained how organs and bodily structures can rearrange themselves so completely. A squirming, consuming larva one day stills and turns into a pupa, becoming completely immobile. If this case is opened, liquid leaks out, a formless fluid where once were legs and mouth. Then, after this apparent death, one day the pupa cracks, a butterfly emerges, and flits away. The rudimentary six eyes of the caterpillar turn to the multifaceted compound eyes of the adult. Entire body parts appear where before there were none. How could such an existence evolve? Bernard d'Abrera, in his 2001 book *Concise Atlas of Butterflies of the World*, complains at length about the misguided theory of evolution via natural selection. At the height of forums on college campuses, creationist debaters will issue the final challenge, daring opponents to "explain metamorphosis."

Wonder is built into the language. One of the earliest terms for "butterfly," used by Aristotle, was "psyche," also the word for "breath" and "soul." The "larva," the creeping early stage, takes its name from "mask," but its Latin roots are tangled with the notions of "ghost" and "hobgoblin," too. The "pupa," the stage of rapid change in an immobile shell, means "girl" and "doll" in Latin. In German, Merian's native tongue, it still has that meaning. In English it became a "puppet," waiting for animation. "Chrysalis," the usually naked and often particularly beautiful pupa built by a butterfly, comes from the Greek for "gold," commemorating the metallic glow or spots on species like the monarch and painted lady. The "cocoon," the protective silk enclosure many moths spin around the pupa, comes from the French for "shell." The "imago," the winged final stage, in-

dicates that everything before was just practice or a mask for the revealed true form, as it has the meaning of "natural shape." Of all these phrases, perhaps nothing is so lovely as "imaginal disk," used to describe the pockets of cells in the caterpillar that become complex eyes and wings. They are, of course, the seeds of the imago, but it's easy to see them too as the aspirations of the caterpillar, imagining its future.

While many natural phenomena capture a grim vision of life and potential—the rosebud doomed to fading—metamorphosis offers the reverse trajectory. A humble worm becomes an iridescent moth. A plague of caterpillars turns into a blessing of butterflies. It is a biological adaptation that embodies hope, from religious use of the butterfly as a symbol of rebirth to high school girls who tattoo butterflies on their arms, a promise of blossoming.

Beyond capturing hope in a metaphorical sense, metamorphosis exemplifies success in evolutionary terms. About 300 million years ago, when insects first developed the ability to separate their lives into distinct phases, they set the stage for world domination. Metamorphosis is efficient because the young and their adult counterparts don't compete with one another for the same limited resources. A larva can live inside an apple, gorging on the sweet pulp, in a body tailored to the task of feeding. The hatched (or "eclosed") moth can survive on nectar, superbly crafted for the work of flying to new territory and attracting a mate. It allows one creature the benefit of two completely different bodies and life strategies, each employed when most useful. Within the insect class there are varying levels of change: hemimetabolous insects like grasshoppers go through an incomplete metamorphosis, moving gradually from molt to molt into an adult; holometabolous insects like maggots and caterpillars metamorphose completely, undergoing a dramatic

change in the pupae into flies and moths. While butterflies, transformation is most astonishing, at least to human eyes, others metamorphose as well. Young crabs look like armored tadpoles, all head and tail. As they molt, they gain muscles, lengthen the abdomen, add legs and claws. Amphibians also do without a pupa, but no one would confuse a tadpole with a full-grown toad. Some sea snails spend their youth as larvae with flaps that allow them to swim, before settling down to an adulthood of creeping. But their heavy reliance on metamorphosis has helped make insects the most successful of animals with 1 million known species and an estimated 4–5 million yet to be discovered.

Though we have centuries more experience and libraries now contain countless volumes about butterflies, for many of us, a hatching chrysalis is no less mysterious than it was for Merian, sweating over her boxes in a wooden room in Surinam. In fact, it might appear even more of a marvel, since she spent so much time watching pupae building and breaking. To explore these two stories — that of Merian's experience as an artist and naturalist and that of the developing understanding of metamorphosis to which she contributed — it's best to start at the matrix where they intertwine: a transformation.

Inside the Conservatory of Flowers in San Francisco's Golden Gate Park, a crowd clustered around a display cabinet featuring live chrysalises hanging on pins. Behind the glass door of the case, the cloudless sulphur pupa was bent as a fat comma, meatiest at the curve. The Julia chrysalis hung like a carved wood totem. The monarch was perhaps the most improbable. Pale sea green with dots of gold, it looked like it should come in a blue box from Tiffany. The curators must have had an impeccable sense of timing; a

new chrysalis broke open every minute, slow-motion fire-crackers. All around, adult butterflies tasted trays of oranges, felt for nectar in the potted flowers, flocked to corners by the heating pipes, tangled in girls' long hair.

Behind the glass, a modest green pupa, slightly translu-cent, began to tremble. *Anartia jatrophae*, the white peacock, it was the same species Merian captured three hundred years ago in a cassava field. It shook more violently. Finally, the pressure too high, the skin ripped. The abdomen pushed forward, legs flailing through the gap. Blood-colored fluid dripped from the ribbed thorax as the legs found purchase and the insect crawled out. It was hard to tell part from part in the glistening rush. Then it came into focus. Wings bulged like cheeks on either side of the thorax, and the insect turned to hang from the shell of the pupa, no longer preg-nant and dark. There was something too quick and raw, almost obscene, about the split, the body shoving its way out. Now transparent and broken, the empty shell dangled, holding a shape that no longer existed, a memory of an ear-lier life.

Resting, the hatchling was diminished, huddling more like a housefly than a butterfly. It seemed like it would never move, that it would harden and die in this shriveled shape. Then, the insect stirred. Somehow, wings emerged from those wrinkled balls. Opening and closing, they stretched to a long curve, a taut sail. A familiar landscape appeared, as when a hand flattens a map: the pattern of white banded with orange and black, with dark spots echoing eyes. The wings pumped more confidently. The peacock rolled and unrolled its proboscis as if sampling the air. It was fully it-self, and something new.

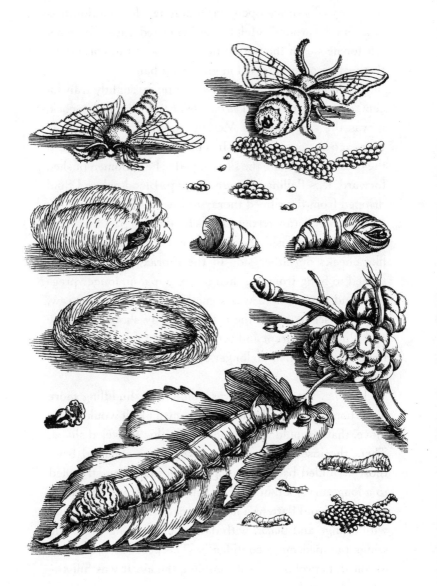

# The Most Noble
# of All the Worms

How many creatures walking on this earth
Have their first being in another form?
—Ovid, *Metamorphoses*

*Frankfurt am Main, 1647–1665*

Another pupa, another time. Cocoon walls, thick with silk, wrapped their contents tight. Inside, the organs altered. The mouth disappeared. The white body darkened, turned dusky gold. Pressed between the wings, the antennae waited to sense the morning.

At a table near dawn, the girl watched and gripped her paintbrush. She'd woken early enough this day to catch the adult moth dissolving the silk strands and pushing them aside. Other times she got up too late or waited and waited, grown cramped from sitting still. How to capture the thin threads swathing the oval, the precise folds of the pupa? Once out, the moth changed so fast, shifting from second to second as it dried. It was hard to move her wrist quickly enough to make the black lines of scrabbling legs.

This pale silkworm, its dowdy moth, drew her in. At thirteen, she may have felt her own innards alter, traced a finger over a face now unfamiliar in the mirror. It's the time when the young most anticipate a spectacular transformation,

hoping for a future saturated with color, shimmering with iridescence. But she had chosen to focus not on some gaudy butterfly, but this dowdy little insect. Those strands, so thin, so strong, that wrapped the cocoon, tied the worm to stockings, and skirts and hair ribbons, bound it to daily life. It was a practical choice, though no one could call this activity practical. She labeled the silkworm "the most useful and noble of all worms and caterpillars."

Between chores, she cared for her subjects. In the chill of early spring when the mulberry leaves were not yet in bloom, she raised the caterpillars on lettuce. She built them cone-shaped paper houses where they could spin their cocoons, covering the insects if a storm threatened. Thunder made them ill. So many things could go wrong: a room too cold, leaves wet and rotten, eggs that collapsed and failed to hatch, a clumsy finger brushing scales off the wings.

But eventually she captured the whole process, egg to adult. It was an odd picture, not like any her stepfather showed her—full still-life paintings where a moth might echo a color used on a flower petal, or more humble engravings where beetles and butterflies of many species crowded together. Just the simple insect, alone with all its stages. The wings, crumpled like paper, not fully dry. The adult tipped forward, as if still finding its legs. A tiny caterpillar, no longer than a thumbnail, inching across the page. A larger version, fat on mulberry leaves, made of bleached white segments, large as teeth. The pupa lay curved and motionless, wrapped like a mummy in its hard casing, covering the knots of nerve as they came undone to reform in another shape.

As she rinsed her hands and rubbed her brush to clean it, she probably couldn't say what pulled her to gather all these parts and paint them together, condensing and stop-

ping time for a moment. More likely her thoughts jumped to the unknown striped caterpillar she glimpsed along the riverbank, whether she could find another, how to raise it, when she could do it again.

While curiosity could be suspect, even dangerous, in a girl, Maria Sibylla Merian was born into the ideal household for an inquisitive mind. Her father, Matthaus Merian the Elder, owned a thriving Frankfurt publishing house, specializing in books illustrated with lavish pictures and maps engraved by him, his children (including Matthaus the Younger), his sons-in-law, and apprentices.

Maria Merian's early childhood would have been punctuated by the clatter of the printing press, the heart of the business and family enterprise. Peering into the workshop, she could watch her father or brothers selecting type or planning the next season's catalog. Trays of metal letters of different fonts and sizes lay jumbled on shelves. Printed sheets hung overhead like laundry out to dry. Murmurs of conversation of visiting artists and buyers curled in the corners of rooms. Hired workmen in smocks bustled around the printing press itself, a hulking machine that looked like a bookcase straddling a table, often braced with boards against the ceiling, with scissors and a hammer dangling off the front. On the table lay three boards hinged together, like a triptych on its back. One man smeared ink on the letters arranged in a tray, called a "coffin," that made up one of the three sections. The other put the paper on the middle board, cushioned with blankets or padding. The final panel, just a hollow frame, contained another piece of paper, with holes cut for the text to go through. It sopped up any spills. The frame folded over the paper, which folded over the coffin, and one man slid the whole stack under the press. Then

he grabbed the handle called the devil's tail and screwed a plank down to meet the coffin, banging the text against the paper. This way, they produced 200 pages an hour.

The press's ability to spread information so rapidly made it invaluable but also gave it the taint of subversion. The business depended on the dreaming up of fresh ideas, always a risky endeavor when the only reading material above suspicion was the Bible. Some had doubts about whether anyone but ministers should read even that. A refuge for scientists, religious minorities, and visionaries, a publisher's workshop drew free thinkers of every stripe. Whether the writers wanted to publicize discoveries about the mechanism of the human heart or incite a religious revolution, they needed the type, the paper, and the press, to have any influence. The astronomer Johannes Kepler, when he wasn't contemplating the orbits of planets or the movement of the tides, lingered at the printers where his books were in progress, looking over tables and evaluating illustrations. It was a coffee house before anyone in Europe drank coffee, where the heady brew was ink.

The Merians themselves had their own secrets. The whole extended family comprised refugees from one place or another. The publishing house was launched in the late 1500s by the de Bry family, Calvinists who fled Belgium when Catholics took over. Theodor de Bry, the founder and noted engraver, passed the company on to his son Johann Theodor de Bry. As a young man, Matthaus Merian, originally from Basle, worked for Johann Theodor and eventually married his daughter, Maria Magdelena. Though Matthaus wasn't the most obvious successor (he had moved away and other sons-in-law were more involved in the day-to-day operations), de Bry's widow must have respected his business instincts, because she helped ensure that Matthaus

took over the print shop when his father-in-law died in 1623. Matthaus split the company assets (backlogs of books and engraved copper plates) with another son-in-law, but Matthaus got by far the more valuable share.

When his first wife died, Matthaus quickly remarried, wedding Johanna Sibylla Heim. About Johanna Heim, not much is known: her family were Walloons (French-speaking residents of a region of Belgium), who moved to Hanau, where her brother served as a preacher. Since Hanau was a Calvinist city, the Heims were probably also fleeing religious persecution. By the time Johanna and Matthaus's daughter, Maria Sibylla, was born in April 1647, many of Matthaus Merian's older children from his first marriage were adults, skilled artists themselves. The youngest in a family with two half brothers and two half sisters in their twenties, a half sister in her late teens and another half brother who was twelve, the young Maria Merian risked being underfoot.

Later, biographers writing just after she died would say this youngest daughter was her father's favorite, that as the toddler raced around with outstretched fingers, he prophesied Maria would ensure the name "Merian" lived on in fame. They said her mother worried over her odd and dirty interest in insects, an obsession thought to have been launched when Johanna looked at a collection of bugs while Maria was in her womb. Sensitive and porous, the pregnant body let in all sorts of impressions — sight of a lame beggar could result in a child with a damaged foot and an unmet desire for strawberries could leave a strawberry-colored mark.

Other rumors said Merian raised her caterpillars in the attic and stole a tulip from a neighbor's garden to paint. And that the neighbor was so enchanted by her artwork,

that he forgave the girl for taking the flower and asked only for the picture in exchange. Who knows if it's true? But it shows what admirers wanted to believe about the girl who would become such an exceptional woman: Her rule-breaking and blazing talent were apparent from the first.

Whether or not Matthaus Merian recognized his artistic gifts in his youngest daughter, he would surely have recognized his face. The planes of the cheekbones, the long nose, the mouth—a little too wide, a little too thin—that looked clamped down on some funny secret. The likeness was as apparent as if an engraving had been run through the printing press twice, with a few revisions, with a span of years in between, but the main lines clear and unaltered.

Outside the front door, the world of Frankfurt was more perilous and less forgiving. Germany, ravaged by the Thirty Years War, was just staggering to a recovery. Infestations of soldiers, like locusts, had become a fact of life, bringing famine and taking prize livestock. Villagers abandoned the countryside for the protection of city walls. By some estimates, a third to half the population of Germany died in the war that had ensnared much of Europe in battles between Catholics and Protestants. The economy was in tatters. In addition, the plague had coursed through Frankfurt eleven years earlier, leaving holes in families and suspicion among neighbors, killing 7,000 people, almost a third of city residents.

A contemporary of Maria Merian's, Johanna Eleonora Petersen, recalled in her memoir fleeing through an unstable countryside to Frankfurt as a four-year-old in 1648, the year after Merian was born. At reports of approaching troops, her mother tied an infant to her body, grabbed the hands of her two other children, and raced toward the city. "It was

summer, the harvest stood high in the fields, and we could hear the noise of soldiers marching on another road about a pistol shot away from us," Petersen remembered.

Though battles came right up to its walls, Frankfurt possessed the resources to pull itself toward recovery. A center of trade, the city was defined by the river Main, deep enough to drown criminals pushed from the bridge as punishment, wide enough to affect the weather as wind swept down along its length, strong enough to pull heavily laden boats downstream with the current as it prepared to enter the Rhine. Land routes crisscrossing Europe also converged in Frankfurt, bringing goods and news. Annual book fairs drew visitors from over the Alps, both readers curious to see the latest literature and printers eager to compare wares and haggle over type. One French traveler described all the academics who flocked to the fair, creating a living library: "Here very often right in the shops of the booksellers you can hear them discussing philosophy no less seriously than once the Socrates and the Platos discussed it in the Lyceum."

The city sheltered people from all over Europe, its relative religious tolerance (a rare commodity in a time of struggles for control between Protestants and Catholics) attracting Calvinists, like Merian's father, to the primarily Lutheran town. Calvinists differed from Lutherans in their sweeping views of God's power, the belief that some were predestined for salvation, and their insistence on simple, even austere living. Even though Frankfurt allowed them entrance, they were endured rather than embraced. Until the treaty that ended the Thirty Years War, Calvinists still faced barriers in employment and political representation. In 1628, the Lutheran-dominated city council decided not to accept any more Calvinists as citizens (the category with

the fullest rights) and Calvinists continually fought for and failed to win the right to worship in public. But Matthaus Merian, who either obtained his citizenship before 1628 or bought his way in, felt comfortable enough to trumpet his religious beliefs in his books. They lacked political clout, but immigrant families like his controlled much of the money flowing in and out of the city.

The worlds inside and outside the house met in the volumes that emerged from the family printing press: dreamed up, discussed, agonized over, waiting in stacks to be sold. While other publishers folded, Matthaus Merian's strong business sense guided the enterprise through the crippling war. The large-format pictures made them accessible even to a child too young to read. They brought the ideas of a developing Europe to Maria Merian before she was old enough to venture out into it on her own.

The Merian press churned out material from almost every field. Natural history books displayed plants and their medicinal uses. Geography books offered thousands of maps of cities throughout Europe. Matthaus Merian sketched these maps on site, offering his readers detailed, first-hand representations where previous books often used one crude woodblock image to represent diverse cities like Verona and Mantua. Religious books argued for a reformation of the Reformation. Alchemical books revealed secrets of the universe through symbolic pictures of a man with his feet on the two heads of a dragon or a crowned mermaid with two tails: modern-day hieroglyphics. Other publishers released less expensive products — political broadsides sold in the markets or pamphlets of prayers and household tips — but Matthaus Merian specialized in expensive books targeted to the wealthy and enlivened by meticulous illustrations.

Some of his most lucrative publications were series

started by Theodor de Bry, the grandfather of Matthaus's first wife and the founder of the publishing house. Perhaps the most ambitious was *Historia Americae,* later to be called *Grand Voyages,* an illustrated series detailing adventures of thirty-five early explorers of the New World. Basing his pictures on travelers' accounts de Bry depicted the French explorations of Florida, Girolamo Benzoni's adventures from the Caribbean to Peru, and John Smith's report of dazzling the Powhatans with the compass, among many other tales.

A public that had only heard the sketchiest stories of New World wonders could now pore over pictures of burials of Peruvian princes, techniques of turtle fishing, a tropical hurricane. De Bry showed patches of lush countryside and Balboa with a heap of gold at his feet. Rumored animals took shape on the pages: albatross, flying fish, mermaids. Never one to shirk from sensationalism, de Bry played up the dangers faced by the explorers, showing Hans Staden captured by natives in Brazil and Amerindians attacking French ships with poisoned arrows. Cannibalism is a recurring theme with images of heads on plates and children munching on a hand or a bit of viscera. Illustrations also portrayed mistreatment of native people by the excoriated Spaniards: Amerindians stabbed in the back, pushed overboard, hanging by the neck from the yardarm, raped while they bathed, running from a village up in flames. Matthaus Merian inherited the plates after his father-in-law's death and continued the series until 1634, the appetite for New World views providing his business with a financial backbone. The pictures lingered in the mind of European readers, for many their only idea of what the Americas might look like.

The Merian publishing house also had the plates for the

*Florilegium Novum,* a book of flowers engraved by Johann Theodore de Bry. Flipping through the volume of hand-colored copperplate engravings, Maria Merian could have seen page after page of highly stylized blooms: rod-straight cactus; smooth, oval pineapples; round, frilly carnations. All looked more like they might be found woven into a tapestry or embroidered on a sleeve than growing in a garden. Most were posed like specimens in a herbarium, cut from stems and with labels, some with pods, seeds, slices of root, but beauty was obviously the main concern. Matthaus Merian republished the *Florilegium* in 1641, so Merian could have encountered not just the pages, but the plates.

What would she remember from these early years? Her father's face, sharp with intelligence, holding a printed page up to the light. Silhouettes of older siblings, hunched over an engraving, drawing a needle through cloth, pulling feathers from a grouse. But maybe it was here, in the stacks of books, more than in the warm kitchen or the garden, that she saw all she might do. Each book was a door that eased open as she traced a finger over the illustrations of streets of Heidelberg or the scaly back of a Florida crocodile.

When Merian was three, her father died. He left her with his name and pride in it, a feel for the way black lines on parchment carve a story, and a 1,300 guilder inheritance. In a time when a day laborer might earn a little over a guilder a week and a university professor might earn 150 guilders a year, this would keep her until she got married if she were frugal. He also left her the emblem of his printing press, a stork with a motto that sounded like a parental admonition: "Pious diligence wins."

The city itself was a remembrance of her father. The cathedral spires, the tight, closely packed lane of the Jews,

the cranes along the riverbank, hauling wine and wood from passing ships, the fields and sleepy roads that reached beyond the city walls, all had been observed and mapped, by him. The pictures he engraved and published were, for many, defining images of Frankfurt. Alleys, church steeples, birds over the water: he recorded and printed each one, and it must have been at times difficult to see them fresh. Even after he died and she and her mother moved out of the house, she still could have glimpsed his hand in the sun gleaming off a line of roofs or in a strange alley that suddenly turned familiar.

But in time she developed her own maps of the city. Even if she didn't absorb a fascination with insects in her mother's womb, they must have caught her eye early. Here was the rotten tree stump, riddled with termites; here was the neglected corner garden with plentiful caterpillars on the tangled plants; there were the rosebushes so carefully tended they never yielded any life beyond their waxy petals. A certain patch of flowers might reliably lure butterflies, which she called "summer birds," probing for nectar with their long proboscises. Particular eddies along the limestone banks of the river Main drew skimming insects in the summer. The city forest held its own creatures, as did cracks in the fortification wall. People, too, took on new layers of personality: the man who gave out silkmoth cocoons, the woman who let a girl look under leaves in her turnip patch, the family that kept their lantern lit late, drawing moths to tap against the windows.

Before long, this map needed to incorporate a new home. A year after Merian's father died, her mother married Jacob Marrel, a painter and art dealer. A student of Frankfurt's still-life master George Flegel, Marrel studied in Utrecht as a young man, but came back to Germany with

the children from his first marriage: nine-year-old Sara, eight-year-old Franciscus, and Fredericus, the same age as Merian. There was also a boy of about eleven, Abraham Mignon, whose father sent him to Marrel as an apprentice when he was nine. Serving as a painter's studio and an art dealer's showroom, hosting apprentices and attracting customers, the building was as full as the Merian household, but even louder with all those children.

The young Maria Merian's personal chart of the city also likely included a school. Germany's principalities were some of the first to require elementary education for both sexes (though in separate classes), either in church schools or in the independent "corner" schools that cost more, but taught more of substance. Here, for a few hours a day, girls between the ages of roughly seven to fourteen sang psalms, learned to read and memorize Bible stories, practiced forming their letters and writing their names. They went over the simple arithmetic so important for those who would marry merchants and calculate inventory or sell vegetables in the marketplace. To lead these classes, one tract titled "On schools for girls" recommended "an honest matron who can teach, who knows how to deal properly and reasonably with girls, who loves the Word of God and likes to read the Bible and other good things." Under her care, they learned not only how to spell, but how to be a good woman, obedient to her husband, committed to her religion, devoted to the management of her household.

The war disrupted many of these schoolrooms and parents often bucked the edicts and kept their children, particularly their girls, home. They needed them to bring in the harvest, look after younger siblings, or contribute wages from work as servants. The required supplies — paper, for instance — could push the cost of even this basic education

out of reach. In the middle of the seventeenth century, only about half of eligible students showed up to class and only a third of those were girls. But if any girl mastered reading and writing, it would be a printer's daughter.

And Merian did learn to write, though it would never be her strong suit. Her study book entries use simple sentences and the text of her books is nowhere near as eloquent as her illustrations. Framing an argument and mastering the complexities of grammar came with studying Latin, which was only taught to young men preparing for the university or the occasional daughter of the aristocracy who learned from her brothers' tutors.

Between Bible verses and the handwriting manual, there were other lessons to be learned. It was here, in these classes, if her mother hadn't already taught her, that she might memorize and recite the proverb of King Solomon:

> *Go to the ant, you lazybones;*
> *consider its ways, and be wise.*
> *Without having any chief*
> *or officer or ruler,*
> *it prepares its food in summer,*
> *and gathers its sustenance in harvest.*

For someone who found the spider weaving its web on the schoolroom window as riveting as the teacher drawing an "A" on a sheet of paper, the words of Solomon had a particular resonance. God had blessed Solomon with great knowledge, the same kind Merian craved. In the apocryphal book "Wisdom of Solomon," Solomon learns:

> *How the world was made, and the operation of the elements:*
> *The beginning, ending, and midst of times: the alterations of*
> *the turning of the Sun, and the change of seasons:*
> *The circuits of years, and the positions of stars:*

*The natures of living creatures, and furies of wild beasts: the*
*violence of winds, and the reasonings of men: the diversities*
*of plants, and the virtues of roots.*

As an adult, when Merian uncovered a teeming nest of ants and engraved their life stages, she wrote, "I have consequently recorded them here so that like Salomon I can investigate their virtues."

Her real education, though, would be at home. Girls played an integral role in a business like her stepfather's and her father's, and teaching them well was worth the investment. Household industries depended on the work of women, whether daughters engraving illustrations, maids carrying stacks of paper and buying pigment in the marketplace, or wives planning meals for a whole crew of employees or updating account books. Throughout Germany, the powerful craft guilds that governed each industry tried to curb this female participation and excluded women from the steps to professional acceptance: apprentice, journeyman, master. Journeymen's organizations encouraged these prohibitions, viewing women and children as unpaid competition. Often wives were the only ones officially allowed to contribute to the workshops, and a widow of a master could run a workshop for only a limited time after her husband's death before she was encouraged to marry a journeyman or step aside for a son. But the reality of making a living dictated these rules be subverted. Some widows headed printing houses for decades. In places where daughters were permitted to work in the business but not maids, masters adopted their maids. A 1676 engraving captures the busy frenzy of a printer's workshop in Nuremberg with one man wetting paper for the press, two others at the machine,

still others debating letters and engravings. And off to the side, near one of the racks of type, handing something to a man leaning over the trays, there is a girl.

One of the stepfather's apprentices, Johann Graff, drew a picture in red chalk and ink of Sara, Merian's stepsister, when she was 16, embroidering in the artist's studio, capturing the feel of the home that doubled as a workshop. An easel rested against the diamond-paned windows in the back wall. Tools littered the drafting table. Sara gripped the needle with her fingertips, looking down at the emerging design. Her hair was smoothed beneath a handkerchief that, edged with lace, came to a point at the top of her forehead. Another square of fabric, pinned in place, protected the front of her dress. Her concentration was intense.

It's easy to imagine Merian in a similar pose. At the time of the drawing, she was eleven — an inquisitive, ambitious girl — racing toward adulthood. And there was so much to learn on the way. In her homes of books and art, she learned to spell and subtract, cook and sew. As she grew older, responsibilities heaped up, fingers became more nimble and additional abilities piled on. How to spin wool into yarn; how to knead a loaf of bread; how to choose herbs along the riverbank; how to judge a piece of fish.

On top of this, she collected the skills that would let her venture her first portrait of a silkworm two years later. Guild rules banned women from painting with oils, but not watercolors. Though she wouldn't have a formal apprenticeship like a male artist, complete with a trip abroad, she could pick up a lot as Marrel advised Mignon and Graff or had a spare moment to look at her sketch. How to mix a dish of carmine red; how to choose a piece of parchment; how to render the cupped petal of a rose.

Though it seems like nothing—the sweep of a brush across a clean, white surface—going from pigment to paint involved time and dedication. With mortar and pestle, she ground the pigments to the right consistency—light enough to hang suspended in water, smooth enough to load a brush with liquid red or green and no clumps—then mixed them with gum Arabic. These golden chunks, the sap of the acacia tree, bound the pigment to the page.

She tried her own ratios of pigment to gum Arabic, searching for the clearest, brightest reds and the endless greens—the green of the underside of a cyclamen leaf, or a new shoot on an oak branch, or the metallic sheen of a beetle.

With pigments from all over the world, paintings themselves became artifacts from many countries with their exotic colors, offering a different sense of global riches than that provided by *Grand Voyages*. Brown ochre ground from the earth, sap green distilled from buckthorn sap, indigo soaked, fermented and pressed out of woad plants, golden orpiment, scraped from the lips of hot springs and volcanoes, tyrone purple extracted from shellfish, and the most precious of all, ultramarine, ground from sea blue lapis lazuli stone, its heavenly hue often used for the madonna's cloak. Then there was the rich carmine, a red for berries, lips and blood, its origins then a mystery. Artists stole nature's colors for their own.

Brushes required equally tender care. Made of quills, they were sorted into size by bird: eagle, swan, goose, duck, crow, lark. The lustrous tips of martin or sable were kept sharp by dipping them in water and burning off wayward strands. Without animal tongues to keep them clean, they needed careful washing. Though Merian favored moths, she probably tried to keep the larvae of clothes moths out

of her brush tips by applying camphor, lending her paint-box a pungent smell.

Like the mixing and grinding, she would learn to paint by copying. Rather than sitting down with a vase of flowers or a grasshopper reaped from a flowerbed, she traced the marks made by those ahead of her, studying how to capture the frilled skirt of a snail's body beneath its shell or the puffed lip of an iris petal. Her earliest watercolor and sketching efforts repeated a grasshopper modeled by Marrel, a narcissus captured by her step grandfather de Bry. To practice accuracy, she drew a grid in chalk and sketched the plants tentatively before inking them.

She also learned how to engrave, carving pictures into a plate to be run through the printing press. Since her stepfather was a painter, not a printer, her deft touch as an engraver argues for a continued relationship with her half brothers, Matthaus the Younger and Caspar, who ran the Merian publishing house after her father died. Matthaus the Younger had been traveling Europe for more than a decade — Amsterdam, Paris, Venice — honing his oil painting ability on portraits of nobles and officers, not returning home until 1650. Caspar, more engraver than painter, had been laboring beside his father all these years, helping with the hundreds of landscapes of European towns that appeared in the series *Theater of Europe*. He had been in the house when Maria Merian lived there as a child and continued publishing as she became a young adult. If anyone told her stories about her father, let her copy de Bry's flowers, took her to visit the book fair, and showed her how to hold the burin, guiding the blade by the wooden handle nestled in her palm, it would have been Caspar.

Engraving took more muscle than painting and the pressure needed to carve metal with metal made it hard

work. Imagining her picture in reverse, she gouged the lines on a sheet of copper coated with varnish and soot so the red pattern would show up clearly against the black. Then there was scraping away the copper curls peeled by the tool, the burnishing out of mistakes. This kind of thing, if kept up for hours, would make the eyes water, the arms ache.

For a more delicate look, she might cover a copper plate with varnish, then draw her picture with a needle, scraping away the varnish in thin lines. She then put the plate in a tray of acid, which left the varnish alone but bit into the plate along the exposed channels. With the varnish washed away, an acid-carved picture was left. The etching was ready for the next step, and she would bathe the burin- or needle-carved plate in ink and wipe it away with a rag, leaving dark threads in the lines on the surface, ready for the press.

In these workshops, Maria Merian collected not only skills, but attitudes about art and nature. Marrel, a specialist in floral still lifes, knew the dangers of the acquisitive passion that made his patrons crave flowers and their pictures. During the height of the tulip mania that gripped the Netherlands in the 1630s, he drew illustrations for a tulip catalog. His pictures of streaky blossoms, round-bottomed and glossy as teacups, helped fuel the fever that caused fortunes to be won and lost on tulips, the rarer the better. Eager buyers bartered their homes and acres of land for one oniony bulb of a Viceroy. Since the plants reproduced so slowly, many of these transactions consisted of only paper, haggling over bulbs that didn't yet exist. Entranced by the flower's beauty, then its rarity, then the money-making possibilities, people lost their heads, and their money, too, when it was all over. On the petals and leaves in Marrel's catalog

crawl tiny bugs: a rearing larva, a hornet with its forefeet busy. There is something cocky in the insect perched on the perfect, costly bloom, about to go the way of everything edible. Maybe this is where Merian learned to put so much personality in a caterpillar.

The apprentice Mignon developed a different vision: for him insects had a darker spirit. He portrayed them as emblems of death and decay. In his later paintings, they emerged from overripe fruit: larvae feasting on plum flesh, ants toiling on the skin of a peach, a beetle lingering near a hole-ridden cherry. He was part of a tradition of using plants and animals to represent elements of Christianity and morality, infusing them with symbolic resonance. Some of the finest insect engravings of the day appeared in the 1592 *Archetypa* by Jacob Hoefnagel, which featured detailed portraits of dragonflies and spiders over Latin phrases about flowers wilting but virtue blooming forever. Larvae and flies served as *memento mori*, reminders of death, as they flourished when the soul departed. The fly figured the devil. An ant might stand for hard work. Christ could be seen in a worm, a stag beetle, a grasshopper. The transformation of caterpillar to butterfly, in particular, spurred religious interpretation, with the larva as the human Christ and the butterfly as his resurrection.

As part of Merian's education, Marrel sent her out to find insects to use as models. As she wrote later, she was encouraged to make flower drawings "decorated with caterpillars and summer birds and such little animals, like the landscape painters do. They make one alive through the other."

What she found in these leaves and roots was both beautiful and terrible. A swarm of caterpillars could cripple a precious rose. A butterfly paddled the air with aching

grace. Some had mysterious writing on each wing, with Latin Cs and Ms and Bs along the edges. Some burrowed into the ground; others drank nectar. Her eyesight grew more keen as she searched through the garden. Pursuing these insects involved muddy riverbanks, rain-soaked leaves, the fruity smell of larvae, their shed skins and excrement, at close quarters. It must have been difficult to keep fingers and clothing clean. Like the words of Solomon, these excursions offered a sort of roundabout permission for an activity harder to justify than engraving or painting.

Despite the rush of learning, despite her budding fascination, it wasn't a uniformly happy time. Johann Maximilian, her baby brother, died at the age of two. In the next five years, a half brother and sister, Jacob Matthaus (apparently named after both Heim's first husband and her second) and Maria Elizabeth, would be born and die young. Merian's mother must have been exhausted and sad, knitting herself closer to her only surviving child.

And then, Marrel left. Taking Abraham with him, he went back to the Netherlands in 1659, when Merian was twelve. Maybe it was too hard to earn money in Frankfurt. Maybe with his two children with Johanna dead and his daughter and sons by his first wife almost grown or ready to be sent out as apprentices, there was little reason to stay. He didn't abandon the family completely—he came back periodically and undoubtedly supplied financial help—but much of the time, he was gone. The other apprentice, Graff, vanished too, heading to Italy to continue his artistic education with the traditional period of travel. The house, with no students, no buyers coming to look at paintings, must have been quiet.

This put Johanna in a tight spot. A married woman had few legal rights separate from her husband. She couldn't

make a contract, file a lawsuit, or cast a vote. A widow could represent herself in court if need be, but she wasn't a widow. More importantly, if Marrel didn't come back or failed to send money, there were few legally sanctioned ways she could make a living. Between the rules of the city council and the regulations of the guilds, a woman's economic life was tightly constrained. A woman could spin, at low wages capped by the weavers (who bought the yarn), or sew for a tailor for roughly two guilders a month. As a master's wife, she could run the workshop under his license, but there's no indication Johanna knew how to paint.

For Maria Merian, this upheaval was a loss, but also an opportunity. This time when the household was just the two of them may have strengthened the tie between mother and daughter. Throughout her life Maria Merian made a priority of looking after her mother. Even as an adult with her own family, she worried about her mother's finances, named her first daughter "Johanna," and returned to her side from far away.

Maria Merian could stretch in the newly opened space, let voices submerged in the babble grow louder. She now had more responsibility, more concerns about money, but fewer people looking over her shoulder. It was too early for her to get married, take up her husband's business, start a family, put aside what might be considered childish interests. And yet, she was old enough for years of lessons in art and observation to take root. Brush strokes grew more sure. Colors mixed true and rich. She added her own perspective. The year after Marrel left, Maria Merian hunted down a silkworm cocoon and began her insect investigations. As she would later record in her study book, after a lengthy discussion of her methods of raising and hatching cocoons,

"This research I started in Frankfurt in 1660." And then she added, "thank god."

As she waited for a caterpillar to spin its casing, or saw a butterfly go its indecisive way, what did she think? How to interpret this insect that so completely changes, trading earth for air? It makes a difference if, watching a moth drawn to the light on some warm summer evening, the viewer imagines "there goes the soul of the dead," or "an image of Christ," or "the nuisance that ruined my only wool coat," or "a species of Lepidoptera." How we understand those flapping wings triggers the flight of our thoughts, whose trajectory makes up who we are.

In the early part of the seventeenth century, those who thought about insects at all thought they reproduced by spontaneous generation. Old meat, rotten fruit, and heaps of trash transformed into maggot bodies. Insects were born from the mud. From dew. From books. Old snow gave birth to flies. Old wool to moths. Cheese to worms. Raindrops yielded frogs, and a woman's hair could turn to snakes if left in the sun. Cabbage was particularly potent. Caterpillars wriggled from between its thick leaves, poking through holes carved by appetite. And if the generation wasn't spontaneous enough, if the viewer couldn't wait, natural philosophers provided recipes:

> To get a fly —
> Sprinkle dead flies with honey water
> Place on a copper plate heated with warm ashes
> Watch worms appear
>
> To get a bee —
> Find a sunny space roofed with tile
> Beat a three year old bull to death

Put poplar and willow branches under the body
Cover it with thyme and serpellium
The bees will emerge

To get a scorpion —
Pound sweet basil
Put between two tiles
Cement together with sand and horse dung
Place in the cellar for a month
Open to find scorpions

Snakes, frogs, worms, all could be produced with a little care and the right ingredients. Even, some said, a man. But if these ambitious transformations happened less frequently, if they were hard to observe and document, maybe it was because the earth had little energy left for that kind of drama. Indeed, as one theory went, "After a long period of fertility, during which time many monstrous and marvelous generations were brought forth, the Earth Mother became at last exhausted and sterile and lost her power of producing man and the larger animals, still she retained enough vigor to bring forth (besides plants, that are presumed to be generated spontaneously) certain small creatures, such as flies, wasps, spiders, ants, scorpions and all other terrestrial and aerial insects." Like the fairy tale about the evil sister cursed with burping toads, the earth could still offer up the occasional surprise, pleasant or not.

These notions had their roots in ancient times, unearthed during the Renaissance. Aristotle was still considered an ultimate source and authority, but insects eluded his efforts to fit them neatly into his philosophy. A little like plants, a little like animals, their development was riddled with exceptions to any rule. He thought they reproduced in one of three ways: sexual reproduction that produces animals like

themselves, as spiders do; sexual reproduction that pro-
duces something unlike them, as lice do (they form nits
which generate nothing); and spontaneous generation from
a potent mixture of heat and decay, as gnats do. But then he
writes that the larva itself is a kind of egg: "their Nature,
owing to its own imperfection, deposits the eggs as it were
before their time, which suggests that a larva, while it is yet
in growth, is a soft egg." And still, he allows for some cater-
pillars that spring from dew and clothes moths woven from
fabric. Of the wax moths that plague beehives, he said they
arose from cobwebs on the comb. Fire, particularly that
used to smelt copper in Cyprus, could spawn flies. Even
snow had its worms. Connections between one life stage
and the next are tenuous.

Pliny the Elder, an eager Roman encyclopedist, relished
a good story and included all he could find in his *Natural
History*. As he writes in his much quoted book, "when I have
observed Nature she has always induced me to deem no
statement about her incredible." Silk moths come from
vapor on oak blossoms ripped from the tree by rain. Their
cocoons start as fur to protect them from the cold. Dew
on radish leaves shrinks in the sun to seed-size, then pro-
duces maggots. Unlike writers who thought of insects as
brothers to filth, he ascribes to them a certain nobility. Re-
spectful clothes moths wouldn't eat funeral fabric. During
the Olympics, flies absconded across the river so as not to
anger the god Zeus.

Often storytellers offer more evidence than natural his-
torians. In one of Aesop's fables, a butterfly complains to a
wasp that in a past life as a human, he gave great speeches,
fought great battles, excelled in the arts. Now he is dizzy
and insignificant, fragile as ashes, while the wasp who used
to be a mule—a beast of burden—can give his enemies a

painful sting. The wasp replies, "Look not to what we were, but to what we are now." The tale, not written by a butterfly lover, apparently, reinforces both the common notion that butterflies are the souls of the dead and that wasps come from mules, as bees come from dead oxen.

Lacking other categorization, insects were often classified by what they destroyed. There were the bugs that chewed on helmet feathers, and those that specialized in the leather on shields. When Odysseus, disguised as a beggar, reenters his house in Ithaca, he schemes to get his hands on his hunting bow by staging a contest to see if any of the suitors can bend it. In the moments before he strings the weapon and unleashes slaughter on his competitors, he tests it for soundness, listening for hollow places carved by bow-eating termites.

Then there were the most feared insects of all — those that feasted on the dead. In the *Iliad*, as Achilles weeps and clings to the corpse of Patroclus, refusing to go back into battle, his mother Thetis drops a gift of divinely created armor at his feet with a clang. He is distracted, entranced, and ready to enter the fray, but he adds that he is afraid for Patroclus, "Lest in his spear-inflicted wounds the flies / May gender worms, and desecrate the dead, / And, life extinct, corruption reach his flesh."

Here Achilles, though prized more for his brawn than his intelligence, displays a good grasp of the insect life cycle. There is no indication that the larvae will arise spontaneously, and he seems to know that they come from the flies, as part of the conversion of death. Though Patroclus is dead, Thetis volunteers to block the hatching and feeding.

In his *Metamorphoses*, Ovid wrote of violent transformations spurred by passion. Physical changes like the sting of

a blush or the rush of adrenaline only hint at what's possible. In Ovid's retelling of Greek and Roman myths, a beautiful boy, consumed by self-love, turns into a white and gold flower; a talented young woman weaves a tapestry so intricate and daring that she angers the goddess of weaving and shrinks to a busy spider. A nymph, overcome with desire for a naked young man who dives in a forest pool, wraps herself around him and together they become a tree. Even the tellers of this tale are turned into bats for spinning stories and embroidering instead of celebrating the feast of Bacchus.

But Ovid also describes non-human animals and their transformations. Citing examples "tried by proof," he lists these alterations:

> *We see how flesh by lying still a while and catching heat*
> *Doth turn to little living beasts. And yet a further feat:*
> *Go, kill an ox and bury him (the thing by proof man sees),*
> *And of his rotten flesh will breed the flower-gathering bees*
> *Which, as their father did before, love fields exceedingly*
> *And unto work in hope of gain their busy limbs apply.*
> *The hornet is engendered of a lusty buried steed.*
> *Go, pull away the clees from crabs that in the sea do breed*
> *And bury all the rest in mould, and of the same will spring*
> *A scorpion which with writhen tail will threaten for to sting.*
> *The caterpillars of the field, the which are wont to weave*
> *Hoar films upon the leaves of trees, their former nature leave*
> *(Which thing is known to husbandmen) and turn to butterflies.*

For Ovid, the change of the caterpillar to butterfly is the same as that from crab claws to scorpion, from mud to frog, from horse to hornet. It is a total transformation. And in his proof, only the information that comes from farmers is accurate.

Maria Merian would have been familiar with all of these stories, particularly the Ovid. Her father published an edition of the *Metamorphoses*, a version originally printed by de Bry, and the brutal images and the questions they raised were part of her inheritance. But the metamorphosis story that might have resonated most strongly for Merian, she undoubtedly never read. Called "The Lady Who Loved Insects," this Japanese fairy tale is only a fragment, attributed to Kanesuke Fujiwara in the 10th or 12th century.

It goes like this: Once, there lived a young woman who loved insects, particularly caterpillars. How shallow, she felt, to praise only butterflies and not the creatures they grow from. She collected snails, crickets, reptiles and larvae and kept them in boxes to see how they would develop. Her ragged hair and shaggy black eyebrows (rather like caterpillars) scared off suitors, but not the town's little boys who brought insects to her house, placing them on the white fan she held out the window.

She was straightforward about her desires and ambition: "I want to inquire into everything that exists and find out how it began. Nothing else interests me."

She tried to share her passion, persisting despite frequent rebuffs. As Arthur Waley translates: "Then she again explained to them carefully how the cocoon, which is like the thick winter clothes that human beings wear, wraps up the caterpillar till its wings have grown and it is ready to be a butterfly. Then it suddenly waves its white sleeves and flits away."

But her eccentricities and notions met with indifference. Well, not complete indifference. One young man sent her an artificial snake, hoping to scare her, knowing that she only loved natural creatures. She was not frightened. Another, a captain of the horse guard, paused outside her gate

and watched as the boys dropped off their squirming prey. He wrote her a letter, saying that he couldn't keep his eyes off her hairy eyebrows. But when she responded, he lost his nerve and wrote back: "In all the world, I fear, exists no man so delicate that to the hair-tips of a caterpillar's brow he could attune his life."

And then, it stops. The promised chapter two is nowhere to be found. The captain neither rides off nor changes his mind. The young woman neither converts the town to caterpillar love nor plucks her eyebrows. The rest of the story is lost or unfinished. Sad, but probably for the best. Compromises would have to be made, and her straggly hair is endearing. How could it end, but badly?

But this is not only a fairy tale. It documents stages of insect transformation. An even earlier description and indication of understanding of at least one insect's metamorphosis also comes from Asia. In Chinese tradition, in 2700 B.C. Si-ling-chi, wife of prince Hoang-ti, discovered how to use the thread spun by silkworms. After examining caterpillar and cocoon, she determined how to raise the insects, capture the silk, and make it into radiant clothes. She is remembered as the "Goddess of Silkworms."

Merian's most direct reference for information about insects would have been one of the encyclopedias, popular during the sixteenth and seventeenth centuries, that offered to show all the animals on earth. Each in its own way reflected clearly the conflicts about insects and their origins. The Swiss natural historian Conrad Gesner started his series *Historiae Animalium* in 1551, but died with the insect book incomplete. Thomas Moffett incorporated much of Gesner's work in his *Theater of Insects,* but he too died before it could be published. The book, finally released in 1634, covered not just the bees and ants that so fascinated Pliny

with their industry, but glow worms, horse leeches, and flying lice. Moffett expanded the field of creatures deemed worth understanding. The author makes claims for direct investigations, complaining of "how many stings the Insects of the lower ranks have assaulted me, how much they have troubled my brain, my right hand, my eyes, whilst I accurately dissected and observed all their parts," but the book is thick with citations of ancient philosophers.

Moffett divides flies into those that "come from themselves by way of copulation" and those "that are bred in Dung, Apples, Oaks, Beans." He mistakenly suggests that butterflies adopt the same colors as their caterpillars and that the tail of the caterpillar becomes the head of the butterfly. Though the text clearly states that one turns into the other, Moffett puts the imagos, larvae, and pupae in their own chapters, wrenching life stages from each other. The preface, by Theodore Mayerne, who finally wrestled the book to the publishers, sees hope for alchemy in insect metamorphosis. If these worthless creatures can transform, why not metals? Though he admits he can't see what good insects do humans, the preface states in their defense: "If men should deny that they contribute very much to feed, and fat, and cure many other creatures, Birds and Fishes would plead for them, and the brute beasts that feed on grass would speak in their behalf."

The Italian Ulisse Aldrovandi made his attempt at confining the natural world between covers in 1602 with his thirteen-volume compilation of animal life. The range of coverage was so broad—giraffes, hippopotami, dragons, common birds, and monstrous mutations—much about behavior had to be guesswork. His *History of Serpents and Dragons* shows snakes and human-faced lizards that lived not on hair and skin like lice and fleas, but inside the stomach and

uterus, raising a host of unsettling questions. But he also incorporated his own observations, tramping through fish markets for models, raising flower specimens in his botanical garden, offering an inkling of the upheaval to come.

Between 1650 and 1653, the Merian publishing house produced its own version of the natural history encyclopedia, a series by Johann Jonston illustrated with hundreds of pictures. The books offered a snapshot of contemporary thinking: a hodgepodge of trust in authorities, belief in magic, and glimmers of uncertainty about often-repeated claims. Jonston unwittingly revealed the perils of relying on stuffed specimens rather than observation of live animals. In his discussion of birds of paradise, whose feet were traditionally removed before they were shipped, Jonston dutifully reports they have no feet. For his volume on insects, Jonston leaned on Aristotle and Pliny as well as more recent natural historians. He wrote about the insect eggs that farmers find in trees. He was dubious about birth from dew. But, like most catalogers before him, he was openminded to a fault and concluded: "I have no doubt that they can arise in all these manners, particularly during wet periods when the moisture first falls and is then followed by hot sunshine."

And then, around 1662, a very different book appeared. Johannes Goedaert, a painter in the Netherlands with no university education, wrote the first of three volumes called *Metamorphosis Naturalis*. The books, surprising in their narrow focus, detailed the transformations of dozens of caterpillars. Goedaert's friend Johannes de Mey shored up the book's academic credentials with learned commentary, adding citations to Goedaert's text, but pictures made the series's reputation. The plates showed insect metamorphosis, most often with each stage on top of the other in a ver-

tical stack. Goedaert rarely included eggs, showing just lar-
vae, pupae, and imago, and he allowed for spontaneous gen-
eration in some instances. But unlike Moffett, who placed
the stages in separate chapters, Goedaert put them all on
the same page, underscoring the importance of connections
from one to the next. The pictures aren't particularly stun-
ning. And though he had nimble touch with a paintbrush,
the engravings are stiff, each insect floating in a blank white
field. If this is a depiction of time, Goedaert seems to have
captured the mechanical clock rather than the grace of time's
movement. But still, their record of close observations was
revolutionary.

Somehow, either at the book fair or through her half
brothers, Merian got her hands on a copy of *Metamorphosis
Naturalis*. The book left marks throughout her work. At
several points she cites Goedaert's descriptions of worms
and butterflies. She eventually produced three caterpillar
books, an echo of his series of three.

But his most important legacy was the way he studied.
He kept the caterpillars in jars, fed them leaves and watched
their changes through a microscope, noting details of when
and how they transformed and then painting what he saw.
He searched for caterpillars by day. He examined moths
by candlelight. It was a technique available to anyone. His
words must have resonated with the young woman who
looked so closely at whatever crawled by: "I make mention
in the following of nothing that I have not observed with my
own eyes, and the only reliable approach to the study of nat-
ural process is through one's own observations."

As she sorted through these old-fashioned views, fol-
lowed Goedaert's new techniques, and watched the insects
turn and change, Merian took more notes and made
sketches. As she ranged further and searched out each new

insect, it soon became apparent that caterpillars other than silkworms changed shape, too. She witnessed repeatedly the butterflies and moths laying eggs that turned into caterpillars that, in time, cycled back into butterflies. Every time she tried it, the result turned out the same. Documenting the precise nature of each metamorphosis became suddenly important. Tending the insects through all their stages took "great effort," but memories of the drudgery vanished whenever a caterpillar revealed its new body. Given time, she might uncover things that had never been seen before. She kept gathering the caterpillars for what she soon would start thinking of as experiments.

In 1664, Graff came back from Italy. He had wandered through Rome and Venice, soaked up that golden southern light. He was twenty-eight, well educated, ready to step out of his apprenticeship and his journeyman's travels and into his career. And if he wanted to become master, the guild in many cities required he get married.

What did the sixteen-year-old Merian think of him as he showed up again at the door? In light of all that came later, it's one of the central mysteries of her life. Maybe he was the arresting apprentice whose hands she watched as they stretched a canvas over a frame. Or maybe he was the one she tried to elude as she slipped out in the dark to catch night-crawling beetles. Maybe it was time to leave home and he was a convenient vehicle. Money might have been hard to come by with Marrel gone: In his autobiography, Matthaus Merian the Younger complains that Johanna ran through most of the inheritance left by his father. A promising artist, Graff could continue the training that stopped when Maria Merian's stepfather left, and as the wife of a master artisan, she could engrave and paint in his work-

shop. And maybe, probably, her feelings inhabited the name-less territory between hope and dread, attraction and disgust, where most strong emotion lives.

By this time she would have watched the unfurling of hundreds of silkworms, so many she could predict each movement, like shifts in a treasured piece of music. She would know the price exacted by their usefulness. Tied to humans so long, dependent on them for food, the big-bodied moths could no longer fly. Their wings were an ineffectual decoration. And the majority, after doing their women's work of spinning and weaving, were killed in their cocoons and never made it to maturity at all.

She was still young to be a bride, particularly with a groom who was almost 30. Most of her contemporaries waited until they were in their mid-to-late 20s to get married and chose a spouse only a few years older. But time was acting on her as well. Holding still was not an option.

In 1665, the plague crept through London block by block, and doctors and preachers competed with their cures. Robert Hooke looked through a microscope and saw cells for the first time in a piece of cork. The Royal Society of London published its first transactions, covering both the appearance of Jupiter through a telescope and the discovery of an "odd Monstrous Calf" with a three-pronged tongue, like a dog of Hell. In his *Subterranean World,* Jesuit priest Athanasius Kircher described receiving a dragon's head from a Romanian hunter. It was, unfortunately, too decomposed to display in his museum. As the summer heat seeped in all over Europe, Maria Sibylla Merian shed her childhood identity and became Maria Sibylla Graff. It was time to be of use.

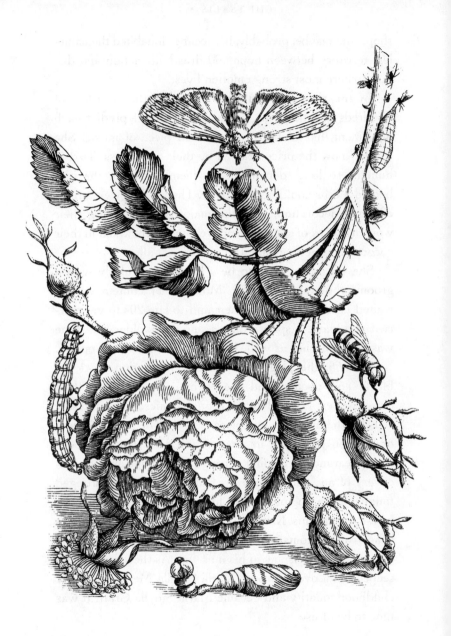

# Godly Miracles
# in a Little Book

Ruder heads stand amazed at these prodigious
pieces of Nature, Whales, Elephants, Dromidaries and
Camels;...but in these narrow Engines there is more
curious Mathematicks. Who...wonders not at the
operation of two souls in those little Bodies?
—Thomas Browne, *Religio Medici*

*Frankfurt am Main and Nuremberg, 1665–1686*

In 1668, Merian herself began to change shape. Well-
known curves swelled, her balance shifted. Her vision
perhaps grew keener, her sense of smell more acute. She
may have felt short of breath, in need of certain herbs, tied
to kitchen and bedroom and garden. Ranging through
the city became more difficult. Maybe, unable to sleep, she
stayed up later even than before, hearing moths beat against
the glass, biding time with bound cocoons.

Her pregnant womb had the tightness of a chrysalis,
and the same buried movement. Picturing the transforma-
tions taking place inside tested the imagination. Somehow,
within, an infant assembled herself. At times, forms turned
under the skin—a ghostly ripple of fingers, the rise of a
knee. Only time would tell what would emerge.

And all over Europe that same year and the next, great

minds puzzled over questions of reproduction and development, wondering about birth, about metamorphosis. How could a creature change so completely? And what did it mean that it could?

By the end of the 1660s, natural philosophers were developing doubts about the orthodoxy of spontaneous generation. The microscope, its first prototypes invented early in the century, showed that instead of lumps with legs, as they appeared to the naked eye, insects unfolded increasing layers of order. God apparently worked in not only mysterious, but very minute ways. New beauties of compound eye and fuzzy torso argued for even the smallest creatures as worthy of study and attention. Was spontaneous generation really how they were created? On the one hand, the theory seemed like a relic of ancient times — no one had tested it with the developing standards of observation and experimentation. On the other, if a caterpillar could become a butterfly, was that any different from a cabbage turning into a caterpillar? Was this change a new birth, or merely development? How could matter reform itself? How could a creature gain parts — a wing or an arm? What about a human embryo becoming an infant? These mysteries prompted a two-year explosion of research and writing that changed the landscape of not just insect investigations, but science itself.

In 1668, as Goedaert's final *Metamorphosis* volume went through the press, an Italian doctor picked apart a silkworm in Bologna. The secretary of the Royal Society of London had written to Marcello Malpighi, praising his studies of the human brain and the eyes of fish, lauding his devotion to first-hand observation and dissection. The Royal Society, a loose group of men who gathered to study "Experimental

Philosophy" as touted by Sir Frances Bacon and Galileo, often sought contributions from those whose work most interested them. The members were not scientists — the word didn't exist. Like members of similar societies in Germany and Italy, they were "natural philosophers" — doctors and curates and mathematicians taking on the whole world with an investigative eye, from puzzles of geometry and mechanics to blood circulation and the character of comets. The secretary mentioned that the Society was particularly intrigued by the silkworm. Would Malpighi consider a study? Malpighi embraced the challenge, pushing himself to finish this work promptly. Strained and puffy-eyed, in a matter of months he had looked more closely at an insect than anyone had before.

Malpighi examined the silkworm under the skin. He unraveled the long silk gland, and uncovered nerves, a heart and glands in a larva that many had considered a sac of undifferentiated goo. But what he found in the late stages of the caterpillar was most significant. Pulling the innards apart under a microscope, he discovered traces of antenna, legs, and wings. When pierced, these structures in the shape of future body parts collapsed. Liquid leaked out. The shapes dissolved. But still he concluded, "it will not be absurd to entertain the possibility that this new stage, the pupa, is nothing but a mask or covering for the moth already engendered, so that if not aroused or harmed by blows from external objects, it may in this disguise acquire solidity and grow up, like a fetus in utero."

In the Netherlands, naturalist Jan Swammerdam read Malpighi's work with great excitement. Though his father urged him to get a real job, maybe as a doctor or clergyman, Swammerdam kept tapping into family funds, chasing more dragonflies, and fashioning himself into the insect expert of

the age. With a large collection of specimens at his disposal, Swammerdam had been conducting detailed studies using methods similar to Malpighi's. Unfortunately, in 1667, at about age thirty, he contracted some kind of "quartan ague," possibly malaria. This blood disease, left untreated, would have flushed him with bouts of high fever and chills, headaches and sweating, periods of delirium and periods of incapacitating weakness. His life alternated between fervor and collapse.

Swammerdam, inspired by Goedaert and intrigued by Malpighi's detailed diagrams, became a master of the miniature. Looking at his illustrations of the interior organs of a louse, bulbs and tubes and bristles splayed along the page; or the thread-like nervous system of a snail; or a mayfly larva, upper skin removed to show carefully labeled trachea and intestine; is enough to give a viewer eye strain. To imagine creating them—the steadiness of hand required; the patience to spend a full day, as he often did, cutting layers of skin with tiny scissors, washing away the fat, inflating vessels using minute glass tubes—is even more exhausting still. But he found what he uncovered entrancing, all of it, writing "the glint of an elegant prettiness might be encountered anywhere, even in the excrement of the hornet larva, where fragments of flies it had eaten now shone like gold." Secrets were revealed with every snip: the hermaphroditic life of the snail, the ovary that showed that the king bee was a queen. He kept at it despite the tedious nature of the work, his dwindling funds, the fever that never quite cooled, his father's unending disapproval.

Following close on the heels of Malpighi's silkworm book, Swammerdam brought out his *Natural History of Insects* in 1669. Categorizing his subjects by type of metamorphosis, Swammerdam came out adamantly against spontaneous

generation. After many hours spent hunting and hatching insects, he stated with confidence, "It is certain that all insects proceed from an egg laid by an insect of the same species, with whatever warmth almost all philosophers have maintained the contrary."

He was equally opposed to "metamorphosis," but he used the word in a different way than entomologists today. What he objected to was the notion that one creature became a completely different one. This was implied by William Harvey, an English doctor most famous for discovering the circulation of the blood. Harvey compares metamorphosis to a sculptor carving stone or a seal biting into wax. The raw material of the caterpillar is refashioned in the "egg" of the chrysalis into something new.

Swammerdam sought to show that the butterfly existed all the time. He dropped a caterpillar about to turn into a pupa into boiling water, then jerked it out and peeled off the skin. To harden the internal organs, he soaked the animal in a mixture of vinegar and wine, then separated each part from the mass, claiming to have revealed the butterfly latent within the caterpillar body. It became his favorite party trick, and in 1668 he performed it for the Grand Duke of Tuscany. What did he actually see? Maybe the ghostly traces mentioned by Malpighi, the imaginal disks, which come into view just before pupation and contain sketches of a future shape.

This vehemence, though, labeled him a "preformationist"—someone who believed that each creature, shape complete though miniature, nestles in every egg. This was opposed to the idea of epigenesis, put forward by Harvey, that the organism adds limbs that weren't there before, developing from shape to shape. The questions of when a life began and how it developed slipped easily from issues

about spontaneous generation and metamorphosis. Swammerdam used his skills to preserve and draw a human uterus, sending it to the Royal Society. Malpighi moved from silkworms to the embryos of chicks, tracing movement from stage to stage. Dissections of women who died while pregnant and experiments conducted on babies still attached by the umbilical cord provided clues. Ovaries and fallopian tubes came into view, their purposes unclear. Most extravagantly, the preformationist belief led to the conclusion that Adam and Eve contained all humans that came after, perfect creatures tucked inside them, waiting to expand.

At the same time as Swammerdam unveiled his butterfly within the caterpillar, Francesco Redi, an Italian doctor, took a different route. He rolled up his sleeves and tried to generate creatures spontaneously. With recipes listed by Jesuit Father Athanasius Kircher as a guide, Redi cut up snakes, toads, pigeons and let them putrefy, expecting to breed snakes, toads, and pigeons. But he only got flies.

Redi decided to concoct his own experiments, to see if he could prevent spontaneous generation from happening, to keep the meat from yielding flies, as it did so reliably. In his first try, Redi took three newly dead snakes and put them in a box. Worms appeared, stripped the meat to the skeleton, then slithered off through the cracks. He plugged all the holes and did it again. This time, when the worms had nowhere to go, they turned into pupae, deepening in color from white to red and near black. The red ones soon cracked their cases and emerged as brilliant green flies. Some black ones shed their skins later and crawled out as hairy flies with black and white stripes. Others took longer, and flew off, on silver wings, marked by bright red hind legs and fine white spots.

Next, he put a snake, fish, eels and a piece of deer meat into individual flasks and sealed the tops with paper. He put the same ingredients in four more flasks, and left the tops open. As the meat began to stink and disintegrate, flies buzzed around the open containers, and worms crawled in and out of the flesh. The meat in the closed containers remained untouched, though the occasional frustrated worm squirmed on the paper cover.

As a final test, to be sure that fresh air didn't stir the worms to life, he put meat in flasks, covered the flasks with a fine mesh, put the flasks in a container of the same mesh, and watched as the flies circled, dropping eggs where they could, but not reaching the meat itself.

Behind the glass, the fish liquefied, the eels swelled, the deer meat dried — offering no visible quickening, except in the mind.

How many of these debates reached the house in Frankfurt, sheltering Merian, her husband, and infant daughter, Johanna, born in 1668? And, if they did, how much time would she have to explore the answers? Expectations of a wife were different from those of a child. No longer merely helping her mother, she shouldered responsibility for the entire house, spinning, embroidering, cooking, cleaning, laundering, as well as feeding, teaching, and chasing after Johanna. Merian's life was so different from Swammerdam's, swept up with her child, a spouse, the constant need to make money. All these precluded a whole day spent in contemplation of a caterpillar, as much as she might have enjoyed it.

Many women who worked in their father's business as young girls found it impossible to keep on after they married. Merian's friend Susanna Maria von Sandrart engraved and etched before her first marriage and after her

first husband died, producing images from cosmopolitan costumes to sea battles. When she married again, she wrote of her craft: "Because of the heavy demands of housekeeping I then had to give up this work completely."

But for a determined science-minded woman, the kitchen itself could be a site for experimentation. In a way, testing was part of the domestic and crafts culture. How-to volumes, called "books of secrets," contained instructions on everything from cooling a fever, to changing the color of gold, to crafting quality armor. The Royal Society recognized the value of this knowledge and, while members reached out to educated men like Malpighi, they also launched a "History of Trades," to plumb the expertise of dyers and winemakers for clues to chemistry and fermentation. Many of the books of secrets targeted tradespeople, but others were aimed at an audience of housewives. As a girl, Merian might have looked at these recipe books with Marrel, reading artists' and apothecaries' records of the chemical combinations used to make ink or a lustrous yellow. As a housewife she might have sought out chapters on medicinal herbs or scouring powder. These books served as practical guides but also as a record of a different kind of science than that being practiced in universities, one where experimentation, testing and replication were central in a way still foreign to much of the academy. They opened side doors and secret passageways into the study of the natural world.

In a seventeenth-century handbook detailing a proper education for gentlewomen, experimentation is actively encouraged. Merian was a craftsperson, not an aristocrat, but the suggestions are still revealing. In addition to learning how to embroider "pourtraitures and similtudes of Birds, Beasts, Fishes, Flowers," young ladies should know recipes

of physic and surgery related to their own health, and all "re-experimented experiments thereunto belonging." They should learn "perfect directions for the timely gathering of all sorts of Hearbs, Roots, Fruits, etc. therefore, or for any other purpose, with the true manner of using them, and the plenary discovery of all the effects of simples, etc. all rare and new devices and experiments of Cookery, not any thing omitted, relating to the illustration thereof, with all physi- call observations, naturall effects, operations, and cooper- ations of meats etc." On the other hand, gentleman were supposed to know about music and dancing, fencing and horsemanship, as well as "Fortification, besieging, defend- ing of places, fire-works, ordering of Battalies and marches of Armies," but little of experimentation.

The midwife who attended Merian during Johanna's birth, cleaning and washing the infant, preparing the swaddling clothes, negotiating any complications, provided another model of knowledge in action. Licensed by the city, charged with a vital responsibility, paid for their services, midwives were often married to artisans and so would have been Merian's social peers. For the most part, midwives could read, and their training included anatomy books, but also practical lessons from their own experiences and those of the women they tended. A 1690 handbook written by a German midwife finds a middle path between these two ways of learning. It opens with an engraving of female anatomy, information gleaned by dissection by a premier Dutch doctor, but is structured as a conversation between two midwives, the older sharing tips on medicines and birthing techniques developed through trial and error at many bedsides.

And so, among ladles and stacks of plates, pots of boiling water and heaps of onions, Merian made room for boxes to

raise caterpillars. The fireplace and mixing bowl became a laboratory to test formulas and observe chemical reactions. She explored notions, found in Aristotle, of heat generating life, and tried to get a look into the pupa: "When put on the warm hand it started moving vividly and you could clearly see that inside the changing caterpillar or better inside its date kernel was life nevertheless. But if cut open too early or after two days nothing but colored watery material/matter comes flowing out," she wrote. When Merian received larks for a meal, she killed them, then left them for three hours. When she came back for the plucking, seventeen fat maggots clung to the feathers. The project changed from dinner to discovery. Over the course of a week and a half the maggots turned into brown pupae and hatched into pretty green and blue flies. But the experience left her puzzled because, as she recorded in her study book, the larks "had been covered by me so that nothing could have come to them during that time." This sounds like an attempt to replicate Redi's famous experiment, where he covered the meat, forbidding flies from approaching and laying their eggs.

Around 1670, the Graffs and their now two-year-old daughter Johanna moved to Nuremberg, Graff's hometown. They followed the Main upstream, from the low hills around Frankfurt through country that deepened and broadened until towns nestled at the bottom of steep-walled valleys or looked out from the top of high peaks. These crests protected villages, and isolated them. The sleepy, shallow Pegnitz that ran through Nuremberg was so unlike Frankfurt's rushing Main.

The city itself harbored a touch of the medieval: in the way the houses faced the street; the way the streets wound

through neighborhoods; the tall towers with tiny windows to peer out at the surrounding countryside; the wall that embraced the city, and the moat that girdled it, breached by a drawbridge. Warmer than Frankfurt, Nuremberg was a place of strong allegiances and tight prejudices, reluctant to release imperial ties. Not long before, it had been the center of the Holy Roman Empire. Like a hothouse rose, the city was tended and displayed, petals closing themselves around the bud.

Even more so than in Frankfurt, city laws designed to curb vanity, slow the creep of foreign fashions, and reinforce class distinctions governed the minutest details of daily life. A woman shopping for a cap would have to recall the code as she fingered the merchandise. Caps trimmed with sable and martin, with pearls (on festival days) but no diamonds, were allowed the first rank. Second-rank women could wear velvet caps but with no buckles or lace. Daughters of the third rank could wear velvet caps trimmed with martin or silk caps decked with silver bangles. Fourth-rank women could wear only the cheapest velvet. Shoes, horse bridles, coach cushions: Everything was subjected to the same scrutiny. Merian, as a craftsperson married into an established Nuremberg family, would likely have been in the third rank, and adjusted her cap accordingly.

Wealthy families perched at the upper slopes of the hills, next to the castle, in houses of such extravagance that they would wipe guests' minds clean of their hosts' merchant pasts. They lived in rooms paneled with dark wood carved in the shape of columns, lion heads, angels. Sunlight streamed through the round panes of bull's-eye windows. One house, just a few down from the Graff's, had a painting of scenes from Ovid's *Metamorphoses* on the ceiling.

Gods and mortals flipped through their changes overhead, watched over by still more angels, pierced by wings like feather-handled daggers.

As much as Frankfurt was marked by Merian's father's vision, Nuremberg was marked by her husband's. Graff grew up there, his father a noted poet and rector at a high school, and his engraved portraits of the city helped frame her view. In some, he focuses on the parts of the city teetering near chaos. His street scenes, like those that might catch the eye of a roving newspaper photographer today, display a Nuremberg that eluded the mapmaker or a painter documenting the town square. One engraving shows a church in the middle of construction. Heaps of brick and strands of rope jumble together on the ground underneath scaffolding. Carpenters and masons, dwarfed by the size of the building, lay stones and haul materials up to each other in a barrel rigged to a pulley. In another, circus tightrope walkers balance high above a crowd. One acrobat slides down a rope on his stomach; another stands on his head on one of the posts that anchors the line. On the ground, children shoot marbles, dogs fight, musicians wail away on a violin, a horn, and a tambourine. The scenes pulse with busyness, but, somehow, not vitality. One twentieth-century critic described Graff's work of exhaustive detail as "executed with great care, but obviously in a fairly dull manner."

Outside the window of the Graff's house near the milk market, sausages grilled in a nearby shop. Knife-winged swallows squealed overhead. Dogs nosed around the front of St. Sebald's, a Lutheran church, where a large Christ stood crucified between the two entrance doors. Further up the hill was the house where the famous Albrecht Dürer had done his work, crafting images of stag beetles and lop-

eared rabbits in his quest for ideal beauty. Politicians headed to the statehouse; women hauled loads to the main market where they would sit beside their baskets of wares — heaps of cabbage, sheaves of grain, trees in pots. In the new rooms, Merian may have settled in to grind a dish of carmine red, or sat by her daughter, passing on all she'd learned: looking at a flower a certain way, engraving patterns on copper, mixing a moth-body gray.

She also sought to put these skills to use, to build the family's finances, to establish herself as an artist, using her private training in the public sphere. This would be a delicate negotiation. Nuremberg, a town famous for its crafts, had stronger guilds than Frankfurt. The painters' guild banned women, so even if Merian wanted to work in oil rather than watercolor or paint portraits rather then flowers, she couldn't have made a living that way.

Moving through the market, she would have met more subtle obstacles and warnings. Street sellers hawked misogynist broadsides, reflecting the ongoing debate about women's worth. None were more vicious than those published by Paul Furst, a printer the Graffs knew. One described a good man driven to distraction by a shrewish wife. She complains that he drinks too much, and turns his children against him. Finally, he gets a cudgel and beats her to death; "then the man's joy began."

These broadsides, as well as those depicting the "battle of the pants," struggles for household power, were supposed to be funny and release anxiety in relatively harmless ways. But the tensions over what to make of those who didn't know their place, worry about the collections of covert knowledge developed in the kitchen and bedroom, the clash of budding science and waning superstition, the

search for explanations of events like the plague or a cold snap that killed all the crops, erupted in far more sinister ways.

Like wildfire in a drought, witch hysteria flared up with the slightest stir of the wind. Some felt the cruelty and torture were a legacy of the Thirty Years War, where the sheer number of deaths made the populace numb to atrocity. Whatever the cause, by 1666, after decades of witch seeking and burning, the German Lutheran leader Benedict Carpzov boasted of sentencing 20,000 devil worshipers to death. Though that number may be an exaggeration, Germany executed more suspected witches than all the rest of Europe.

Some of the most notorious trials occurred not far from Merian's new home. In Wurzberg, according to concerned citizens, the Devil held a mass with turnip scraps in the place of wine and wafers. While the typical suspect was a poor, elderly, woman inhabiting the fringes of society, when full-fledged panic hit, even wealthy, high-status citizens could get caught in its path. Doctors, pastors, religious students, and a hazardously beautiful nineteen-year-old girl fell under suspicion, and executions followed. In Bamberg, the mayor himself confessed, after torture with thumb screws, that a woman in his orchard had turned into a goat and convinced him to renounce God. With crippled hands, he wrote to his daughter, saying it was all lies, but he was burned at the stake anyway.

Poisoning was a particular concern, casting suspicion on women who knew about plants. In 1650, according to accusers, more than two hundred children died at the hands of one diabolical midwife. Insects could be poisonous, too. The wives of innkeepers were suspected of killing guests by

serving them rats or caterpillars. Merian herself speculates that the horns on the back of one caterpillar made the Medicis consider it poison and stir it into potions used to off their enemies. Insects generally gave off a whiff of vice. One contemporary engraving shows a man exchanging his coat for caterpillars, over the inscription: "The trading of good for evil." An insect lover, collecting specimens in Spain, reported: "I have been suspected for one that Studys witchcraft, Necromancy, and a Madman by some who observed me in following butterflies, picking of herbs and other lawful exercises and I have had much to do to escape the censure of higher powers."

The twisting shape of metamorphosis could be godly, a remembrance of Christ's rebirth or the ascension of the soul to heaven; it could also be a sign of witches. Contemporary accounts of these women are filled with stories of unholy shape changing. In a discussion about whether werewolves exist, the French judge Henri Boguet cites insects as an example of where such transformation is possible. "It is again instanced in the transmutation of all sorts of herbs and plants into various kinds of worms and serpents... And in the town of Darien, a Province of the New World, drops of water are in summer turned to little green frogs." He ultimately concludes that witches don't turn into wolves, though allows that Satan himself might.

The birthing bed, the mayor's orchard, the roadside inn: Nowhere was safe. Boguet wrote in his 1602 witch-hunting handbook, "If we but look around among our own neighbors, we shall find them all infested with this miserable and damnable vermin. Germany is almost entirely occupied with building fires for them... there are witches by the thousand everywhere, multiplying upon the earth even as worms in a garden."

Even if she found permission in Solomon's nature studies in the Bible, Merian's interests remained inextricably odd. It was a dangerous time to have muddy fingers. A dangerous time to be different. How could Carpzov be boasting of the numbers of witches he killed at the same time as Redi pioneered standards of scientific experimentation with his flasks of flies? But the threat was very real. In 1617, the astronomer Johannes Kepler, busy with mathematical harmony, had to defend his mother against charges of being a witch. A young woman developing a reputation for seeking out caterpillars, with a burgeoning store of knowledge and stacks of cocoons in her kitchen, would have to be very careful.

One route to protection, a path Merian would take throughout her life, was to quickly ally herself with the powerful. Respectability was a cloak thick enough to cover almost any strangeness. As they settled into the city, the Graffs entangled themselves in a social and professional web. The Sandrart family, an artistic dynasty that was a Nuremberg mirror of the Merians, offered a link to the community of painters and engravers. Joachim von Sandrart had served as an apprentice to Merian's father, then in turn taught her half brother, Matthaus Merian the Younger. In his 1675 survey of German artists, he included not only Merian's brothers and father, but Merian herself. Sandrart described her as most famous for "all kinds of decorations composed of flowers, fruit and birds, in particular also the excrement of worms, flies, gnats, spiders and all such kinds of creature, with all their possible permutations; she showed how each species is conceived and subsequently matures into a living creature, as well as indicating the plants on which

they feed." She is nothing if not prolific: "works like these seemed to emerge from her hands daily." All this, while being an excellent housekeeper, Sandrart noted.

His nephew Jacob von Sandrart was the most renowned engraver in the city and his daughter, Susanna, learned from him and included copies from Merian's pattern books in her work. Susanna's sister-in-law, the painter Dorothea Maria Auer, became a close friend of Merian's. Among all these new acquaintances, the young couple kept in contact with the old. Merian's stepfather, Marrel, who traveled back and forth from the Netherlands to Germany, stopped by and visited. Merian's half brother Caspar had married a woman from Nuremberg, and likely came to town.

Though still young herself, Merian became a teacher, gathering around her a group she described in a letter as a "company of maidens." She taught the girls in the style where she felt most confident, painting decorative blooms like those found in the *Florilegium* of her step-grandfather. She and her students also actively experimented with their paints, investigating the constant question of color: how to make it stay? She searched for the clearest hues, concocting a mixture that was waterproof on fabric. One of her customers put this claim to the test, washing a tablecloth decorated by Merian and hanging it out for all to see. With these lessons and recipes, she knotted herself further into Nuremberg society.

Her pupils prompted Merian's first publication in 1675, a book of flowers, her *Blumenbuch*. Similar to her grandfather's *Florilegium*, each page showed a blossom or two, across from the name of the plant. Merian sold the loose sheets together in bundles of twelve. They were a distant project from her insect studies, but undoubtedly using her

artistic skills gave her satisfaction. And with a house, a child, a circle of wealthy friends to keep up with, the Graffs also may have been running short of money.

In her flower book, Merian plays with different techniques, sometimes copying directly from her mentors: a still life with flowers in a Chinese porcelain vase, like Marrel; marigolds planted in the ground, with the patch of earth visible; baroque hyacinth leaves that curl around the stem in perfect curves; streaked tulip blossoms that could have come from a tulip book; a goldfinch, emblematic of Christ, like the ones Mignon painted; an iris that is an exact copy of one by artist Nicholas Roberts. Still learning, she cast about for a style.

She painted flowers in all their ornamental glory, not as players in the complex ecological tales she would tell later. For instance, though she'd watched insects consume a rose from the inside out, the glossy leaves are marred by only a few picturesque holes. One of the roses is missing petals, the better to display the spray of stamens. But the overall impression is of perfection—the flowers artificially round, lush, and frilly like those that might be found in de Bry's *Florilegium* or pinned to the toe of a slipper. The sole insect, a butterfly, rests upside down in the curve of the stem, balanced in the center of the picture. It doesn't interact with the rose except to use it as a pedestal. Its small brown body is dwarfed by the exuberant blooms.

Like this butterfly, insects in the book were as purely decorative as a dragonfly pin with emerald eyes. In fact, one use of the sheets, as she instructs the reader, is for embroidery patterns. When this modest first publishing venture was successful, Merian issued two more sets of twelve, one in 1677 and one in 1680. She bound them as a book, and sent individual sheets to friends and students.

Though the flowers are engraved with care, Merian's ambiguity about this useless beauty comes through. In her introduction to a bound version of all the sheets, she warns of the dangers of pretty flowers. She cites the tulip speculation in Holland, which she must have heard much about from her stepfather. She tells of the red-flamed *Semper Augustus*, so rare there were only two in all the Netherlands, so rare it couldn't be purchased for any amount of money. She describes the buyers who ransomed everything — houses, estates, the tools of their trade — to get their hands on tulips, "the flowers that had neither smell nor taste, only so that they could enjoy for a short time the transitory beauty."

Another story is even more pointed. Emperor Maximilian, she writes, saw a farmer planting date palms as he was passing by. The emperor called out to ask why the farmer spent time on trees that grow so slowly the fruit would ripen long after he's dead. The farmer replied that he did it to honor God and provide for his children, an answer that pleased the emperor so much he gave him a heap of money. Planting date palms represents wisdom and foresight. "On the other hand," Merian writes, "those who plant flowers or give flowers as presents don't think of God or the generations to come but rather would have the use of the flowers today rather than tomorrow."

Perhaps her feelings about the luxurious gardens and Nuremberg, the city that cultivated them, are best summed up by a story she tells in her study book. One day Merian and one of her favorite students, Clara von Imhoff, from one of the oldest and wealthiest families in town, took a stroll along the city wall. They were dressed magnificently, Merian notes.

While walking, they found a black caterpillar speckled with white and yellow on a plain-looking plant. Of course,

Merian brought it home to raise. The way she relates the tale, emphasizing the picture of the richly clothed ladies pouncing on the insect on the weedy herb, is inescapably amusing. Later, in her second caterpillar book, she gives the episode a moral cast, explaining they had been expecting to find beautiful insects on beautiful flowers, but "since we encountered nothing there, we moved to a common weed and found these caterpillars on the white dead-nettle." The insect with humble origins hatched into a stunning moth, wings with their upperside a constellation of white and yellow dots on a black background and their underside a rich red. Merian valued insects differently than her contemporaries, that much is clear. Perhaps teasingly, or perhaps out of genuine awe, she often described the caterpillars as if they were clothed in finery of their own, portraying their appearance as velvet or silver. In her paintings, she streaked occasional wings with real gold.

And so, far from her Frankfurt training ground, her investigations never stopped, though Merian may not have known what they were good for. New insects waited for discovery everywhere: on lilies in a garden she kept near the castle, on a carrot, in an old scarlet cloth. Holes in the wall of the Graff's Nuremberg property revealed mouse-colored pupae. When they eclosed, she fed the moths sugar water. A wasp's nest the size of a man's head hung in an old attic. The sandy earth in front of her house offered slinky white worms with black heads. Patches of sweet-smelling herbs traditionally scattered by the door of newlyweds yielded caterpillars that gobbled their food.

She ranged outside the city in search of her prey and gained permission from aristocrats to see what she might find on their exotic plants. By her early twenties, her pas-

sion for insects was so well known that the curious flocked to see her collections and friends sent her caterpillars as gifts, a tangible encouragement.

If she had trouble tracking the life of a particular insect, she raised the species repeatedly until she figured it out. Slow to draw conclusions, she rarely hazarded a grand theory, mostly sticking with what she saw. But what she saw was a web of interrelationships far more complicated than the dynamic of insect eating plant.

Sometimes, strange and unexpected patterns emerged. Two different caterpillars — one white with black arrows down its back, the other brown with two dark bands near its head — spun themselves cocoons and emerged as identical moths. Tiny white worms curled in twin pockets in an oak gall. How did they get inside the sealed chambers? Sometimes, when a caterpillar shed its skin, an identical, but larger caterpillar was revealed. Sometimes, though, the colors changed completely from molt to molt. Even stranger, though, were the caterpillars that shriveled up as if dead, only to yield a maggot or two.

One spectacular specimen proved particularly troublesome. Black with a red line down its back that ended in a spike like a tail, the caterpillar came in a box as a present from a friend in 1672. It arrived wriggling, but Merian didn't know what to feed it. It died before she could witness the change. She then tried for five consecutive years to raise one to a moth. One year, the caterpillar died in the cocoon. Another year, the caterpillars became infested with maggots that hatched their own kind of flies. In still another, red-eyed flies, rather than the moth she expected, buzzed out of the cocoon. These all challenged her notions of how a transformation should occur.

All this time spent experimenting gave her a chance to

observe the species closely. They started yellowish and turned red as they grew and shed their skins. When touched, they squirmed violently, "as if they were mean." Wolf's milk leaves (now called "leafy spurge"), the food she found for them, was considered toxic. Finally, twelve years after she first unpacked the gift box, a pupa opened into a soft pink and beige moth, now called *Hyles euphorbiae,* an emergence so lovely, interesting, and hard-fought that she was eager to paint it and "make it something that will be on the page forever."

Merian was alert to the scientific debates going on at the time, and in her methodical way, she tailored her observations to specific issues of contention. She may have kept abreast via a loose group of nature lovers, poets, and celebrators of the German language who dubbed themselves The Order of the Flowers on the Pegnitz. These men (and the occasional woman) took code names of plants — Mayflower, Meadow Clover, Hedge Rose — and wrote pastoral poetry. Her insect collections and flower drawings fit well with their interests, and members provided support and assistance. One let her search for specimens in his "maze" garden, a mile or so out of town. Another, Christoph Arnold, a professor of languages and poetry at the Egidien school, had traveled throughout Europe and met some of the scientists doing pioneering insect work. Through conversations with these men and browsing in their libraries, Merian could have learned of breakthroughs in insect studies far beyond the borders of Germany.

Though against spontaneous generation in most cases, even Swammerdam and Redi had been at times stumped by exceptions. What about the worms that appeared as if by magic, in the gut of dogs and men? What about the galls — swollen bumps of plant flesh — that revealed tiny

worms when opened? What about the cocoons that yielded flies in the place of moths? These all disrupted the pattern. Redi, who argued so passionately against spontaneous generation, allowed that it might happen in plant galls. Swammerdam suspected insects must deposit something in the plants, but he didn't have the proof.

So Merian sliced open the galls and drew what she found inside. One of the earliest images in her study book shows a blistered poplar branch. Growths like apples bulge on the stem; longer, finger-like galls spread in the leaf vein. Two kinds of aphids lived inside, along with the larva of a hover fly that preyed on them. She details this small universe, enclosed in plant matter, but doesn't contemplate in writing how the creatures got there. As for the flies that hatched from caterpillar pupae in the place of butterflies, no one had a satisfactory answer.

Spring of 1679 broke early and wet. Warm rain slicked streets and washed church windows. Clusters of lackey moth eggs wreathed plum tree branches. Hundreds of caterpillars feasted, gorging themselves on new leaves, spinning lacey communal webs. Fruit trees were stripped bare. Undoubtedly, many Nurembergers watched in dismay as prize plants were reduced to stalks and stems. Rather than writing of this as a plague or judgment from God, though, Merian speculated the previous hot summer or the unusually balmy showers created ideal conditions for the larvae.

As the insects flourished, circumstances proved ripe for Merian's work as well. The year before, in February, she gave birth to a second daughter, Dorothea, named after her friend Dorothea Auer. But even with a new infant to look after, she pressed forward with plans for a book based on her years' worth of insect observations. Notes on hatchings

and behavior piled up, alongside images of wing shapes and pupal casings. Members of the Order of the Flowers of the Pegnitz continued to express interest. The crowd-pleasing flower book may have given her the confidence to try something far bolder, taking what until now had been a mostly private obsession public. This book would be "a completely new invention."

The title told it all: *The Caterpillar's Wondrous Metamorphosis and Particular Nourishment from Flowers in which for the benefit of explorers of nature, art painters and lovers of gardens though a completely new invention the origin, food and development of caterpillars, worms, summer-birds, moths, flies and other such creatures, including their times and characteristics are diligently studied, briefly described from nature, painted, engraved in copper and published by Maria Sibylla Graff herself, daughter of Matthaus Merian the Elder.*

The pictures are, as promised, an entirely new way of seeing. They show the butterfly not just as a decoration, an emblem, or subject of dissection, but a member of a community. The reader encounters not merely an object to be examined, but a drama of miniature proportions. In each picture, a caterpillar appears on the plant it eats, along with its pupa, its cocoon, if it makes one, and the resultant moth or butterfly. Sometimes, the butterfly is laying eggs on a leaf or along the stem. Often the caterpillar's predator, a fly that will emerge from the cocoon after killing its host, appears also, with many of its life stages. All these elements made the illustrations startlingly unique. There had never been anything like them.

The watercolor of the rose used as a model for plate 24 shows most clearly the distance she traveled from her first book. Rather than the ideal, it is almost a witty commentary on it. The pink flower seems, from a distance, flawless.

Then the reader notices the tiny black head sticking out of the lower bud, as if leaning out of an upper-story window. And a cocoon, no longer than a pinky fingernail, curled against the stem leading to a bunch of leaves. A black-headed green caterpillar inches across the top petal of the other bud. The centerpiece bloom has its petals marred by a tiny banded larva. Two yellow moths hover nearby. Life has taken over. The rose is a whole neighborhood.

Christoph Arnold, her friend from the Pegnitz Society, wrote a poem bound in the introduction. While her references in the flower book had been mostly to previous artists, Arnold places her firmly within the budding scientific tradition. He addresses the reader:

> *It is remarkable*
> *that women also venture to write for you*
> *deliberately*
> *what has given flocks of scholars so much to do. What Gesner*
> *Wotton*
> *Penn*
> *and Muset neglected*
> *to write about; in this*
> *England*
> *my Germany has emulated you*
> *with the pen of an intelligent woman.*
> *What Gudart*
> *and Mey*
> *in Seeland*
> *once wrote*
> *one reads*
> *albeit with pleasure: Yet it is praiseworthy*
> *that a woman desires to do so for you also.*
> *What Swammerdam promises*
> *what Harvey once lost*

*now comes to the knowledge of all;*
*that an ingenious woman has achieved all this herself*
*to occupy her time.*
*What the famous Red*
*in Italy*
*recently heard; what*
*so many years ago Stradan*
*formed in metal*
*at Florence*
*is only a joke to her.*
*Spain may also praise Bustamantin highly*
*we shall hold the same tests; and show*
*what can be done*
*by his daughter's diligence*
*the worthy Merian!*

In this long list of natural philosophy luminaries, Goedaert (Gudart) and Mey come in for the best treatment, indicating the esteem in which Arnold, and surely Merian, held them. The caterpillar book very obviously used Goedaert's *Metamorphosis Naturalis* as a model. Gesner, Wotton, Penn and Muset (Moffett) all produced early natural history volumes that were misguided in their representation of insects. "What Harvey once lost" could refer to his claim of birth from an egg for most everything but insects. The poem also acknowledges Swammerdam's importance, though Arnold paints Merian's contribution — a volume in the vernacular of German rather than scholarly Latin — as educating a larger populace. Interesting in his list, he mentions that Merian, at least, felt she had observed metamorphosis before Redi did in 1668.

Arnold wasn't the only one placing Merian within this scientific framework. Though in her introduction she por-

trays herself primarily as an artist, she uses the language of science very deliberately in her notes. Merian describes her efforts to "invent" techniques to bring a caterpillar that kept dying on her into the butterfly stage. In the same entry, she mentions finding tiny creatures on lily leaves and bringing them home to "investigate" what would emerge.

Despite Arnold's poem, despite her own claims about experimentation, Merian remained reluctant to put her work on the same plane as that of the university-educated men. This may have been because she genuinely felt doubts; it may have been her gauging the risks of stepping outside of her prescribed role. She was already operating close to the limit of what was possible. The introduction reminds readers she is a wife working with her husband's permission as she thanks Graff for his help with rendering the plants. Hesitant to venture an explanation for the fly and moth that appeared from the same cocoon, she indicates she will "leave this to the gentleman scholars."

But her ambition is unmistakable. The caterpillar book was no slight accomplishment, no few pages for her pupils to paint within the lines. Over the course of three volumes she would ultimately produce, she recorded the life histories of hundreds of insects.

In the introduction she outlines her view of the insect world. Feeling for a language to describe her observations, she places the specimens in broad categories. Some transform into a pupa "like a swaddled child" that hangs upside down from a plant and is flecked with silver or gold. She calls these butterflies by the traditional expression "summer birds," because they fly, for the most part, in the summer. Though she knows the term accepted by natural philosophers ("pupa"), she deliberately chooses the vernacular,

coming down on the side of common knowledge. Some, like the silkworm, form a cocoon, a dense oval web that surrounds and shields the pupa; still others create a pupa with no cocoon that lies on a flat surface, like a leaf. These two she named "moth birds," and mentions they can be identified by their big heads and love of the dark.

In a modern view, butterflies and moths are both in the order of Lepidoptera, which means "scale winged." The rules for dividing one from another are riddled with exceptions. In general, if a lepidopteran is brightly colored, flies during the day, and has smooth antennae with knobs at the end, it's called a "butterfly." If it is brown or grey, flies at night, and has feathery antennae, it's called a "moth." Except the day-flying, brightly colored speckled yellow moth and many others like it. In general, moths rest with wings lying flat, and butterflies rest with wings held upright, like hands pressed together. Except some skipper and metalmark butterflies, which rest with flat wings. In general, moths build cocoons or bury their pupae in the earth for protection, while butterflies change in naked pupae, the chrysalises. Except certain skippers and parnassian butterflies, which build rudimentary cocoons. All spin silk to some extent, whether to make the elaborate shelters of tent caterpillars; a protective cocoon; a thread to drop from one leaf to the next; or a tiny silk button from which a chrysalis can hang. Merian classed by type of transformation and behavior, and her categories roughly line up with those used today.

Though Arnold's poem seems to embrace the work of Swammerdam, Merian allows for spontaneous generation, at least among flies. Her caution, like that of Malpighi and Redi, resists overturning the idea entirely. Unlike caterpillars, which she sees as springing from eggs or "seed," mag-

gots and worms grow in rotten caterpillars, garbage, or caterpillar feces. Since they create oval cocoons which appear to play the role of eggs, Merian keeps the term "egg" to describe these structures and she distinguishes the adults by the name "flies."

For pupae, she uses the old German expression "date pits," arguing that this reflects their appearance. It also ties them to that wise farmer cited in her flower book, planting palms, possibly date palms, with his eyes on the future. The pupae, her observations, her engraved images for wide use and generations to come are the seeds of later sweetness. In late 1679, she brought volumes to the Frankfurt book fair, where undoubtedly she went as child. In the fall air, in the same spot where the Merian printing house displayed its wares, with her book side by side with what the best publishers had to offer, she might have got a lingering taste of her labor bearing fruit.

In 1681, Marrel died. Though he had been gone more often than home, he still provided support for his wife, and his loss would have been keenly felt. Merian, her husband, and their daughters traveled back to Frankfurt to be with her mother.

After fourteen productive years in Nuremberg, Merian settled back into her home town. She scrambled to be sure her mother had enough money, filing a lawsuit against her stepsister, Sara, over Marrel's inheritance, and winning. A carpenter brought her a split piece of fir and pointed out a cocoon nestled there. When he found a worm that had eaten a chamber in beech wood, he brought her that, too, and later, she wrote in her study book, "we also found another one that had already turned into a pupa." Around June of both 1683 and 1684, her study book records that

she was in Bad Schwalbach, a small town outside the city known for its spa. Her father had died there in June 1650. Perhaps she went to pay her respects, discovering a pale, quiet caterpillar and oak galls even while standing by his grave. She lingered in Frankfurt, and produced a second volume of her caterpillar book, published there in 1683. She had left the city as a young wife and mother and returned as an author.

She wrote fond letters to her pupil Clara back in Nuremberg, addressing the young woman as "very noble, honourable and virtuous, especially beloved Miss," praising her artwork and reminding her gently to keep at it. "[I]t gives me boundless contentment to see that my very honoured Mistress devotes herself more and more to her art and does not grow neglectful, but instead beautifies the art with her own precious skills," she writes after Clara has sent her a painting. The letters might contain a package: a shell of paint, a jar of varnish, an engraving for Clara to color, a sketch for Clara's brother's album. Folded four times and sealed with a splotch of red wax, they were carried by friends traveling between Frankfurt and Nuremberg. The seal bore the imprint of men in her life. The image — a stork with its leg raised — recalled her father. The initials JAG were her husband's. But the words and enclosed watercolors were her own.

Throughout her time in Nuremberg and Frankfurt, Merian painted roses over and over. She engraved them more than once in her books, jotted quick roses in friend's albums. The flowers were beautiful and prized almost as much as tulips. But, through time, the emphasis shifts. The insects take over. While the rose from her first caterpillar book is enlivened by caterpillars and moths, the roses from her second caterpillar book, published in 1683, look de-

feated. On one, a small larva builds its pupa right in the center of a hedge rose and another, larger caterpillar webs the whole plant together, tying petal to stem to leaf with tiny threads. Two of the blooms turn their openings away from the viewer, etched in shadow. On the previous plate, the bloom hangs upside down, petals dragging on the ground. One bloom has lost its petals entirely. It is overrun. A caterpillar, long as a leaf, props itself on the frills of a petal edge with its hind feet and reaches for a rosehip. Tiny flies wander the stem. A large striped fly has chewed off the top of its cocoon, stepped out and inches toward a bud. A moth hovers at the top, taking the measure of a leaf with its antennae and feet, positively triumphant.

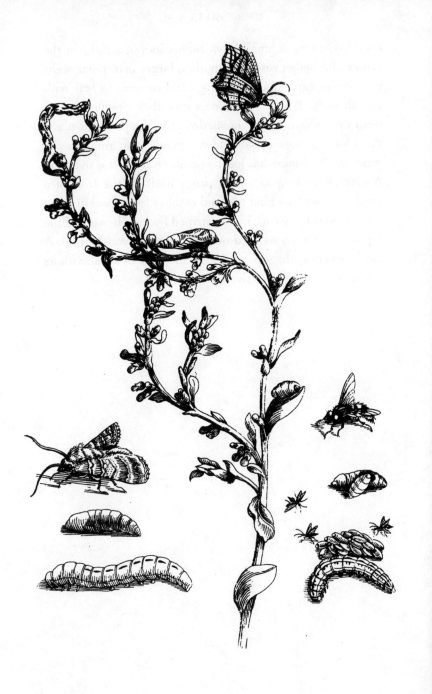

# That Which Is Found in the Fens and Heath

The omnipotent finger of God is presented
to you in the following sheets, in the anatomy
of a vulgar and loathed insect, the Louse; wherein
you will indeed find miracles heaped on miracles,
and will be amazed at the wisdom of God,
most clearly manifested in a minute point.
—Jan Swammerdam, *The Bible of Nature*

*Wiewert, 1686–1691*

A way from the quince trees and sloe hedges with their
caterpillar fruit, in chapels and private rooms, a reli-
gious revolution flickered within Frankfurt city bound-
aries. Now that the Thirty Years War faded in memory and
people no longer had to scramble so hard just to survive, a
certain self-indulgence took root. Some said the decades of
fighting had coarsened people, made them care more about
possessions and less about God. Fashion and manners from
France replaced the simplicity of local wear. Dresses shone
with velvet. Triple strands of pearls encircled necks; caps,
once simple, white and modest, were embroidered, shot
through with gold, replaced by ribbons. The contrast be-
tween the flaunted wealth of those who had come through
the war with resources intact and the beggars who flooded

the streets made some feel queasy. In response, many searched for respite in the church.

This unease was captured by a new senior pastor of the Frankfurt Lutheran ministry, Philipp Jakob Spener. He had long been mulling over how to get his flock to live Christian lives rather than merely showing up for services. In his 1675 book *Pious Desires, or Heartfelt Desires for a God-pleasing Improvement of the True Protestant Church* he laid out the arguments that launched the movement of Pietism.

He preached a simple, holy life. Christianity should focus on moral choices made every day, rather than arcane intellectual debates about theology. He preached that believers didn't need a priest to answer their questions about the Bible. They could keep a Bible themselves and meet with like-minded people in their homes to discuss scripture. He preached believers should teach religion to their children and servants, convert their neighbors, and correct them when they went astray. He preached an intimate, emotional, relationship with God.

And apparently he preached it very well. In Frankfurt, religious discussion groups put his ideas into practice, with members ministering to each other. The parlor became as valid a site for religious conversation as the cavernous cathedral hall. In some ways, this shift paralleled the release of natural philosophy into the hands of tradespeople and merchants—anyone willing to try an experiment.

And, just as in the scientific realm, the turn from academic disputes opened a portal for women. They didn't have access to university libraries and discourses in Latin, but Pietism allowed them to express religious thoughts and feelings. Johanna Eleonora Petersen, who as a girl had fled to Frankfurt with her mother and heard the soldiers marching

nearby, met Spener on a boat from Frankfurt to Mainz. The conversation changed her life. Unlike hypocritical Christians she knew who went to church in the morning and drank and danced in the evening, Spener came across as deeply sincere. "I felt truly consoled and strengthened and ready to break through and leave behind those worldly things that, out of ignorance, I had pursued until then," she wrote in her memoir. She promptly quit her position as lady-in-waiting to a duchess to find a holier life, one which included launching prayer groups, interpreting scripture, and, most radically, writing her autobiography. The autobiography, with its suggestion of the importance of an individual life and decisions, was not a common form and was practically unheard of for women. Another woman, a countess whose tutor corresponded with Spener, used inspiration from Pietism to write the first female-authored book of prayers for use during pregnancy. Unlike previous devotional handbooks that stressed the pain as punishment for Eve's transgression and dwelt on fears about miscarriage or stillbirth, the countess's book thanked God for the blessing of bearing children. The prayers for use during stages of childbirth grew progressively shorter, mimicking the breath of a woman in labor.

For all his criticism of the main Lutheran church, Spener carefully avoided advocating for a separation. But some craved a more drastic change. All over Europe, people felt themselves pulled from the heart of the church. Charismatic leaders who saw no place for their views within the traditional structure called for a clean break. Pietist sects splintered off. And people flocked to them. Doctors, scientists, painters, cobblers, tanners, and pastors retreated to the countryside or behind the gates of compounds under

the protection of some sympathetic noble. Others abandoned Europe, like Quakers and Moravians, escaping persecution and trying for a new start in the New World, perceived as a clean canvas unmarred by old and encrusted church traditions.

Jean de Labadie drew followers as a magnet draws iron. His long, thin, nose, like a scimitar, sliced between bony cheeks and eyes with bags stitched underneath them. His expression, at least as recorded in a 1669 portrait, is both mournful and acute, melancholy, but firmly grounded in the world. He started life as a Catholic, then turned Protestant before becoming dissatisfied with that too and launching his own sect. Chased from Amsterdam to Herford and Altona, gathering disciples as he went, he envisioned himself as John the Baptist, a voice crying in the wilderness, in rough clothes, preaching the second coming of Christ.

Like Spener, he expounded on the importance of a worshiper's individual relationship with God. But unlike Spener, he saw the world and the church as too corrupt and corrupting to take part in, so urged his followers to reject it. The prayers in his *Manual of Piety* called for a complete immersion in holy life, calling to God: "We lose ourselves in thy vastness; we plunge into thy depths; we are dazzled by thy light and are blinded by thy infinite brightness. We are absorbed into thy ocean!"

Caspar Merian, Maria Merian's half brother, met the Labadists in Amsterdam and fell under their spell. He moved with them to Wiewert, a tiny village where the Labadists had retreated behind the wall of a mansion. This house, called Waltha Castle, was owned by Cornelius van Sommelsdijk and lent to his three sisters — Lucia, Maria,

and Anna—wealthy aristocrats who'd packed away their gems and embraced Labadism and, as it turns out, Labadie. Considered handsome, or at least arresting, despite many missing teeth, Labadie at age sixty-one married the youngest sister, twenty-two-year-old Lucia. The sect originally promoted celibacy, a proscription that was short-lived, as became clear once young female disciples began to turn up pregnant. It was from this compound that Caspar may have written Maria Merian, telling her about life there, maybe enclosing tracts from the sect's printing press, including passages from one of the most luminary Labadists, a figure who would have had a strong attraction for his half sister.

The "tenth muse," the "Star of Utrecht," the "most noble virgin who excels in every form of virtue," the most educated woman of her age threw over her life as an intellectual superstar to join the sect. Anna Maria van Schurman was born in Cologne in 1607 and raised in Utrecht. Educated by private tutors, she became famous for her letters and essays filled with eloquence and ruthless logic, in particular her advocacy of education for women. In her book *The Learned Maid, or Whether a Maid May Also be a Scholar,* she argues that women should shun idle amusements and embrace mathematics and history, physics and languages. In a letter defending her position, she protested the "narrow limits" some would place on a woman's education, "thinking it makes little difference to us whether the machine of this world flowed together from atoms; whether it emerged from unformed chaos...whether the setting sun is immersed in the ocean; whether it owes its light also to the antipodes; whether the earth has taken a square or round shape; finally, whether the entire earth or just the

perception of our eyes is bounded by the horizon of the world."

Her own accomplishments seemed boundless. She could interpret the Bible in the original Hebrew. Explain Ethiopian grammar. Debate theology. Pick out a tune on the lute. Spend a month creating a self portrait in wax and philosophize on transience when her aunt dropped and destroyed it.

In a picture by one of her many male admirers, Anna Maria's face is thin and pale, her mouth serious, her tired eyes staring frankly out at the viewer, her curly hair pulled back on top and left loose at the sides. She appears small and sharp, more a clever girl than grown woman. Her plain features are dwarfed by her dress, laden with scalloped lace at the shoulders and sleeves, ribbons at the waist and chest, pearls around her neck and wrist. Compared to her straight-laced posture, the books on the table next to her display a refreshing disarray of wavy paper and loose ties, indicating a mind perhaps freer than the body.

But when Schurman's brother, who had spent time with Labadie in Switzerland, wrote her about this man and his cause, her fondness for her books faltered. Concerns about how her studies swallowed her and the way she flushed with praise rose to the surface. Ultimately, the intoxication of exploration seemed to draw her further from God rather than closer. In her autobiography, she explains, "I confess that sometimes, when I painted flowers and insects with watercolor (which seemed a simpler and more innocent kind of picture than others), my mind was no less occupied with heavenly thoughts than my hand with earthly exercise. But sometimes the same activity so filled my brain and even my heart itself with new discoveries that I was not able easily or unwaveringly to contemplate or enjoy God ei-

ther in himself or in his creatures." Joining the Labadists, she renounced her studies as so much frivolity. Her autobiography was one of the Labadists' most passionate tracts and found a receptive audience in Frankfurt, where it was read and appreciated by Johanna Eleanora Petersen, among others.

Schurman was very old when Caspar arrived at Wiewert, but she still made an impression. Merian's stepfather Marrel, who spent time in Utrecht and joined the same painter's guild as Schurman, likely knew of her as well. Seeing the ambitions of his stepdaughter, ambitions he had nurtured, he might have mentioned the accomplished woman and her achievements, igniting an interest in the young painter.

In her study book, as Merian describes seventy caterpillars that came together like a patch of velvet on a sloe branch, she mentions, in an aside, that she had come back to Frankfurt after fourteen years spent in Nuremberg through "God's will." As a Calvinist, Merian would have given great weight to the notion of fate, God's predestined plan for her life. But the ideas of Spener, or the Labadist teachings sent by her brother, with the emphasis on an individual relationship with the deity, might have changed her perception of how God expressed his will. Until now, she took other people's wishes as a translation of heavenly commands. Her mother may have wanted her to marry Graff and she did. Graff wanted to move to Nuremberg and she went. But now, with license to listen to God directly, she began trusting her own impulses as she gauged God's desires.

Religion had always been central to the Merian household, and their Calvinist beliefs prompted many moves. Her mother, whose brother was a cleric, and who faced an

uncertain future with her husband dead, may have pushed Merian to ask questions about her own life. The calls of Pietism may have appealed to Johanna Marrel, even more than to her daughter. But Merian could also have been open to persuasion. Maybe, like Schurman, she mistrusted her pleasure at the compliments heaped on her books. Maybe the vanity of her and Clara's strolling through the city in their finery no longer appeared so funny. Maybe it turned her stomach.

And if unease with the state of her soul wasn't enough, something had rotted at the core of the marriage of Maria Sibylla and Johann Andreas Graff. Like a bad tooth, the decay pained everything it touched. Though she spoke of Graff affectionately in her caterpillar book, acknowledging his assistance with the flowers, by the time she settled back into Frankfurt, the warmth was gone. Corrosion this deep couldn't have remained out of sight, even if the arguments took place in the bedroom rather than the street. To someone trying to peer into the house across the distance of centuries, the curtains remain firmly closed. What Merian reports about the Frankfurt home are the pupae in the fir wood, and the sloe branch webbed in by black caterpillars. But neighbors, daughters, friends would have sensed trouble in the icy silences, or in Graff's anger as another seductive letter arrived from the Labadist colony, or in the gray, empty space between them as they spiraled out into two increasingly separate lives. It was into this fissure in Merian's routine of plants and paint that the ideals of the Labadists found their way. Like water expanding as it forms ice, the trickle of words from the sect slowly turned into a wedge strong enough to crack stone.

If Merian's return to her mother's side rekindled reli-

gious beliefs rooted deep in her childhood, that might have been one source of friction. Graff, like the majority in Nuremberg, was probably Lutheran rather than Calvinist. His eye for the chaos of circuses and half-built buildings, the vision captured in his art, could have grated against the craving for austerity that pulled his wife toward the Pietists. Whatever the reason, after twenty years of marriage, two children, travels together up and down the Main, Merian pulled away. She may or may not have craved a life with Graff when she was 17, but it wasn't something she wanted anymore.

Her reluctance to fully accept him or the domestic role may be evident in the number of their children. In an age when a woman at forty had generally been pregnant ten or twelve times, Merian had her second and last child at thirty-one. This could have been chance; it also could have been design. She witnessed her mother give birth to and lose child after child. She watched talented women like Susanna von Sandrart, born and trained in artist families, give up their craft as housework overwhelmed them.

Motivated women found ways around the constant cycle of pregnancy and birth. Couples used withdrawal or animal bladder condoms as contraception. While abortion was frowned on, it wasn't unheard of, particularly among those who studied plants or had recourse to an apothecary. Penny royal, laurel, rosemary, savin—all were rumored to flatten a swelling belly. Court records and memoirs record that women shared these secrets with each other (though other women policed their use; midwives were charged with reporting hidden pregnancies and suspected abortions). In 1665, a lady hinted to her maid, pursued by the lady's son, that penny royal could prompt an abortion. In

the same year, a pregnant woman whose suitor decamped tried both pills from a doctor and a powder from her mother. Merian may have used these remedies, or educated herself about them just in case. Or she might have just stayed as far away from Graff as she could.

Divorce was possible, but hard to achieve. Adultery, abandonment, inability or unwillingness to have sex, and venereal disease were all recognized as reasons to end a marriage. But a woman's husband was her legal representative, so to bring him to court, she needed to find another man to stand for her. And city and community courts, governed by married men, showed reluctance to separate husbands and wives. In 1652, in an area of southwest Germany near the Black Forest, when a wife left her farmer husband after he used her dowry to buy land then sold it without telling her, the court sent her back home. In 1674, when a butcher beat his wife because she didn't hand over money from vegetables she sold, the courts sent her back home, too. Sometimes, when women ran away from their husbands, the cities they fled to refused them entry. And, if a woman succeeded in her suit, she risked losing her children. While there was a place in the laws for a divorced woman, there was no place for her in society.

By summer 1685, Graff had returned to his native city, this time alone. Once again, Merian wrote to her former pupil Clara. The tone is very casual for someone who, within months, will be on her way to a new country to join a religious sect, leaving her husband miles behind. "I have no news, aside from the fact that my husband wants to journey to Nuremberg," she concludes one chatty note about how the house is in disarray, her time very full. The only hint that the separation may be permanent, may have emo-

tional ramifications, comes in the next line. "I ask that if he should need counsel you should be recommended to his humble person, for he will indeed need good advice."

Merian traveled north and east, farther than she had ever been, to where the land was flat as a copper plate and a woman could see from field to field to the field beyond. Wind and water ranged everywhere, unfettered by hills. Towns built themselves mud mounds, high ground, to escape the winter floods.

Three generations moved together through Holland, toward Wiewert: seven-year-old Dorothea itching to stretch her legs, seventeen-year-old Johanna forming ideas about her own future, Merian's elderly mother who spent most of her life in Frankfurt, and the thirty-nine-year-old Merian, looking after them all. As she bumped over the rutted roads in a carriage, lulled by the clop of horse hooves, Merian must have weighed her decision. Even were she not drawn by religious devotion, the move gave a justification for leaving a husband who had become more of a burden than a pleasure. Breaking up her marriage was a drastic action, and a desire for God perhaps offered an acceptable excuse. She also gained an escape from the world of business, time to draw and paint, a reconnection with her mother and a brother she was close to, and exposure to a wider world, even one tucked behind castle walls.

What must she have seen, arriving in Wiewert? A modest church and the small town clustered around it. Farmers bent over their crops. Cows in the surrounding meadows lowing and lifting their heads to gaze at the rare visitors. And, on closer inspection, a leaf laced with holes, willow branches webbed with silk, a swallow tracing a jagged gray

line in the sky as it chased down a moth. She could live here.

A drawing of the way to Waltha Castle shows a wide path with trees looming over to form a closed canopy. Two figures, dwarfed by the road and the trees, head toward the castle grounds, a cluster of buildings in the distance. The gate to Waltha was high and forbidding, out of keeping with the tiny village. Two tall doors fit into a curved arch. A small house near the gate provided shelter for those seeking admittance while the sect debated their fate. Maybe because of the big trees, the long approach, the mysterious goings-on, the town's folk called the Labadists the "people of the woods."

For a woman who'd spent all her life in cities, humming centers of trade, the emptiness of the land around Wiewert could have been daunting. On the other hand, maybe the countryside reflected the calm she sought. On either side of the town, few roads split the smooth acres of farmland. Certainly, no paths pointed her way from here.

Inside the gate, the Labadists lived stripped down, Spartan lives, with warmth and comfort sought only in God. Sin held on with a tenacious grip and disciples whipped it out of themselves. Peat for fires was expensive, and they knelt to pray on cold floors. Families crammed into a single room. Every butter pat and piece of bread was counted. Wearing jewelry, even twisting hair into decorative styles was banned. As they settled in, Merian, her mother, and daughters would have removed silk handkerchiefs or cherished tokens and exchanged them for the plainest dresses. Smoothing their hair back, they would have unraveled any braids, brushed the road dust out of the strands, and donned the coarse

wool habits of the Labadist women. Finally, they would have unpacked their boxes, and spread their blankets on narrow beds.

They had rid themselves of many belongings, preparing for a long trip and entrance to a community where silver cups and lace collars would have no use. Now they would shed most of the rest. The Labadists pooled their finances and possessions, an act that, as some had found to their dismay, could be irrevocable. The sect's history was spotted with complaints from members who wanted to get their money back when they left, but met resistance from the leaders. But Merian, so often able to slide by the rules somehow, held on to her specialized tools: her book of notes, her paints, her brushes, her expensive vellum—*carta non nata,* skin from unborn lambs, that held the color like nothing else. She brought her mixing materials and pigments. She would have a long way to go to replenish stock, over roads that were often impassable in winter.

The gate ringed a city in miniature. Walking the grounds, Merian and her family would have passed disciples weeding cabbages and turnips in the large gardens that fed the community. A printing press hammered out proselytizing tracts. No less than Matthaus Merian the Elder, the Labadists had an appreciation for the power of this machine. They had lugged it with them as they fled from spot to spot in Europe before settling in Wiewert and assigned up to twelve sect members to tend it. In a lab within the compound, doctor Hendrick van Deventer concocted pills to ease pain and promote sweating and devised cures for the rickets that plagued the children. His spouse served as the midwife. In some rooms, students like the seven-year-old Dorothea sat for lessons from the more educated

Labadists. The curriculum mirrored the beliefs of the adults, emphasizing abnegation and obedience. Separate dining rooms accommodated the international clientele: A hymn in French might float from one hall, a hymn in Dutch from another.

Like any isolated settlement, the economy at Waltha teetered on a precarious supply of goods. The clay soil proved better for raising livestock than crops, so the Labadists kept cows, pigs, chickens, and sheep, and their "Labadist wool" earned a fine reputation. They sold inspirational books by Labadie and Schurman as well as Deventer's pills, but with a community of 400 to feed, money often came up short. Simplicity may have been enforced by circumstance.

Quaker leader William Penn offered a glimpse of the colony when he visited in 1677. He arrived after a tour through Holland and Germany, a trip where he sometimes slept in homes of like-minded worshipers, and sometimes curled up in a meadow when a disapproving noble forbade him entrance to a town. Alternative religion could be a dicey business. Nervous because Jean de Labadie snubbed him six years earlier, Penn remained intrigued by the sect even though Labadie himself died in 1674. He wanted to try again, and one July evening found him tramping through the field toward the Waltha gate. Outside the mansion, he met a young Labadist who escorted him in. He asked to see the new leader, Pierre Yvon, and the famous Anna Maria van Schurman, but arranged to come back the next morning. It was too late for all he wanted to say.

When he returned, he joined Yvon, a pastor, the doctor, one of the Sommelsdijk sisters and Anna Maria van Schurman, sitting in plain clothes on plain furniture. Schurman, old, sick and unable to walk, detailed her conversion in a

broken voice, stressing that her learning had all been vanity. She was an imposing presence, even in old age. Less impressed with the Sommelsdijk sisters, Penn noted rather snidely that they were "people of great breeding and inheritances." But still, he came away feeling that though their separatism was a mistake and their affection for Labadie a distraction from God, genuine devotion fired them.

"Certainly, the Lord hath been amongst them," he mused.

In their stark surroundings, the Labadists found comfort in each other. When Penn visited, his interviewees referred repeatedly to the family they found with fellow worshipers. They called each other "brother" and "sister" and relished the company of Christians behaving as they felt Christians should. By the time Merian arrived, both Labadie and Schurman had died and Pierre Yvon led the community. While he didn't have Labadie's magnetism or Schurman's way with words, he kept up the collegial spirit. Though Merian may have missed friends in Nuremberg, she had those most important to her along. She must have relished a reunion with her brother. At twenty years older, Caspar could easily have been her father, and she obviously trusted his advice.

But still, the first year would have been a rough one. Labadists divided themselves into two main classes: probationers and the elect. Probationers, those seeking admittance into the upper echelon, performed most of the grunt work and were assigned tasks deliberately out of their area of expertise to help them beat back pride. The elect, those who had demonstrated their worthiness, had an easier time of it. Within this framework, Merian initially tried to keep up her studies and even explored metamorphosis in new realms. Just before Merian left Germany, she drew a liver

fluke living in a snail. When a frog at Wiewert caught her eye, she captured it to see what she could learn.

Her dissecting knife revealed eggs in an ovary, and Merian noted in her study book that, contrary to popular belief, the female frog, "doesn't bear little ones through the mouth as some writers have thought." She raised another set of eggs in a container. The black dots in the center of each gelatinous sphere grew tails and eyes and she provided the tadpoles with grass, mud, and daily bread. Legs sprouted from the back of the tadpole, then the front. They lost their fishy look.

Then, she records no experiments for more than two years. If she underwent trial as a probationer, she might have been too busy at the washbasin. But perhaps events proved too overwhelming. A few days before the frogs hopped onto land, her beloved Caspar died. A few months later, Graff arrived to claim her.

The trip from Nuremberg to Friesland may have seemed long to the painter, chasing a wife who (by now, it must have been obvious) actively fled him, preferring the stark company of strangers. The odds of his receiving a gracious welcome were small, either from his wife or her new companions. But as he made his way from Germany to Holland, following shrinking roads away from the cities, he would have had plenty of time to mull over what he wanted. And, despite the maggots in the kitchen, he wanted Merian and his daughters back, even at the price of leaving his home and embracing a religion he didn't believe in. In the summer of 1686, he arrived at the gate.

Life with the Labadists was hard on a marriage. Bonds once firm could dissolve when exposed to the commune's

atmosphere. When a family with five children joined one Labadist colony, the wife soon chafed at the constant criticism from leaders: Her kissing her husband in public must stop (too much of the flesh), she drank too much during meals (even though she was breastfeeding). Meanwhile, the Labadists picked at the husband to distance himself from this discontented, worldly woman. And if she was not holy enough, their marriage wasn't valid, they reminded him, warning that: "It was for God alone to judge whether he cohabitated with a harlot or with his wife." "Harlot" was clearly the prevailing opinion. Miserable already, building fires in the forest to thaw his frozen hands, scrambling to achieve the proper self-abasement, he began to turn away from his wife, spending nights elsewhere.

When Graff showed up, surely an unsettling surprise, Merian used Labadist proclamations about the nature of marriage to shield herself. In a loud and public scene, Graff entreated her to come back to him, and she refused. Petrus Dittelbach, one of the Labadist brothers who translated Anna Maria van Schurman's writings into Dutch and who had his own marital problems springing from the colony, witnessed the exchange. He argued with Merian that the marriage tie shouldn't be torn lightly. According to I Corinthians 7: "If any woman has a husband who is an unbeliever, and he consents to live with her, she should not divorce him." The Bible says she sanctifies him.

Pietism encouraged women to read and interpret religious tracts, though, and Merian took full advantage of this permission. She argued right back, citing the sect's leader, Yvon, who had written that spouses must both embrace Labadist principles or "the marriage cannot be considered holy; and a believer may not assume the yoke with an

unbeliever." Her vehemence shocked Dittelbach, who described her as hard and unyielding. Though he had come so far, Graff's daughters wouldn't see him.

Graff lingered in Wiewert a while, living outside the gate, working construction, sketching the compound (the only picture of it that survives), maybe hoping Merian would eventually come around. He tried to join the sect, and was refused admittance, according to Dittelbach. Then he grew sick and thin. Merian visited him, but didn't change her mind. Then, finally, he left. There's no evidence she ever saw him again.

The gap in Merian's investigations could be pinned on the physical and emotional turmoil of the first few years in the colony. If she felt her studies were sinful, she would have stopped the moment she arrived, which wasn't the case. But if Merian came to Wiewert intending to continue her work, hoping to eventually publish further, it was a risky maneuver. Schurman's currency in the academic milieu she'd fought hard to enter plunged when she joined the sect. Jan Swammerdam, the entomologist who uncovered so much about metamorphosis, paid an even higher price for dabbling in unsanctioned religion. In his effort to make his soul right with God, he lost everything.

Like Schurman, he felt the need for a change acutely. His passion for insects and all their parts had always bordered on the religious. Even the most avowed atheists could not resist the sight of a swirl-shelled snail being born, in a rare species that didn't lay eggs, he wrote. Swammerdam invited these non-believers "to observe this most wonderful happening, that they may learn to give the praise and glory to God alone."

Eventually, though, Swammerdam grew wary of the deep pleasure he took in this work. He told himself the absorption in his studies reflected absorption in God, and that every time he discovered a new structure, minute and perfect, he swelled with appreciation for God's greatness. But could this really be true? Maybe the time spent pulling apart a louse to look for its ovary would be better employed in prayer. Maybe the workings of a butterfly's tongue were not as revealing of divine wisdom as the text of the Bible. In 1673, he sent a letter to Antoinette Bourignon, seeking advice from this writer of religious tracts who saw divine visions and predicted the imminent end of the world.

Bourignon, marked at birth with a harelip, felt herself marked in other ways as well: the ability to hear the voice of God. When she was a teenager, God spoke to her, urging she embrace Him as her true spouse. St. Augustine appeared, too, and charged her with renewing his order. In books and letters she recorded a life filled with adventure: running away from home dressed as a man to escape an arranged marriage, capture by an untrustworthy cluster of soldiers, rescue from their captain's clutches by a priest.

Salvation through the priest didn't last long, however. Dismayed with the church and her experiences in a nunnery, she began to write and print her own work, saying she was transcribing celestial prose. It was a harsh vision. Fully three fourths of men conspired with the Devil. Only long days of hard work and prayer could keep the mind trained on heaven. Academic learning counted for nothing; in fact, she herself didn't read even the Bible because, when she once tried, she found she knew it all already. Direct communication with the Holy Spirit allowed her to deny all church authority, both Catholic and Protestant. Labadie

courted Bourignon for his circle, but, always independent minded, she refused.

In 1674, Swammerdam joined her sect on the coast of Friesland, where he translated some of her work into Dutch. He sought advice about his ungovernable passions and gnawing ambition, and confessed his concerns about the Old Testament's prohibition on dissecting humans. What would this mean for the uterus he preserved? While most natural philosophers of the time were able to convince themselves that their investigations served God, something about what Swammerdam saw made him question the holy nature of his work, and his doubts ripped him apart. Not long after moving north, he destroyed his manuscript on the silkmoth and weighed down a volume on the mayfly with religious poetry. He eventually returned home, still torn. When he finally succumbed to his fever in 1680 and died at age forty-three, he left his unpublished magnum opus on insect life in the hands of a trusted friend. The book, caught in legal wrangling, then forgotten, not published until fifty-five years after he died, wed his two sources of inspiration in its title: *The Bible of Nature.*

As for Bourignon, her radical stance ultimately drew her too far outside any circle of protection. At the end of her life, her finances collapsed, her friends abandoned her, and a warrant was issued for her arrest on the charge that she could alter her shape, alleging that she could diabolically "contract and enlarge her person."

Even if Merian considered briefly giving up her insects, she did not feel that God frowned on her studies for long. Pietism held scholarly learning in contempt, but its focus on individual religious contemplation carved a place for devo-

tional aids, including pictures of God's works that might inspire wonder. Within this framework, pondering the intricacies visible at each level of discovery brought Merian and her readers closer to God. In the introduction to the caterpillar book, she writes that the insects and their transformation are a reflection of God's "power and brightness" and tells of her desire to put "such Godly miracles in a little book." She reassures the reader that in publishing, "I was looking not for my own honor, but God's honor to praise him as the creator of these smallest and least important little worms that had their origin not in themselves but in God." For Merian, the metamorphoses revealed an amazing, and to her at this point, "Godly" side to insects others dismissed as "useless." Every metamorphosis, every new discovery, every further complication, offered a testament to his glory.

But, given her background, she mentions God less than she might, even in her most devout phase. The notion of a religious "rebirth" fascinated Labadie, who believed this kind of conversion was central to religious understanding. He spoke of it often and it undoubtedly lingered in the teachings of his disciples, like Yvon. The comparison between this and the insect's transformation within pupal walls would have been hard to miss, yet she doesn't make it. Arnold, in one of his poems adorning her caterpillar book, compares metamorphosis to the rebirth of the soul after death: "Dearest GOD, thus will You deal also with us in due time; as the caterpillars are transformed, they who through their mortality become enlivened anew, like the dead in the ground: Let me, poor little worm, at that time be commended to You!" In Anna Maria van Schurman's and Johanna Eleonora Petersen's autobiographies, the turning point in their lives is their discovery of Pietism, a

truer relationship with God. In the snatches of life story Merian offers in her study book and caterpillar books, her awakening is the discovery of metamorphosis.

Compared to other authors, Merian speaks of the religious nature of the caterpillar infrequently. Once she mentions that Goedaert makes a nice comparison between one insect's transformation and the resurrection, but that's all. Swammerdam, even before his religious tract on the mayfly, drew expansive moral lessons from the caterpillar's life. Of a moth where the sexes have different appearances, he notes: "The observation made in the place here cited appears to be of the utmost importance, viz., 'that the male of the nocturnal Butterfly is always provided with wings, whereas the female never has any;', so that the male can enjoy the sweet refreshments which the free air affords, and ramble at pleasure over the smiling fields and fragrant flowers, when, on the other hand, the care at home, and management of the fruits of wedlock are committed to the female only... Nature, therefore, intended to afford us in these insects the most striking examples of an affectionate mother and a careful father; and perhaps, as the slothful were formerly referred to the ant as a pattern of industry, married people who neglect the duties of their state, may, with equal propriety be desired to consider this other little insect as a model of conjugal solicitude." It is unlikely Merian would have come to the same conclusion.

When she speaks of conduct, she mentions that the caterpillars put people to shame, not in their domestic harmony, but in that "they keep time and order and don't hatch before they can find food." In addition, butterflies only lay their eggs "where they know that their young could have their nutrition." Her caution keeps her from making the leap to a large unifying theory of insect life (for which she

will much later be faulted). But, as a result, she notes be-
havior without layering in human judgment.

Merian's focus on the particular is another contrast with
Swammerdam. Swammerdam dismissed the notion of re-
cording metamorphosis after metamorphosis. He wanted
one detailed examination that would serve as a model for all
others. Merian, on the other hand, seeks what is specific to
each insect. His method was to go deep, searching for rev-
elations at a single insect's core; hers, to go wide, capturing
a spectrum of colors, behaviors, surroundings.

In the castle, Merian set herself to recopying her field
notes in an elaborate calligraphy. In painstaking handwrit-
ing with many flourishes, each letter as carefully rendered as
a hornet's leg, she straightened her hasty lean and opened o's
and a's. Along with dates and times of hatchings, she had a
stack of small watercolors on parchment scraps that served
as a reminder when she launched a full painting or engrav-
ing. She numbered each and attached them to the page. Then
she wrote her observations of each transformation, creating
a study book that documented her process. If Merian had
any doubts about her labors, they may have centered on the
public nature of printing and selling. Devoting time to this
study book took her back into the private realm. Neatening
it all up for some imagined reader, she contemplated not just
her afterlife, but of the afterlife of her work.

By the summer of 1688, though, caterpillars again en-
snared her in their sticky threads. Life was once more di-
vided by the changes of insects, their overlapping feeding,
cocoon building, and hatching. In 1689:

On July 14, a thick-bodied moth crawled out of a
cocoon. The same day, a cocoon built by caterpillars
that ran unusually fast yielded only flies.

On July 25, black stinking flies hatched from a brown
cocoon.

On August 27, a black and yellow caterpillar grew
still, preparing to shed its skin.

On August 28, a green-dotted, willow-eating
caterpillar changed into a pupa.

As she went back to drawing from life, the meticulous
penmanship in her study book faltered. The writing sped
up. Her carefully copied-out entries became marred by
hasty notes inserted if she encountered the same butterfly
again. As her new studies began to absorb her, the focus
moved from glorifying her past work to making progress in
the present.

But here in Friesland, she hunted in a markedly differ-
ent landscape. Pleasure gardens of flamed tulips and cos-
seted roses had no place at Waltha. In their place, neat plots
served as medicine chest and apothecary's cabinet: feverfew
to treat a cold; gout-weed for aching joints; bryony with the
poisonous berries, for asthma; snakeroot as a stimulant. She
raided the kitchen garden, too, and captured fennel, sage,
chicory, and glossy, red currants. These useful, humble
herbs are painted in a style different from the caterpillar
book. There insects loomed larger than life and the images
huddled in the center of the small sheets of paper. These
watercolors mimic herbarium specimens: Roots dangle from
the bottom, stems are split, giving the illusion that they
needed to be cut to fit on the page. Here the plants rather
than the insects represent the overlooked and under appre-
ciated, redeemed through her notice, and they sprawl all
over, tendrils reaching to the parchment edge. She also nar-
rows her focus, scrutinizing small alterations from plant to

plant. In the case of chamomile, four different varieties lie side by side.

The insects, too, follow a different trajectory. Either she couldn't find many she hadn't painted before (she'd documented more than one hundred in her two caterpillar books), the Friesian insects were riddled with parasites, or they posed some puzzle she wanted to solve. With this time, the quiet hours she'd traded her marriage and country for, she returned to questions that stumped her in her earlier observations. Why did some larvae and pupae hatch moths, while others produced worms, smaller pupae, or flies? Of the seventeen paintings suspected to belong to the group Merian worked on at Waltha, called "the herb series," seven show caterpillars that yielded flies rather than the expected moth or butterfly. Three are parasitic flies that feed on a caterpillar or pupa and hatch in its place; four are sawflies, an unusual type that has a larva like a caterpillar but an adult like a fly, and one is an early umber moth, whose small-winged female looks like a fly, too. Sometimes in her caterpillar books Merian shows two alternate family trees, parasitized and non-parasitized, with a plant like a divider in between—caterpillar, pupa, butterfly on one side and caterpillar, pupa, buzzing flies on the other. In a particularly gripping example, a dotted green caterpillar banded with yellow and obviously alive, arches up as worms emerge from its back. Tiny flies buzz above their squirming host, and Merian pictures the dead, shriveled caterpillar on the same page.

The life strategies Merian paints here are some of the most devious and disturbing in the animal kingdom. Called "parasitoids" because they feed on one host like a parasite but kill it like a predator, ichneumonid and braconid wasps,

tachinid flies, and others inject their own eggs into the target egg, larva, or pupa so their young can eat their hosts from the inside out. A parasitoid searches for insects in ways a naturalist would, looking for characteristically chewed leaves, following the feces. Once it's found the right host, the parasitoid employs a needle-like ovipositor with a sharp edge that lets it punch through stems and wood to attack insects hidden there. The jab paralyzes the host, which might die immediately or might recover but remain infested by larvae that eat away at it, careful not to kill it until the right time. When they've eaten their fill, some parasitoids metamorphose and erupt from the living host as Merian depicted; others use the husk of their host's dead body as protection during their transformation, in the same way a caterpillar might use a cocoon. These husks are named "mummies."

For someone seeking the usual rhythm of egg, larva, pupa, butterfly, these false metamorphoses could be frustrating. While she doesn't specify that the flies are parasitoids, she writes of them as something unnatural, a strong statement for someone who believed metamorphosis displayed God's glory. For five years in Nuremberg and Frankfurt, she tried unsuccessfully to get a moth from the red-and-black caterpillar with the horned tail. First the larva rotted and maggots crawled out and then, when she finally got a pupa, it hatched a fly. "All of which showed me and taught me a lot of accidental, wrong, and useless transformations rather than the natural transformations," she wrote in her study book.

These parasitic flies bedeviled other naturalists, as well. Their appearance from the shell of another species made them one of the last arguments for spontaneous generation,

at a time when disproving this theory was taking on increasing urgency. Despite the arguments of Francesco Redi and Swammerdam, people still believed in frogs that fell with the rain, lice that crawled out of the heads of dirty children. But if a cabbage could create a caterpillar and an old wool shawl birth a moth, what did that mean for God's power in the universe? It would be shamefully diminished. Only the notion that all species came from parents of their kind could ensure him his rightful place as Creator.

John Ray, son of a blacksmith, author of an early system for categorizing plants, published a book expanding on ideas Swammerdam expressed as he tried to convince himself his studies were blessed. In his 1691 book *The Wisdom of God, Manifested in the Works of the Creation,* Ray covers a vast array of creatures, the map of the heavens, wind and water, the way in which each animal is fit for its own place and own food. In one lengthy section, he tackles the three remaining arguments in favor of spontaneous generation: the existence of galls, the worms that seem born in human intestines, and the flies born from caterpillars. He takes a stab at explaining away each one.

Though Ray has his suspicions, he doesn't have proof, and begs his fellow natural historians to find some: "The Discovery of the Manner of the Generation of these Sorts of Insects I earnestly recommend to all ingenious Naturalists, as a Matter of great Moment. For if this Point be but cleared, and it be demonstrated that all Creatures are generated univocally by Parents of their own Kind, and that there is no such Thing as Spontaneous Generation in the World, one main Prop and Support of Atheism is taken away, and their strongest Hold demolished: They cannot then exemplify their foolish Hypothesis of the Generation

of Man, and other Animals, at first, by the like of Frogs and Insects at this present day." His vehemence comes from the notion that during Genesis God created every species exactly the way it still appeared. Each mosquito and toad is part of a grand plan and nothing but God — not a dead bull, not a moldy cheese, not accident or chance — can make a new creature. Here he argues against creeping suspicions that maybe even he harbored: "A fourth and most effectual Argument against Spontaneous Generation, is, that there are no new Species produced, which would certainly now and then, nay, very often happen, were there any such thing."

All through Merian's first years in the colony, Labadists stumbled back from the sect's ventures in the New World. Sunburnt or jaundiced with yellow fever, their bodies, glimpsed at a collar or cuff, spoke volumes. Faces, windbeaten and wrinkled, presented a stark contrast to the pallor of those who never left the castle. Monitors policed dinner-table conversation, but returned colonists undoubtedly told their tales in low voices as they milked a cow or weeded the herb garden. That is, if they were allowed back in the compound. Some, deemed failures for their inability to persevere abroad, had to stay in the visitors' huts outside the gate.

With the stated goal of converting native peoples and finding land untainted by European corruption, the sect had been investigating likely spots for offshoots. On a scouting mission to Maryland in 1679, Labadist Peter Sluyter met the son of a Dutch West India Company official, converted him, and convinced his father to sell the Labadists land. On the 3,750-acre "Bohemia Manor," one hundred colonists staked their claim in the New World.

Apparently the family feeling that pervaded Waltha didn't survive the ocean crossing, and the focus on punishment and deprivation took over. Part of the problem may have been some colonists' reluctance to leave Europe: Sluyter's own teenage stepson wept at the docks, pleading to go back home, but was hustled on board. Sluyter, by most accounts, was cold and dictatorial, without Labadie's ability to inspire religious devotion. One visitor to Bohemia Manor described a silent and unsettling meal. At the start, a group of men filed in, sat down, and each removed his hat to pray at a different moment, when he felt the urge. The emphasis on authentic, individual experience resulted in a disjointed cacophony. Others noted, cynically, that the leadership recruited most heavily those who could supply the sect with cash. The godliness Penn sensed was gone.

Another group was even more ambitious. Several years before Merian arrived, the brother of the Sommelsdijk family, Cornelius, bought a one-third share in Surinam, a tropical Dutch colony on the northeast shoulder of South America. The other two shares belonged to the Dutch West Indies Company and the city of Amsterdam. Surinam, a beleaguered country, limped along after being fought over by the English and Dutch for most of the century. It was one of many trophies in the competition between the two sea powers, but a climate fit for rich sugar plantations and rumors of gold in the interior made it a particularly glittering prize. In 1667, the Treaty of Breda ended the second Anglo-Dutch War and resolved this particular skirmish. The Dutch got to keep the swampy patch of South America with all its sugary promise. In exchange, the English took Manhattan.

As Surinam slipped from their grip, English plantation owners burned houses and sugar mills and trashed their

property as they left. It was now a colony largely without colonists or the infrastructure for profit. In fall of 1683, Sommelsdijk, the newly appointed governor, set out to put things right. Part of his plan for his newly purchased country was to import model citizens. Jews, fleeing persecution in Brazil, had already staked a claim to an area that would be called "Jews' Savannah." They were good neighbors, but he wanted more. To this end, he loaded Labadists on the ship with him. A cook, a carpenter, a doctor and the governor's youngest sister (Labadie's widow), Lucia, among others, boarded the boat to set up their new society in the New World.

Upon arrival in Surinam the governor began molding the country into the financial engine he hoped it could be. Though perhaps not dressed for the tropics—long curly hair rolled down to the breastplate of his heavy armor—he battled through the heat. He imported horses from New England, mended fences with some Amerindian tribes, set the idle soldiers to digging a canal from the Surinam River to the Saramacca River, increased the number of plantations from fifty to two hundred, erected a town hall and set up a court system. He tried to expand potential crops and imported peach trees, pomegranates and ginger. Though not a Labadist, he had a certain righteousness that made him both energetic and inflexible. According to one contemporary: "He was the enemy to everything loose, vicious, or immoral, and without regard to the offenders being of high position or low degree he condemned them fearlessly."

A second wave of Labadist colonists to Surinam, including the middle Sommelsdijk sister, Maria, experienced the difficulties of colonizing before they even landed. (The oldest sister, perhaps the wisest, chose to stay home.) Pirates

Merian family portrait by Matthaus Merian the Younger, 1641. From
left to right: Matthaus Merian the Younger (son), Matthaus Merian
the Elder, Susanna (daughter), Maria Magdelena (Matthaus Merian
the Elder's first wife), Margaretha (daughter), Caspar (son). There is
disagreement about the identification of the children to the far right,
but the older may be daughter Maria Magdelena and the younger may
be son Joachim. This portrait was painted six years before Maria
Sibylla Merian was born.

Portrait of Sara Marrel, Maria Sibylla Merian's stepsister, by Johann
Andreas Graff, the man who would become Merian's husband, 1658.
At the time of the portrait, Sara Marrel was fourteen and Maria Sibylla
Merian was eleven.

Map of Waltha Castle at Wiewert, attributed to Johann Andreas Graff.

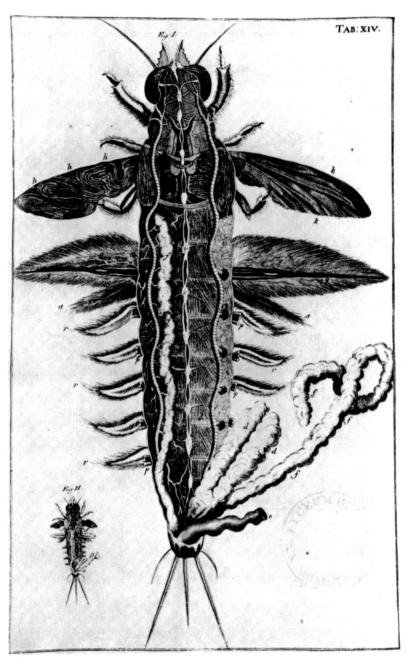

Engravings of a mayfly from the English translation of Jan
Swammerdam's *Book of Nature*, 1758. Swammerdam's careful
dissections revealed that insects were far more complex than

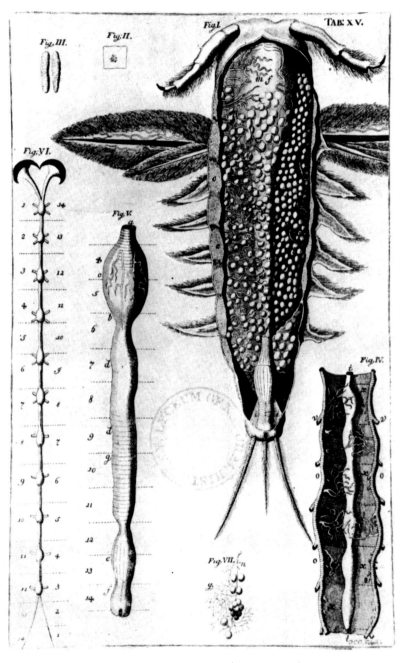

previously imagined and helped disprove spontaneous generation.

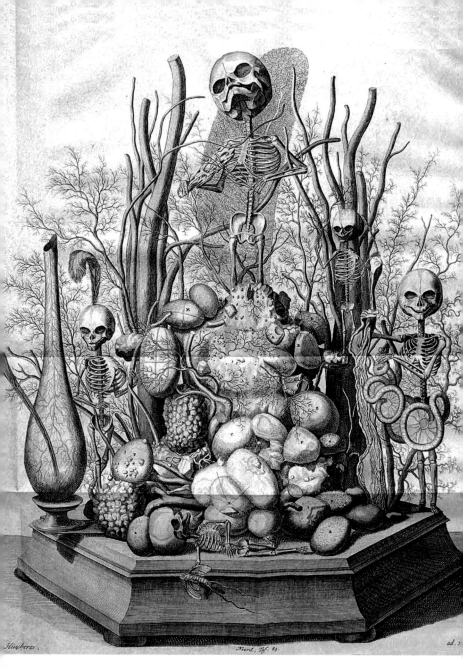

Engraving based on a display in Frederik Ruysch's cabinet of curiosities and published in a catalog of his collection: *Alle de ontleed-genees- en heelkindige werken*, Amsterdam, 1744.

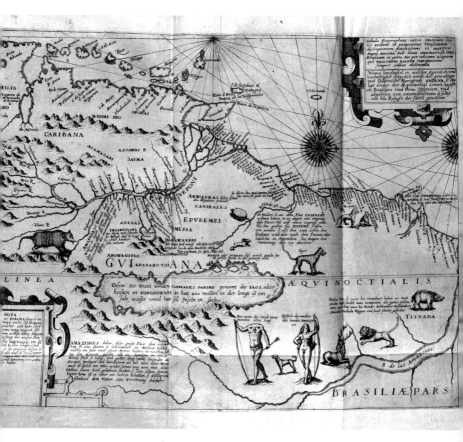

Map of Guiana, an area that included Surinam, appearing in *America* (later known as *Grand Voyages*), Part 8, published by Merian's stepgrandfather, Theodor de Bry. Frankfurt am Main, 1599.

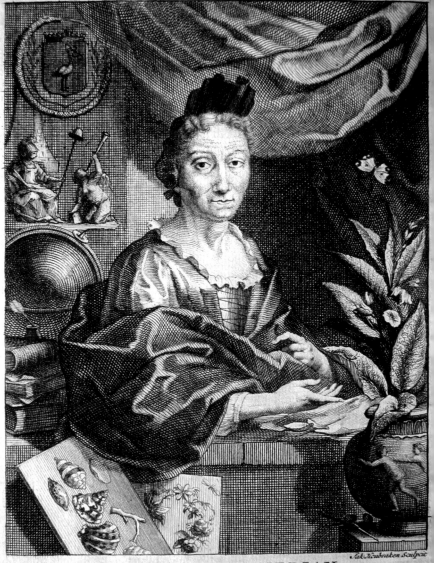

## MARIA SIBILLA MERIAN
Nat: XII. Apr: MDCXLVII. Obiit XIII. Jan: MDCCXVII.

Engraving after a portrait of Maria Sibylla Merian by her son-in-law, Georg Gsell. This image is bound into the volume containing all three of her caterpillar books: *Erucarum Ortus*, Amsterdam, 1717.

attacked the ship near the West Indies, taking the boat and its cargo of salt pork and medical supplies. In return, the colonists were left naked, abandoned in the pirate ship before landing on the Cape Verde Islands. An English ship took mercy on them and dropped them in Surinam's capital, Paramaribo. As they stepped onto the shore of South America, in borrowed shirts and without promised supplies, one wonders what they thought of their new home.

At first, when reports from the colonies crowed over the rich soil, Yvon read them out loud during meals. But soon, as the letters' contents changed to complaints, he stopped this practice and preached against rebellion instead. Hardship and deprivation were cheap and plentiful in the Surinam rain forest. Mosquitoes, ants, and wood lice feasted on the colonists and their belongings as they struggled to make a living off the land that offered abundant sugar cane, but not much else to eat, particularly to a European palate unused to cassava. Discontent festered, and disease wormed its way in. The cook died. The tutor for the children died. The children themselves had irritated eyes and one was lame. Curses against Labadist leaders drowned out prayers.

But the colonists also sent back artifacts that reflected another side of the country: moths, lizards, beetles, heavenly scented fruit. Governor Sommelsdijk shipped a twenty-three-foot stuffed anaconda, ample demonstration of the country's wonders and dangers. For Merian, holed up in her nunnery-like retreat, these were a view into a tantalizing world, one soaked in color in contrast to the grays of stone walls and Friesian sky. The streaks and spots on these new butterflies were cryptic as an unknown alphabet. Some thought the markings on the back of one Surinamese

snake were a form of Arabic. The fire-striped harlequin beetles, the morphos with wings covered in glowing blue dust, the lantern fly with its ungainly, outsized head were like nothing on European soil. And Merian had looked, in the Friesian meadows and German orchards. If new native species were in short supply, here was the solution.

They must have worked on her mind, these remnants of a far off forest, during the long morning prayers in darkened rooms, where Yvon discoursed on Bible verses and led psalms, lyrics sung in a smattering of languages all to the same tune; during the mealtimes, where dishes of cabbage were passed around; at night, listening to her mother and daughters breathe in the dark. The richness, the strangeness that she interpreted as the presence of God, glowed in these specimens like fire in the heart of the wood.

In late 1688, when Merian had been at Waltha for two years, grim news arrived at the castle gate. Whether encased in a letter whose ink had dried in the tropical sun, or reported by a Labadist limping home, nothing could soften the blow: Governor Sommelsdijk was dead. The soldiers had mutinied and slaughtered him.

Extra work and cut rations had made the soldiers surly. One day in the height of the dry season, they halted work on the canal, refusing to continue until they got more food. The governor dismissively sent them back to shoveling. Two days later, the soldiers stopped digging again and came to the fort, threatening to kill the governor if he didn't meet their demands. Sommelsdijk greeted them with sword drawn, Lawrence Verboom, the military commander who was mediating the dispute, at his side. The soldiers shot them both and took over the fort in a brief rebellion. Those with eco-

nomic interests to protect, though, wanted an orderly, stable government and didn't see the soldiers providing it. Both Jews and Labadists joined forces with other landholders to wrest the colony back from martial grip. All this trickled back to the mansion full of prayer.

For the community at Waltha, the death of Cornelius van Sommelsdijk was one setback among many. The overseas ventures were failing as was local morale. Doctor Deventer wanted to keep some of the profits from his valuable medicines for himself and was grumbling about the "community of goods" to which he contributed so heavily. Disciples looked at each other and suddenly saw the same weaknesses in this new family as in the ones they left behind. Petrus Dittelbach, the increasingly disgruntled translator, was gathering information for a tell-all book about the sect. Called *Rise and Fall of the Labadists*, it promised to detail every all-too-human flaw.

As the edifice crumbled, colors and sounds from the outside world came in through the cracks. Many of the Labadists had been in Amsterdam when the community lived there. Visitors must have brought tales of life in the vibrant, though evil, city. The techniques Merian used in her herb series show the influence of contemporary painters from the Netherlands for the first time. As stories of artists and scientists revealing universal secrets eased through the gate, perhaps Merian's attachment to the place and its austere dictates wavered.

Maybe, more fundamentally, she began to question God, or at least the Labadists' method of worship. Those devilish parasitoids she spent so much time on could have been a trigger. While the increasingly tiny layers of order revealed by the dissecting knife might argue for a divine

architect, what kind of argument did these unpredictable flies with their deft eviscerations of her caterpillars make? This same phenomena would make Charles Darwin doubt, two hundred years later, though the life cycle of the parasitoids was far more clear to him. His knowledge made it no less disturbing, and he would write to botanist Asa Gray with a shiver: "I cannot persuade myself that a beneficent and omnipotent God would have designedly created the Ichneumonidae with the express intention of their feeding within the living bodies of Caterpillars."

Merian's daughters, now twenty-three and thirteen, might have been voicing their own opinions, their own criticisms. While a refuge for Merian in her middle age, the colony limited their chances at education and marriage. If Merian had wanted to make a break earlier, she may have been reluctant to move her mother again. When Johanna Heim Marrel died in 1690, so did one of the last reasons she would have had to stay. Eventually, perhaps, the rooms seemed too austere, the walls too close. Outside the gate, life beat its wings.

If she needed a final push, she got it in the summer of 1691, when disease arrived at Waltha Castle. Up to forty Labadists took ill at one time. Deventer struggled to treat them, often to no avail. Conducting burials and tending to sick beds consumed community members. Yvon occupied himself keeping up the register of the dead, writing letters of condolence to families. The Lord himself was busy, according to one Labadist in a letter to his mother-in-law. "God is receiving now one and now another," he wrote.

In August of 1690, a black caterpillar streaked with gold had knit itself a cocoon. In the past, Merian had fed similar caterpillars many times, gathering the apricot and quince

leaves they preferred, laying the food hopefully at the insects' feet, only to watch them shrivel up and die. But this one lingered for almost a year, not drying out, not spawning flies. It stayed wrapped as she reclaimed any forfeited trinkets, packed up her boxes once again, folded her simple clothes. It hatched into a gray moth with soft squiggles on its wings in June, 1691, just as the first Labadists fell ill.

Three months later, she found another. This time, in Amsterdam.

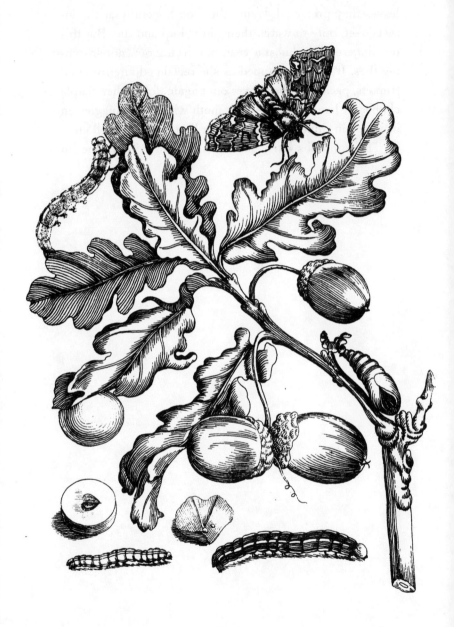

# CHAPTER FOUR

# Le Grande Monde

I have had several gentlewomen in my house,
who were keen on seeing the little eels in vinegar:
but some of 'em were so disgusted at the spectacle, that
they vowed they'd ne'er use vinegar again. But what if one
should tell such people in the future that there are more
animals living in the scum on the teeth in a man's mouth,
than there are men in a whole kingdom?
—Antoni van Leeuwenhoek, *Letter 39*

*Amsterdam, 1691–1699*

The good doctor's secret injection formula kept skin impossibly plump, unbelievably firm. Pores visible, lips pink, eyebrows drawn together in slight dismay, the faces of infants floated in jars, perfectly preserved. He draped their necks with lace collars to conceal the cut.

A respected surgeon and city obstetrician, Frederik Ruysch had easy access to the bodies he used as subject matter. As Amsterdam's designated anatomy expert, he was required to conduct one public dissection each year, usually during the winter when the cold slowed decay. His wax-based mixture of mystery ingredients and his skillful cutting brought arteries and organs to light in ways they never had been seen before. He kept the body parts on display in

his cabinet of curiosities, where the public could view them, for a fee. Though he had a scientific purpose, he arranged them for beauty, and to make a point, as if the femurs and skulls and flesh were pigments he could use to create an allegory, a vanitas, like the paintings that hinted at the transitory nature of life. He created them as art. Tiny skeletons posed clutching anatomical accessories. A violin bow made of artery. A handkerchief of lung. Captions accompanying the tableaux underscored the message: "Why should I long for the things of this world?" read one. "What is life? A transient smoke and a fragile bubble," said another.

Though his anatomy displays were his most famous, Ruysch also collected more traditional specimens. Glass bottles contained tropical fish speckled with white dots, a turtle half out of its egg (cupped by a severed arm), clusters of shells and dried seaweed branching like miniature trees. A plump midwife toad from Surinam floated in brandy, split to reveal the spine, where young toads emerged from the eggs she carried on her back.

Amsterdam at the end of the seventeenth century was crammed with cabinets that were packed with wonder, gleanings from the new continents discovered all the time, at the end of a microscope, in a seashell from Jamaica, in the rib cage of the corpse of a criminal. The Netherlands had only vaulted recently into the position of an international powerhouse, displacing Portugal as the leader in the spice trade, battling England as a sea power. The highly successful Dutch East India Company and its less lucrative counterpart, the West India Company, set up colonies in the Americas, Indonesia, and Africa and sent fleets of ships crisscrossing the ocean. All roads, and rivers, and canals, led to Amsterdam. The flood of wealth and new information, combined with rapid advances in anatomy, astronomy,

and natural philosophy, provided items for collections, money for collectors to build their storehouses, and an increasingly curious public.

Specimen collections like Ruysch's, gatherings of international artifacts and local oddities, had been around for more than a hundred years, ever since Europe made contact with lands across the Atlantic and sailors began bringing their finds home. The encyclopedist Ulisse Aldrovandi, for instance, referred to his private hoard when writing his natural history books as early as 1602. Merian herself had kept boxes of display insects to awe her friends in Nuremberg. But Amsterdam's cabinets, drawing on an ever more accessible global stockroom, dwarfed these earlier efforts. Including both collections owned by physicians and professors, who subjected the objects to sober probing in the hope of coming to a deeper understanding of nature, and junk shops that sold handfuls of miscellaneous shells, these cabinets of curiosity spanned the bridge between science and spectacle.

They were the personal, messy, disorganized forerunners of museums. But the guiding principles behind many collections were only "more" and "stranger." Often they were arranged according to whim of the owner, as scientific classification was still in flux, new systems evolving all the time. Categorizing a universe that shifted every time a new ship blew into port proved both necessary and a challenge. No one had yet come up with a satisfactory solution. Some classified shells as "knobbed" versus "wrinkled," "the right lip broad" versus "parallel lips," "smooth" versus "spiked." Others grouped by geography, or listed insects as "naked wings," "sheathed wings" or "creeping." Some owners echoed Ruysch, and arranged for artistic effect. Apothecary and collector Albert Seba patterned his shells into horned and sneering faces with clamshell cheeks.

Some of these collections were lavishly decorated and included fine art in their holdings. Others were literally cabinets, their hinged wooden doors swinging open to reveal many tiny drawers, thin as trays, where moths and beetles lay, pinned and splay winged. Rembrandt sketched items from his own cabinet—a conch shell and a bird of paradise. The mania for acquisition helped drive him into bankruptcy, and his creditors painstakingly recorded many items he had gathered, from Indian javelins to a bust of Seneca. In Levinus Vincent's cabinet, famous throughout Europe, a wooden chest of trays pulled out to reveal, like designs in an embroidery hoop, butterflies posed to highlight the artful shapes on their wings. Beetles had a harder beauty—antennae and forefeet too long for elegance, but not for awe. The politically influential Nicolaes Witsen owned a heap of novelties, too, built through his connections with the East India Company. A visitor could view a whole array of flies, spiders and caterpillars from Surinam, one of the main outposts of the West India Company, while breathing in the cabinet's cedar scent.

With warnings from Labadist Anna Maria van Schurman's autobiography still ringing in their ears, cautions about "foolish company" and "involvement in the amusements and adornments of worldly girls," Merian and her daughters moved into a house on Amsterdam's Vijzelstraat. The crowded city where merchants piled tables high with fish, sailors wobbled on land legs after months at sea, horses jostled flank to shoulder, must have seemed dizzying after the measured life of contemplation behind the castle walls. At 200,000, the city had four times as many people as Nuremberg, five hundred times as many as Waltha Castle. Here was the country Marrel had warned about with his

tales of decadence and tulip speculation, the country that
had drawn him back. Here was the city her older brother
fled for Wiewert. The Labadists called Amsterdam *le grande
monde*. Worldly girls and men and women were everywhere.
Amsterdam was capital of the worldly, and they were in the
thick of it.

In Nuremberg, the Graffs tumbled into a net of family
and friends. Now Merian had to build the web herself,
strand by strand. Single without a convenient explanation
now that the Labadist colony had disbanded (the leader
Pierre Yvon's thoughts on marriage, which she'd quoted
with such assurance in her effort to get Graff to go away,
might not carry much weight outside Wiewert), she needed
to support herself and Dorothea, still a child. So she started
making connections, tracing a path from apothecary, to
botanical garden, to Ruysch's house, to fellow painters' gal-
leries, picking her way along alleys of this nimble city, laced
by canals, a delicate, point-heeled slipper compared to
Frankfurt's workboot.

The sect encouraged shedding belongings, but Merian
had been unusually stripped, mostly by her own will. Mer-
ian had left her religious community and filed a petition to
give up her citizen rights in her native Frankfurt, seeking to
avoid city taxes. Within a few years of her move to Amster-
dam, other ties would be severed, too. In 1692, her hus-
band, back in Nuremberg, initiated a divorce and soon
remarried. The same year, Johanna Helena, Merian's older
daughter, married Jacob Hendrik Herolt, a businessman
and former Labadist who had trading connections in Suri-
nam. The Labadist colony's notion of a "community of
goods" finally dissolved that summer, under pressure from
Deventer. All members were invited to reclaim their assets,
which may have left the young couple with a few more

resources to start their life together. A glimpse of Herolt's personality comes through Petrus Dittelbach, the former Labadist, who noted in his exposé of the colony that Herolt protested the harsh beatings and flagellations meted out at Waltha. When the couple moved to Amsterdam, Johanna launched her own artistic career.

Merian's mother, brother, husband, older daughter — she had lost so much in the past few years that lightness and anxiety, hollowness and freedom may have been part of what she carried through the racing streets. Hints of a wistful loneliness are captured in a letter to an old friend from Nuremberg, Clara Regine Imhoff, now Clara Regine Scheurling: "It has been many years since I last heard from all my dear friends, particularly those I had in Nurnberg. I confess that it would make me very happy to hear something from them or to see some of those, and although I regard myself as unworthy of it, I would much appreciate the kindness of having a few lines to read." Her pleasure in being back in contact shines through in her exuberant handwriting. She addresses the letter to her former pupil in a large, boisterous script, either celebrating the young woman's marriage (she calls her "Madame"), or the happiness of a renewed friendship. Though the girl always knew her as "Graff," she signs her name "Maria Sibylla Merian."

Part of assembling a new life involved redefining herself. As a girl, she'd been part of a household artistic unit as the daughter of a master. As a young woman, she'd played the role of artisan wife, another acceptable way to produce art and make a living. In her thirties, she'd joined the Labadists, adopting a part far out of the mainstream, yet still inhabiting a recognizable story. But here, a woman on her own, not really a wife, not really a widow, who could she be? As a start, she took back her father's name.

This might have been a symbolic severing of the marital tie, or a practical calculation. Dittelbach published his long-threatened and scandalous book about life with the Labadists in 1692. It quickly sold out, requiring a second printing only a few months after the first. With her married name she was easily identifiable as the wife of the "Graff" from Frankfurt so firmly rejected at the castle gate. It was hardly a flattering portrait. Calling herself "Merian" might have caused professional confusion as she wrote her first three books as "Graff." But her famous father's name still had currency and even when married she had identified herself as "daughter of Matthaus Merian the Elder" on the title pages. She signed her new paintings "Merian," and scratched out "Graff" on the copperplate of the title page of the caterpillar books.

She deliberately cultivated relationships with natural philosophers, publishers, and patrons as well as artists like portraitist Michiel van Musscher, contacts who would help build her business. Amsterdam was a good place to make a living, particularly for artists. Money flowed through the economy. Decorated objects were in demand, their value heightened by a painter's touch. Trade made many rich, but even members of the middle class bought portraits and still lifes, and the walls of houses were often crammed with oil paintings. Collectors wanted pictures of the items they'd gathered, both to form catalogs of the whole and to record individual favorites.

Artists who painted natural curiosities found themselves documenting a world emerging and disappearing at the same time, a brief encounter as species heading for extinction and humans crossed paths. Pieter Withoos, who worked for several collectors, made watercolors of a plump white bird with a large beak that reached up into the mask of its

face. It had tiny wings and several nodding tail plumes. This was the Reunion dodo, mentioned in a few travelers' accounts as a solitary bird that couldn't fly and was so fat it could barely walk. It had the legs of a turkey and the tail of an ostrich and very tasty flesh. For his portrait, Withoos may have painted a bird that survived the trip back to Holland from the island in the Indian Ocean, or he may have used a stuffed specimen. Live or preserved, it vanished, as did the population on Reunion. The last Reunion dodo was seen alive around 1746. Withoos's images are all that's left.

In this economy, Merian experimented with selling not just her paintings but insects themselves. She knew well the value a plant or animal could have for a passionate collector. In her letter to her former pupil Clara, she wrote of the many spice seeds and species from the East and West Indies on the market in Amsterdam, and added "if anyone is a collector, I shall be happy to send some, if I could obtain in return all kinds of creatures found in Germany, such as snakes of all species and every variety of butterfly or stag beetle."

As part of her effort to establish herself, Merian sought out many of the cabinets of curiosity, bending close to examine a coral branch, lingering over the insects. Their owners were both potential clients and potential colleagues in natural history investigation. She visited Ruysch's, Vincent's, and Witsen's collections, among others. In some cases, she brought her watercolors with her and sketched a specimen or two, tucking the image away in her study book for future reference.

Van Sommelsdijk's butterflies and dried plants had only been a taste of these riches. Whatever these personal treasure chests lacked, it wasn't ambition. The aim was to en-

close all the riches of the earth in a wooden case. And it was an ever-escalating contest. One traveler to South America doesn't even bother describing the crocodile: "their Skins being so commonly to be seen in England, in almost every Apothecaries Shop." But the deluge of new creatures could be bewildering. Exactly how big was Noah's Ark?

The large, the beautiful, the poisonous, the highly peculiar were particularly prized. Anything that could trigger the intake of breath, the flooding of the senses that was so like a religious experience. Some animals revealed the strangeness of the New World by their very existence. Who could ignore the lantern fly, with wings to make any butterfly proud—warm greens and browns like a branch in the sun, with glaring eye spots—grafted onto a grotesquely swollen peanut-shaped head? The lantern fly's powers were legendary. In Moffett's *Theater of Insects*, he described a "glow worm" found in Hispaniola. It looked like a beetle with a long head like a lantern: "the eyes whereof shine like a candle, with whose brightness the air is so enlightned, that any man may in his chamber, read, write, or do any necessary business. Many of them joyned together make such a light that an army may march by them whither they please, maugre all winds, darkness, rain or storms whatsoever." He adds that the natives made the insects into a paste and rubbed it on their skin, to make their bodies glow. As early as 1620 the Dutch artist Jacques de Gheyn II made a watercolor of one of the bubble-headed insects, labeling it a "lantern-bearer," and Nehemiah Grew of the Royal Society mentioned the fact that their heads lit up in 1681. Of course the ones in the collections didn't glow—they were dead. But it would be something to see.

The rattlesnake, with its mouthful of venom and sinister-sounding tail, lay coiled in many collections, including that

of the Royal Society. Live ones, shipped from the Americas so the crowds could hear the rattle for themselves, appeared on European docks. Venomous snakes in general had long attracted notice. Beyond his work on spontaneous generation, Redi weighed in on vipers, too. Contrary to popular belief he wrote, the potency of these snakes lay in the yellowish liquid in the fang and not in the strength of their rage. But reports from the New World claimed rattlesnakes had truly mysterious powers: They could charm their prey, staring down birds and squirrels out of trees with their lidless eyes, their colors deepening as they cast their spells. One bite could turn a victim the same color as the snake, "blew, white, and greene spotted." If a man's legs broke out in a rash, the snakes may have poisoned the ground. Though cold-blooded, the reptiles didn't lack maternal instinct. At the first flash of danger, they called their young to them with their rattle and opened their mouths so the children could crawl to safety in the stomach.

Even the rules that governed the natural world appeared different on the new continents. What about the manatee, apparently a fish, that nursed its offspring with breasts? One of the earliest cabinets, that of John Tradescant in England, displayed a manatee's flipper labeled as a mermaid's hand. The pirate/naturalist William Dampier provided a description filled with less magic but no less strangeness, reporting: "The mouth of it is much like the mouth of a Cow, having great thick Lips. The Eyes are no bigger than a small Pea; the Ears are only two small holes on each side of the Head. The Neck is short and thick, bigger than the Head. The biggest part of this Creature is at the Shoulders where it has two large Fins, one on each side of its Belly. Under each of these Fins the Female has a small Dug to suckle her young." Not exactly the ideal of female

beauty, but still, years later, when Carl Linnaeus sat down to give all species a Latin name, he put manatees in the order "Sirenia," commemorating their seductive potential.

Then there was the opossum that carried her children in a pouch on her front. The animal, a seeming mishmash of many species with outsize ears and paws like human fingers, was first observed by Vincent Pinzon, traveling with Columbus. In his *History of Four-Footed Beasts and Serpents and Insects*, Conrad Gesner included stories of the opossum under two different creatures, both markedly female. There was the vicious "su" of Patagonia, drawn like an emaciated lion with squirrels (supposed to be children) on her back, that "to save her young ones from taking and taming, she destroyeth them all with her own teeth." Then there was the gentler "Simivulpa" or "Apish-Fox" who had a flap of skin on her belly "wherein she keepeth, lodgeth, and carryeth her young ones, untill they are able to provide for themselves, without the help of their dam." For colonists looking for signs about ways the New World environment might mold them into a new shape, the opossum offered a worrisome example of what this climate produced. This apparent uterus on the outside seemed like a gross distortion of the way things were supposed to happen in an age when ovaries and eggs were just beginning to be understood. William Byrd II brought an opossum from Virginia in 1697, causing a stir at the Royal Society. One inspired Fellow wrote a sixty-page paper detailing its dissection.

But, wondrous as they were, these specimens proved unsatisfying to Merian. "In every collection I found these and countless other insects, but also in each, the insects' origin and propagation were absent, that is, how they transformed from caterpillars into pupae and so forth," she wrote later. The butterflies in boxes were out of place, cut

from time. Wooden dividers separated caterpillar from moth, worm from plant. Dust gathered in the furry moth bodies and a leg or two might have been lost in transit. More often than not, the caterpillar and the pupa were missing entirely, leaving only the moth. It was like a book with the first two-thirds ripped out. What would engender the bulging head of the lantern fly? Did a spectacular caterpillar or dull-colored one make a morpho? Did metamorphosis across the ocean even follow the familiar steps? The flow was paramount. She was interested in what could not be encased — the moment-by-moment shifts. Impatience stirred.

If these prickles of discontent made her antsy, Amsterdam itself would have acted both as a pull to stay and as a push to go farther. Its position as a center of global trade was reflected not only in the cabinets and collections of the wealthy, but the streets themselves. To walk through them, pushed by the human tide, heart high with excitement, was to be tempted. The fish-smelling docks bristled with masts. Ships blew into port filled with adventure tales and cargo, then sat, slack-sailed, flags drooping, rope coiled, while men raced like ants over their surface, refurbishing them to go out again. The ships would be scraped clean, seams caulked, layer of tar applied in the hives of industry by the shore containing the forge, the sail makers, the sawmill. Each vessel, venturing from some far spot on the globe, might still have a trace of algae from a South Sea island on deck or a hole from some exotic worm in the hull. And in the hold!

Right on shore, the Dutch East India Company built stables for the cassowary, dodo, and elephant unloaded as part of its valuable freight. In the markets, the twisted

shapes of carrots and turnips, common and hearty roots, piled next to heaps of the foreign orange. Salt, pepper, cinnamon, nutmeg and plentiful sugar from South America spiced the discriminating palate. The aroma of coffee, not long arrived from New World plants, mingled with the smell of ox, slit open at the chest, lungs and liver displayed for approval of the meat inspector. Cloth and paper from the Orient worked their way into crafts. Sellers and buyers haggled in Portuguese, Turkish, Danish, and a mix of languages that became its own flavorful soup.

Even the most intimate spaces, the sunny corners and household tables painted several decades earlier by Jan Vermeer in nearby Delft, contained far continents. Behind women wrapped in contemplation, holding the small, domestic seductions of a glass of wine or love note, he often included a map, a globe, or an oriental rug. A geographer and astronomer, eyes trained on the distance, rank among his subjects. The window, through which his celebrated sunlight poured, was often open.

In 1697, Merian couldn't have missed the hullabaloo surrounding arrival of another curiosity, this one from Russia. The towering, clumsy young man swept through the busy streets, eager to absorb everything he could—from the docks where he learned how the Dutch built the ships that coursed back and forth from the Indies with such ease, to Ruysch's dissection rooms. Rumor had it that one preserved child was so lifelike, he bent down to kiss it. He traveled disguised, first as a workman to blend in at the shipyards, then by walking on foot through the streets rather than going in carriages.

But it was hard for him to hide, what with his 6-foot-7-inch frame, heavy accent, and the tics that distorted his face into a series of winces and grimaces. He was on the verge

of being a subject for Ruysch himself. Despite the costumes, most people recognized in this enthusiastic oddity Russia's monarch, Peter the Great. The artist Michiel van Musscher, a friend of Merian's, painted a flattering portrait of the czar flanked by a winged cherub blowing a horn.

This swell of activity at the harbor meant that, besides painting and specimen dealing, it was possible to make a living by going out and collecting the prized plants and animals. All of Europe was a market for new species, and connoisseurs were looking for people willing to seek them. Markets offered up narwhal horns and American lizards as well as asparagus and sugar. Some collectors, like England's Hans Sloane, gathered the core of their collections themselves. He traveled to Jamaica to serve as doctor to the Duke of Albemarle and tried, unsuccessfully, to keep his hummingbird specimens safe from insects by suspending them from the ceiling. He brought back cocoa, popularized chocolate drinking, and published a catalog of plants he found, as well as *A Voyage to the Islands Madera, Barbados, Nieves, s. Christophers and Jamaica.* His reasons for making the journey would have made sense to Merian, wanting to follow in the footsteps of "many of the Antient and best Physicians having travell'd to the Places whence their Drugs were brought, to inform themselves concerning them." Others advertised to Europeans abroad who might spare a moment to take a cutting or two. "I humbly intreat that all practitioners in Physik, Sea-Surgeons or other curious persons, who travel into foreign countries, will be pleased to make collections for me of whatever plants, shells, insects & c. they shall meet with, preserving them according to directions that I have made so easie as the meanest capacity is able to perform, the which I am ready to give to such as shall desire them," wrote apothecary and collec-

tor James Petiver in *Philosophical Transactions of the Royal Society* for 1696. The extremes to which Petiver expected his explorers to go are revealed in his directions for preservation: "You may often find in the Stomachs of Sharks, and other great Fish, which you catch at Sea, divers strange Animals not easily to be met with elsewhere; which pray look for, and preserve as above." Still others were professional collectors, like keen-eyed herbalist Thomas Willisel, hired by the Royal Society specifically to search out prizes. A woman experienced in tracking down and preserving insects might see this as another option. Unlike many of the cabinet owners and her patrons, Merian had paint and soil on her hands. For the moment, though, she invested in possibilities presented by the city and its collections.

Not all the specimens she inspected were preserved or stuffed. Some bloomed. Ruysch, in addition to his other occupations (physician, collector, anatomical artist), oversaw the city's Hortus Medicus, a medical botanical garden that started in the 1630s as a "plague garden," a plot of possible cures. As trade ships brought back increasing numbers of shoots and packets of seeds, the garden pushed past its original borders. Stinking passionflower and climbing cactus, both from South America, and lavender starflower from southern Africa grew separated by walkways rather than oceans. Merian's daughter, Johanna, painted two flowers from South Africa for the *Moninckx Atlas*, a collection of illustrations of new species brought to the botanical garden. Caspar Commelin, a young botanist specializing in exotic plants, organized the project.

The Hortus differed from both the pretty gardens of Nuremberg and those prosaic ones of Waltha. Its neat landscape melded diverse purposes: scientific, commercial, aesthetic, spectacular. It provided a classroom for doctors,

a marketplace for those seeking remedies, inspiration for artists looking for new shapes, and satisfaction for visitors wanting to marvel at a stalk of American aloe (so tall it required its own fold-out page in the garden catalog). To stand in the center of the circle of flowers, plots laid out in curved rows, paths radiating in every direction, was to witness as careful a display as the cabinets of curiosities. Layers and layers of colors underscored the sense of being at the vortex of things.

Another exotic garden bordered a manor several miles out of town, owned by Agnes Block. Wife of a silk merchant, Block had a talent for coaxing tropical plants to grow in Holland's chilly, damp climate. She bred birds and plants, including hibiscus and lemon trees, gathering specimens from international botanists and hiring artists to paint what flourished on her grounds. The resulting images — 400 in all — would comprise an album commemorating Block's accomplishments.

At the request of Agnes Block, Merian painted eighteen botanical portraits, including a yellow aster from seeds gathered in Africa's Cape of Good Hope. She topped one bud with a South American butterfly with loose eyespots and a coiled tongue. A South American angel's trumpet flower was probed by two tiny butterflies of unknown origins. She added azure tropical butterflies with black streamers at the bottom of their wings to a glowing yellow and orange flower by Willem de Heer. Who knew if they belonged together? Life histories were impossible to include. She could only speculate on food plants and where the insects laid their eggs. The benefit of patronage was that it paid the bills; the downside was it required looking through the patron's lens. The time and energy required for her own metamorphosis studies were slipping away.

But working in Block's garden she may have seen for the first time, or for the first time close up, a pineapple. The fruit was Block's pride. One of the first successfully raised in Europe, it is featured in a family portrait. That Block got it to bloom in the 1690s—the coldest decade of a very cold century—was a particular triumph. With its woody teeth and forbidding exterior, thick serrated leaves and heavy stalk, the pineapple was a plant wrapped up in defenses. To the touch, it was rough and prickly, but when split open it smelled so sweet. And the shape, the unwieldy bulb with sprouts from the top and sides, asymmetrical and off balance: It was not lovely, exactly. Something more fierce. It invited questions, unanswerable in a Holland greenhouse. What was it fending off? Where did it grow? What would it attract?

It wasn't many years before Merian's hard work paid off. Her list of patrons grew. She was welcomed into the houses of the politically and socially well-connected. She moved to a house on Kerkstraat, which she referred to as the "rose house." It would be a place where she could conduct her life on her own terms, admitting visitors and raising her daughter as she chose. The culture of artistic and intellectual discussion couldn't have been richer.

For the first time, she was at the heart of things. No longer was Merian waiting for printed books from Amsterdam or England to make their way to the Frankfurt book fair, or to hear their contents relayed secondhand. She could ask Ruysch if she had a question. She could seek out Caspar Commelin and discuss new finds from the West Indies with him. And she did.

Here, Merian entered a community of science and experimentation far changed from the one where she wrote

her first caterpillar book. Steven Blankaart, a doctor with medicinal books under his belt, was also examining insects. His 1688 book *Showplace of caterpillars, worms, maggots and flying creatures* had twenty-two plates, including an Atlas butterfly supposedly from Surinam, one of the most glamorous of all. At the more pedestrian end of the spectrum, he also discussed booklice and may have been the first to do so. Adamantly against spontaneous generation, he cited Redi and repeated his experiments.

In England, The Royal Society geared up again after a period of dormancy. Sloane, newly appointed secretary, started regular printing of the *Transactions* again in 1693 after six years of infrequent issues. The Society delineated the boundaries of science, giving the nod to methods and theories it found valuable. In 1687, Isaac Newton published his *Principia,* laying out his three laws of motion, based on mathematical principles, bringing physical science into the modern age. Specialized tools grew more important, Latin, less so. In Delft, Antoni van Leeuwenhoek, who started life as a cloth maker's apprentice, wrote letters in Dutch (he didn't know Latin) to the Royal Society about his refinements to the microscope. At first they found his reports of little critters gamboling in a drop of water ludicrous, but soon began anticipating his latest bulletins from the planet of the minute. An expert grinder, Leeuwenhoek spent hours polishing each lens, then rushed the rest of the contraption together. Two metal plates clasped each lens, through which a viewer, face right up to the glass, could peer at an object stuck on a pin. Some of the finer lenses could magnify over two hundred times. Turning various screws moved the item up and down or side to side, bringing it into focus.

Under the microscope, the human body was an undiscovered country. Grit pulled from between Leeuwenhoek's

teeth revealed "animalcules" spinning in dizzy circles. Creatures propelled by whipping, transparent tails swam through semen (from a sample acquired during lawful, marital intercourse, he assured his readers). Diminutive pillows tumbled through the blood. A sliced hair appeared as complex as a seashell, all bumps and swirls in gritty patterns.

He turned his lens on insect life, too (though the difference between insects and the animalcules was not clear). The microscope allowed him to chart life cycles invisible to the naked eye, like that of the flea. He also investigated the persistent mysteries of insects that lived in plant tissue and those that hatched from caterpillars and pupae. Pulling apart a lethargic specimen, he found a whole larva inside. Like Merian, he looked at larvae curled in oak and willow galls. Then he used his up-close focus to go further, and determined that the little worms created the galls in which they lived. Though he compiled evidence against spontaneous generation, "lice" he picked from leaves appeared to be born without their parents mating. This scrutiny provided the first view into the mercurial nature of the aphid, where virgin females often give birth to live daughters. As the days grow shorter and colder, though, they start producing males, too. The new generations mate and then the females lay eggs, where the young spend the winter before hatching in the spring. If that's not dizzying enough, most of the aphids are wingless, except when conditions are crowded and they develop wings to fly away. As the previously invisible came into sight, amazement only increased, confounding efforts to make some general statement about the nature of life.

Of course, Merian wouldn't have been able to see anything displayed at the Royal Society, though she read and

mulled over Leeuwenhoek's published letters. The Society prohibited female members. When Margaret Cavendish, Duchess of Newcastle, requested and was allowed a visit on May 30, 1667, to peer through a microscope and observe experiments with an air pump, she was really the one on display. Samuel Pepys recorded in his diary that the event would undoubtedly be the subject of many ballads and that "The Duchesse hath been a good comely woman; but her dress so antic and her deportment so unordinary, that I do not like her at all, nor did I hear her say anything that was worth hearing, but that she was full of admiration, all admiration." If Merian heard the story, it would have reinforced her sense that, for her work to be taken seriously, she needed to blend in.

In the Netherlands, though, the culture was far more permissive for women than the one Merian left behind. Women could run businesses, reclaim property brought into a marriage, move relatively easily from one community to the next, serve as and train apprentices, belong to certain guilds, launch paternity suits. Their ability to support themselves financially was much less dependent on their marital state. In some places, like Friesland, they could vote. Unlike Merian's native Germany, where witch fever was just starting to cool, and unlike Salem, Massachusetts, where in 1692 girls were falling into fits, seeing ghosts of coffins, displaying bite marks of the Devil on their tender wrists, Holland had not burned a witch for one hundred years. For the first time Merian found herself in good company of other female artists, professionals at the level she aspired to. Maria van Oosterwyck painted bouquets for royalty in France and England. Several decades earlier, Margaretha de Heer composed images of cut flowers tossed on a table surrounded by butterflies and beetles. Even earlier, in the

1630s, Judith Leyster captured musicians, backgammon players, children with an eel on her canvas. Her work, influenced by Frans Hals, also included a frankly cheery self portrait and a tulip book, like Marrel's.

Merian knew and inscribed a book to Johanna Koerten, Amsterdam's "scissor Minerva," who sold her cutout paper creations for up to 4,000 florins. In addition, Merian would likely have met Ruysch's daughter Rachel. Roughly the age of Merian's daughter Johanna, and recently married in 1693, Rachel was already a noted still-life painter, though only in her mid-twenties.

Frederik Ruysch's daughter showed all that a woman could do if given a measure of freedom. While Merian picked up engraving and paint mixing at her stepfather's side, Rachel Ruysch learned from her father how to prepare specimens for his cabinet, perhaps trying her hand at surgical techniques and embalming. While his first collection was housed in rented rooms (where he sometimes slept to continue his work) the second was packed into his house. The access provided lessons in botany and anatomy, invaluable for a painter, though it might be rather discomforting to have to confront those preserved babies before breakfast.

When his daughter showed artistic promise, Ruysch gave her an education similar to that a young man might receive. Though it taxed ideas of what was proper, as a teenager Rachel Ruysch studied with the professional still-life painter Willem van Aelst, a man who was unrelated to the family and somewhat of a drunk. At his side, she learned to paint nosegays and flowers in vases, in oil on canvas, a medium prohibited to women by most painters' guilds in Germany. She mastered complex backgrounds, gave her bouquets depth and volume through artful shading, played with perspective, attempting things that Merian, whose

rather slapdash artistic education stopped at twelve when Marrel and Mignon left for Utrecht, never learned. As an oil painter, Rachel was able to enter the sphere of Rembrandt and Vermeer in ways Merian couldn't hope to. Rachel's work earned comparison with Mignon, Merian's childhood companion, who had become a famous still-life painter before his death in 1679.

Rachel's paintings reflected her scientific training and the use of cabinets as a source, both the mishmash and the riches. She included a Surinam toad, most likely the one from her father's collection, in her artwork and introduced unconventional flowers to her bouquets, from wild native plants to rare exotics. Like her father, who forged his art from human limbs, Rachel may have also included actual specimens, pasting butterflies on the canvas, leaving them to provide their own hue.

Rachel Ruysch tried her hand at the genre of "forest floor" paintings that displayed the treasures from all over the globe in a seemingly "natural" environment. One of her canvases shows, clustered at the base of a tree, a pumpkin, peaches, an ear of corn, translucent grapes, flowers, snails, a nest with eggs, and a lizard licking out the center of a broken one. It is like a harvest centerpiece spilled in the woods. These odd, imaginary grottoes, though they liberate the creatures from the cabinets and feature earth and rocks and live plants, have no more sense of place than a painted backdrop. The insects and reptiles, while accurately represented, have little relationship to one another. A similar fashion reigned in bird paintings where in canvases like "Concert of Birds" or "Birds by a Pool," a pelican, a flamingo, a turkey, a crowned crane, and a cockatoo might all preen side by side. Echoing the interests of the cabinets, these birds inhabited a landscape purely of the mind.

Rachel was well on her way to a very successful career that would see her elected to the painters' guild in the Hague and named court painter to the Elector Palatine in Dusseldorf. She also had a long and apparently happy marriage to a fellow artist and raised ten children. Though Merian might not have aspired to a life like Rachel's, buoyed by the support of father, husband, and wealthy patron, it certainly must have seemed easier than her own.

As thrilling as it might be to stand at the axis of the "grande monde," as much as she learned by talking to Ruysch and visiting the botanical garden, as easy as it was to earn a living in this cosmopolitan swirl, all this was a dazzling distraction. Her study book entries and new observations dropped off precipitously. If her investigations into transformation slowed in Wiewert, they stalled in Amsterdam. A small caterpillar and its parasite, a few moths, a larva so still it looked like a growth on a leaf, a nest of ants, that's about all. She may have been busy with other, money-making ventures during these eight years. Or it may have just been the nature of animal life in the growing city. She wrote later, "In Holland more than elsewhere I lacked the opportunity to search specifically for that which is found in the fens and heath." To push her studies further, she would have to go elsewhere.

She had always craved a kind of solitude. Of her earliest insect studies, she wrote, "I removed myself from human society and busied myself with these explorations." In Waltha Castle, she sought out a calm place away from urban distractions and family complications where she could work. It's easy to imagine that human life is like that of an insect, a linear transformation from stage to stage, but so often it seems circular, shooting off in one promising

direction only to wheel back and touch on an earlier place, one inhabited before. Was Merian getting an inkling of this as she again felt the desire to leave the bustle and complexity of the city and head off somewhere completely new, to reinvent herself and her relationship to her art in yet another place? As in Frankfurt when her second caterpillar book came out, she reached to grasp a very conventional success, only to encounter the urge to throw it to the wind. Surinam would be one more renunciation of an all too hot-breathed world, a deliberate flouting of comfort and seeking out of hardship.

Merian had acquired skills and raised her children and built her name as an artist. One daughter was married, the other, newly adult. By 1699, after eight years in Amsterdam, Merian was independent, financially and emotionally. She had in mind a book about the metamorphosis of insects that would act as its own kind of cabinet—an arrangement, a trapping within order, a display—but she would push beyond the drawer's edge, beyond the sheet of parchment. Scientists and artists had documented all of these new things—the skies, the inside of the body, foreign coastlines—so why not change itself? Her cabinet's contents, like Ruysch's, would present the passing of time and reveal forms not previously visible. But rather than highlighting the separation between one stage and the next and creating meaning by putting natural objects out of place (beads on a dead infant, a hand cradling a turtle egg) she would provide context for her readers, and for herself. Connections would be clear. Nothing would be stillborn.

Reasons to stay home piled high. She was old to be an adventurer—fifty-two—and would have to fund the trip herself. Other women of her age and class were settling into status afforded by grandchildren or a fruitful career. Her

family and friends would be all the farther away. There was no guarantee she could recoup her money or even come back alive. But the butterflies offered their own rebuttal. Eventually, all her futile insect-hunting walks led to the docks. As the legend to one of Ruysch's tableaux of bottled anatomy declared: "Time flies and cannot be recalled."

In 1699, she placed a newspaper ad offering 255 of her paintings for sale. She gathered her materials. She wrote her will, making the portraitist Musscher her executor, providing for her daughters. Then she peered out Vermeer's glowing window, drank the wine, went out the door, and stepped off the map.

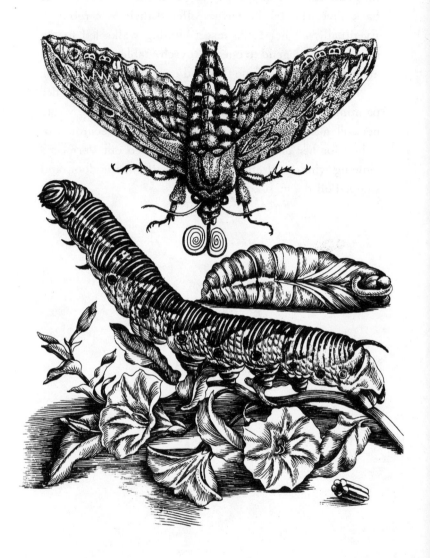

# CHAPTER FIVE

# An Awesome
# and Expensive Trip

Who from seeing choice plants in a hothouse
can magnify some into the dimensions of forest trees,
and crowd others into an entangled jungle? Who when
examining in the cabinet of the entomologist the gay exotic
butterflies, and singular cicadas, will associate with these
objects, the ceaseless harsh music of the latter, and the
lazy flight of the former — the sure accompaniments
of the still, glowing, noonday of the tropics.
—Charles Darwin, *Voyage of the Beagle*

*Surinam, 1699*

In June, 1699, Merian and the twenty-one-year-old Doro-
thea boarded a ship to Surinam. Now, Merian was on
the other side of the view she must have looked at so many
times from Amsterdam's docks. Moving from calmer water
near shore, they left behind bobbing fishing boats and chil-
dren scampering on the chilly beach, navigated through
the thicket of masts, and eased out to where the waves
kicked up higher. Outbound boats clustered at Texel, the
island blocking the North Sea from the more protected
waters near Amsterdam. As the winds pushed the ship
faster and farther, Merian launched herself to a place no
one, much the less a woman, had been before: setting out

on a purely scientific journey to do field research in a foreign country. Engraver, teacher, pietist, Matthaus Merian's daughter, Johann Andreas Graff's former wife: who exactly was the artist of this new maneuver? Did she know herself? The dream, sparked in the cramped rooms at Waltha, unfurled into life.

As the ship stopped along the English Channel to pick up passengers or wait for storms to pass, fogs to lift, the push of the right wind, the mother and daughter could have walked the dunes of the small coastal towns, breathing in, for the first time, ocean air. On board, they tucked themselves into a necessarily tiny berth — it wasn't worthwhile to set out with a ship less than full — made even more crowded by their luggage. The West India Company required their colonists heading to South America to pack, among other things: a pea jacket, three pairs of stockings, four pairs of shoes, material for a mattress, a pickaxe, a kettle, a pan, and goods to trade for food. The dinners at sea, after Amsterdam's plenty, might have been a reminder of lean years at Wiewert: salt pork and fish, worm-eaten biscuits, white peas. The swaying of the ship and the smells of other unwashed bodies didn't make it go down any easier. The captain led prayers at morning and evening, prayers that, as Labadists traveling to the New World noted critically in their journals, grew more fervent as a storm approached and waned in calm weather. In time between meals and services, Merian fed aspen leaves to dark-headed caterpillars she'd brought with her.

Over weeks, the ship moved south and west, past the coasts of Spain and Portugal. Tiny islands near Lisbon marked the departure from Europe, and those who hadn't crossed the ocean before might be "baptized" by being dangled from the yardarm into the water, as part of a rough,

alcohol-soaked celebration that included a sailor dressing up as "King Neptune" and making a speech. As women, Dorothea and Merian would likely have been spared the dunking if not the pageant. As the sails swelled in the trade winds, approaching Africa and the equator, sailors and passengers shed wool coats and hats like molting ducks. And suddenly, swept into the Atlantic, they were in a new world, even before they landed. Down by the hull, schools of jellyfish glowed with phosphorescence. Sea turtles pawed through the current. The curved backs of dolphins and lumbering hulks of whales broke the waves. Overhead, entirely new constellations tilted into sight: a cross near the South Pole and a long ridge of stars in the "Scorpion's Heart."

Trips like these, though exhilarating, must have also been shot through with anxiety. Guns, gold, brass sewing thimbles, wood-handled razors, Chinese porcelain — cargo from a hundred merchantmen — lay scattered across the ocean floor. In 1668, the *Sacramento*, carrying supplies from Portugal to Brazil, met a storm as it nosed into the Bahia harbor. Winds blew it against a shoal, cracking it, then pushed it back into the ocean. When the *Sacramento* sank, 930 of the 1,000 people on board sank with her. Hurricanes, fire, and bad directions took down ship after ship. The Dutch loved these disaster stories and created a market for books about heavy losses at sea, water-logged tragedies, and rescues against all odds. Exploding ships and starving sailors who had to eat their boots were popular themes. This was all well and good for the man sitting flipping pages by the fire, a warm drink washing in his stomach, a silk-haired dog sleeping at his feet; it was unnerving for those pacing the deck of a ship bound for South America.

Crashing into reefs and rocks wasn't the only concern. The same month Merian and her daughter left Amsterdam, a cabin boy named John Johnson boarded the *Peace,* also bound for Surinam, loaded with supplies for colonists. When it left Surinam for Tortuga, the French pirate captain Lewis Guittar swooped down and captured it. Under the pirate's control, the *Peace* ransacked nineteen ships in Lynnhaven Bay in Virginia, and Johnson stayed on as the assistant cook. Eventually a guard ship attacked the *Peace,* won the battle, and arrested the pirates. Unfortunately for Johnson, the courts of Virginia were not sympathetic to his tale of forced labor, found him guilty, and shipped Johnson, Guittar, and the rest of the crew off to England to be executed. Their bodies hung from gallows along the Thames, rotting, a warning to others who might consider going astray.

Pirates trolled waters of the Caribbean and off the South American coast, searching for fat-bellied merchantmen stuffed with indigo, silver, and gold. As Merian's ship headed west, Captain John Bowen, a Creole pirate from Bermuda, cast about for likely victims in West Indies ports. The pirate ship *Dolphin* pounced on and raided a big prize from Denmark. The English government began closing in on Captain Kidd in New York, sniffing after his most recent haul of silk and coins. The pirate William Dampier took a different course, and in 1699 stayed home and published the second of his successful books about his adventures and his observations of plants and animals: *Voyages and Descriptions.* The Labadists who had been seized and thrown off their boat on the way to Surinam would have been able to provide dismaying details of pirate capture.

Sitting outside on some quiet night, in a breeze that grew daily warmer against her skin, Merian may have tried

to etch herself a portrait of what she would find. A modern-day tourist, preparing for a trip, will buy a guidebook detailing each city, the roads that lead from place to place, the climate, habits of the people, tips on the language and what to pack. Statistics give population numbers and the heights of various mountains. She can pore over glossy color photos of the landscape, and watch a video so comprehensive that many views seen upon arriving are not a surprise, just a burnishing or tarnishing of images cast and cooled.

In contrast the seventeenth-century traveler set off with precious few pictures to hang her expectations on, a lacuna filled by imagination. There might be a map, a long shoreline cracked by rivers and streams. Sketched-in trees and town names would grow scarcer as one approached the interior until most New World maps bleached out into blank parchment.

Though largely unexplored by Europeans, Surinam and its surroundings did appear in some logbooks and stories. The whole eastern bulge of South America was called Guiana, and was carved into three countries, now called Guyana, Surinam, and French Guiana. Christopher Columbus provided the first description of the area to Europe in 1498, after his third voyage. Missionaries and businessmen scouting investments provided much of the other detail. Englishman George Warren wrote *An Impartial Description of Surinam upon the continent of Guiana in America* in 1667, alerting his countrymen to financial opportunities and scantily clad Amerindian girls. In addition to these inducements, Warren's brief account includes the following: a story about an English woman robbed and killed by Amerindians, who then fled beyond the Surinam River's waterfalls and the reach of a revenge mission; the fact that only a handful of people have ever been eaten by jaguars, though

one man was snatched right out of his hammock even as a widow fired a shotgun to scare it away; a report of an electric eel that paralyzed both a dog that bit it and the man who reached to save the dog; descriptions of frogs that croak like the "Grones of a Dying person" and birds that sing like a "Hell-bred" choir; and a whole chapter entitled, "Of things there Venomous and Hurtful." But at the end, perhaps regretting his honesty and remembering his job as a booster, Warren assures readers that remedies have been found for some of these problems. He has no doubt that cures will soon be discovered for the rest.

Reports of nearby Brazil provided another glimpse of what Guiana, just north of the Amazon, might hold. In 1648, Willem Piso, doctor to a Dutch count overseeing territory in Brazil, and Georg Marcgrave, a medical student, compiled a relatively comprehensive *Natural History of Brazil.* The book focused on medicinal plants, incorporating those used by the Amerindians, but also examined fish, birds, snakes and insects. Merian certainly read it — she admired Piso and Marcgrave's description of the pineapple. Combine these with a few tales told by return visitors, maybe of natives thought to be cannibals, maybe of bizarre creatures in an almost sinful abundance, and that was all the information most travelers had. That, and a shimmering butterfly on a pin.

Merian would have had other, more personal images, too. As a young girl in her father's house, she could have pored over New World pictures from Sir Walter Ralegh's *The Discoverie of the Large Rich and Bewtiful Empire of Guiana,* published in *Grand Voyages* by Theodor de Bry in 1599 and then again by Matthaus Merian in 1634. Ralegh, fallen from Queen Elizabeth's favor, set off to find the city of El Dorado, the legendary undiscovered hoard of South Amer-

ican gold. Ralegh's first trip to Guiana in 1595 brought back few precious metals, but many gilded promises. Due east of Peru, El Dorado was said to be the last stronghold of the Inca who fled the Spanish, taking their most valuable treasures with them. Just as chiefs told him the fantasy stories that pushed him farther and farther upriver, Ralegh relayed them back to the people of England, embellished with tantalizing detail. Despite a crew member who dove in for a swim and was eaten by an alligator, despite hours spent lost in the dark, in the thick forest, he emerged with tales of paradise: "Guiana is a Contrey that hath yet her Maydenhead, never sackt, turned, nor wrought, the face of the earth hath not beene torne, nor the vertue and salt of the soyle spent by manurance, the graves have not beene opened for gold, the mines not broken with sledges, nor their Images puld down out of their temples."

The map of the Guianas in *Grand Voyages*, with its ominous blanks, fills the space between the river Amazon and the Orinoco (the land that made up Surinam) with armadillos, tigers, and wild boar. At the bottom of the page, next to the "Ewaiponoma," (a man with a face on his chest, drawn from a report by Ralegh), an Amazon flexes her muscles. According to Ralegh these fierce warriors gave their sons away and raised their daughters to fight. The plates, rumor filtered through English and German sensibility, show blond Indians costumed in feather loincloths and crowns. They feed on pineapple and pelicans and drink goblets of spicy herb juices from cauldrons, like those that might be found in a European kitchen, imbedded in the earth. In the background of a picture where natives attack Spanish gold seekers with clubs, distinctly European trees shade a pastoral stream. Pictures like these, even if Merian recognized them as faulty, would tend to linger.

The last and, perhaps most important, aspect of life in Surinam was glossed over by promoters like Warren with his promise of imminent "cures." South America roughed up the constitution of its European visitors with a heavy hand. Just as the Amerindians hadn't built up resistance to smallpox, the French, Spanish, English, and Dutch had little defense against the mosquito-borne diseases that coursed through the tropics. The deeper one went into the forest the more likely one was to be struck down by debilitating fevers that stole the ability to work if they didn't kill outright. In the late eighteenth century, thirty of thirty-four new missionaries who went far up the Surinam River to preach got sick soon after arrival, and eleven died. Though Merian wouldn't have known these statistics, she would have hardly gone in blind. The danger was clear in stories of the Labadists' struggle to stay alive at La Providence, told by those who came back skeleton thin and left unspoken by those who didn't come back at all.

And how, exactly, did Merian see her and her daughter fitting into the picture, either the one recorded by de Bry, relayed by the Labadists, or detailed by Amsterdam business contacts? Letters indicate she planned a long stay, perhaps the five years it took her to research and write her first caterpillar book. She would use the time for "vigorous investigations," delving deep into insect lives in a way she hadn't been able to for fifteen years, since she moved to Wiewert. With the sale of her paintings, she'd bought herself the luxury of time, long days of tracking and drawing. The market for specimens would help pay her way; she could gather them to supplement her income. Perhaps she would find new sources of pigment, unheard of hues, and bring those back, too. Dorothea's presence kept her from being a woman completely alone, and her daughter could

offer a hand with record-keeping and logistics, as well as giving her someone to talk to who spoke her language, someone on her side.

This support was ostensibly the reason Dorothea came on this South American adventure. Throughout the expedition, she is in the shadows, propping up Merian, the main character. But there may have been an additional motivation. Dorothea was still young. If she was considering getting married, her mother might have brought her along as a delaying tactic, given the disastrous results of Merian's own teenage wedding. Any such distractions were thankfully, at least from the mother's perspective, thousands of miles away. And if this younger daughter had designs of her own about what she might accomplish in South America, we have no inkling of what they were.

In a way, Merian had already traveled to foreign countries by spending so much time in the world of the insects, where the costumes were outlandish, the customs unfamiliar, the language indecipherable. What could be more alien than the worms that lived by the hundreds in a silken tent pitched in the fork of a branch, or the eggs that lay wrapped in a waxy gall on a leaf? The joints that bent backward and the many-faceted eyes? The jerky way of moving, so different from the sinuous slinking of a rat or the gliding of a bird? How much stranger could this new land, thousands of miles away, but still inhabited by humans, be?

After two months at sea, in late summer the ship approached the shore: a low green land marked by river mouths that the first European explorers had called the "Wild Coast." The thin strip of beach, dotted with clumps of mangrove, was so muddy it was hard to pinpoint where water ended and land began. It was a sweep of emptiness

against which the fortress of stays and stockings and hair-
pins that propped up a European woman's identity pro-
vided only the flimsiest protection: empty except for the sea
turtles that crawled slowly out of the ocean to bury their
eggs in the sand, empty except for small rags of clouds,
wiping the sky even more clean. Farther west, this swamp
yielded to grasslands that ultimately turned into dense,
tangled, towering rain forest. Earlier visitors spotted Amer-
indian tribes on the beaches. At the time of Merian's arrival,
though, Caribs and Arawaks, who had battled for centuries
over prime village sites on rivers and streams only to be dis-
placed by European aggression, had begun their retreat to
the interior.

As they approached shore, passengers could see a plume
of brown spreading in the green sea water, mud draining
from the river. Passing over sandbars at the river entrance,
the ship left the ocean and headed inland, taking a right
turn at the fork to enter the Surinam River rather than the
Commewijne. "Here the Air was perfumed with the most
odoriferous Smell in Nature, by the many Lemons, Or-
anges, Shaddocks &c with which this Country abounds,"
wrote Captain John Stedman as his ship passed along the
river, seventy-four years after Merian's ship took the same
turn. A soldier sent to fight escaped slaves sequestered in
the woods, his first view was of Ralegh's paradise. Mo-
ments later, though, he stepped onto shore: "Here I found
the Grass very long and very Coarse, which covered us all
over with the most disagreeable Insects.... They both stick
fast to the Skin, and occasion the most disagreeable itch-
ing." He had entered the hellish country that tormented the
Labadists.

The small town of Paramaribo was tucked into a bend
several miles from the Atlantic, where the rocky ground

was firmer than the marshy coast and more protected from pirates. The tight core of the city, housing fewer than a thousand Europeans in two-story and three-story white wood buildings, modeled on those of the Netherlands, was laid out in orderly blocks divided by streets of crushed seashells. Where the streets ended, the governor's house stood with its own woods and gardens, and beyond that lay the walled Fort Zeelandia. The church and city hall marked the other side of town, but most of the action was down at the docks.

Dozens of ships swayed at anchor just off shore, red-brown river water sloshing against their hulls. Canoes and larger boats, rowed by slaves, covered with canopies to shield plantation owners from the sun, continued farther upriver, weighed down with new-bought supplies. A green lawn sloped right down to the water. Pet monkeys and parrots chattered and screeched from cages in windows. Women recently from Africa, brought over as slaves, walked through the seashell-covered streets, children wrapped against their backs with swaths of cloth. Caribs came from the forest to trade fish they'd shot through with arrows. Dutch men clustered around arriving ships, hoping for letters, a newspaper, or perhaps a creamy Holland cheese. The sun sucked the color out of everything. With the ships that crowded the harbor shooting off their guns and naked women bathing in the river, Stedman recalled the city as "a verry lively place."

The Dutch looked at the swamps, the flat land meeting the river, the canals Sommelsdijk had cut to control the flow, the land reclaimed from water, and saw their culture reflected. They imported beef, jackets from Amsterdam tailors, flatware and linen to complete the illusion. But the mirror threw back a distorted image, warped by the heat,

the distance from home. The real danger, as John Johnson (cabin boy turned pirate) discovered, was not so much shipwreck or capture, but losing a sense of who you were and what you were striving for. In time, many wouldn't recognize themselves.

For the whole cross-ocean trip, Merian must have been eager to get to land, to start her investigations. But the first month or so was absorbed with finding a house in Paramaribo, one with a vegetable plot, where water flowed by past a garden wall. Houses in town, built from the plentiful wood of the rain forest, mixed Amsterdam and Surinam in their construction. Gauze covered the windows because glass might make it too hot. Cisterns collected rain water for drinking. Though the Amerindians slept on hammocks, letting cool air circulate and keeping out of the way of rodents and ants, many Europeans stubbornly stuck to their beds and got bitten.

In this small community Merian and Dorothea established themselves. They needed to shore up supplies and to secure permission to visit plantations and search for insects there. Merian's son-in-law Herolt had contacts from his Surinam trading ventures who might be helpful. From notes of the plantations she explored, it's clear Merian had other connections too, perhaps built during visits with patrons and scientists. Unlike Amsterdam, where educated women painted in oils and experimented in their gardens, Merian would have a hard time finding female counterparts here. Paramaribo's white population was a mixture of plantation owners, (often businessmen who hadn't been able to make it in the Netherlands), convicts exported to work as soldiers, and sailors between voyages. Having recreated Dutch elegance in their plantation homes, some women

rarely left them, for fear both of the wild animals and the unruly people. Of all the conversations it would have been nice to eavesdrop on, the ones where Merian and Dorothea explained to Surinam's colonists exactly what they were doing there, would have been most interesting.

With the many domestic details accomplished, Merian wasted little time recording her first metamorphosis. In fall 1699, she scouted near Fort Zeelandia, the walled building on the banks of the river. A chunky white caterpillar, fountains of hair sprouting from red knobs on its back, crawled along a guava, leaving the tree's foliage in tatters. As she reached out to touch this undulating fur, someone more experienced may have stopped her hand with a warning: Brushing against these insects causes shooting pain and swelling. Like a number of South American species, the larva prickled with urticating hairs, barbed or venom-filled spines that broke off on contact. Perhaps she used a glove or handkerchief to bring her toxic treasure home.

Merian wrote a brief note in her study book about her fort find, capturing the way "these caterpillars wrap themselves tightly to the trees," and the "beautiful flies" that hatched from some cocoons instead of moths. But her comments shield as much as they reveal. The fort, while a good spot for guava trees, had a bloody past and present. Cannon pointed out over the river. Guns bristled in guards' hands. In front of this same wood building, Governor Sommelsdijk had lain, shot by his soldiers. Slave owners brought their charges to the fort for punishments they couldn't or wouldn't inflict themselves: laming a runaway by cutting his Achilles tendon for a first offense, taking his leg for a second. Men and women dragged in shackles and metal collars were a common sight. As the center of Dutch power in Paramaribo, the fort served as the stronghold of

colonial anxieties about keeping control. From its grounds, the insect would have been the least noxious thing she saw.

The Dutch West India Company, never as profitable as the East India Company with its monopoly on expensive spices, made most of its money in the slave trade. Of the slave colonies that stretched up through the Caribbean islands to the east coast of North America, Surinam was the worst. When Merian arrived, about 1,000 Europeans ruled over just under 10,000 Africans. And for many of these, the country was a burial ground. Surinam consumed its captives. Some estimates say a plantation could go through four full staffs in twenty-five years. With these grim figures spurring them on, many escaped, running away into the interior to form tribes of "maroons." As more and more captives fled to the rain forest, punishments grew more severe. A 1730 list of sentences for escapees included hanging by a hook through the ribs and burning alive. The country served as inspiration for many abolitionist tracts, including Voltaire's *Candide*, which uses Surinam as an example of slavery's excesses.

The complex interplay on South American soil was captured by an earlier female visitor. Spy, publisher, playwright, the notorious Aphra Behn had traveled to Surinam in the 1660s while the colony was still under English control. She would have been closer to Dorothea's age than Merian's when she was there — twenty-three or twenty-four — and eager to embrace novel experiences. While Merian always stood firmly on the line of propriety, to the extent that she hardly ever mentioned the mating of her butterflies, Behn didn't seem to know or care if such a line existed. In her plays, novels and poems, she wrote about sex and impotence, treachery, politics, hypocrisy. She would have mocked down Waltha Castle brick by brick.

Behn liked Surinam, and mourned Charles II's letting it go, saying "certainly had his late Majesty of sacred memory but seen and known what a vast and charming world he had been master of in that continent, he never would have parted so easily with it to the Dutch." In the swap of Surinam for Manhattan, Behn may be the only one who thought the English got the worse part of the bargain.

Behn describes a lush environment of constant spring. Amusements for a young woman from Europe consist of seeking out "tiger" cubs while the mother was away from the den (jaguars, most likely), traveling eight days upriver to visit a remote Amerindian village, sitting down to eat an electric eel so large and powerful it almost killed the man who caught it. The jungle, though dangerous, is filled with spectacle. It's a marvel, she writes, "how such vast trees, as big as English oaks, could take footing on so solid a rock, and in so little earth as covered that rock, but all things by nature there are rare, delightful and wonderful."

Against this background, Behn sets a romance that is part *Othello*, part *Arabian Nights*. Her 1688 novel, *Oroonoko*, tells the story of a young African prince who has the misfortune to fall in love with Imoinda, a woman coveted by his grandfather, the king. Foolishly, secretly, the lovers meet anyway and are discovered, adding insult to the king's injury, and Imoinda is sold into slavery.

Lured onto an English slave trader's ship with a false invitation to a feast, Oroonoko is soon also in chains, bound for Surinam. Once there, the young prince discovers Imoinda nearby, and plantation owners, recognizing royal blood, let the couple live in peace with promises they will soon be liberated and sent home. Before long, though, Oroonoko becomes impatient with the Englishmen who lied to him so many times, particularly when Imoinda becomes pregnant

and he fears the child will be born a slave. With a stirring speech, Oroonoko rallies his countrymen to rebellion and they hack and burn their way deep into the forest. They are prototypes of the maroons, just beginning to escape as Behn arrived. As the English close in, the rest of the escapees abandon Oroonoko, leaving him with one trust-worthy companion and the pregnant Imoinda to face their captors. Imoinda shoots the governor with a poisoned arrow, but his Indian mistress saves him.

They talk Oroonoko into surrendering with promises of freedom, and then tie him to a stake, whip him, and rub pepper in his wounds. A few days later, he steals away into the forest with Imoinda and her unborn child and kills her, with her consent. The governor and his men catch him, weak from despair and lingering by the body, and chop him to pieces in a final scene almost too violent to read.

It was a complex moral universe for someone, like Merian, who had taken her morality so seriously. In some cases, the reality was not much less grisly than *Oroonoko* portrays. Many Europeans accepted slavery, but embracing it theoretically on a distant shore and encountering it face to face were two different things. Behn, who never makes a case against slavery as an institution, creates a disturbing picture of the way it acts on one noble individual. John Stedman, an author who was hunting escaped slaves in Surinam, wrote such grim descriptions of whippings and abuse that abolitionists adopted his book for their cause. And, what-ever the bulk of people in the Netherlands and England thought, Merian heard arguments against slavery from the Labadists at Wiewert who frowned on it. But, like the Labadist colonies in Maryland and Surinam, both of which had slaves, Merian adapted to the mores of her new life. As part of establishing her new household, she hired Africans

whom she calls, in her Surinam book, "slaves," and an Indian woman, "my Indian," who most likely worked as a servant. (As a result of treaties between the Amerindians and the Dutch, some tribes could be enslaved, while others, like the Caribs, Warao and Arawaks, could not.) Merian's discomfort would eventually bubble to the surface, but, as usual, only in the most oblique ways.

In her scant records, Merian speaks of happiness only when hearing from old friends and uncovering a new metamorphosis. Here, where she didn't even have to leave her garden to find unique specimens, there would be plenty to trigger her joy. Cocoons stuck to the wood window frames. Tadpoles beached on the grass outside her garden door during the rainy season. Beetle grubs nestled in the potatoes in her garden plot. In one corner of her house, a blue lizard laid four pearly eggs. The room where she slept was alive all night with insects' hum.

In this environment, her painting shifted, absorbing the techniques she'd learned in Amsterdam, as well as the vibrant tropical colors, the eeriness that got under the skin. It was as if a ribbon, knotted in a tight bow, had been released. The pictures almost pour over the sides of the page, and show their subjects glimpsed from strange angles: a view from beneath a banana branch, the underground life of a cassava root. Unlike her European plants and caterpillars, centered and balanced, these portraits show asymmetry, like those of Rachel Ruysch and her mentor Willem van Aelst. Even the chips in Merian's study book expanded — the extravagance of wings resulting in an extravagance of parchment.

And what of Dorothea? Somehow, it doesn't seem like she would have been chasing tiger cubs for a lark and dressing up in finery to astonish the Amerindian villages, like

Behn's young narrator. Unlike Behn, Dorothea grew up surrounded by Labadist mores of simplicity and sobriety. She also would have had to support her mother. During the last two journeys the pair took together, from Frankfurt to Wiewert and Wiewert to Amsterdam, Merian would have smoothed the way for her daughter, still a child. Now the roles began to turn as the fifty-two-year-old woman and her twenty-one-year-old daughter set up their house, planned insect-hunting excursions, and negotiated the bumpy terrain of a new country. One felt her muscles grow strong beneath her dress, while the other was a little less quick to snatch a butterfly out of the air than she used to be.

In some ways, this tropical life was beyond sweet. Pineapple, which sprouted grudgingly under Agnes Block's care, grew "as easily as weeds" in Surinam. When one split open, Merian noted, "then the whole room smells." Given that she starts her Surinam book with two paintings of the fruit, and describes in detail how to peel one, and eat it raw or cooked or pressed into wine, one imagines her house often held the scent of the fragrant fruit.

At dusk, flocks of coral-colored birds drifted along the beaches, flapping off to roost for the night. A harsh cry occasionally interrupted their silent gliding. Plain brown young hatched from nests in the mangroves, growing pinker with age. People called them "Surinamese flamingos" and that is what Merian wrote at the bottom of the watercolor where she captured one.

The scarlet ibis on the page holds itself almost painfully erect, a thick splash of solid color, except for the black tips of the wings, the long curved beak, the toenails, the eye. The curling lines of head and chest threaten to escape the page. The eye looks slightly puffy and tired, but gives a

knowing glance at the observer, belying the rigid profile. The colors, so rich they mock the three hundred years, make it seem like the pigment was ground yesterday.

The egg on the ground marks the ibis as female. Her father's stork, dipped in pink, transported to a tropical climate. A self portrait.

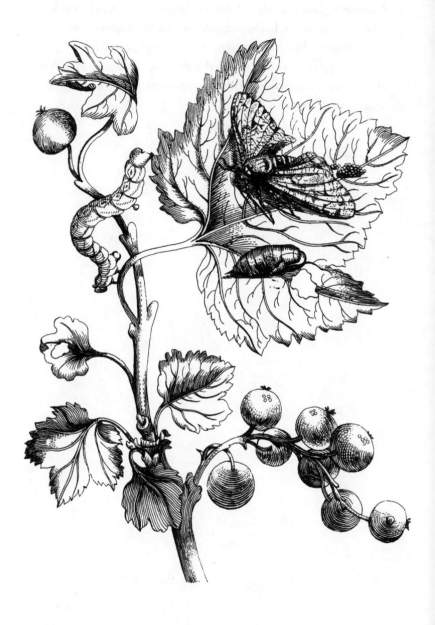

# CHAPTER SIX

# Far Out into the Wilderness

Where are also some rare Flies, of amazing
Forms and Colours, presented to 'em by my self;
some as big as my Fist, some less; and all of various
Excellencies, such as Art cannot imitate.

—Aphra Behn, *Oroonoko*

*Surinam, 1700–1701*

Somewhere in the forest, three hundred years ago and today, a blue morpho butterfly lurches through the understory, haunt of strangling vines and dead leaves. Great plates of color, flashing blue, flashing silver, the wings look as heavy as genuine china. It is, for someone who mixes colors, grinding pigment, trying to capture gleam, a truly impossible blue. His metallic shine and palm-width expanse add to the impression of weight, an insect just catching itself before sinking too low. It's almost clumsy, this slow flailing.

Another azure glint. A second male ventures along the forest edge. Is there a female somewhere close, cracking her pupal casing? He floats down to investigate. Sensing the intruder, the first morpho launches into a chase, with speed and control that didn't seem possible a moment before. The insects tumble after each other, their deadly earnestness

undercut, in human eyes, by those outsize wings. If the movement was a sound, it would be a twitter. They twitter up above a thick tangle of bushes, down along a rocky stream, until the trespasser finally tires, gives up, and moves on.

The morpho stops on a broken vine, drawn by the sap, unrolls a long proboscis and probes the vein. Then he folds his wings to a single line, resting on a low plant. The underside of his wings, ribs of soft gray and tan, are all that's visible now. Still against the stalk, he becomes a brown leaf, immobile, just within reach of an outstretched hand, a very steady hand, sneaking closer with butterfly net held firm. He pauses a moment longer. And then he's off, rising and halting, high to where branches jut out, now dipping down again, now gone, leaving an echo of blue in the air like a taunt.

At some point early on, the sheer difficulty of collecting insects in Surinam must have hit Merian hard. While some species, particularly those that fed in fields, were easy to document, others were out of the question. Tracking their life cycles, as she intended to do, edged close to hopeless. Her traditional methods wouldn't work here, the ones she'd perfected over thirty years. Find the caterpillar. Put it in a box. Note and gather the food plant. Feed the caterpillar. See what it would become. If a pupa hatched flies, and died in the box, draw the flies, their larvae, their cocoons. Then, find another caterpillar and raise it again, and again, and again. It took her years of patient caterpillar cultivation to gather the material for her first book. Now, as moth after moth escaped her grasp, she was running out of time.

The rain forest, with its dense tangle of trees and shrubs and mysterious insect life, shielded much of the country as

effectively as a fortress. Anyone who ventured in risked getting caught. Skirts stuck on roots. Branches snagged hair. Wood lice rained down the neck of a blouse, and sweat pooled between corset and skin. Snakes could choose any moment to release their grip on tree trunks and drop onto shoulders. Garcilaso Inca de la Vega, describing Gonzalo Pizarro's expedition of the early 1500s, reported on the difficulty even soldiers had making their way through the South American tropics in European clothes: "On account of the constant waters from above and below, they were always wet; and their clothes rotted, so that they had to go naked. Shame obliged them to cover themselves with the leaves of trees, of which they made girdles to wind round their bodies. The excessive heat of the region made their nakedness bearable; but the thorns and matted underwood of those dense forests (which they had to cut by blows of their axes), cruelly tore them, and made them look as they had been flayed."

In Amsterdam's botanical garden or her family vegetable plots in Frankfurt, planted for human pleasure and use, flowers perched knee- or maybe waist-high. Collecting a German butterfly could be as simple as reaching out a finger. In contrast, the rain forests of Surinam grew out of all proportion to human need and scale. To walk along the bases of the 150-foot-high trees was to stroll far from the action. Life teemed in the canopy, in the high branches. Pacing the undergrowth, unable to fly, unable to climb, a woman could only deduce what went on through fallen clues. Petals from geranium-like flowers, torn apart by an invisible hand. Palm-sized globes of fluff that looked like dandelions, one dark seed, big as a hazelnut, suspended in the middle. A sudden smell of honeysuckle from unseen

flowers. A curl of white feather. Vine ropes, kinked and twisted, dangling like ladders to the sky. Noises drifted down as well. A loud bird call, like a wolf-whistle. The chatter of spider monkeys, black tails flicking into view for an instant, before they scrambled out of sight.

Many insects, too, spent much of their lives in the canopy, feeding on that remote nectar, though they descended occasionally to find food or take refuge in the underbrush. If a naturalist did catch sight of one, it could be difficult to tell exactly what she was observing. The lives of tropical butterflies are more complex than Merian could know. More complex than anyone would suspect for a long, long time. Some steal poisons, absorbing toxins from plants they feed on, remixing the chemicals for their own use in the same way an apothecary might blend medicines. A bird might snap up a luscious-looking butterfly snack and moments later find itself retching and spitting every last wing fragment off its tongue. If the taste is bad enough, it will avoid all insects with similar patterns. Other butterflies, perfectly palatable, have evolved to look like the poisonous ones, mimicking their shape and color, warning predators away from their tasty bodies with a clever costume. As a result, three butterflies, identical to the casual glance, can come from completely different biological backgrounds: some with six walking legs, some with four; some from smooth larvae, some from spiny larvae; all with black wings, all speckled white toward the edges, all splotched with orange close to the abdomen.

And it gets more intricate still. An entomologist shimmying up a rain forest tree would find that each level hosted butterflies segregated by color, like an apartment building with a separate family on every floor. One 1975 study by Christine Papageorgis, based in Peru, shows how each

"mimicry complex," or guild, blends in with the unique environments of varying heights. Closest to the forest floor, transparent winged butterflies fly from trunk to trunk, letting vines and rotting leaves show through. Higher, just above a man's head, patches of orange and yellow replace windows in the wings, like bits of sunlight struggling through the branches. Farther up, where the leaves start, dark butterflies with uppersides splashed with red and yellow disappear into random spots of brightness as they rest against the bark. In the upper canopy, butterflies with blue iridescence near the body and dark wings cut with yellow take advantage of the sharp contrast between light and shadow. And above the trees, orange-winged butterflies dominate, wings beating gold in the sun.

Not only did the insects live out of reach, wield toxic poisons, and look dismayingly alike, their sheer numbers both thrilled and confused. Grasshoppers, cicadas and beetles crawled over every available surface. The entomologist Henry Walter Bates wrote about the richness of Para, Brazil, in his 1863 book *The Naturalist on the River Amazons:* "It will convey some idea of the diversity of butterflies when I mention that about 700 species of that tribe are found within an hour's walk of the town; whilst the total number found in the British Islands does not exceed 66, and the whole of Europe supports only 321...An infinite number of curious and rare species may then be taken, most diversified in habits, mode of flight, colours, and markings: some yellow, others bright red, green, purple, and blue, and many bordered or spangled with metallic lines and spots of a silvery or golden lustre."

Merian must have felt a similar sense of abundance. Interest and opportunity had led her to one of the richest sources of insects in the world. Surinam is part of the

Guiana Shield, a 2-billion-year-old rock formation that bred diversity as continuous forest flourished during wet periods, only to become forest islands separated by savannah during dry periods. In the isolation of these islands, unique trees, birds, mammals, and insects evolved, from anteaters scuffling along the ground to radiant parrots in the treetops. Modern-day estimates of insect diversity dwarf those drawn up by Bates. Some say the number of insects reaches into the millions. Most of these live in South American rain forests where just the inventory of ants is dizzying. Brown ants march across the forest floor, carrying circles bitten from leaves above their heads. Others claim a tree as their own, building their nest in its heart and racing out to attack any interlopers. Red, black, small as a quill tip, long as thumb joint, ants are everywhere. Ants carry squirming caterpillars back to their lair; ants raid the lairs of other ants; blind ants cruise through underground tunnels — they make the forest move. One tree in Peru can host as many as forty-three species of ants. If Merian found an intriguing larva, then it didn't pupate, or a parasitoid sucked it dry, or she couldn't discover the right food, there were no second chances. Twenty moths would flutter near the late-burning candle every evening, each like a shard of bark from a discrete tree, no two the same. In a forest with thousands of butterflies, there was no certainty of finding the same species twice.

Time, too, was unmoored. Merian always admired caterpillars for their orderly schedules. But here, where sun alternating with rain defined the seasons, a winter of dormancy and a summer of hatching and mating could no longer be relied on. As Aphra Behn wrote of Surinam: "'tis there Eternal Spring, always the very Months of April,

May and June; the Shades are perpetual, the Trees, bearing at once all degrees of leaves and fruit, from blooming Buds to ripe Autumn." Plants flowered two times a year, or more. Insects hatched three times a year, or more. The seasons had their own pulses, but it would take years of experience to feel them.

If, in Amsterdam, Merian's discussions with the city's great men yielded answers to her queries, if insect lives began to cohere under her gaze, if her readings of Swammerdam and Leeuwenhoek provided pieces to the puzzle, and side studies of anatomy and botany made a picture emerge, Surinam and its creeping inhabitants cracked open all of the questions again.

At first, the snarl of vegetation kept Merian close to town or hunting in the evenly spaced rows of plantations. She sampled as she investigated the fields and kitchen gardens. Guavas (made into cakes and jam), papayas (they "melt in the mouth"), cassava (baked into bread), red peppers (added to sauces), lemons (candied), watermelon (refreshing for the sick), soursop (pressed into juice), vanilla (used in chocolate), bananas (good both cooked and raw), as well as oranges, grapes, Surinam cherries, and pomegranates all found their way onto her easel and her plate. She doesn't mention if she tried roasted palm worm, considered a delicacy by the Amerindians, but says that palm trunk, when cooked, "tastes better than artichoke hearts."

But it was insect discoveries and observations that filled her first months with sketching and writing in her study book, particularly after the rainy season spurred an explosion of hatching. During one week in February, 1700, she picked green caterpillars no bigger than bits of string off a

cabbage; the orange-spotted caterpillar feeding on orange trees spun itself a cocoon; and a pupa that twitched in her palm broke open to reveal a grey-winged moth.

Like Sommelsdijk, Merian wanted to learn which Surinam species could be adapted for human purposes. Like the sensible farmer who planted date trees so future generations could harvest fruit, she thought this cultivation of the land and its products represented wisdom and foresight. It was the justification for her interest in insects, which could never quite be squared with practicality. She also sought out the caterpillars and food plants of many of the gaudy species that had caught her eye back in Amsterdam, tracing their lives from egg on leaf to butterfly sipping nectar, and tracked the development of pests of cotton plants, cassava, figs and grapes, from their habits to their chosen food. This knowledge would be vital to those who wanted to control these species and protect their crops. She investigated the reproduction of two kinds of cockroaches, including the pests that slipped through keyholes into the house. Her focus on changing hues continued from her early studies in Nuremberg. She found grey pupae that opened into butterflies with completely different wing patterns and painted them on a certain rose that changes from white to red over the course of its life. Insects were the key to the ecology of the country.

Though the life in her garden could have kept her well occupied, the forest wouldn't let itself be forgotten. She must have been able to feel its draw in the same way one can feel the tug of the ocean on a coast even when it's out of sight. Monkeys' chucking cut through the thick afternoon air. Flame-banded coral adders, mouths full of venom, slipped through the brush. Bright green parrots

flew out of the trees to feed on fruit, then darted back again over the invisible line that separated the cultivated from the wild.

Always a solitary worker, she found that in Surinam she needed help, particularly with species beyond town boundaries. With the plantation owners interested in little but their cash crop (she complains that they "mocked me for seeking anything other than sugar in the country," and sugar cane is conspicuously absent from her drawings though models would have been everywhere), she relied heavily on the Amerindian and African women, not just for cooking and cleaning, but for information about and as liaisons to the forest world.

Always interested in the mechanisms of color, Merian noted the seeds the Amerindians soaked and dried and used to paint their bodies with red patterns, and the fruit that when pressed and left in the sun provided a long-lasting black. She writes, "these decorations remain intact for nine days; before then they cannot be washed off with any soap." Later, Captain Stedman, the eighteenth-century soldier who recorded his impressions of Surinam, would press one of the Amerindians about the purpose of the designs, only to be asked in return the purpose of the white powder falling off his wig.

The Amerindians told her the names of the trees, showed her which they ate, demonstrated plants they used as medicine: the leaves to wrap wounds, the seed oil to prompt healing, the sap to stop itching. They could access areas almost literally fenced off by downed branches and crisscrossing vines. When a flower with a long, white throat caught Merian's eye, an Amerindian dug it up for her, roots and all so it wouldn't wilt in the heat, and planted it in her

garden. Others brought Merian eye-catching insects they might find on a fallen limb, wrapped in a leaf for protection.

This was a whole new education, a rich perspective far different from that gained in Amsterdam. As she picked her way carefully through the wasp's nests and thorny pine-apple patches, she moved into an alternate matrix of beliefs about transformation and metamorphosis. In Amsterdam, she'd absorbed the terms of scholarly science, the codes of university-educated men. Here, talking with the Africans and the Amerindians, there was another language to learn, based in traditions a world away from those of her Euro-pean peers wrestling with Aristotle and spontaneous gener-ation from plant galls. According to Warao traditions, the tribe was born from the mating of a man and his bee wife. The Kayapo society in Brazil thrived because its members learned lessons about cooperation and community from the wasp. According to the tribe's stories, these traits enabled them to defeat the well-armed rhinoceros beetle in a battle long ago. All this fed her thinking and her investigations.

One night, a loud noise jerked Merian out of sleep. As she would write in her Surinam book, she and the others in her household "jumped out of bed and lit the candle, not knowing what the noise in the house could be." The sound was coming from a box of lantern flies, those ungainly crea-tures whose heads, a third as long as their bodies, were alternately described as those of an alligator or snake.

These peculiar insects were coveted by Amsterdam col-lectors and Merian had sought them out deliberately, ask-ing the Amerindians what they knew. In response, they gathered a large number of lantern flies and brought them to her. Of course, she would have particularly wanted a young lantern fly to chart its metamorphosis, but locating

one would have been very hard. Lantern flies are, in the words of one source, "cryptic, nocturnal, solitary, silent, and rare." Still Merian caught an immature insect that she found promising, crawling along like a green beetle, and charted how it molted. Like similar insects, it underwent an incomplete metamorphosis. Its wings were slightly more developed each time it left behind a castoff skin. Merian recorded: "They make a sound like a lyre so that they can be heard singing a long way off." The Amerindians told her these insects, actually cicadas, were the "mother" of the lantern fly, in the same way the flightless beetles were the "mother" of the adult cicada. One transformed into the other: beetles to cicada to lantern fly. She put the insects they brought her in a box, hoping to see the change herself.

Now, apparently, the insects had something to say on their own behalf. When the women opened the lid, "a fiery flame came out," which, once they calmed down, they realized came from the lantern flies. Their glowing heads were a marvel. Again, there is something funny in the description of the frightened women, the panic in the night, their dropping the box in surprise at the fire shooting out, and the humble bug that caused the commotion. Merian offers up the story with a sly smile.

Given that modern biologists consider the lantern fly mute and don't think its hollow head emits light at all, what did Merian see? And what was the noise that woke her up? The story is so graphic, so detailed. Linnaeus, familiar with Merian's work, would call the species *"Fulgora laternaria"* after the Roman goddess of lightning. Making up a story would be out of character for Merian, who carefully noted throughout her Surinam book what Amerindians told her and what she saw herself. Did she keep live cicadas in the

box, too, waiting for them to transform into lantern flies, and were they the ones making the ruckus? Were fireflies in the box, as well, shining in the dark? Perhaps dead and live lantern flies lay next to each other, and bioluminescent fungus grew on the dead tissue. Maybe the insect specimens caught fire, resulting in the crackling and flood of light. On the other hand, if this was the case, Merian might have mentioned the need for dousing the blaze before going back to bed.

When she painted the insects for her book, Merian included a transitional form, the mysterious "mother," between cicada and lantern fly, though she couldn't have observed it. She says she saw such a specimen, but that she never observed the whole transformation. This idea, that the young of one cicada species turns into an adult lantern fly, is long-lasting and pervasive. When a twenty-first-century enthoentomologist interviewed residents of a village in northeastern Brazil, a spot that used to be inhabited by Kiriri Indians, they told him a separate insect was the "daughter" of the lantern fly. As insects with a gradual metamorphosis, during which they gain wings little by little like the cicada rather than all at once like a moth, a young lantern fly does indeed look like a cicada trunk grafted onto an adult *Fulgora*. It would be two hundred years before a western scientist would find and describe the lantern fly larva. With the exception of the wings, it resembles Merian's picture.

A similar appearance was thought to indicate kinship in creatures besides the lantern fly and cicada. In the nineteenth century on the Para River in Brazil, the entomologist Henry Walter Bates shot his gun and found he'd brought down not the hummingbird he'd been aiming at, but a moth with a hummingbird's coloring and shape. It had a needle-

like proboscis and sharp wings. He reported: "This resemblance has attracted the notice of the natives, all of whom, even educated whites, firmly believe that one is transmutable into the other. They have observed the metamorphosis of caterpillars into butterflies, and think it not at all more wonderful that a moth should change into a humming-bird."

A moth changing into a hummingbird or a cicada changing into a lantern fly makes more instinctive sense than a cabbage birthing a caterpillar, a notion many of Merian's contemporaries still believed. In this instance, Merian saw through the lens of her expectation. Everyone said the head of the lantern fly lit up, and that's what she witnessed. She chose many of the species she examined partially because details about popular and mystifying creatures like the lantern fly would spur sales, partially to enter the conversation these weird forms triggered, and partially because she was unable, in this instance, to step outside the frame of her culture. It's the trap for every naturalist, even those most committed to direct observation.

Reproduction and transformation here seemed to obey different laws than those in Europe. Other creatures were just as bizarre in their habits as the lantern fly. She sought out and painted an opossum, a mouse-sized species missing the pouch in front so fascinating to the Royal Society, and put the six young instead on their mother's back (where they migrate when older), tails wrapped around hers like vines. A winged insect lurks on a tree trunk overhead, catching the attention of the juveniles as the mother opossum ferries them under a branch.

The Surinam toad, popular in Amsterdam's cabinets of curiosity, prized by Frederik Ruysch, painted by Rachel Ruysch, was on Merian's list to investigate. When the male

and female mate in murky ponds, the male pushes fertilized eggs onto the mother's back. They settle into cells, like those in a bee hive, but in her flesh. Her skin grows to cover them, and the female carries the eggs, part of her body, yet not, through the water as she seeks out worms in the mud at the bottom of pools, shoving them with her fingers into her tongueless mouth. Strangest of all, where were the tadpoles? Perfect little frogs burst, legs, forefeet and all, straight from their mother's back. "One could only see the head of some of the young, while others were already half out," Merian recorded. She didn't spend long admiring them, however. The moment the frogs popped through the skin, she tossed the whole family into a jar of brandy.

The new perspective was invaluable, but it had its pitfalls. She'd always treasured Goedaert's methods and felt the importance of first-hand observation. Now, when someone carried a caterpillar from the forest, how did she know what plant it ate? When someone brought her a butterfly, how could she work backward to find its larva? The lives of many creatures that piqued her interest in the Amsterdam cabinets remained obscure. Though she'd traveled all this way to track these life histories, in many cases they eluded her. She asked the Amerindians and Africans to fill in some of these blanks. As with the lantern fly, they told her at least part of what they knew.

Some of these stories would have been difficult to hear. Poisons of the forest were legendary, though writers usually focused on those used for hunting. After gold, explorers were most fascinated with the juice on the blow darts that downed monkeys (and people) with such ease, the well guarded secret of curare. Modern-day ethnobotanist Mark

Plotkin calls the recipe for the powerful drug the "Holy Grail." Particulars of plants used to mix the ointment (each tribe had a separate recipe) would have to wait for Edward Bancroft, who wrote in his *Essay on a Natural History of Guiana* in 1769 about the curare of the Akawaio Indians. In the early 1800s, Charles Waterton, who managed a sugar plantation before setting off into the forest specifically in search of a recipe from the Macushi tribe, brought some curare back to test it and better learn its properties.

But Merian may have had another mystery in mind. Unlike her search for living cabinet specimens, guided by interests of the mostly male collectors, here she followed her own lead. If one image from de Bry's *Grand Voyages* lingered in the memory of a young girl, it might have been one from Benzoni's expedition to Hispaniola (the island now split between the Dominican Republic and Haiti). In it, a woman eats a plant, two dead children beside her. The caption describes how some natives, faced with the European onslaught, killed their sons and daughters while others, "terminated their pregnancies with the juice of a certain herb in order not to produce children." In the background, both male and female suicides hang from the trees. What was this unnamed herb with sinister powers over female anatomy?

One day, Merian wet her brush and painted a sprig of scarlet and yellow flowers spilling long stamens. The colors may have caught her eye, or her servants and slave may have drawn it to her attention. She called the plant "peacock flower," capturing its lavish display. The top of the tree (she says it's nine feet high) threads into round buds, some gold and ready to bloom. A gray moth with a spotted body, *Manduca sexta*, feeds on the nectar. Seeds dangle like peas in

a pod. One seed shows through, where part of the pod is peeled away. In its colors and composition, the picture is bright and cheerful, starkly at odds with the accompanying text.

Both Amerindians and women from Guinea and Angola told Merian they used peacock flower seeds to abort children to protect them from slavery. As for the women in the *Grand Voyages* plate, abortion offered a grim kind of control over their destinies. Suicide provided a similar escape. Merian wrote next to plate 45, the peacock flower, in her Surinam book: "Indeed they even kill themselves on account of the usual harsh treatment meted out to them; for they consider that they will be born again with their friends in a free state in their own country, so they told me themselves." It's the saddest metamorphosis fantasy of all.

In a rare glance up from her pigments and magnifying glass, Merian writes that the slaves "must be treated benignly," to prevent these acts of despair. It's the only time, besides her complaints about the planters' sugar obsession, that Merian describes any conditions of human society in Surinam. It's also the only time she mentions the use of a plant that her readers in Amsterdam and London might not see as a business opportunity. Maybe she hoped to sway her readers, if only slightly. Amsterdam politician Jonas Witsen, with his natural history interests and large curiosity collection, would be an ideal customer for her planned Surinam book, and he owned a slave-run Surinam plantation. Like Behn's novel, Merian's mention of slavery is not a plea for abolition, just a request for humanity in an inhumane institution.

Though the vivid frilled petals made the peacock flower an irresistible import to European gardens and the plant it-

self flourished, the history Merian records from her African and Amerindian sources faded away. This particular use of the plant, this medicinal value to women, is glossed over by its good looks. Linnaeus, familiar with Merian's book, christened the plant *Poinciana pulcherrima,* later changed to *Caesalpinia pulcherrima,* honoring its pulchritude, or beauty. More commonly called "red bird of paradise" or "yellow bird of paradise," depending on the variety, it is the national flower of Barbados.

Pulled by the promise of further discoveries, Merian slowly ventured out of the city, farther upriver, where the trees grew thick as broom straws. In spring 1700, Merian went up the Surinam River to La Providence, the last outpost of the Labadists. Though the Wiewert sect had dwindled to the most devoted (once members were allowed to reclaim their goods, many gathered their belongings and left) and most acolytes fled Surinam, a few remained. Merian refers to the plantation as "belonging to the Misses Sommelsdyk," though the sisters themselves appear to have abandoned it. Her choice of words — identifying the land as the sisters' rather than Labadists' — may reflect reluctance to associate herself with the sect in print. But the community, and what Merian saw there, had provided the spur for this whole trip, and it made sense for her to pay a visit.

La Providence was the farthest settlement up the river, out of reach of the fort's protective cannon, beyond the safety of government men with guns. This far-flung plot of land, named for God's wisdom, evidence of the Labadists' desire to be as distant from corrupting civilization as possible, put them out of contact except for the occasional canoe bearing letters. With few roads cut into the

countryside, waterways served as the main artery, ferrying goods and visitors up along their course. The trip inland to reach La Providence took several days. Slipping upstream, the boat carrying Merian and Dorothea would have passed the plantations carved into the bank: Toutluy Faut plantation, and, farther inland, the Vredenburg plantation, owned by a former governor of the country, where Merian had searched for caterpillars in the rows of cassava.

In the breaks between fields, where the forest took over, wood storks waded along the shore, pulling long legs from the muck. The smell of vegetative rot rose over the banks. Traces of Amerindians and their villages lingered on here, but most had vanished deeper in the woods, if they wanted to remain free. Life of the forest wasn't seen as much as sensed through a paca scuttling through the undergrowth, the loud plop of a frog, a coati gobbling the papaya, the occasional flick of a hummingbird. Passengers eyed the murky water for the rise of an anaconda. Piranhas nosed around in schools, scenting out flesh to strip to the bone. Stingrays buried themselves in the river bottom mud. It wasn't water to trail fingers through.

Caimans patrolled the banks, keeping paddlers in their canoes and bathers close to the shore. Merian painted a watercolor of one rearing up, battling a snake. It holds the reptile's middle in its jaws as the snake's head reaches for the caiman's egg. The snake's body wraps around the caiman's tail. The egg is torn and spoiled. Behind them, under protection of the mother caiman's foot, an infant caiman pokes its head from an eggshell. On another parchment, a different lizard basks in the sun, tongue protruding, a pattern of stripes scattering into hundreds of scales on its back. Its powerful tail loops in a circle near the top of the page.

The middle of the river, unprotected by trees, left travelers at the mercy of the tropical heat. The country, just above the equator, felt the full force of the sun and more than one visitor would feel they were smothering in its hot, humid embrace. Brother Johann Riemer, a Moravian missionary who went this same route to preach to the maroons eighty years later, described just this situation on the water. "The most burning sunbeams shot directly down on me," he wrote, taking refuge from his misery in fantasizing about European shade trees.

The boat moved past Plantation Waterland, past its fancy boiling house with covered porches facing the water and the fields, its distillery, and more humble slave quarters, all hunched low against a bleached-out sky. In the clearing of the Dombi property, run by the wife of Jonas Witsen, domestic cows and horses grazed against a fence of tropical trees. Merian had visited Witsen's cabinet back in Holland, preparing for her trip, probably examining specimens from this very spot. These upriver journeys would be broken by stops at the plantations where owners were often willing to offer a meal or bed for the night in exchange for gossip or supplies from town. A tired visitor might stumble on a feast in progress, or interrupt a bout of hard drinking. At Jews' Savannah, grasslands had been turned into forty sugar plantations, a small town in its own right. Heat shimmered off the yellow-brown stalks. The boat moved on, past the inrush of water from Cassipora Creek, where the Jews built their synagogue, the first in the New World; past the Henriquez plantation, then past the sprawling Castilho plantation built on a rise with its long steps leading down to the water. Some of these fields were worked by a handful of enslaved people, others by a hundred. And then, finally, the thousands of acres of La Providence.

Across the river and just upstream at Matjau Creek, one of the largest tribes of maroons had built their village. At any moment, they might storm the plantation, raiding for guns and food, rescuing relatives, swelling their numbers. Not only that, but another group, those that escaped from La Providence itself, also lived nearby. Among slaves and maroons, La Providence had a particularly vicious reputation. The sweetness of pious companionship found in Wiewert soured in the heat. Desire for relief of sin through suffering spun into a desire to see others suffer. Severe beatings lived in the memory of maroons for centuries afterwards. So did recollection of the meager food, possibly an expression of religious belief, possibly an indication of want. A descendent of La Providence escapees remembered of his ancestors: "They would give you a bit of plain rice in a calabash...And the gods told them that this is no way for human beings to live."

They fled. In 1693, men, women and children scrambled for boats, leapt on board, crossed the Surinam River, and paddled away from La Providence south and out of reach of search parties. The story, passed down to twenty-first-century tribes, is one of exhilaration and mourning, marked by the image of an older woman who hurried but did not make the boats in time. Her daughter begged her husband to go back and stop for her mother, but he kept going, likely unwilling to jeopardize his chance at freedom. He would regret it later, when the wife, Kaala, thinking of her mother back in slavery, abandoned him and became the leader of the Abaisa maroons, a tribe that still exists in the Surinam interior.

During the day at La Providence, Merian would have had her hands full with her collecting and sketches. Each

new environment provided new material. She gathered a green and black caterpillar with a yellow face from a wild tree that dripped sap like that used in gum Arabic. She put it into a box, fed it leaves, noted how it molted into a red and black caterpillar, then wove an egg-sized cocoon. Out came the "white witch" or "ghost moth." La Providence offered good fortune. The wings of this species, *Thysania agrippina*, with soft beige and brown markings tinged with violet, have the widest span of any New World moth. They can reach up to a foot when spread. It was a collector's treasure. She would have pinned and kept it.

But after the sun went down and the butterflies folded themselves away on the underside of leaves, she would have returned to the house. Dinners with the Labadists had always been simple affairs of carefully monitored portions. Perhaps a glass of sugar water, a Surinam staple for those not drinking rum. A plate of fish, as always in this capsicum-rich country, liberally seasoned with pepper.

At first, conversation could have been easy, padded with introductions and small talk. Politeness would have eased the way. Maybe they asked about friends back in Europe. Maybe Merian had questions about Labadie, the leader she followed but never saw in person. Any remaining Labadists in Surinam were the satellite of a vanished planet, orbiting around emptiness. Did they find the flame of belief hard to keep lit here in the understory, where tests would come in the form of deadly disease rather than a coat with shiny buttons? How many times did they have to shield their Bibles from wood ants? So many of the others had given up and gone back home.

As night fell, the geckos lurked near the lanterns, waiting for the light-stoned moths and clumsy grasshoppers to

edge near their mouths. The air cooled. A match scratched against flint. Would words have run out their meanings? Would darker thoughts have swum into the silence? The howler monkeys filled their lungs again, sending out moans like a hungry wind, using sound to define territory and map the endless, indistinct, flood of green.

The itch of curiosity spurred Merian on, and eventually the rain forest, even past this most remote plantation edge, was too tempting. To get there, she relied even more heavily on help. In her Surinam book, she described the labor-intensive entry to the jungle: "The forest grew together so closely with thistles and thorns, I sent slaves with hatchets ahead, so that they chopped an opening for me, in order to go through to some extent, which was nevertheless rather cumbersome."

In this realm, the trees were nameless, at least to the record keepers of Europe. Back in town certain branches must have looked familiar from her walks in Amsterdam's medicinal garden. They dangled fruits she'd tasted before. But not here. The "our father" tree with its fruits strung like beads on a rosary, leaves webbed together by a communal caterpillar nest. The "sweet bean" tree that frustrated her attempts to raise its caterpillars because the leaves dried up and became inedible as soon as they were picked. The "marmalade box" tree, used to treat breathing ailments, fruit in a rind like a jam jar. Each seemed ripe with uses. She mourned repeatedly that they would never be tapped by her sugar-obsessed countrymen.

The trees' sheer size could be a shock to the sense of proportion. Every artist, every scientist has a scale where she is most comfortable. Matthaus Merian liked the spread of a city, viewed from a hillside, its steeples like pins and

town square reduced to the size of a thumbprint. Swammerdam extracted the nervous system of a caterpillar, and blew it up until it filled a whole sheet with the branches and crossings that delighted him. Some spend their lives looking at the movement of galaxies, charting the way grizzly bears travel from valley to valley, or following mutations of tobacco hornworm genes. Merian, even more as she grew older, preferred a life-size view, up close. She looked at wing scales through a magnifying glass, but didn't paint this intimate picture. Of some tropical moths, she wrote, "They are so beautiful, if one looks at them without the magnifying glass, so strangely ugly, if one regards them with its help." Too large was as bad as too small. More than once in her Surinam book, she wrote that she didn't include a drawing of a palm tree, because it wouldn't fit on the page.

While discoveries about mimicry and the evolution that drove it were many years in the future, she did suspect that each level of these giant trees hosted different insects. Walking the fields of Germany, looking for caterpillars, she checked all the way down the stalks, knowing some crouched close to the ground. It was the same with the trees. The towering crowns must hold butterflies she could only imagine. Of the swallow-tailed *Urania leilus*, she wrote, "they fly very fast and high and thus cannot be obtained undamaged except as caterpillars." Sometimes, one dropped, a shiny spark of luck. The lovely *Philaethria dido*, its wings segmented into panes of green and black, hardly ever descends to the lower realms as an adult. She found its larva in grasses near a pineapple plant.

Eventually she would solve the problem of insects too high to reach by using a ladder to pull down a web of caterpillars near the top of a palm tree. She installed the whole

teeming mass in her house to take notes. If the trunk was too unstable, as was the case with one hollow papaya, she requested the tree be cut down so she could search the upper leaves. A tiny white and yellow caterpillar wandered these downed branches and would hatch into a hard-to-find moth she never would have encountered otherwise.

The life in these glades was truly nothing she'd seen before, and she took a stab at capturing it on paper. Not just the facts, but the feeling. Her work often incorporated a baroque flourish, even as she moved away from embroidery patterns: curls in moth proboscises, plant petals, snake tails. In the Surinam paintings, the coils tighten their grip. A potato plant winds its way up a reed and tendrils of a grape either cradle pupae or threaten to strangle them. A snake's eggs lie in a hole burrowed into a cassava. A waterbug eats a young frog. This endless consumption was like that she witnessed in the sliced-open plant gall, but writ large. And then larger.

On a bone-colored branch, its few leaves chewed to tatters, a dark tarantula emerges from a webbed egg, and grasps an ant in its pincers. Other ants scurry, just out of reach. A second tarantula, also black and hairy, lunges over a hummingbird lying prone, throat exposed. The spider is feeding, and one leg dangles into a nest with four eggs that the hummingbird may have been warming moments before. Another spider sits at the center of her tawny web, young spiders fanning out before her toward ants that dwarf them in size. Life barely gets its start before it is preyed upon. An insect, only one wing remaining, is tangled in the web. The ants are hard at work: attacking a plump bug, building a bridge of their bodies to crawl from twig to twig, grasping a fourth spider in what looks like a wicked bite. The dying

hummingbird holds most of the brightness in the picture with its red head, blue wings, green body. The spiders, the ants, the web are all in black, and they are winning. It is a world of voraciousness, of consuming hunger. It's hard to tell, sometimes, who is eating whom.

Here the picture and text sound the same note. The words accompanying the engraving in the Surinam book underscore the ring of predation. The spiders eat ants, and hummingbirds when they can't find enough ants. Amerindian priests also eat hummingbirds (it's their only food, Merian reports). Certain kinds of ants "can eat whole trees bare as a broom handle in a single night." They bring leaves, scissored to bits with their teeth, to feed their young. While the spiders devour the ants, the ants can also gang up and eat spiders. The ant eggs in turn feed Surinamese chickens, which nourish the people.

Like the lantern fly and morpho butterfly, this spider had a European reputation. In 1666, the Royal Society had drawn up a list of questions pertaining to various regions of the world. For Guiana and Brazil, members wanted to know if it was true that toads could be created by throwing water on the floor, whether the Brazilian locust turns into a plant and another insect changes into a swift-flying bird. For Virginia and Bermuda, they were curious about plants that cause blisters and were eager for "a particular account of the Spider in the Bermudas said to be large and beautiful for its colours: weaving a Web betwixt several Trees, which is affirmed to be of a substance and colour like perfect raw Silk; so strong that Birds, like Snites are snared therein." Because of its fame, Merian may have asked the Amerindians about this legendary spider specifically.

Once again, she based her descriptions on what they told her. Whether or not she witnessed a tarantula feeding, she didn't catch a spider to use as a model. The sketch pasted in the study book is apparently by her stepfather. Merian labeled it with Marrel's name and indicated he painted it in 1645. As she plotted the scene, she took several stabs at the spider lurking over the bird, one where it hunches over the bird's back, as if strangling it, but chose to have it crouched over its prey pathetic and prone. The hummingbird nest, tidy as a teacup, is obviously not drawn from life. It rings as false as the goblets the Amerindians drink from in the illustration for Ralegh's tale in *Grand Voyages*. But still, the page depicts a resonant vision of the tropics, moving beyond her observations to interpretation of her experience. The ants are daunting, not because they represent some Biblical evil as they would in a Mignon portrait, but because their actual behavior — the excavating eight-foot nests, the swarming — is overwhelming. Based in the imagination, fed by biology, in some ways this plate is closest to art.

The picture captures a reality far beyond the crook of one limb. It tells the story of the whole rain forest. Liana vines web the trees together like some vegetable spider. They grow up from the leaf litter, climbing the trunks, draping themselves over branches, gathering bushes, other vines, adjacent trees in their grip. Strangler vines drip down from above, until the whole host tree vanishes into their fist. Trees send out their own emissaries, not just branches but buttress roots, aboveground support systems that flare out in every direction, supporting the tall trunks the way buttresses support the ceilings of cathedrals. Cacti sprout on high tree branches and grow fruits shaped like

red flowers. Birds hang on them upside down and pick out the seeds. Plants emerge on top of other plants and frogs live in them. Every form of life casts about for a foothold where it can flourish, and every form of life, from infant spider to the tallest tree, sustains someone else, hungrier.

It couldn't be more different from the "forest floor" paintings that hung in Amsterdam mansions, with their unrelated specimens scattered in the grass. What comes to the fore is not the light glinting off an individual fly, but the interaction of species. It's a harsh story of entanglement that may well express the feeling of Surinam, bursting with life and, consequently, death. In her description, humans are part of the equation both as predator and prey. If it serves as a reflection of God, it's a darker god than many would accept. It's hard to find the salvation here.

At some point, as she checked on her latest batch of pupae or pulled a caterpillar off a branch, Merian started to feel shaky. She interpreted the blinding sun and the unforgiving heat as the source of her unease. But the cause more likely lay with the insects.

If Merian got yellow fever, which was common and spread by the dense clouds of mosquitoes attracted to the swamps, the weakness would have been accompanied by pounding headaches, backaches, nausea. A mirror might have shown her inflamed eyes and yellow skin; her heart may have beat in an uneven rhythm. Malaria, also carried by mosquitoes, wouldn't have been much kinder with its alternating chills and sweating, a feebleness that robbed one of the ability to hold the simplest objects, much less a drawing pencil. Whatever it was, she thought she might die. As she would later write to a Nuremberg colleague who

contacted her about her project: "The heat in this country is staggering, so that one can do no work at all without great difficulty, and I myself nearly paid for that with my death, which is why I could not stay there longer." She had come to take a piece of Surinam, and it had taken a piece of her in return.

In the grip of a fever, she might have watched ships traveling down the Surinam River toward the sea, squinting against the sun sparking off the ripples, the blades of the palms, and thought of cool mornings in Amsterdam. She would have been torn between desire to be back in a more friendly climate and the need to finish the work she set out to do. Her vision called for a longer stay, more observations, additional discoveries. Two years had only given her the first clues how to study these species. She'd sunk everything she had into this venture and couldn't leave without enough for a book sufficiently successful to get her out of debt. And pious diligence wins. Recalling the family motto might have kept her there and painting an extra week, a month, but eventually her ill body made irrefutable demands. It was time to give up and go.

She wrote of the dilemma in the introduction to her Surinam book, the taste of disappointment lingering even as she offered up the pages filled with wonders: "In this land, I did not find the proper opportunities to pursue the observation of insects that I had imagined, because the climate there is very hot. This heat treated me poorly, and I was compelled to return home earlier than planned."

She would have packed up her specimens with trepidation. Each butterfly, so hard-won, represented hours in the baking sun. Dozens of jars and boxes, sketches and notes, each recording a unique transformation, would have to be

trusted to wind and waves and clumsy crews. Her financial future depended on the silk cocoons and dead geckos. Sailors had a bad reputation for drinking the brandy and discarding the lizard. In later years, collectors would often make two complete sets of notes and specimens and send them in separate boats, in the hopes that one would arrive safely. A hundred years later, another naturalist from the Caribbean would sum up his difficulties shipping plants and insects: "The only place in a merchantman in which such perishable things should be deposited is in the after cabin, and this the captains will not give up unless they have no passengers and even then not without receiving a most exorbitant recompense...if placed in the hold of the vessel they would in a day or two be swimming in the molasses which drains from the sugar hogsheads."

Live specimens proved even more difficult. One later collector from Surinam killed off a menagerie in an effort to get his creatures to Europe. A paca, left in a box in the sun by a forgetful ship captain, broiled in the heat. A male green parakeet perished when his food box fell on him. The female then apparently died of grief, despite a mirror placed in her cage to cheer her up. A crew member tested the sharpness of a knife by chopping off a chameleon's leg. Another chameleon made it to Lisbon only to die a week later, done in by a cold snap.

Merian could at least take comfort that she had some plants, animals, and paintings to load. On Ambon, a tiny island off New Guinea, Georgius Rumphius had struggled to put together a book covering all he had observed as an employee of the East India Company for forty years, from lobsters, to sand dollars, to chunks of amber. He prepared detailed explanations and pictures, hoping to bring it all to

life for his readers. He persevered through an earthquake that killed his wife and blindness that left him dependent on others for descriptions of the crabs and shells that so fascinated him. Then, in 1687, a fire raged through the town where he lived, consuming illustrations and decades of specimens. Rumphius was left with only his words.

In the summer of 1701, Merian packed her snakes, pinned beetles, and dead hummingbirds in sugar jars. She then enclosed those in still larger boxes, loaded them onto the *Peace,* and hoped for the best. One of her Amerindian servants traveled with her, as did Laurentia Verboom, daughter of the military commander who died with Cornelius van Sommelsdijk in the soldiers' rebellion. Dorothea boarded, too, of course.

Despite Merian's care, she sustained some losses. She'd gathered pearly lizard eggs from the floor of her Paramaribo house and brought them on the ship. They hatched on the way home—each a tiny blue dragon. But, she recorded, "without their mother or proper nourishment they died." Other specimens appear to have gotten mixed up or lost.

Even in the face of the fever, the troubles with insect study in the tropics, and her early departure, a sense of power must have flooded through Merian as the ship returned to Europe. As cool mists and breezes wrapped the boat and the passengers pulled wool coats over their shoulders, she must have anticipated the Amsterdam docks. Ahead of her lay the streets of *le grande monde,* the negotiations of getting her boxes back to her house at the outskirts of town, walking the canals, conversation with friends about all she'd seen. Her notions of what she could accomplish must have been radically altered. Even if she had to lean rather hard on Dorothea as they disembarked.

She had taken her own grand voyage and the images she would drop in the lap of Europe would make those from the old *Grand Voyages* as outdated as Moffett's woodcut caterpillars. And the buzzing classes of Amsterdam would never view South America, or insects, the same way again.

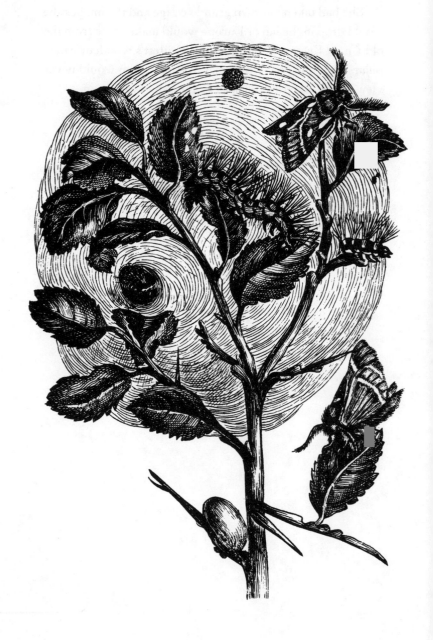

# The First and Strangest Work That Had Ever Been Painted in America

My cocoon tightens, colors tease,
I'm feeling for the air;
A dim capacity for wings
Demeans the dress I wear.
—Emily Dickinson, *Poem 1099*

*Amsterdam, 1701–1717*

However hard she found field work in Surinam, however sickening the sun, the boisterous, exuberant images Merian recorded from her trip were not portraits of depression. Illness might have drained her energy, but she still appeared to have three times the normal share. Back in Amsterdam, insects unpacked, damage assessed, she launched into the book she'd mulled over for years. Ideas bubbling inside her as she made her sketches in Paramaribo breathed their steam into her chilly city rooms. Now they could condense into something real.

Even a year after disembarking, her excitement was palpable. In October 1702, it shone through in her response to a note from Johan Georg Volkammer, a Nuremberg doctor who'd recently published a book on the city gardens. He

had visited Amsterdam in 1699 and could have heard of her and her first caterpillar books through Caspar Commelin, the head of the Amsterdam botanical gardens. Her letter overflows with enthusiasm and plans. The book on Surinam would be bigger than the catalog of the medicinal garden. Alternate versions would have text in Latin and Dutch, maybe English and German, too. The completed watercolors contain "many wondrous, rare things in them that have never come to light before." Even the harsh climate of Surinam, the searing heat that almost killed her, had a bright side: "[T]his work is not only rare now, but will surely remain so." She hoped to be done with the watercolor models for the engravings in two months.

Some of these paintings she may have completed in Surinam, but most needed to be compiled from study book sketches. She often drafted several versions, trying one arrangement, discarding it in favor of another. Balancing her desire to reveal the metamorphoses with the need to include the species most popular among collectors was a challenge. One sketch crams both the Hercules beetle, *Dynastes hercules*, and the giant long-horn beetle, *Titanus giganteus*, whose outsize horns and antennae would have put collectors all in a tizzy, on a plate already occupied by a weevil grub. She removed them later, added a click beetle. In two paintings of sweet-bean pods she played with placement of flies and grubs in the pulp: sometimes they burrow into the fruit and leaves; other times they rest on the surface. Parchments filled with lizards, snakes, beetles that never found a place in the book at all.

The city posed a counterpoint to her tropical musings. As rain scrabbled against the windows and weak sun coaxed tulips from the bulbs, peat sellers peddled chunks of turf for fires in the nearby market. Along Spiegelstraat,

art dealers offered more traditional still lifes by Merian's friends, relatives, competitors, Rachel Ruysch and Abraham Mignon among them. Wildness was held in check. Rivers shunted into canals. Not a crocodile to be seen. Against this urban background, she threw herself into work, pored over her sketches, visited the medical garden to check her finds against the passion flowers and coffee trees. She consulted her notes about lemons and guava, holding a dried moth up to the light, tracing the pattern of a leaf vein.

There is a drawing by Rembrandt of his Amsterdam studio, which brings Merian to mind. In it, a woman sits with her back to the viewer at a desk piled with books, boxes, and a drape of fabric. An easel looms to the left. Light floods in through the high windows, each made of small, square panes. It hits the shelves, the wall, the woman's face, glances off her arm and gets lost in the folds of her skirt. The picture catches an introspective moment, as the woman sits at the table in the sun. She could easily be remembering a plant with a blooming white flower carried through the forest to her Paramaribo garden. As Graff's portrait of Sara Marrel offers a look at a girl in a workshop, here is what an adult female artist might look like in a studio, though the caption identifies the subject as a model and, certainly, Merian's shoulder would not be bare.

Dorothea wasted even less time than her mother. In December, 1701, back only three months, she married Philip Hendriks of Heidelberg. But Merian's daughters, though they had families of their own, didn't completely step outside the sphere of their mother's influence. The older daughter Johanna and her husband would soon be on their way to Surinam, where he would run the orphanage and she would paint and collect specimens, perhaps continuing

the project Merian hadn't been able to complete to her satisfaction. Less than a year after the wedding, Hendriks was gone to the East Indies to serve as a surgeon. He promised to send Merian some insects.

Into all this busyness came a tempting offer. Georgius Rumphius, the man who spent his whole life trolling Ambon's beaches in search of shells and crabs, had died. He never made it back to Europe and was buried on the islands he studied so carefully, but the text of his manuscript rested safely in the hands of an Amsterdam publisher. Many of the pictures and items in his collection, though, were either burned up in the fires, stolen, or sold to the Grand Duke of Tuscany. Merian was asked to create some illustrations to flesh out the book.

Rumphius's project was diametrically opposed to Merian's. Modeled on a collector's hoard (the published book would be called *The Ambonese Curiosity Cabinet* and be annotated by Simon Schijnvoet, a famous collector rather than a naturalist like Commelin) his work reflected a similar jewelry-box jumble of flash and sterility. It included none of the connections — between plant and animal, juvenile and adult, parasitoid and host — that animated Merian's work. Crabs, lobsters, sea cucumbers, urchins lay stacked on top of one another against blank backgrounds. They were no different from the inanimate objects that decorated other pages — "Father Noah" shells found high in the mountains, judged to have been left there after the Flood; rocks that when cut and polished showed pictures of a city, a tree, a web, a gate to a heavenly landscape; oily chunks of ambergris expelled from sick whales.

Occasionally, Rumphius had left a specimen or a sketch of a creature he described, but more often than not Merian

used models from curiosity collections like Schijnvoet's, some bearing only the slightest resemblance to the species Rumphius detailed. The method resulted in odd juxtapositions: a Cuban snail among the Ambonese, for instance. One sheet of shells, not described by Rumphius, is included only because they were pretty and rare, and Schijnvoet advises collectors to get them if they can. Sometimes there wasn't a specimen of any kind to use as a model. All Merian had to go on was Schijnvoet's recollection of a certain clam.

In the frenetic three and a half years when Merian illustrated both books, churning out more than one hundred watercolors total (not counting discarded drafts), she immersed herself in two separate views of natural history, dipping into one and then the other. She would finish up a row of clam shells, then pick up a new piece of parchment, wet a fresh brush, and paint a caterpillar chewing a lemon leaf. There's no doubt where her heart lay: She didn't even sign the Ambon pictures.

These divergent attempts to represent nature competed with each other not just on Merian's desk, but in cabinets, libraries, Royal Society journals. It was as if a museum's staff of feuding curators each put on a separate exhibit, each in a different room. And, though it might not have been predicted at the time, Rumphius and his rows of shells would come out ahead. With help from Linnaeus, who within a few decades would have issued his comprehensive catalog of all life and given every species a name, Rumphius's comparison of many shells on one page would frame the direction of natural science. In Linnaeus's wake, scientists wanted to know how creatures related to those similar to themselves. They wanted to itemize the small shifts that indicated a new species. Swammerdam's pictures of slit-open

insects viewed through a microscope and dissected finished a strong second, offering a key to understanding how life functioned within that hard exoskeleton. The collection of Hans Sloane, who gathered artwork and natural history curiosities from around the globe, became the foundation of the British Museum, charting a path for future collectors and displays. In the short term, natural scientists would be less interested in Merian's concerns — what a given caterpillar ate and what might eat it, the relationship of an organism to its environment — than they were with marking each species off from the others.

And farthest behind, left in the dust, was Ruysch. The doctor who deemed his embalming fluid so valuable a secret he said he'd only sell it for 50,000 guilders, who woke up at 4 A.M. for days on end perfecting its recipe, who battled with the worms for corpses to practice on, would be completely disregarded, his precious babies in jars and their weighty moral pronouncements reduced in the opinion of history to stomach-turning oddities, no more.

But at the moment, Ruysch was wildly successful, Swammerdam all but forgotten, Merian painting as fast as her aging hands would let her. All the rooms of the museum were open for business. A guilder would get you in.

In the first years of the eighteenth century, all parties interested in the budding field of natural history were engaged in a social dance, a complex cotillion of bowing and promenading through arches of upraised hands. The choreography dictated letters exchanged, visits eased by an introduction from a trusted source. Fish fossils and vials of phosphorus served as bouquets and calling cards. Microscopists, sea captains, botanizers, politicians, physicians, illustrators, and insect lovers all joined in. Some were uni-

versity men, swapping seeds for their botanical gardens. Others were collectors, seeking the most phenomenal find. And some were dilettantes, young men completing their education with a tour of the world and its wonders.

At the intersection of all these stood the apothecary. In his shop, lined with glass containers of herbs and leeches, chemical, magical, and artistic supplies battled for shelf space. In literature, probably the most famous is the apothecary, so desperately poor, who sells Romeo poison in violation of Verona's laws. But in England, apothecary James Petiver was thriving: a fellow of the Royal Society, official apothecary for the Charterhouse Hospital, and a member of the Temple Coffee House Botany Club, an informal group including Hans Sloane and Nehemiah Grew that met once a week to chat about natural history at a London cafe.

Petiver collected with zeal, the way Swammerdam dissected, the way Labadie purified himself. He papered the globe with his instructions for catching butterflies, contacting ship captains and colonists to request their help. The aim was to gather many species, and rare ones; their quality was not so much of a concern. A missing leg or two, a broken wing, these didn't bother him: "[S]o I can have them cheap" he wrote to one correspondent. In fact, he asked Ruysch specifically to save him any damaged Surinam insects. Dismayingly, he wrote up details of these crippled creatures and published them as definitive accounts. He acted as a bridge between the natural philosophers and collectors, revealing on the one hand, how at this time there wasn't so much of a difference between the two, and on the other, the consequences of these fluid boundaries. Of the man himself, the student Zacharias Conrad von Uffenbach was most damning, recounting that he expected to meet "a

paragon of learning and refinement" only to find a man "wretched both in looks and actions" who spoke "very poor and deficient Latin and scarce able to string a few words together." In short, his long-distance friends, when they finally met him, were often appalled.

Though Petiver's methods might be flawed and his Latin halting, his letters knotted together what would have otherwise been a disparate group of collectors, artists, doctors and explorers all pursuing their own interests. His collectors kept dying off, which must have been a frustration — killed by natives, done in by a mysterious illness, lost at sea — but he always recruited more. His enthusiasm and willingness to go to great lengths for a new insect made him a valuable asset to the Royal Society, even though he lacked the education and status of some of the other fellows. Ever helpful, he bought curiosity collections for Sloane, tried to drum up illustrations for John Ray's *History of Plants*. If any of his far-flung correspondents needed venereal disease treatments from his apothecary shop, he would provide that, too.

And in the summer of 1703, at the height of Merian's industry, Petiver offered her an invitation to the dance.

To grease the way, he sent a gift of insects. To butter her up further, he must have commented on their metamorphosis, because she wrote back on June 4 that she "discovered with love that your work deals with the same things I recently observed with regard to the transformation of insects in America." In return, she offered him her first two caterpillar books and sent, as an advertisement, a Surinam plate. Would he, she requested, see if any of his friends would care to subscribe? Over the next few years she would write to him in Dutch, German, and French, employing translators on her end (for the French) and on his

(to get the information into English). Inquisitive, energetic, well-connected, Petiver must have been just the kind of contact in England she was looking for.

Her next letter to Petiver, only a few weeks later, pushes for more favors. Could the call for subscriptions appear in an English newspaper? If one hundred subscribers committed to the project, she could arrange for a translation in English. Later, she will ask his opinion about coloring a copy and dedicating it to the Queen: "A woman, I would personally regard it as only natural to do this for a person of my gender." This gives voice to a pattern throughout her life of seeking out thriving women and forging connections with them. Anna Maria van Schurman's tracts (and accomplishments) may have lured her to the Labadists. The wealthy gardener Agnes Block hired her and showed her species she hadn't seen before. Queen Anne would be the ultimate patron, if it could be arranged. For now, the pressure to finish the Surinam book was mounting, and she signed the note "in a great hurry." (And she had more than the book on her mind. Two days after this letter of June 20, 1703, Merian would be a witness at the baptism of her grandchild, Dorothea's daughter, Maria Elizabeth.)

Good to his word, Petiver advertised the book in the *Philosophical Transactions of the Royal Society*, wooing subscribers with tales of Merian's Surinam trip and her book-in-progress, "a Curious History of all those Insects, and their transformations that she hath there observed, which are many and very rare." In his advertisement, the author is as much a rarity as her subjects. All were painted, he notes, by "That Curious Person Madam Maria Sybilla Merian." He brought samples of her plates to a Royal Society meeting and handed them around. Interested buyers could stop by his apothecary shop on Aldersgate Street to see more

and give him a down payment of a third of the book's purchase price.

But now the insufficiency of her Surinam research began to haunt Merian, a wasp of doubt around her painting hand. A few of the plates she was finishing pair caterpillars and moths that don't match: a blue morpho butterfly hovers above a pupa with knobs and hooks like a witch's profile, unrelated to the imago; another morpho is linked to a hawkmoth caterpillar, and several insects perch on plants they don't eat. The amendments might have been made for aesthetic concerns. Usually, though, when she includes a species for artistic reasons, she is upfront about the substitution in the text. She freely announced that the lizard on the cassava branch is an advertisement for a future book, all about reptiles, and a huge gold beetle with gaping jaws appears on one plate because it looks good. In some substitutions, she just didn't have the caterpillars. She simply didn't know what plants they ate. The confusion is documented in her study book, where some parchment scraps reveal a missing life stage — no cocoon, or just the imago. Some include all the stages, but use the wrong specimens — a larva that couldn't turn into a given pupa. The alterations of her method, forced by the South American environment, are shown in how few parasitoids she documents. A naturalist could only uncover one insect preying on another through careful, repeated observations of the kind she'd done in Nuremberg. Her ambition to detail these Surinam lives, of building a portrait of species through its ecological details, was more than she or any of her peers could accomplish at the time.

She tried to brush away the uncertainty by tapping other experts. She buttonholed Caspar Commelin, exotic-species expert at the botanical gardens, consulted with him

about her flower sketches and convinced him to write commentary on the plants at the bottom of each page of her book. He translated her Dutch text into Latin, too, so it could reach a more scholarly audience. Plants have a much more central place in the Surinam book than they do in any of her previous works, likely because of the growing interest in their medicinal and chemical properties, an interest she wanted to capitalize on.

Leeuwenhoek, too, was on her mind. Though there's no record of them meeting, the book of Leeuwenhoek's letters, published in 1702, served as her touchstone, much as Goedaert's *Metamorphosis Naturalis* did when she was a child. In one of his letters, Leeuwenhoek wrote about a discovery made during a silkworm molt: "I inspected many times their cast horny skin, which surrounds the whole of their head, through the magnifying glass, and saw to my astonishment all the organs on the head, and particularly when I saw that on each side of the head there were six protruding eyes so arranged that they could see whatever was in their vicinity." Merian evaluated her first Surinam find in this light, the toxic caterpillar she'd discovered on guava near the fort. She appears to have misread Leeuwenhoek slightly, mulling over whether the red bumps striped along the sides of the larva were eyes. She decided they weren't because she couldn't see eye sockets and wrote in the Surinam book: "They would then be able to find their food from behind and from the sides, which I have not observed to be the case." What Leeuwenhoek documented on the silkworm face were primitive eyes called "ocelli," which allow a caterpillar to detect light and shadow, but not much more.

Merian looked at her preserved Surinam specimens through a magnifying glass, noting their other-worldly appearance, incorporating details into the text next to each

image, mentioning butterfly wings like "fish scales with three branches on each scale," a proboscis like "the neck of a goose or a duck," and moths covered in "hair like that on Hungarian bears." She might have hoped to build on the fascination generated by Leeuwenhoek's descriptions of life under the microscope, but after the first ten plates or so, she gave it up. Maybe she didn't feel it was a helpful contribution, or words failed her and she couldn't capture details on that scale with paint.

Leeuwenhoek had been at work on other mysteries as well. Back in 1700, while Merian packed up for her Surinam trip, Leeuwenhoek marveled at a strange spring. Fruit trees exploded with blossoms, bringing with them small black flies and smaller green aphids. As Merian probed the Surinam swamps, he put the flies and aphids (which he called "lice") in a glass tube with a currant branch. With his impeccable eyesight, he saw what had eluded so many others: "These Flies, as soon as ever they came near the said Lice, brought the hinder part of the Body, which was pretty long, between all their Feet, and stretcht their Body so far out, that their Tail making a kind of semicircle with the rest of the Body, (as you may see in the Draught annext) stood out beyond their Head, and in this manner they insinuated their Tail into the Bodies of the Worms." His drawing shows the ovipositor of the fly, sharp as pen nib, poised to jab some poor aphid. He speculates that the flies inject eggs into the aphids, which feed on them and grow as their hosts die. This would be an explanation for the "accidental" and "wrong" flies that emerged from pupae and live caterpillars in place of the moths Merian expected.

Leeuwenhoek, like Swammerdam, believed that young life was to some extent "preformed" inside the parents. But Swammerdam, an ovist, believed the female contributed

the germs of potential and Leeuwenhoek, a spermist, thought they lived in the squirming animalcules he'd seen under the microscope in male semen. All Leeuwenhoek's digging into metamorphosis was founded in the desire to shore up his spermist position. The sperms, after all, looked like little worms. If a worm could transform of its own volition into a butterfly, why couldn't a sperm unfold into a man without any female contribution?

Part of the confusion concerned what, exactly, an insect was. Early natural history encyclopedists often grouped insects with snakes and serpents. Worms, spiders, crabs — these all came under the heading of insects at one time or another, and now that germs and rotifers and sperm came into view, some thought they should be included. Even the darling of eighteenth-century entomology, René-Antoine Ferchault de Réaumur, wrote: "The crocodile is certainly a fierce insect, but I am not in the least disturbed about calling it one."

At the same time, Godefridi Bidloo, a doctor of anatomy, looked at worms in sheep, calves, men's livers, and wounds. He concluded they didn't originate there, but arrived, maybe as the cows ate the eggs along with their food. Merian read Bidloo as well as Leeuwenhoek. She mentions Bidloo's anatomy book in the introduction to her Surinam volume, saying that she used it as a model for her balance of text and illustrations. One by one, the dangerous props for spontaneous generation Ray had identified were being swept away.

Of all the insects Merian brought back, the lantern fly, in particular, remained an enigma. By now she had a sense of the ways of metamorphosis and something about a cicada turning into a lantern fly didn't seem right. Grasshoppers

did shed their skins gradually, filling out larger bodies, growing wings, but their heads didn't swell or their wings change pattern so dramatically. On the other hand, she observed caterpillars shift color from molt to molt. As she puzzled it out, she went to find Ruysch, perhaps at work in his cabinet. In his ever growing collection, she could compare dried specimens of lantern fly and cicada, search for intermediate forms. Their relationship had moved beyond her merely visiting his specimens: He brought her insects from Petiver; she felt comfortable consulting him when stumped. As described in a note by an unnamed third party at the meeting, Merian asked Ruysch whether he thought the Amerindians' description of the lantern fly metamorphosis could be right. Ruysch, with his expertise in human anatomy, confident in what bones and blood vessels would allow, confirmed her doubts; the bodies were too different. Only God could perform the kind of complete "re-creation" necessary to turn one into the other.

Here, though Merian had in hand a learned scientific opinion, she went back to what the Amerindians told her. No one in Amsterdam would have more credibility than Ruysch, but while she could seek academic opinion, she could also ignore it. Experts often contradicted each other, and she knew from first-hand experience that they could be wrong. In the end, she painted the lantern flies, wings spread to display their false eyes, on the same page with a more mundane cicada and a combination of the two—a lantern fly head on a cicada body. Perhaps she had seen an immature lantern fly and recollection added the wings. She specified that the Amerindians told her one changed into the other. No one else had observed the transformation to show her wrong.

So she tried to patch holes in her knowledge through reading and through conversation. And when that failed, perhaps when she discovered a missing pupa in her specimen boxes, she went searching in the cabinets of curiosity for one that matched her memory. This would be contrary to her obvious concern about drawing creatures from life, and at odds with the purpose of her Surinam trip. But the entire book she'd painted for Rumphius had been composed this way. If she did it, the only rules she broke were her own.

In an additional move to have her new book be embraced as serious science, she eliminated the use of "date kernels" and uses the more standard "pupa." In the introduction, she mentions the work of fellow insect aficionados, but still shies away from theorizing: "I could have probably made the text more thorough, but because the modern world is very sensitive and the scholars have different opinions I simply stayed with my observations. By doing that I provide material which then everybody can interpret in the way they want and they can also evaluate that material according to their own opinions, which has already been done to a great extent by, for example, Mouffet, Godart, Swammerdam, Blanckaart and others." But the illustrations, no less than the text, present an argument in and of themselves. They make an elegant case for the way a caterpillar doesn't end at its last segment, but stretches to include the flower it eats, the season it molts, the leaves it webs into its cocoon, the parasitoids that lay eggs there, the moth it becomes. To see clearly, a viewer needed to see it all.

All through the spring and fall of 1704, Merian's stack of watercolors grew. They were good — she must have known

it—vivid colors that almost let the viewer feel the sting of a wounding caterpillar or taste the guava pulp. Tropical plants and insects grew so large and peculiar they pushed her even farther from the decorous creatures she recorded in the flower book and the caterpillar book. The watercolors by themselves would fetch a good price. She expressed her temptation to recoup her investment quickly in a letter to Volkammer: "[I]f I were to sell the painted works, they would be worth the money and the expenses of the journey due to their great rarity, but then only one person would have them." Merian came from a family of publishers. She dreamt in books, multiple copies, "for the benefit and pleasure of scholars and lovers of such things, so they might see what wondrous plants and animals the Lord God has created in America." Once again, she wanted to be of use.

It was a financially risky decision. Illustrated books were incredibly expensive and time-intensive to produce. John Ray felt his *History of Plants* would be damaged without pictures, but he couldn't come up with the money, so text had to suffice. Sometimes an author garnered institutional backing, but even this didn't ensure solvency. The Royal Society paid for illustrations for Francis Willoughby's *History of Fishes*, only to find the cost pushed the sale price of the book too high. The Society was left with piles of unsold volumes and ended up paying its clerk's salary in copies of *History of Fishes*.

Often, like Merian, the author or publisher solicited subscriptions for the project, getting money up front from buyers who would receive the final product at a discounted price. But this required a broad network of wealthy patrons who could be convinced to invest in a book they hadn't seen. To bring this latest venture off, she needed to use business acumen inherited from her father as much as his

artistic talents. Petiver helped, Volkammer helped, but it remained a daunting task. It had been twenty years since she published anything.

Despite these considerations, she envisioned a project beyond bold: sixty folio-sized plates, much larger than her caterpillar book (one way to solve the problem of portraying these huge tropical beetles life-sized was to make the pages bigger). It would be available hand-colored, capturing the outsized vibrancy of South America. Roaches, palm weevils, stag beetles, Harlequin beetles, owl moths, hawk moths, sphinx moths, morphos, orange sulphurs, caligos, swallowtails, skippers, grasshoppers, lantern flies, cicadas, wasps and tumble bugs would crawl, fully realized, into her readers' laps. The initial run would be two versions — Dutch, language of newspapers, idle conversation, and Leeuwenhoek; and Latin, language of the Royal Society, universities, and scientific papers. Too weakened by her disease and encroaching age to do the engraving herself, she hired engravers. She paid for the finest Amsterdam had to offer.

Her letters as she raced to finish the book are mired in accounting: prices of her books, prices for boxes of butterflies, angling for advertising, worry over backers. Letters detail her asking price for a menagerie of imported animals (twenty florins), her first caterpillar books (four ducats), a subscription to the Surinam uncolored (fifteen florins) and colored (forty-five florins). A florin was roughly equal to a guilder, which was roughly as much as a vat of honey or three hundred pints of beer; a ducat, a little more than three guilders. All this business correspondence had one exception. In a letter to someone in Nuremberg, dated October 8, 1702, Merian inquired after her good friend Dorothea Maria Auer: "I ask that you extend the most cordial greetings to my dear Mistress and cousin Auer on our behalf. I

would gladly give a ducat if I could have wings and fly to her. I would have so much to tell her that she would be greatly surprised."

It is an engaging image, dropped in the middle of all this wrangling over costs and inventory: the two of them sitting together, women who had known each other as young wives and mothers, sharing the tales of what has happened in the intervening years, gossiping about Merian's daughters, changes coming to Nuremberg, the trials of Surinam housekeeping. The conversation might have offered a loosening of the mask Merian wore for her gentlemen visitors and learned correspondents. The meeting never happened, though Merian learned from Volkammer that Auer was still alive. It's interesting that she wishes she could fly, offering a flicker of envy for her subjects who are always, in time, granted wings. It's noteworthy, too, that even here she puts a price on her desire.

Progress on the Surinam project inched forward, though not at the optimistic pace she set forward in her first letter to Volkammer. In the summer of 1703, thirteen plates were done; by that fall, she had completed twenty; the following summer the book was up to thirty pages with ten more ready "in a number of weeks"; and finally, in April 1705, she wrote to Volkammer that she was sending him a colored edition of the completed book, along with text in Latin for Volkammer's brother to read and in Dutch for the doctor.

The finished book is organized as a trip into the unknown. The opening two plates depict the most prominent plants and animals, offering two views of the pineapple, which Merian says is so famous that she skimps on details in her text "because this fruit has been exhaustively described by

various scholars." The first image is of a pineapple still growing in the ground. It's all spines along the fleshy leaves that explode outward, covering the outside of the fruit, which sits in the middle, painted in reds and golds. Two species of roaches, each in three stages of development, negotiate the prickles. They are equally well-known. She calls them "the most infamous of all insects in America" because of the way they ruin food and clothes. The second picture offers just the fruit, ripe and yellow, topped by a bush of green leaves, shorn from the rest of the plant. The insects here are a particularly lovely butterfly and the cochineal, a small red bug at the center of a long-time puzzle, and its ladybug predator.

For years, artists had been unsure of the source of the rich scarlet pigment carmine red, imported from Central America. Was it a berry or some plant sap? Leeuwenhoek, Blankaart, Petiver, and Merian investigated and concluded it was an insect, the cochineal, which lives on the prickly pear cactus. Though she found the butterfly near the pineapple, she notes the cochineal was drawn from a dried one and that she added it for decoration (and advertisement, because the insect attracted such strong interest, making it as famous as the cockroach and pineapple). She follows up with two plates of cassava, another staple, and proceeds to march her pictures through field and orchard.

Later in the book, she includes more and more nameless plants gathered from the forest. This is a similar structure to her first two caterpillar books, which end with the unexplained worms in the heart of an oak gall and a caterpillar that turns into a fly rather than a moth. The final picture in the Surinam book is of a caterpillar that she found in the "wilderness," which she isn't sure she provided with the right food. She says it hatched into a blue-winged species

that she recognized as "the great Atlas" (though modern entomologists don't think the caterpillar, pupa, and butterfly could go together). She may have had her doubts, signaled by her putting the caterpillar on a plant with wavy scarlet petals of which "neither the name nor the properties of this tree are known to the inhabitants of this country," and which Commelin could not identify. The book concludes on an open question.

Though the 1705 Surinam book didn't immediately become as famous as later editions would, collectors she'd wooed, including Sloane and Seba, snapped it up for their collections. Readers marveled at the artistry of the plates and relished the view they provided into this bright, mysterious country. The Surinam book re-established a reputation that might have waned with only Merian's German caterpillar books to support it. Reviews praised the work for the "great passion for investigation and tireless diligence of this woman" and noted that her paintings contain plants never described before. Despite the admiration for the beauty of the pictures and her adventurous nature, though, the ecological innovation of her portraits passed without notice.

Behind the facade of glory, there were signs of financial strain. Empty frames dotted her study book, designed to be an archive of her life's work. She was selling off images for one or two florins. One parchment scrap, showing the blue and black butterflies darting around a pineapple in the second Surinam plate, went on February 24, 1706. She illustrated copies of the *Ambonese Curiosity Cabinet* and the botanical gardens catalog and sold those, too. The Surinam book attracted enough subscribers for her to print it with sixty plates rather than the twenty she feared she might

have to settle for, but perhaps not enough to erase her Surinam debts and pay for the pricey engravers.

Her final series of paintings shows garden plants with butterflies, a return to her first money-maker, the flower book, though her technique is much more sophisticated. In a development of a style she launched in Wiewert, plants flow diagonally over the page, they are looser, stalks nodding under the weight of buds, tulip mouths gaping open, crown imperial leaves waving in attractive disarray. Her never-ending experiments with color have resulted in a palette of subtle greens and reds and golds that glow. But the butterflies, shorn of their life stages, are mere decoration. Wings open, wings closed, they are models with no relation to the plants, but they are very pretty.

Her financial straits were viewed unsympathetically by Levinus Vincent, a silk merchant and the owner of one of Amsterdam's finest collections. In April 1704, when Petiver sent Vincent several boxes of insects and asked him to distribute them, Vincent wrote back, "I am very obliged for your present and also for the box of butterflies with which we are very well supplied, being from the country, but being exotic (according to what I'm told) the box for Madame Merian would have been more appropriate for me, since that lady never keeps anything for herself, selling everything she receives, having no other goal but to get money from everything she does or receives—you can guess the rest."

Apparently Merian wasn't much fonder of Vincent, though she mentions his cabinet gratefully in her Surinam introduction. She writes Petiver back that he should stop using Vincent as an intermediary because she is reluctant to be obliged to him and because "I must give him a commission of 50%. This means that my loss is greater than anything I would earn on the insect book."

As she did before her trip, she supplemented her income with selling insects and other creatures she'd preserved. In a 1702 letter to Nuremberg, Merian writes about "animals in liquid" she has for sale and lists:

*1 crocodile,*
*2 large snakes,*
*18 of the same, small,*
*11 iguanas,*
*1 gecko,*
*1 small turtle*

She continued to seek out and advertise specimens for the next decade, though her supply of foreign creatures dried up at times due to blockades or inconsistent suppliers.

But Vincent was wrong about her caring for nothing but money. She cared about what she'd always cared about: transformation. Almost as soon as the last engraving on the Surinam book was complete, Merian went out looking for insects again. She never lost sight of her project. In a letter to Petiver, she tells him she can't use many of the creatures he sends, because she's not interested in collecting, but only "the generation and reproduction and transformation of the animals, and how one emerges from the other, and the properties of their food." With the letter she included a box of Surinam butterflies, useless to her because "the man who sent them to me has died. And he was unable to tell me about their generation."

And after the taxing work on her own book and Rumphius's, she didn't sit down to rest but immersed herself in her third and final caterpillar book, the one that would detail her discoveries in Friesland and make her project a more perfect echo of Goedaert's. Her study book, sadly ne-

glected since her return, shows new entries just after the Surinam book was published in early 1705.

On June 8, green caterpillars knit pale oval cocoons.

On June 30, black caterpillars that live on the heath turn into slick black pupae.

On August 15, 16, and 17, caterpillars, also from the heath, prettily patterned, became pupae. They didn't emerge until 1706.

Often she found a species she'd seen earlier and jotted a note about either a successful metamorphosis she hadn't achieved before or a parasitoid not previously recorded. On June 21, 1706, she found a green caterpillar on grape leaves. She had discovered a similar one almost thirty years before but hadn't been able to get it to hatch into a moth or butterfly. At the time she wrote: "So I guess I have to wait for the right bird to come out when it wants to come out (since I don't think that one is the right one)." And here, finally, was the moth. She went back to the third plate of her first caterpillar book and added it in. Patience is a beneficial little herb, indeed.

Her house and collections were now part of the choreography. Visitors lined up at her door. After years of letters, Petiver stopped by on a 1711 trip to Amsterdam. After Petiver's visit and his glowing descriptions of the botanical garden there, Richard Bradley, a plant enthusiast (who would become the first professor of botany at Cambridge), had high hopes that Merian would be willing to take on a piecework project. This is another indication that the Surinam book, however well respected, did not make her rich. Bradley, planning a book about succulents, wrote Petiver: "You may easyly guess how much I am dissapointed after

the character you gave me of them & what a loss it will be to my designs if your interest cannot procure me some cuttings of their Ficoides that are most rare & the draughts of those which may be the most acceptable. I believe your letter to Dr Rouse could gett us the former & Mad^m Mariana might order the other I will spare no costs to gain what I desire of this kind."

Next came Zacharias Conrad von Uffenbach, a student from Frankfurt, touring after graduation. A trip to London the previous summer had whet his appetite for Merian's work. In between watching cock fights (Uffenbach bought souvenir spurs), visiting a man who made glass eyes (his brother got a bargain on a pair that matched his own), tackling a windy river ("it is especially difficult to boat on the Thames, because men's wigs look so frightful and, if there is a shower, get quite wet"), and touring an insane asylum, the brothers drank coffee with Sloane and leafed through the volumes in his library. "The book with excellent illuminations by Mad. Merian of insects and plants was among them," he reported. He had also seen insects collected by Merian at Petiver's.

Strangely, she opened up to this rather callow young man, maybe because he was from her home town, could give her updates in her first language, and felt a similar pride in the city. Their conversation, recorded in his journal after a visit on a chilly February morning, provides the only glimpse into the emotional content of that dark marriage to Graff, entered into so long ago. "Poor" and "joyless," she told him. Strong words after so many years to dilute them. Then she lied about the circumstance, and told him Graff died before she went to Wiewert. A divorce perhaps was not a part of the past she was ready to acknowledge. It wasn't the first time she'd presented herself as a widow.

Uffenbach, master of the cutting remark, rarely had a kind word for anyone, but he wrote that though old, Merian was quite polite. He repeated what everyone always said, calling her very "energetic" and "busy." He bought several of her books before taking his leave.

These scientific social hours were necessary, but also could be draining, an impediment to getting work done. Leeuwenhoek, with his marvelous microscopes, was particularly besieged. Petiver was turned away from Leeuwenhoek's house because he didn't have a letter of recommendation. The old microscopist sent him a note, offering an apology and giving as an excuse: "about 8 or 10 Days before 26 persons had taken up 4 Days of my time all of them having recommendations to me excepting a Duke or Count and their Governour with whom I was so tired that the Sweat ran down from all parts of me."

Merian's reputation spread beyond the circle of visitors. When John Ray tried his hand at an insect book, struggling away at it in the final years of his life and sending his young daughters out with butterfly nets to bring him specimens, he limited the scope to mainly British species because he hadn't traveled much abroad and wanted to avoid competition: "I shall not concern myself with those published by the lady Merian as neither with those of Goedartius, Hoefnagel, Hollar, Aldrovandi." By 1710, Ray's posthumous *History of Insects* had been published, probing the mysteries of how galls arise and caterpillars that produce pupae and eggs. Following Leeuwenhoek, he wrote: "I think that the ichneumon wasps prick these caterpillars with the hollow tube of their ovipositor and insert eggs into their bodies: the maggots are hatched by the warmth of them, and feed there until they are full grown: then they gnaw through the skin, come out, and spin their cocoons."

In the light of all this new information, Merian rewrote the preface to her caterpillar book, as she prepared a new version in Dutch for her Amsterdam audience. She extracted all mention of spontaneous generation, and stressed that in the case of flies emerging from a caterpillar pupa, she had seen an adult fly hovering near the pupa before the hatching. The suggestion that flies could be born from excrement or other insects had been one of her rare leaps from the specifics of what she observed to a general statement, and she had been wrong. Now, either because she had figured it out herself, or because she read Leeuwenhoek and Ray, she embraced an explanation for the evil flies that had so disturbed her.

The 1713 and 1714 versions of the first two caterpillar books contain revisions as well as additions. Flies, moths, and caterpillars have been added: on plate 13, extra flies patrol two leaves; on plate 23, a moth, caterpillar and cocoon have been added to a cherry on the lower left; on plate 18 an additional fly, caterpillar and cocoon range up the stem. She etched in new elements of the life cycle as she discovered them, just as she included the hatching she waited thirty years for, and only recorded partially in 1679. Everything was as up-to-date as she could make it.

And still, Merian had yet another book to finish. Two, if the reptile book would be printed. Uncertainty, marked by her body with its aches and stubbornesses, crept in about whether she could do it all. In 1711, Merian updated the will she made just before leaving for Surinam. She also put up another lot of paintings for sale, advertising them in an Amsterdam newspaper. Dorothea's first husband died and she married the painter Georg Gsell. Johanna, still in Surinam, sent Merian a shipment of specimens in 1712, and Merian offered the lot to Petiver for twenty guilders, listing,

among other items: "a flying fish, a spider, 6 snakes, two thousand bones, 2 lizards, an animal that attaches itself to ships, a small fish, all in bottles filled with spirits...two boxes containing 30 insects." She was probably tired. And there was so much to do.

And then, the letters stopped. Notations in her study book grew more and more widely spaced. Amsterdam had always been a poor hunting ground, but one suspects exhaustion had something to do with it. Finally, after a berry-eating caterpillar cast off its pupa in 1711, the study book recorded no new hatchings. As she looked at that last one, mixed a color for the casing, studied the texture of the thorax, did she see anything different than that day, so long ago, back in Frankfurt, as the fuzzy silkmoth climbed out? The awe never dimmed. Something always eluded her, lost between specimen and page. In the revised caterpillar book introduction, she wrote of the "miraculous being and beauty in such tiny little Animals that no Painter with Brush and Paint can reach it." And now, it was coming to an end. She blew the last few scales from her fingers.

Bradley visited in 1714. He came to town pretending to be a doctor, apparently with Petiver's help and without qualifications, but in between writing bogus prescriptions, he visited Ruysch and Commelin and reported to Petiver that Merian "has three times feasted me with the sight of her curious paintings." A stroke shook her in 1715, perhaps related to her Surinam disease, perhaps not. In cases of yellow fever, the illness barged in, ransacked the body and left, killing the host or leaving it immune. But malaria lingered, taking a slow toll. Work on the third caterpillar book ground to a halt. Brushes sat untouched.

At some point, in these long last years of quiet, she sat

for a portrait by her son-in-law, Georg Gsell. Straight-backed, she posed in a plain dress with only the thinnest ruffle at the neck. In contrast, a fashionable fontage sits on her head, stiff pleats of linen like quartz spires, their vertical thrust underscoring the effort it took to sit upright. Her father's face is stamped on hers, alive with a weary intelligence. His seal sits in a framed oval above her head. Lines crease her forehead, bracket her mouth.

Like many collectors, Merian is surrounded by paraphernalia that spans her career—a wreath, a plate of shells, a stack of books, a globe. Unlike them, though, she has not just tomes, but tools resting nearby: a pencil, a burin, shells of paint, a quill in an inkpot. She gestures to a live butterfly flitting over a plant. Lovers chase each other around the side of the vase, an image at odds with the tenor of her life—it's something she might have observed from a distance, the way she watched grubs attack a potato.

It is a humble portrayal, nothing glamorous or showy. But even here, bound by years, possessions, knowledge, the wood of a portrait frame, and possibly paralysis from her stroke, Merian in her official portrait exudes restlessness. Paper and cloth seem to rustle, the quiet scratching of a beetle in a box.

A day in midwinter, caterpillars tucked in cocoons, waiting for the thaw. Frogs slept away the season under mud and leaves. Tulip bulbs pushed their roots out into the cold ground. And something broke, gave up, gave in. If scenes scroll before the eyes of the dying, there would be so much to rise up before her eyelids. A cocoon rocking in her palm. A flock of scarlet ibis cruising along the water. A daughter's cupped hands, a live caterpillar inside. Copper curls on sleeves and skirt from her engraving. The scent of wild lemon.

Was death some creeping spider, binding muscle and bone, paralyzing and constricting, leaving the body a limp bird, or was it the long-awaited hatching, freeing the breath, rushing blood to new limbs, opening into holiness at the end of it all as she went to meet her god? The god of constant, surprising change.

The same cold season, Dorothea pushed a burin over copper, engraving plates for the final caterpillar volume. Worm-eaten leaves and fat fleshy bodies took shape under her fingers. She carved with a firmer pressure than her mother. Dorothea would have had to split her attention between the work at hand and the three children — two daughters and a son — from her first marriage, and Gsell's offspring, who might need a shirt tucked, a grubby hand washed. But the watercolors waited in the study book, pages of notes taken in Amsterdam and Friesland. Her sister Johanna had sent plates from Surinam of insects that she planned to bind in the back.

In the silence after her mother's death, Dorothea would have been left to pull up the sheet, to tidy the sick room, straighten its bottles and linen. The second daughter, who'd shouldered the burden of finishing this last book, must have felt a weight lift. It would be good to put down the burin, to watch the color bleed from the brush until the water was clear. She had the freedom now to take her life in a radically new direction, the way her mother did when Dorothea's grandmother died in Wiewert. The money from the watercolors might be enough to cancel some of the Surinam debts and leave her with a little more room to move.

There were just a few more engravings to do. Type to set. A dedication to write in honor of her mother, lauding her intensity, her accomplishments, one that would end, with a sigh: "her Works are now Complete."

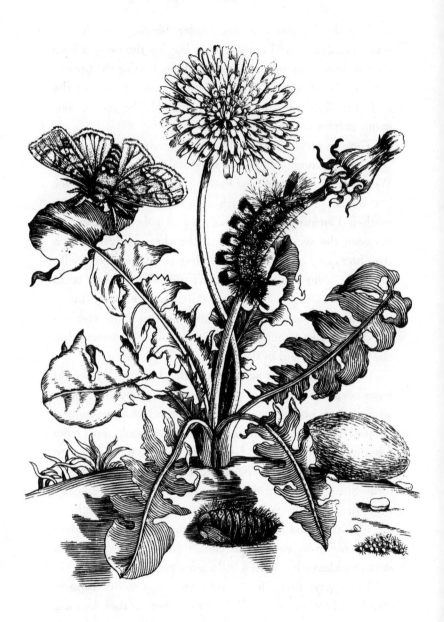

# CHAPTER EIGHT

# *The Modern World Is Very Sensitive*

You will ask —what is the feeling of hatching?
Oh, no doubt, there is a rush of panic to the head, a
thrill of breathlessness and strange sensation, but then the
eyes see, in a flow of sunshine, the butterfly sees the world,
the large and awful face of the gaping entomologist.
—Vladimir Nabokov

*Europe, Russia, the Americas, 1717–1902*

When Merian died, she left behind the remnants of a life's work and obsession: copperplates of her early books; an almost complete manuscript of the third caterpillar volume; her study book, thick with hundreds of slips of parchment illustrated with insects, from wasps to swallowtails; discarded drafts; watercolors of lizards for the reptile volume and other ideas that never came to fruition; unsold copies of the Surinam book; boxes of butterflies waiting for sale, and undoubtedly the tools of her trade — paints, letters, orders to be filled, brushes, burins, palette knives —worn and bent after a lifetime of use.

But no dust would settle in their folds and hollows. In a few years, the items in these rooms would be flung across the globe, coming to rest in places that Merian never thought of visiting. And the ideas? Tracing their influence

should be like following the neat circles left by a rock thrown in a lake, rings floating outward. But it's more like tracking the dust-fine seeds of some canopy orchid, blown from the stem in a gust of wind, each floating germ on its own idiosyncratic path.

Early in 1717 in Amsterdam, Peter the Great was back. On this, his second tour, he'd brought his personal doctor with him, Robert Areskin, a surgeon from Scotland with a flair for natural history (venomous snakes were his specialty). The czar visited old friends, and hired Merian's son-in-law Georg Gsell to advise him about art purchases. Peter the Great also sent Areskin to buy many of the collections the czar admired twenty years ago. The czar planned to bring them to the new palace and academy in the city he was building on the banks of the Neva: St. Petersburg. Areskin had a list of stops to make, some surprise visits, and some business transactions in progress. Seba already negotiated a price of 15,000 guilders and packed up and shipped his collection to St. Petersburg in seventeen boxes, along with medicines, French fruit, and extra embalming oil. Ruysch, too, was on the verge of reluctantly letting his treasures go for 30,000 guilders: a steal, he felt. The butterflies, their meaning so long puzzled over, had turned into a form of currency.

Among all his stops, Areskin made his way to the Gsells' door. The doctor leafed through all that was left of Merian's work. He had an appreciation for these things. His own library, modest without a czar's budget to fund it, still contained an impressive array of books. The watercolors of giant scarlet beetles, fluted shells, swelling cassava roots —these all would suit the czar. The humble study book, with its per-

sonal notes and handmade frames, records of a lifetime of close observation; this, the doctor would keep for himself.

On January 17, the same day Merian was buried in Heiligewegs Kerkof, a churchyard several blocks from her house on Kerkstraat, Areskin paid Gsell 3,000 guilders and packed up the papers for St. Petersburg.

Peter the Great amassed not just snakes, crystals and toads in bottles, but people. And he didn't limit himself to those whose physiques attracted his attention, the giants, dwarves, and hermaphrodites who lived in the rooms that housed his cabinet of curiosities while alive and whose organs he preserved after death. He and his followers also swept up Europe's most prominent artists and scientists and architects, luring them to St. Petersburg with the promise of large salaries to staff the Academy of Sciences. Explorer Vitus Bering came from Denmark; naturalist Georg Steller from Germany; mathematician Leonhard Euler from Switzerland. They themselves were collected, with their bright, shiny talents and exotic European ways.

Maybe as a result of a sales talk by Areskin, himself a transplant from Scotland, or a personal invitation from the czar, Georg and Dorothea Gsell and their children moved to St. Petersburg, too, within a year of Merian's death. With Johanna and her husband vanished into Surinam, remaining family ties were not enough to keep the Gsells in Amsterdam. Dorothea, who'd spent the last months of her girlhood in the South American rain forest, now headed in the opposite direction, northeast to the Baltic Sea and then past it into the czar's dream of a European metropolis on the banks of the Neva.

When the Gsells arrived, St. Petersburg was a city under construction. Palaces, gardens, boulevards lit with

streetlamps, went up in a matter of decades. With the czar's muscle behind it, there was only a heartbeat from idea to execution. Still, at the time the Gsells moved in, streets stretched into emptiness. Houses displayed finished façades but held nothing inside. Digging, paving, logging, excavating formed a constant background hum.

Just as Paramaribo with its canals and Dutch houses was like a postcard of Amsterdam, miniature with a tropical stamp, St. Petersburg offered another image of the Dutch capitol. Amsterdam was one of Peter the Great's favorite cities and he used it as a model in the layout of the streets and the cut of the canals. As in Surinam, though, these touches were only so much window dressing for foundations of climate and geography. The deep and unpredictable floods of the river, the freezing cold that ate into the bones, these defined the nature of the city as much as the gardens packed with European-style statues.

As Dorothea, Georg, and their children settled in, in 1718, Peter launched his Kunstkamera, the cabinet to sate all curiosity. Built in the center of the new city, it was the focus of the czar's scientific ambitions. In addition to Ruysch's artistic dissections and the deformed people Peter invited in, the collection contained thousands of dried plants, bird bones, shells and books. Dorothea received a commission, the first given to a woman, to design the exhibits and document the artifacts in watercolor.

As court painter, Gsell turned his brush to grand subjects like portraits of the apostles and frescos for the newly built Peter and Paul Cathedral. He decorated the czar's "green study" in the Summer Palace with allegorical paintings of "The Victory of Russia," and still lifes of flowers. He also recorded less lofty subjects: the innards of a lion that died in the czar's zoo, the corpse of Bourgeois, a very tall

man the czar found in France. When a whale turned up at the Academy in 1734, the institution's journal records: "The painter Gsell arrived, and was told to paint the fish at once."

Both Gsells taught the new generation of imported explorers and naturalists how to record what they saw, using both the natural history specimens in the Kunstkamera and Merian's watercolors as models. As Bering and Steller prepared to set out on the ambitious Second Kamchatka expedition, one that revealed both the Bering Strait and the Steller's sea cow, they used this training. The instructions Bering gave his artists and scientists are an echo of Merian's beliefs and experience: "To make it easier to portray everything true to nature one must have the subject before one's eyes and not paint from memory. To paint a fish, we must put it in water, so that it will not die; to paint grasses, we must dig them out with the earth, so that they do not wilt."

This fantasy city, made up of rock and mud, is where Dorothea and Georg Gsell lived out the rest of their lives. Socially, they mingled with the expatriate Swiss community. Leonhard Euler was its young star. In a break from wrestling with questions of calculus and the relation of music to math and the shape of the earth (flat at the poles? shaped like an orange?), he courted and married Gsell's daughter, Katherina. When Katherina died, after giving birth to thirteen children, and Euler was a blind old man, he married her half sister, also quite elderly — Dorothea and Georg's daughter, Merian's granddaughter, Salome Abigail Gsell.

As for Merian's artwork, it was spread throughout the czar's holdings. Some pictures lay in the czar's drawers, from which he would take them out and admire them. Others sat in the libraries, where a young Georg Steller leafed

through them, taking notes, annotating a catalog of insects depicted in the Art Cabinet. The collection continued to grow. When Areskin died, Peter the Great bought his library, including the Merian study book. In 1734, Dorothea traveled to Amsterdam to buy more of her mother's watercolors and bring them back. In the mid-nineteenth century, a Russian mycologist left his collection of Merian paintings on parchment to the botanical collection.

In England, Hans Sloane owned a set of the watercolors from the Surinam book, as did fellow collector and rival Richard Mead. When Sloane died, and his cabinet and library formed the core of the British Museum, the paintings went with them. Mead's Merian paintings went to Windsor Castle. But the bulk of her watercolors remained in St. Petersburg. In the wake of Peter the Great and Catherine the Great, and their ambitious reaching out to the rest of the world, her work had the opportunity for sizable influence. But through time and revolutions and fires and war, these and most importantly the study book — record of her thoughts and methods — would be locked away. This particular seed buried itself, as if under layers of frozen earth and snow.

While her watercolors remained out of public sight for the most part, her published work took on a life of its own. So did the character of "Madame Merian," who rushed in to take the place of the woman disappearing into her grave. The slippage started even before she died when her apothecary friend James Petiver uncoupled the insects in the Surinam from their surroundings in an effort to "methodize" them, fitting them into more of a Rumphius-like frame. In his short-lived journal *Memoirs of the Curious*, first published in 1708, and in books that would follow, he put her

beetles, a shell, a swallowtail, and a snake all jumbled to-
gether and numbered on just a few pages. He translated
and rewrote Merian's text, ordering his descriptions under
headings like "single-colored butterflies," "admirals," "at-
lasses," and "lizards, frogs and serpents."

After her death, the process only accelerated. Along
with giving 254 watercolors and the study book to Are-
skin, Dorothea sold the Surinam plates to publisher Jo-
hannes Oosterwyk. Two years later, in 1719, Oosterwyk
printed an altered and expanded version of the Surinam
book. The book opens to a frontispiece featuring Merian
herself. In the foreground, cherubs with pink cheeks and
knees fuss over trays of insects. On the ground, live butter-
flies hold up their wings on spindly legs and hairy caterpil-
lars crawl along. A pineapple plant sprouts in a pot on the
floor, and a copy of the Surinam book lies open to the page
with the voracious spiders and a swallowtail on an orange.
Merian, holding a butterfly and a blooming flower, is as
buxom as the cherubs: red lipped, flushed, almost falling
out of her dress. She is more muse than scientist or artist,
maybe the goddess of the butterflies or some domestic
deity at the kitchen table, inspiring and surrounded by
busy, plump children. The thin wrist, knobby knuckles
and strained expression so evident in the earlier portrait
are gone.

She and her attendants sit inside a high-ceilinged room —
one cherub holds a tray, which he is apparently going to
put into a cabinet. But through a window in the back wall,
Surinam itself is visible. A palm tree ripe with coconuts
bends over a pond with a toad and a waterfall. In an adja-
cent meadow, two gentlemen in white wigs and long coats
talk and look at a woman kneeling on the ground, wielding
a butterfly net, engrossed in her prey.

Other additions are even stranger. Oosterwyk added twelve new plates to the original sixty, claiming to have found ten among her effects when she died and two others in Seba's collection. Some are obviously hers. The first of the new plates are cast-off drafts: the cassava from plate 4 appears with a sphinx moth rather than a white peacock, the cacao tree from plate 26 appears with a moth with eyespots on the wings rather than a more modest-looking species. Lizards for her planned reptile book also turn up, bold and captivating. The opossum with her children on her back shares a page with a winged insect also pictured in a sketch.

But toward the end of the book, the quality disintegrates. The style is no longer recognizable and some other artist must have stepped in. The final plate looks as though its author sampled rain forest hallucinogens as well as cassava and pineapple. The scale is skewed, so that a fuzzy larva crawls up a palm tree that should be bent double from the weight of an insect half as long as the trunk. An equally monstrous beetle waves its antennae on the shore, like a beached whale. A cluster of fruit with a pupa attached floats in mid-air. In the water, a tadpole is pictured at various developmental stages on the way to becoming a frog. Shells line the bottom edge. Each is labeled with a roman numeral. None interacts with another. All the animals, particularly the frogs, seem desiccated and lifeless, while usually Merian infused her smallest fly with the impression that it was about to zoom off the page.

In 1718 Oosterwyk published a Latin version of all of the caterpillar volumes bound together. Yet another image opens the book. This one is also infested with cherubs, and the lead actors are more clearly classical gods (one has a winged headdress) in some domed hall lined with statues.

Peter Gosse followed with a 1726 edition of the Surinam, published in The Hague. The engraved plates then moved into the hands of French publisher Jean Frederic Bernard, who clumped three and four of the quarto-sized caterpillar book and flower book images on each folio page, stripped out Merian's text, and issued it in French as *History of the Insects of Europe.* He also put out another copy of the Surinam book. In 1771, yet another French edition of the Surinam appeared. These all had much broader circulation than the originals.

More and more, the texture of her original brushstrokes began to fade. Lines blurred. Images warped beyond recognition. As uncolored volumes passed from hand to hand, artists who had never seen Merian's watercolor models or insect specimens painted the plates. Green lizards gained red stripes. Morphos turned from blue to purple. A caterpillar's red spines ended up black or brown or yellow. Species identification became impossible.

Through translations of translations and reprints as the copperplates were passed from hand to hand, the order scrambled, the shape of her vision was no longer clear. It shattered into individual engravings. Butterflies, caterpillars, blossoms, and seedpods were as disjointed and disconnected as they were in the grand cabinets that were being dismantled and shipped all over the world.

Even with all this distortion, though, her books continued to wield influence throughout the eighteenth century. Just as images by Roberts and de Bry appeared in Merian's flower book, other books incorporated her pictures, without her name attached. One plate of Bradley's 1721 book, *Philosophical Account of the Works of Nature,* shows Merian's silkworm transformation; others repeat the butterfly, pupa,

and caterpillar that in plate 44 perch on a red dye plant. The caiman lizard with its young poking out of the egg, one of the additional twelve plates in later versions of the Surinam book, cropped up in Oliver Goldsmith's *A History of the Earth and Animated Nature* and in a natural history of quadrupeds, serpents, and fish by Bernard Germain Étienne de La Ville, Count de Lacépède.

The ominous tarantula was particularly popular. Not just a record of species, the engraving was a brutal statement about the nature of existence, and it was hard to look away. The spider crouches in Albert Seba's 1735 book *Locupletissimi Rerum Naturalium Thesauri,* though the bird here is still living, perched on an improved nest. Merian's tarantula, stripped of most ants but with the agony of the hummingbird enhanced (its eyes squint closed; its tongue sticks out), appears in a book by Pierre Joseph Buchoz.

But it wasn't just publishers of illustrated books who consulted her. Artists, particularly those working at the intersection of science and painting, sought out her drawings for details and inspiration. Though her early caterpillar books pioneered the environmental portrait with its food plants and life stages, the Surinam book reached a larger audience. The artist and naturalist Mark Catesby, hired by Sloane to draw items in his collection, had access to Merian's original watercolors and her books. He paged through the Surinam, and commented on her opossum picture in the second volume of his *Natural History of Carolina, Florida, and the Bahama Islands.* He didn't paint many insects, deeming them less consequential than the birds and fish that filled out his book, but he did incorporate Merian's ecological style.

This ecological style would become standard in insect illustration over the course of the next century, in a way that

didn't impact pictures of other animals (until Audubon's bird paintings in the 1820s). Eleazar Albin's 1720 *Natural History of English Insects* included all the life stages. *The English Moths and Butterflies* by Benjamin Wilkes in 1749 also included "The Plants, Flowers and Fruits Whereon they Feed" and Moses Harris's 1766 *The Aurelian or Natural History of English Insects* incorporated life stages and food plants. August Johann Roesel von Rosenhof credited Merian's Surinam with inspiring him to study and paint, from life, metamorphoses of German insects.

South American explorers also used her books as a resource. John Gabriel Stedman, who sailed to Surinam in the 1770s and wrote *Narrative of the Five Years Expedition against the Revolted Negroes of Surinam,* criticized Merian's research in the natural history sections of his report. But he admits that insects are not his specialty, not the least because this soldier, who hunted down escaped slaves, didn't like to push the pins through the live butterflies. When faced with a rhinoceros beetle, he declined to describe it in detail, writing: "I have not the smallest Pretensions to be named amongst the flycatching fraternity." All of his insect illustrations lean heavily on Merian's and some are direct copies. When the Prussian Baron Albert von Sack made an expedition to Surinam in the early nineteenth century, he tried her methods and tested her observations, seeking out a toxic caterpillar she mentioned and deliberately brushing against it, just to see what would happen.

Natural historians and philosophers who stayed closer to home also paged through the Surinam and caterpillar books. Charles Darwin's grandfather, Erasmus Darwin, cited her in his work *The Botanic Garden,* and the German poet J. W. von Goethe, author of a treatise on the metamorphosis of plants, marveled at the way she moved between

art and science. These investigators worked in a world dramatically different from the one Swammerdam, Merian, Malpighi, and Leeuwenhoek were born into. Insects were no longer the magical, devilish creatures that Goedaert began to question with his caterpillar woodcuts. Swammerdam's masterwork, *The Bible of Nature,* had finally been published, almost fifty years after his death. Observation and experimentation continued to improve. Charles Bonnet ruined his eyesight raising nine generations of aphids (and showed the females could go through several cycles of reproduction without males). Following Swammerdam's lead, Pierre Lyonet wrote six hundred pages on the anatomy of a single sort of moth.

René-Antoine Ferchault de Réaumur's *Memoires pour servir a l'historie des insectes (Histoire des insectes)* looked at the ways insects produce sound and delved into the structure of their societies. Like Swammerdam, he believed the butterfly organs lived hidden in the caterpillar, giving him a preformationist view of development. In his *Natural History of Ants,* he referenced Merian's spider picture, and her comments about the ants that swarm through houses and force inhabitants to flee. He wondered how many of her observations are first hand, since at times her details seem incredible. But, as she wrote in the text by the spider picture, army ants do indeed build bridges of their bodies to cross streams. Leaf-cutter ants do excavate nests up to eight feet deep.

While experimenters in physics and chemistry were coming up with solid rules, though, the natural historians were plagued with exceptions. The closer they looked, the more unusual examples they found. Spontaneous generation had dropped out of fashion, but what to make of aphids that gave birth without ever mating? And the hydra that created a new hydra out of whatever piece the experi-

menter happened to chop off? Did God have his hand in the workings and how big a fingerprint did he leave? Putting all this chaos in some sort of order became crucial. Unbeknownst to them, all the collectors, all the artists, all the publishers gathering items from around the world and describing them had been working for one man: Carl Linnaeus.

In his 1735 book *Systema Naturae* the Swedish naturalist created an order that could be imposed on plants, animals, and insects, giving each a Latin genus name, common to a group with common traits, and a species name, marking it off from its kin. For example, he split plants into twenty-four classes based on their kind of stamen and divided those further into orders based on type and number of pistils. Since the stamens were "male" and the pistils "female" this created all sorts of shocking configurations, from bigamy to harems. After looking through Europe's best collections, he sat down to the task of christening everything, an Enlightenment Adam. If he'd launched his project fifty years before, he would have had hardly anything to name, but all the exploration, all the boxes of birds and trees and flies provided him with ample material. He felt that "God had suffered him to peep into his secret cabinet."

Linnaeus, too, relied on Merian's books to define some species he didn't have specimens for (he cites her thirty-seven times in the tenth edition of his *Systema Naturae*). Even he didn't have a solid edition of her work, though, apparently using a later version as his reference point. His student, J. C. Fabricius, more devoted to insects than his mentor and author of the 1778 book *Philosophia Entomologica*, also used Merian as a resource and underscored the importance of the insects' food to the understanding of their lives (he classified by mouthparts, among other structures).

Linnaeus's classification system was an invaluable development, providing a uniform language for natural philosophers to use, organizing the thousands of specimens, letting researchers build on each other's work as they could be sure they were talking about the same creature. This comprehensive map ultimately led to questions about how the similarities and differences in species' structures might have come about. Within this framework, eighteenth-century experimenters uncovered much about insects — the intricacies of the bee hive, the ruling hand of instinct — but metamorphosis studies themselves stagnated. The issue of whether insects had souls or were simply machines caused great consternation. The admiration of God's work, the awe of the small, calcified into the field of "Insectotheology." Insects' intricate perfections prompted books like the 1738 tome by Friedrich Christian Lesser, *The Theology of Insects, or Demonstration of the Perfections of God in all that concerns Insects.* Increasing reliance on the notion of "preformation" allowed natural philosophers to duck the question of how a new body shape came into being. Even as late as 1846, the chapter on metamorphosis in the popular textbook *An Introduction to Entomology* by William Kirby and William Spence included a long poem about the changing insect as a metaphor for religious transformation and quoted Swammerdam as demystifying the process. The book then went even further, saying one can see the skins of each successive molt inside the caterpillar. (One can't.)

Perhaps the brightest frontier was a series of experiments taking place, once again, in the South American rain forests. Like Merian, Alexander von Humboldt chafed at the lifeless cabinets and what, in the wake of Linnaeus, had developed into a full-fledged mania for classification. There must be more to biology than finding and naming. In 1799,

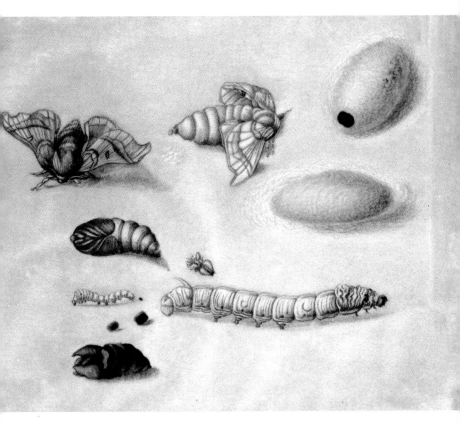

Watercolor of silkworms, the first entry in Maria Sibylla Merian's study book. A facsimile appears as *Butterflies, beetles and other insects: the Leningrad book of notes and studies.*

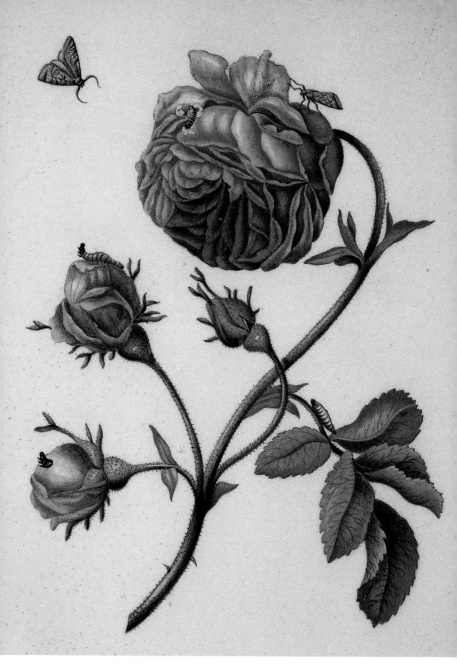

Bush rose with moth, larva, and pupa. This watercolor is a model for plate 24 of Merian's first caterpillar book.

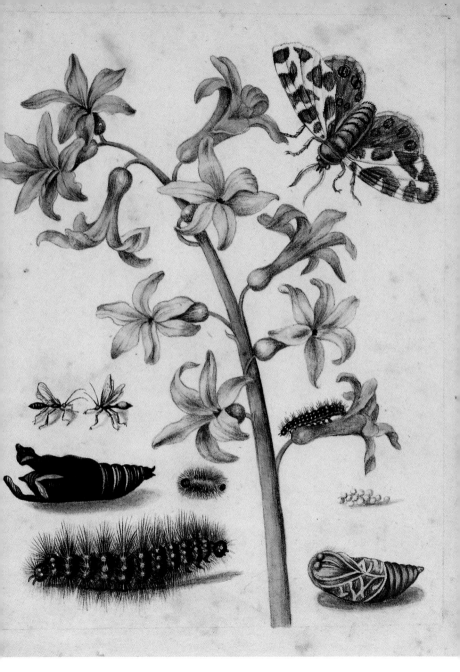

Garden hyacinth, garden tiger moth, and ichneumon flies. This is the watercolor model for plate 5 of Merian's first caterpillar book.

Watercolor of scarlet ibis painted by Merian.

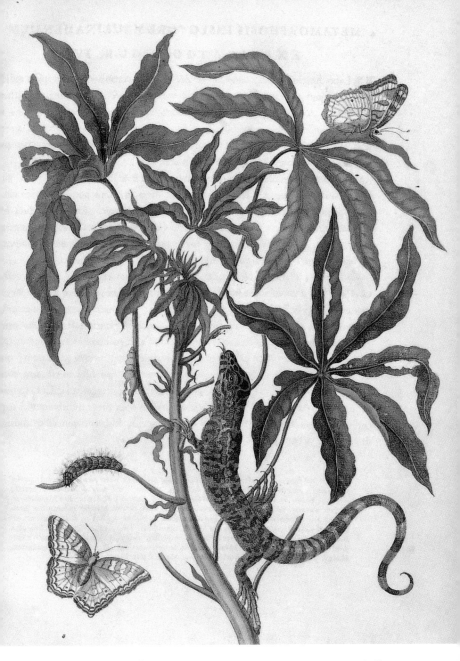

White peacock butterfly and lizard on cassava: Plate 4 of Maria Sibylla
Merian's *Metamorphosis Insectorum Surinamensium*, Amsterdam, 1705.

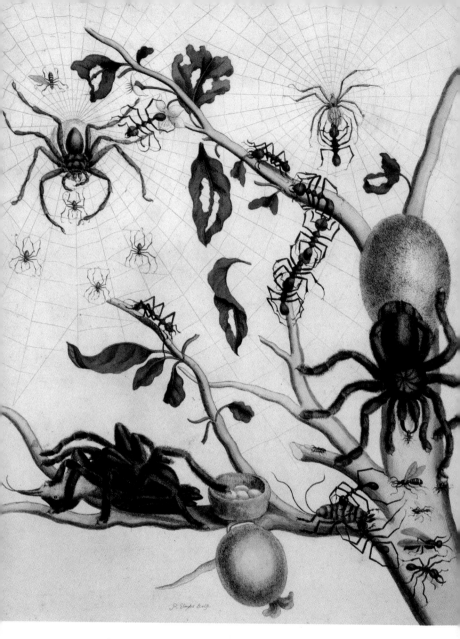

Tarantulas, hummingbird, and ants on a guava tree: Plate 18 of Merian's *Over de Voortteeling en Wonderbaerlyke Veranderingen der Surinaemsche Insecten.* Amsterdam, 1719. This image from a Dutch version of the Surinam book published after her death is reversed from the way it appears in the 1705 version.

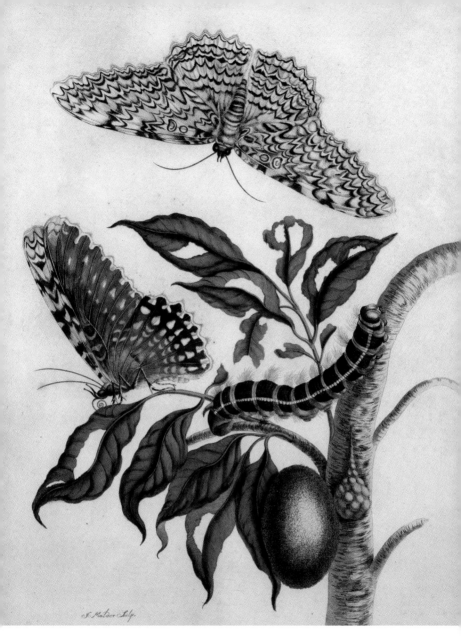

White witch moth: Plate 20 of Merian's *Over de Voortteeling en Wonderbaerlyke Veranderingen der Surinaemsche Insecten.* Amsterdam, 1719. This image is also reversed from the way it appears in the 1705 version.

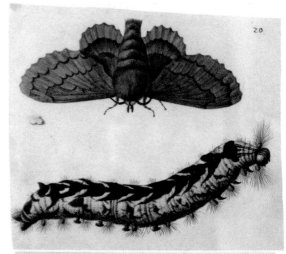

Watercolor of *Gastropacha quercifolia*, entry 9 in Merian's study book. A facsimile appears as *Butterflies, beetles and other insects: the Leningrad book of notes and studies.*

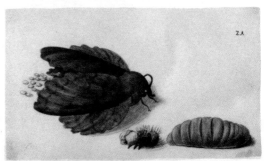

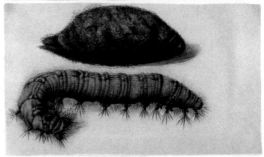

Humboldt and botanist Aime Bonpland set off to explore South and Central America. They carried a load of instruments to measure and chart and quantify factors of their surroundings — from temperature to air pressure — in the hopes that this would yield some logic as to what grew where. Treks up mountains showed the plants changing as Humboldt hiked uphill. Edging deeper into the forest revealed leaves and buds adapted to extreme heat or cold. He began mapping how life was distributed over the landscape. Though the word itself would come later, it was a start toward the science of ecology.

In the early 1830s, debates raged in scientific circles about whether all animal structures adhered to a unified plan, whether evolution of one species into another might be possible, and whether electricity could produce spontaneous generation. (A man named Andrew Crosse claimed to have made some mites this way. Drawing on these theories, Mary Shelley had Frankenstein use electricity to animate his monster.) Doctor John Vaughan Thompson had unsettled examiners of the sea when, in his *Zoological Researches and Illustrations; Or a Natural History of Nondescript or Imperfectly Known Animals,* he showed that the sedentary barnacle, long thought a mollusk, was merely one stage of an animal that zipped around the ocean. Only as an adult did it cement itself to a rock and secrete protective plates. The barnacle was the first of a long line of cases where one sea creature revealed itself as another, in a different guise. Metamorphosis was turning out to be more common and more complex than previously imagined. Intrigued, a young Charles Darwin delayed his writing of *The Origin of Species by Natural Selection* and settled in for a twenty-year study of the barnacle.

But the English naturalist William Sharp MacLeay had another question in mind. He had made his own contribution to the era's controversies by proposing a "quinarian" system that classified organic life into a graceful series of circles that touched at crucial points. Harkening back to the days where a fly stood in for the devil, MacLeay's rings enclosed a moral drama. Some species were "typical," displaying all the virtues of the type. Others were "sub-typical," and, like the spiny and poisonous caterpillars or beetles that live in the dirt, indicative of evil.

In late 1833 or early 1834, though, MacLeay was trying to get a tarantula to eat a bird. His curiosity had been spurred by Merian's engraving, but he anticipated failure, because to his knowledge tarantulas only lived underground. They didn't build nests in trees, where birds might perch, as Merian pictured them. Experimenting from his post in Cuba, he released a live hummingbird into a tunnel with a tarantula, waiting for the pounce and kill. The spider fled.

This evidence formed the first tear in the cloth of Merian's reputation. It was the one thing she'd guarded most carefully, shielding herself behind prominent men, rarely risking a theory, lying about being a widow, trying all the time to be proper and correct. But with the originals of many of her books locked away, her research notes inaccessible to most, her artwork known mainly through bastardized copies, there wasn't much left to make her case. For all except the artists, who adopted her method of portrayal, her notion of metamorphosis in context eluded readers' grasp. Her caterpillar books, the three volumes devoted to European species, were forgotten and with them her observations about cannibalism of some larvae, the large com-

munal nests, the caterpillars of a single species that come in many shades. The only book anyone cited was the Surinam, and they used later versions. The status of her work, built on half a century of detailed observations of insect life, came down to two questions: Could a spider eat a bird? Did lantern flies glow?

At the same time as MacLeay was scaring his tarantula, a brash young reverend on the Caribbean island of St. Vincent was striving to make a name for himself in natural history. Lansdown Guilding wrote a book about the island's botanic garden; studied starfish, centipedes, beetles; and spent a damp night near a volcano to examine its geology. In letters to English botanists and entomologists including the famous plant expert William Hooker, he sent specimens and drawings; bemoaned his "exile" on the island of St. Vincent; pestered one man to make him a doctor, another to get him a membership to the Royal Society; requested that a genus be named after him: *Guildingia*. Far from libraries, he could never read as many books as he'd like, but he did get his hands on a copy of Merian's Surinam.

He planned his own survey of South American insects and lizards (that he was on a Caribbean island rather than in South America was apparently no impediment) and one hundred years after Merian's book was published, she was still the authority to be torn down. Using his poorly colored copy from 1726, he wrote up a critique, using specimens brought by his brother from British Guiana. It was published as "Observations on the work of Maria Sibilla Merian on the Insects, &c of Surinam" in the *Magazine of Natural History* in 1834.

He has a harshly worded complaint for almost every page. Throughout there is "carelessness." Plate 65 is

"worthless." Plate 42 is "vile and useless." Some may express pity for the "good-tempered" lady so easily fooled. But who could excuse her? She ignores facts that "every boy entomologist" could perceive.

At times, his criticisms spring from defects in his copy. He notes that the final twelve plates (the ones tacked on by later publishers) are the worst engraved. Some butterflies, without her watercolors as a guide, are incorrectly painted. Other grievances arise from his own lack of knowledge. When he can't identify an insect or plant (like the *Phobetron hipparchia* —monkey slug—on plate 28), he blames Merian. He refuses to believe that flies—parasitoids—came out of some of the cocoons as she said they did. And some of his observations are apt. On plate 48, the caterpillar like a hairbrush couldn't produce the bee. The moth and pupa on plate 60 don't match. He doesn't think the tarantula builds an egg-shaped nest as she shows, but admits, "Doubtless this species is strong enough to overcome small birds, if it could seize them." The editor of the article, though, adds a footnote citing MacLeay's study and reporting, "Mr. MacLeay consequently disbelieves the existence of any bird-catching spider."

A main thread of Guilding's argument is that Merian relies too heavily on conversations with the Africans and Amerindians. About the lantern fly, he thinks she has been duped by "some cunning Negro" who pasted the head of one insect to the body of another. Another error is based "on the testimony of her serva nigrita." Of the peacock flower, the plant that Merian reported slaves used to abort unwanted children, he says it is "used by Creole doctresses among their credulous patients," and adds "it forms a pretty hedge."

Guilding died of liver disease at thirty-three. His criticisms would live much longer.

Throughout the nineteenth century, following the articles by Guilding and MacLeay, Merian's work was dismissed and devalued. The portrait of Madame Merian that developed was neither that of a woman inspired by missing life histories of insects "to undertake an awesome and expensive trip, and travel to Surinam...in order to continue my observations," as she described herself, or "That Curious Person Madam Maria Sybilla Merian" put forth by Petiver, or the Goddess of the Butterflies with her cherub attendants dreamed up by later publishers. The nineteenth-century Madame Merian was some befuddled lady, dabbling in areas beyond her ken.

A profile of Merian in *The Naturalist's Library* by James Duncan echoed many of Guilding's assertions. The description of the spider and ants, he writes "are to a considerable extent fabulous." The Kirby and Spence entomology textbook cites Merian on the caterpillars wielding toxic spines and the tasty palm tree grub, but adds of her description of ants making bridges of their bodies, "As she is not always very correct in her statements, I regarded this as altogether fabulous, till I met with the following history of a similar proceeding in De Azara, which induces me to give more credit to it." The 1846 *Penny Cyclopedia* offered MacLeay's experiments as evidence her pictures were unreliable. She gets a back-handed compliment in an article "Episodes of Insect Life" in the *Living Age* magazine: "Though she suffered her imagination to run riot, and lent too ready an ear to any wondrous tale relative to the life and habits of her favorites, her works are still deservedly respected."

Underlying all these grievances were the facts of Merian's life. The very traits that had allowed her to enter the world of seventeenth- and early eighteenth-century natural philosophy made her an inconvenient fit for nineteenth-century biology. It was a field trying to establish botany and ornithology as professions rather than as hobbies for amateurs. French botanist Jean Baptiste Lamarck coined the word "biology" in 1802, giving a name to the emerging discipline. Universities launched departments to study zoology and chemistry. Governments created bureaus of fisheries and entomology. In the same way that the professionalizing physicians would shuck off midwives, biologists disentangled themselves, as best they could, from their natural history roots. Merian and her contemporaries conducted their experiments in a field so new, there was an intimidating and exhilarating lack of rules. But now, rules rushed in. In the United States, many of the regulations designed to increase the profession's status had the effect of barring women from its ranks. A scientific society or biologist job that required a graduate degree weeded out most women as only the rare university allowed female students in their graduate programs. The situation had changed from one in which an artist, a draper, an apothecary, a soldier, like Merian, Goedaert, Leeuwenhoek, Petiver, and Rumphius could make a valued contribution. Merian didn't have a formal education; she talked to and trusted the reports of those who lived with the insects for thousands of years; she was a woman.

But even as Merian's reputation was being torn down, her artwork and observations continued to define the way people saw the natural world. An illustration in insect specialist Thomas Say's *American Entomology* includes a black-bodied moth, a caterpillar, and a sphinx moth with a coiled

tongue, copied from plates scattered throughout the Suri-
nam book. The caiman re-emerged in Charles d'Orbigny's
*Dictionnaire Universel d'Histoire Naturelle* in 1849. It also made
its way, in rough form, into an 1836 book about the adven-
tures of Davy Crockett.

But the debate over the spider-eating bird would not go
away. In 1848, naturalists Henry Walter Bates and Alfred
Russel Wallace devised a plan to explore the Amazon River
of Brazil. After stopping first in London to look at the South
American specimens available (Merian's likely among them
since they both would later reference her), they set off.
While Wallace searched for clues as to the origin of species,
collected parrots and moths, and developed his theory of
natural selection in tandem with Darwin, Bates studied
insects and spiders. He wandered through villages and
forests, nurturing his developing ideas about mimicry —
that harmless butterflies and moths may evolve to look like
flashy and poisonous species. While Bates walked the nine
miles from the Tocantins River to the town of Cameta, a
stirring on a tree caught his eye. A palm-sized tarantula
hovered near two finches tangled in a torn web, one dead,
the other alive, though covered with spider spit and in the
process of being eaten. Bates rescued the live one, but it
died anyway.

When Bates saw the struggling finch, Merian's illustra-
tion came to mind. He wrote: "The fact of species of Mygale
sallying forth at night, mounting trees, and sucking the eggs
and young of hummingbirds, has been recorded long ago
by Madame Merian and Palisot de Beauvois; but, in the ab-
sence of any confirmation, it has come to be discredited."
He provided this confirmation and added that if the taran-
tulas "did not prey upon vertebrated animals, I do not see
how they could find sufficient subsistence."

The gray-brown hairy spiders posed dangers for people as well as birds, as he quickly found when he investigated further. When Bates touched the first specimen he tried to prepare, hairs came off on his fingers, triggering a pain and itching he described as "maddening." These spiders were a familiar sight; he recorded in his book *The Naturalist on the River Amazons*: "One day I saw the children belonging to an Indian family, who collected for me, with one of these monsters secured by a cord round its waist, by which they were leading it about the house as they would a dog."

Bates's finished book reflected Merian's vision of the tropics in other ways as well. Three pictures in *The Naturalist on the River Amazons* show Merian's influence clearly — a grim spider hovering over a finch, with its head flung back, very like her hummingbird; the jacaru *(Teius teguexim)*, one of her more famous lizards; and the sack-bearing caterpillar. His illustrators Josef Wolf and Johann Baptist Zwecker were both German-born, perhaps giving them more reason than most to be familiar with her pictures. Still, all these years later, she had the best or only portraits of many South American species.

Bates's observation, tucked away in the middle of a lengthy book, caused a stir. *Scientific American* reported the shoring up of Merian's reputation. So did the *London Gazette*, which related the way Merian was "set down as an arch-heretic and inventor" before Bates came to her defense. In an article on spiders in *Harper's New Monthly Magazine*, Charlotte Taylor wrote with glee of Merian's tarantula picture and the critics "who positively assaulted her veracity. But since those days travelers and naturalists have confirmed all her statements."

In a report made to the Eleventh Annual Women's Rights Convention in the 1860s, suffragettes took up Mer-

ian's cause as their own. In the appendix, the editor records the doubts people had over Merian's claims for the light-headed lantern flies and the bird-eating spiders and rushes to her defense (though her geography is hazy): "To all the contention which arose over these statements, Madame Merian could oppose only her word. Men who knew that her statements in regard to Europe were indisputable de-cided that her word could not be taken in Asia. A very com-mon folly; but two hundred years have passed, 1866 arrives, and her justification with it." She then goes on to describe Bates's discovery of the entangled finches.

One more audience got to have its say as a result of Bates's work. As he traveled up the Amazon, Bates brought with him the recently published *Knight's Pictorial Museum of Animated Nature,* a two-volume companion to the Zoological Gardens. It was a nineteenth-century version of Gesner and Jonston's encyclopedias, heavy on pictures of as many species as the author could compile. At one point, Bates pulled it out and showed it to the Amerindians, who flipped through the 4,000 illustrations of crocodile skeletons, the improbable hippopotamus, cross sections of beehives, and Swammerdam's dissected mayfly. Copies of some of Mer-ian's images were among them, including a silkworm meta-morphosis, as well as pictures based on her reports, like one of a lantern fly whose head lit up the night. What a strange moment in natural history. The Amerindians saw not only elephants and giraffes, but bits of meaty information they'd offered visitors, digested through a European sensibility and laid back at their door.

They were, Bates reported, astonished.

Not long after Bates came home from the Amazon, Charles Darwin finished up his barnacle work and pub-lished *On the Origin of Species by Natural Selection* in 1859.

Bates's investigations of butterfly mimicry provided con-
crete examples for change via natural selection. In 1866,
German zoologist Ernst Haeckel devised the term "Oecolo-
gie" in his *Generelle Morphology*. Built from the Greek "oikos,"
meaning "household organization," it described the interac-
tion of creatures and their surroundings. He complained
physiology had largely ignored these crucial ties. In 1869
Haeckel explained his notion further, calling his new field
"the investigation of the total relations of the animal both
to its inorganic and to its organic environment; including
above all, its friendly and inimical relations with those ani-
mals and plants with which it comes directly or indirectly
into contact." The term, soon changed to "ecology," dove-
tailed neatly with Darwin's theory and its premise that com-
petition and adaptations to novel surroundings could create
new species. Evolution via natural selection offered a new
framework for the questions about insects' bizarre habits. It
also posed a new question. How did metamorphosis help the
insects survive?

Awareness of Merian's contributions lingered in some sci-
entific circles. Louis Agassiz lists Merian and her metamor-
phosis studies under "a list of the most important authors
who may be consulted in reference to the subjects treated in
this work" in his 1856 book *Principles of Zoology*. Wallace
called her a "distinguished entomologist." But as the nine-
teenth century progressed, her contributions were increas-
ingly ignored. Bates's discovery was only a brief halt in her
slip into obscurity. In light of the claims about her fabrica-
tions, it might be helpful to look at how wrong she actually
was. Here are several things she got wrong, mysteriously
wrong, flagrantly wrong. A brief catalog of error:

Hummingbirds have two eggs, not four.
The stems on the coral tree are too thin.
The large horned beetle does not come from the grub
she pairs it with.
No one can tell what some of her butterflies are.
The orchid bee doesn't come from a cocoon.
Lantern flies don't light up and they don't emerge
from cicadas.
A red ibis is not a flamingo.

Here, for comparison, are things Swammerdam got wrong:

Male and female bees do copulate, rather than the
males just spraying their sperm like fish.
The winged female ant queen is not a male.

And Leeuwenhoek:

The sperm does not contain a complete figure of the
next generation.
There are male eels.

And Catesby:

A caterpillar has six legs, rather than eight.

And Audubon:

A sandhill crane is not an immature whooping crane.
The unique species listed in plate 11 of *Birds of America*
is just a young bald eagle.

The list goes on, with most major scientists and natural-
ists offering some contribution. And this is as it should be.
Particularly at such an early time in natural history, with
no standardized naming, no university biology programs
to spread research methods, no regulations at all, really.

Because Merian's work was so unique, in detail and accuracy far beyond what others were doing, because in it she laid out research techniques that sound so modern, it is expected to adhere to standards that were not developed for centuries after her death.

By the early twentieth century, that crazy picture Oosterwyk tacked on to the end of the Surinam book had gathered the power of prophecy. The gigantic larva weighing down the palm tree and the distant mountain peaks didn't represent anything Merian ever saw or drew. Maybe the butterfly, looming over the landscape like an eagle, originally appeared in a study book entry. But these scraps, shuffled together without any feel for the relationship of one part to another, the background by one artist, the frogs by another, add up to nonsense. Though in this picture her work lost all coherence, it had become her legacy.

But in the 1970s, the volumes buried in St. Petersburg began to surface. The Library of the Academy of Sciences of the USSR issued a facsimile of fifty of the watercolors in the collection in 1974. Chamomile in the garden series, sketches for the Surinam, a goldfinch on a glowing, misshapen tomato — all came to light. In 1976, the Academy of Sciences printed a facsimile of the study book with its hundreds and hundreds of sketches and a transcript of Merian's notes. Each was printed only in a limited edition of 1,000 or so, but commentaries appeared in English, French, German, and Russian, offering the world a glimpse into her mind. These, combined with an early 1980s limited edition facsimile of the Surinam, including the 1705 text, reprints of the watercolors in the Windsor collection, and identification of her plants and animals using modern scientific names, unearthed her colors and thoughts in their original form.

These releases opened the path for a new appreciation of Merian. Museums in Frankfurt and Amsterdam launched exhibits of her work. New biographies came out. Germany put her on a bill and the United States issued two of her Surinam plates as stamps. Her name showed up, here and there, in collections about botanical illustrators and anthologies of women in the arts.

But most books detailing the history of science and insect studies still leave her out entirely. John Ray's biographer writes that "he grasped, as no entomologist for more than a century after him succeeded in grasping, the necessity of studying not merely the imago, but the whole metamorphosis of a species." Merian's first caterpillar book had come out twenty-six years before Ray's *History of Insects*.

The second edition of the 2004 textbook *Forest Canopies* covers the ecology of treetops, from rotifers to orangutans, as well as the history of canopy biology and the biologists who breached this new frontier. The text doesn't mention Merian, offers no hint that she was the first European to observe the life in the canopy, the first to provide images of tree-top dwellers, to know that life was different up there. It does, however, have an image from her Surinam book, a giant silk moth hovering near a coral tree, uncredited, on the first page.

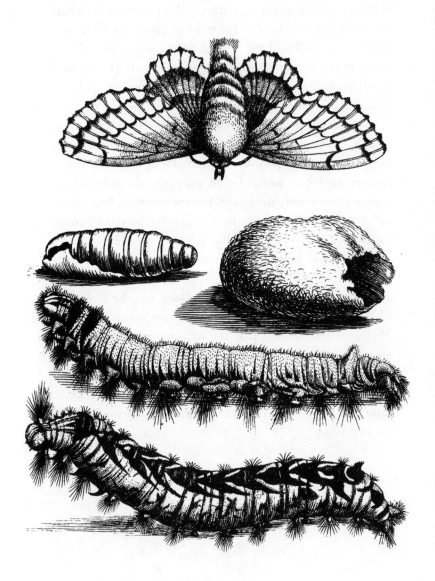

# CHAPTER NINE

# *Because of Its Color*
# *So Special*

The study of butterflies — creatures selected
as the types of airiness and frivolity — instead of being
despised, will someday be valued as one of the most
important branches of Biological science.
—Henry Walter Bates, *The Naturalist on the River Amazons*

*In the lab, in the field, 1902–present*

In the laboratory, an entomologist pulls the microscope close. Through the viewfinder, with magnification so powerful the swirling cells on the pupal skin look like a galaxy, she can watch neurons growing and wasting away as the body rewrites itself from larva to adult. With other equally powerful tools, she can precisely gauge the amount of a hormone flooding in. If she wants to pinpoint one developmental path, she can knock out a single gene and see what happens. She can activate another and chart the results. With a century of evolving ideas about natural selection, hormones, genetics, and neurology at her back, she can measure and quantify in ways Redi and Réaumur only dreamed. It's a long way from the girl hunting insects in her mother's garden.

This is what an entomologist today, looking at a caterpillar changing, might see:

The first shifts are the molts — small slights of hand, practice for the big unveiling. During a molt, the caterpillar sheds one skin and fills out another, a vital process for an eating machine that gets fatter and longer at a rapid rate. When it's time, the microscopic threads securing skin to the outermost layer, called the cuticle, detach. A gel fills this new gap. Cells divide, creating folds in the surface of the skin (or epidermis), like bellows in an accordion, allowing it to expand when the time comes. The skin secretes new cuticle and the gel absorbs the old, or as much as it can. Air fills the space between new cuticle and what remains, which is then shucked off, a discarded shell. The folded skin swells over the bigger body, a waxy layer coats it, and the new cuticle solidifies around it.

But this caterpillar-to-caterpillar molt, though complex, only makes a bigger version of the same shape. To live as an adult, a whole new body is called for — wings, spindly legs, multi-faceted eyes. Tucked inside a larva are pouches of liquid potential that will form the limbs of the mature insect. These are the "imaginal disks" that Swammerdam pulled out and showed to the Grand Duke of Tuscany. They hint at the future adult. A wing, for instance, starts as a tiny kink in the epidermis. This folds in on itself again. Then four layers fuse into two: the imaginal disk and a membrane surrounding it. Both are two cell-layers thick and still lie in the body of the larva, tucked under the skin, like a sweater with a sleeve inside out. Right before the pupa forms, tubes invade the two layers of the imaginal disk, creating a branching net for fluid to flow through and eventually stiffen the wings. All this folding and creasing goes on under the surface of the epidermis, precise origami in a shapeless sack. And then, with a surge of the hormones that govern molt-

ing, the wing flips. The sweater is righted, and now the wing waits only under the cuticle, not far from the surface.

Like the lives of teenagers, the metamorphosis of the caterpillar is ruled by hormones. One, secreted by the brain, spurs glands to make the molting hormone. (The experiments leading to this knowledge make rather grisly reading, involving decapitations, ligatures to stop blood flow, and insect-to-insect brain transfers.) Molting hormone levels rise during the entire molt and drain away as the skin cracks. The hormone's rising and falling appear to conduct diverse elements of the transformation: gut purging, cocoon weaving, imaginal disks turning inside out. Yet another, juvenile hormone, keeps the larva a larva while it circulates. It is the "Fountain of Youth" hormone. When juvenile hormone shuts off, the flood of molting hormone makes the larva create a pupal skin instead of the outlines of a caterpillar again.

Now, it's ready to turn into a pupa. For once in its larval life, the insect stops eating and growing. In fact, it rids itself of its gut and a few extraneous organs, and wanders around, searching for a place to rest. As Merian described many of her caterpillars preparing to transform, "they lay down quietly." If it is the type to make a cocoon to protect the pupa, the caterpillar spins it at this stage. While the caterpillar's movement slows, the imaginal disks burst into action. When the larva sheds its cuticle a final time, and its skin sinks into the mask of the pupa, the elements of the butterfly are in place, though as rough, hasty sketches rather than a fully realized leg or proboscis.

Here, under the sleek bullet-like casing, cells divide, forming, more precisely, the final shape of wing and eye. The ultimate organ depends not only on cell division, but

also on cell death. The scallops of a wing edge, for instance, are carved through attrition. The digestive system dismantles itself, amino acid by amino acid, and rebuilds. Neural pathways sprout for flight and mating. Those for eating leaves rather than nectar waste away. The nerves themselves change shape: Ganglions that carried signals for feeding fuse in the thorax. Eating is no longer so important. As adults, some species won't eat at all. The quiet life of the pupa allows time to develop muscles for new actions — flicking antennae, mating. A new epidermis grows, coating the adult limbs. Certain epidermal cells bulge and flatten, turning into the scales that cover butterfly wings. A few days before hatching they adopt their colors, one per scale: red, yellow, black. The resulting mosaic is the pattern we see on the wing. The new structures take form, each still compacted and wrinkled, a balloon waiting to inflate. And then the almost-butterfly breathes in. Under the influence of two more hormones, the pupal shell breaks open, the wings stretch and flap, and the new shell, the new shape, begins to set and harden.

And our entomologist? If she thinks of the devil, the souls of the dead, or the mechanisms of hope, it rarely makes it into the lab report.

In many laboratories that study metamorphosis the insect under the lens would be *Manduca sexta,* the tobacco hawkmoth that Merian painted in Surinam dipping its proboscis into a peacock flower. *Manduca's* plain moth body, wings a storm of shades of gray, is lit by six pairs of yellow spots along the sides of the abdomen. Thus the *"sexta"* part of its name, meaning "six." Its pale caterpillar (Merian described it as "light sea-green") wields a horn and an appetite for tobacco plants that made it the bane of colonial farmers. Thus

the *"manduca"* part of its name, which means "glutton." It's also large, hardy, and easy to raise, making it an ideal lab subject. Like fruit flies *(Drosophila melanogaster)* and zebra fish *(Danio rerio)*, tobacco hawkmoths are one of the "model" organisms used over and over again in laboratory studies.

Looking closely at one species in controlled conditions is a method of which Swammerdam would have approved. Swammerdam, who wrote more than four hundred pages on the mayfly, who sharpened his minute scissors, complained about Goedaert's pictures of many metamorphoses: "It would have been much more useful, to have exactly, and according to nature described only one transformation of any Nymph, for an example to be applied to all the rest, than to have delineated the changes of all these Caterpillars, with their various colours." Swammerdam would have loved all the modern tools that let scientists go ever deeper, into the imaginal disk, into the cell, into the gene.

Studies of the tobacco hawkmoth have shown how wing cells communicate to form a pattern, how insect eggs develop, the way the abdomen's stretching can prompt molting, the way parasitoids tinker with developmental mechanisms to keep their host from undergoing metamorphosis. At the University of Washington, Lynn Riddiford and James Truman, a husband and wife pair of entomologists, have used the tobacco hawkmoth to look particularly closely at the way hormones marshal the sequential stages of metamorphosis, from building a new skin to the creation of an eye to stiffening the wings. The discovery, by many entomologists over the course of the twentieth century, of the role of hormones went a long way toward explaining the how and why of metamorphosis. More recently, Truman and

Riddiford have used evaluations of hormone levels and comparisons of caterpillar head widths and sensory nervous systems to suggest another insect revelation.

For centuries, the butterfly was considered the marvel of metamorphosis. Collectors only kept the adults. Field guides still rarely show photos of larvae. The word used to describe the butterfly—imago—means "perfect," implying that what came before was insufficient. It was the resurrection, the reward. But now, some scientists believe that the true miracle of metamorphosis is the caterpillar.

About 260 million years ago, give or take 10 million, as the supercontinent Pangea formed and became drier, as ancestors of the dinosaurs took shelter from the rainstorms, and as coral and sponges flourished in the warm, shallow seas, the prehistoric insects emerged from eggs with the shape of tiny adults. Maybe their antennae grew longer as they aged, their thorax swelled, but that was about it. They altered only slightly, like modern-day bristletails. Later, newcomers like the dragonflies and grasshoppers underwent more complex changes in body structure. Their young (called "nymphs") had only wing buds that would then sprout into wings through successive molts. They were hemimetabolous, undergoing only a partial metamorphosis. What evolved when insects became holometabolous, metamorphosing completely, was a free-moving feeding stage, the larva. Here's one way it might have happened:

At some point one of these ancient insects emerged from its eggshell early. The protonymph, an embryonic stage that usually ended with hatching, or shortly after, began to linger longer and longer outside the egg. If females tucked their eggs in protected nooks in bark or in the earth, this would favor young without wings or other encumbrances

that could just slither out. A form of juvenile hormone, acting less like the Fountain of Youth and more like the Fountain of Infancy, started to circulate, keeping long legs from reaching full development. The jaws, originally undeveloped, hardened. Suddenly the juvenile insects could make use of this new environment, eating the leaves and roots available in this habitat. The protonymph became the larva. Meanwhile, the life stage that had always been the young before, the nymphs, didn't need to eat as much when preceded by these mobile, consuming embryos. What they did need to do when the flow of juvenile hormone stopped was to develop rapidly the structures of adult life so they could fly off to find a mate, and they tucked themselves away to do so. Becoming more and more immobile, soon the nymphs built themselves a protective covering and didn't move at all. The nymph became the pupa. When the adult parts were fully operational, the insects shucked off their constraining casing, and flew away.

At least, that's the hypothesis.

This idea, published by Riddiford and Truman in a 1999 volume of *Nature*, has its roots in Aristotle and Harvey, who looked at a caterpillar and wondered if it wasn't an embryo or egg with legs. There is something about larvae, particularly the featureless ones that prompt shudders in the squeamish, that look as though they should be safely tucked out of sight for a little longer. In this hypothesis, metamorphosis evolved from relatively minor changes in release of hormones that prompt the building of different proteins, slowing or accelerating development of individual parts. It offers a model for how a small shift in timing could create a dramatically different body.

But while helpful in all these ways—for uncovering the evolution of metamorphosis or the iron fist with which hormones rule—the *Manduca* in the lab is not the *Manduca* in the wild. A wild hawkmoth caterpillar would dig into the earth and out of sight to pupate, rather than changing in full view of prying eyes. Also, the tobacco hawkmoth raised in a glass box is often blue rather than green because its artificial diet doesn't contain the yellow molecules from leaves that interact with the blue proteins in its blood. Though the tobacco hawkmoth is one of the most studied insects, its natural diet is only now beginning to be understood. For a long time the caterpillars were thought to eat only plants in the nightshade family—peppers, potatoes, tobacco—until researchers in Arizona found them munching on representatives of an entirely different family. Life in the lab is life stripped of seasons, the search for a mate, the need to evade predators, all of which could tip the balance of one hormone or another. How much else could we learn by looking at the organism in its natural context?

As it turns out, a lot.

While the life history of the tobacco hawkmoth may be most useful to those who want to kill it off—many have high hopes for juvenile hormone as a pesticide—looking at the ways insects interact with their environment is particularly important for conservation, whether in the rain forests of Surinam or in the urban niches of Central Park. To avoid extinction, an animal needs habitat that supports every stage of its life, from the leaves gnawed by the larva, to the bark niches that shield the chrysalis, to the nectar sucked by the butterfly. As people have expanded their reach, paving more fields and building new cities, more of these habitats have been lost. The species have vanished with them. In Germany, where Merian charted her first meta-

morphosis, the marbled fritillary *(Brenthis daphne)* and the false ringet *(Coenonympha oedippus)* have gone extinct. In the Netherlands, as many as fifteen species are thought to have vanished in the past century. And these are only the butter-flies—gaudy, showy signposts for other insects, many of which blink out, unnoticed.

The struggle to keep the large blue butterfly *(Maculinea arion)* from extinction in Great Britain is a prime example of the need, during conservation efforts, to track a species through all its phases. In the early 1970s, surveys turned up only a few hundred of the large blues—jaunty cerulean butterflies with black spots—where twenty years before there had been 100,000. Conservationists did everything they could think of, including eliminating livestock grazing on prime egg-laying sites, those covered with the wild thyme that the insects preferred. The insects continued to disappear.

It turns out these large blues lead very complicated lives. After the female lays her eggs, larvae hatch on the thyme. Compared to other larvae, known for gorging them-selves from the moment they leave the egg, this caterpillar is finicky, hardly eating much at all. It's waiting for the right time to hunt its real food. Finally, it drops to the ground, and, if it's lucky, ants patrolling the thyme thickets pick it up, mistaking it for one of their own young, and carry it back to their nest. Once in the nest, the caterpillar contin-ues to imitate the ant larva and, while the adults are fooled, its appetite picks up and it gobbles down the baby ants. The *Maculinea arion* larva eats young ants until it pupates, still underground, only to resurface as an adult.

This intricate and risky game of developing deep in enemy territory is a result of the butterfly evolving to mimic one particular ant—*Myrmica sabuleti*. The large blues don't

imitate any infant ants but those. Any other species of ant would eat the larva instead of raising it. But all the grazing restrictions let plants grow thicker and taller, changing conditions down in the dirt and switching the species of ant dominant in the thyme patches. As a result, the blues dropped down into a predatory field rather than a nurturing one. Jeremy Thomas, the biologist studying the large blue in an effort to save it, learned this crucial information too late. The butterfly went extinct in Britain in 1979, but a population reintroduced from Sweden, once again falling into the clutches of the right ants, is gaining a strong foothold.

The importance of the interplay between environment and development goes beyond saving individual species. Way back in Nuremberg, Merian experimented with a caterpillar that caught her eye because it appeared in so many different guises: white mottled with black darts; bark gray with a dusky collar; lighter gray broken by a green chain. Despite all the color combinations of the larvae, though, the pupa and the moths that hatched seemed identical. Friends sent these diverse caterpillars and she fed them, raising them to adults more than once with similar results. One that she received in the evening started transforming immediately and she stayed up late into the night drawing it before it disappeared into the pupa. Finally, on four pieces of parchment in her study book, she recorded three caterpillars and two moths. She concluded they were all the same creature, noting "I think that they only change their color."

In 1893, entomologist E. B. Poulton worked with the same caterpillar, now bearing the scientific name *Gastropacha quercifolia*. President of the Entomological Society of

London, Poulton was an unconventional thinker, one of the first to have a modern view of species as an interbreeding community. In his annual address, he praised Sir Francis Bacon for his belief in spontaneous generation because, like scientists in the wake of Darwin, Bacon believed one species could turn into another and that chance played an important role. Though Poulton didn't embrace spontaneous generation as seventeenth-century natural philosophers painted it, the theory implied a fluidity also included in the notion of evolution via natural selection. The idea that God crafted every species individually—"special creation"—was as out of favor as spontaneous generation had once been. Perhaps a cabbage could become a caterpillar, given enough time and mutation.

One of Poulton's main research interests was color. He was specifically intrigued by the way hues that made an animal blend in or stand out reflected natural selection, and thought butterflies with their long-lasting pigments were ideal subjects. For several years, Poulton had been experimenting with pupae and caterpillars that seemed to change color based on their surroundings. A friend gave him a mass of *Gastropacha* siblings, so he could test them on branches covered with lichen. He fed them all hawthorn, but raised them in four different environments: hawthorn branches, black oak twigs, reddish brown bramble stems, sticks covered with lichen. After two months and several molts, he had fifteen larvae with deep black or black and white markings on the oak; twelve much lighter larvae on lichen-covered sticks; eleven brownish larvae on the red-brown bramble; fourteen on hawthorn shoots, ranging all over, from black and white to gray and black and white to gray and brown and white. The caterpillars, apparently,

altered their hue to match the twig they lived on. (Later experimenters uncovered photoreceptors on the insect's abdomen. The larvae could determine the color of the branch with their stomach.) They were what they saw.

Poulton's discoveries came at an inconvenient time. As he published his research, the studies of the monk Gregor Mendel on his pea plants were coming to light, offering a model for how traits were inherited. This tied in neatly with Darwin's theory of natural selection. Momentum and excitement built with the gene theory of inheritance and the demonstration that DNA controlled heredity. But Poulton had observed something else entirely—the development of alternate bodies from the same genes, also called "phenotypic plasticity." It was deemed a rather unpleasant aberration. Poulton himself cites W. C. Hewitson, who refused to believe that a male *Papilio merope* butterfly in South Africa could mate with females who looked so dramatically different from each other (all the same species, though with diverse colors and patterns on the wings to mimic different models). Like the sexual strategies of several plant species, it brought to mind a harem. In another species with some, but not as broad variation, Hewitson consoled himself: "There is quite sufficient resemblance not to shock one's notions of propriety."

Poulton's work was eclipsed further when James Watson and Francis Crick unraveled the structure of DNA several decades later, showing how the double helix enabled DNA to make copies and pass on its vital code. Now genetics became, for many, the central theme of biology. Investigators looked at the way genes dictated the future of a pea plant, a pigeon, a child, and sought to unearth genetic explanations for breast cancer, criminals, happiness, parsing the ways these bits of matter programmed lives. But all the

time, on the sidelines, an alternate set of data was slowly building up. Butterfly after butterfly used the same genes to build a completely different body.

And now, at the start of the twenty-first century, metamorphosis is once again undergoing a re-evaluation. The very relationships Merian looked at and field techniques she pioneered are at the center of scientific explorations today. Her insistence on observing development in its natural context is coming back into vogue after decades of tracking metamorphosis mostly in the laboratory and under the microscope, isolating animals from their surroundings as absolutely as the seventeenth-century cabinets of curiosity that Merian found so frustrating. Undoubtedly, Merian's greatest contribution to both science and art was her sense of ecology, the tracking of plants, seasons, parasites, predators, the way a species isn't just a flash of pretty wings in the sun, but a moment in space and time. Why else go to South America when she could have stayed home and looked at Ruysch's toad in a bottle? Why else cut down a palm tree to see what fed at the top?

A new field of developmental biology is taking up where she left off, returning Poulton's experiments to the forefront, enriched by all the new knowledge about genetics, looking at the ecological effects on metamorphosis. And there are many: Butterflies such as the southwestern swallowtail lie curled in their chrysalises until rain makes their food plants grow. Others are dependent on temperature, like the hawkmoth pupa Nabokov kept for seven years as a boy, until he brought it on a train and the heated compartment spurred it to hatch.

For other species, the environment determines not just the timing but the path of development. The European map butterfly *(Araschnia levana)* emerges with black-spotted

orange wings in the spring and black wings with a white band in the summer—forms so different Linnaeus classified them as separate species. And this phenomena isn't limited to butterflies. The spadefoot toad *(Scaphiopus couchii)* lays its eggs in ponds created by spring rains in the Sonoran desert. When tadpoles hatch, those that live in large, roomy ponds eat algae until they develop into juveniles and bury themselves in the sand. Some of those that live in small, cramped ponds develop wide-opening jaws and cannibalistic tendencies. They proceed to eat each other, ingesting a burst of protein that allows the survivors to develop more quickly before the shallow ponds dry up. The same set of genes results in two forms, depending on the animal's perception of the water volume.

Other examples abound. A meadow in southwest Montana burgeons with plants hosting caterpillars that echo their hue and shape. An ice-white caterpillar grazes on the pollen of snowy greasewood flowers, while a green caterpillar with reddish knobs on its back nibbles the greasewood leaves that spring from reddish bases. On black and tan skunkbrush, a caterpillar patched with black and tan inches across a twig, and on the shiny, rust-colored hawthorn branch, a shiny, rust-colored caterpillar makes its way. Black cottonwood, manzanita, serviceberry, Wood's rose and sandbar willow—all have matching larvae eating and growing in their buds and forks. They all turn into the same emerald moth.

They are all the same species. They could even be siblings, according to biologist Erick Greene, who studies this little inchworm, *Nemoria darwiniata*. A generalist, able to eat many Montana shrubs, it evolved to disappear into the habitat of its chosen nourishment. Greene has also re-

searched another inchworm from the southwest, *Nemoria arizonaria*, which either mimics an oak catkin or an oak twig, depending on whether it eats pollen or leaves. The two forms could not be more different: one displaying green and red bumps, the other capturing the colors of a slick, hard branch. Whether the caterpillars are born in spring or summer, they will blend in. They are what they eat.

"The developing organisms are somehow sensing environmental cues," Greene says. "Is it going to be hot, is it going to be dry, is the world going to be green, or is it going to be brown? Are conditions going to be tough and the organism might have to disperse or are they probably going to be good and so the organism can stick around?" These cues are then converted into physiology.

Underground in Panama, female beetles of the species *Onthophagus acuminatus* tunnel below piles of howler monkey dung. At the end of each chamber, they build brood balls, pulling down pieces of dung and packing them into spheres. They lay one egg in each. But the eggs' future depends on many things—whether howler monkeys ate fruit more than leaves, whether the female beetle has been able to find a large enough dung pile under which to begin construction. If it's a good year for dung, the female has staked out prime territory, and the larvae can eat all they want and grow large before they pupate, then the males that emerge from her brood will grow horns. If food is meager and low in nutrition, the male larvae remain small. Their horns never sprout at all.

The main purpose of the horns is defending the entrance to the tunnels and fighting off fellow males who might attempt to mate with the female inside. Smaller hornless males would get crushed in a fight as the larger male generally

wins. But the smaller form persists because these males have developed a strategy that entomologist Douglas Emlen terms "sneaking." They rarely even bother entering the guarded tunnels. Instead, they carve their own, digging first down and then over, intercepting the preexisting tunnels beneath the surface and beneath the horned guards. There they mate with the females and scurry away, their navigation aided by the larger eyes that they grow as a trade-off for the horns. The environment affects not only the size of the beetles, but their shape and behavior.

"The modern view is that genes interact with the environment all the time—they are intertwined and integrated at many hundreds and thousands of points during the development of animals. I can't say they are one and the same, but what I can say is that they are tightly intertwined in some beautiful ways," says Emlen, who studies the *Onthophagus* beetles.

This flies in the face of many traditional ideas about genes and how they work. These new plasticity studies view genes not as blueprints drawn in permanent marker, but as switches that can be turned on and off. Once a switch is turned on, it can launch a whole cascade of events—other switches flipping on and off, assembling some body forms, bypassing others. Switches can be activated for a certain length of time, creating a larger horn, a smaller one, or none at all. And the trigger for the switch can be a factor in the environment—the quality of howler monkey dung for instance—translated into a change in the environment inside the cell. As it responds to the intracellular conditions, then, the beetle shapes itself to meet conditions outside.

For example, beetle larvae, tucked in their dung balls, eat until they run out of food. Larger larvae produce more

juvenile hormone in a surge just before they become pupae. The Fountain of Youth hormone here acts more like a Fountain of Machismo: Juvenile hormone above a certain level at the right time spurs the folding and molding of the epidermis in the pupa into the shape of horns, consigning their owner to an adulthood of guarding rather than sneaking.

These studies are both wide and deep. They use molecular genetics and field observations, hormone titers and population counts. They take place on the scientists' turf — the laboratory — and the insects' — an Arizona oak or a South American dung heap. They combine developmental biology with ecology. They are pulling the machinery more clearly into view, telling us how the genes read the weather, the chemicals in food, the heat of the day, and translate this information into proteins that build a spotted wing rather than a plain one, a horn or a stub.

Like many studies of metamorphosis, the new approach also has ramifications for human development. Since we've gained an understanding of genetics, one of the main wonders has been how the same genes create different bodies: the caterpillar and the moth, the black-spotted orange map butterfly, and the white-banded black one. Now scientists are exploring how interactions with the environment switch genes on and off in us, just as in the spadefoot toad, so that we are constantly in the process of being remade.

In his book *Nature via Nurture*, Matt Ridley pulls together studies from many disciplines about how genes and environment work together to create who we are. He takes the "nature versus nurture" debate — the question of whether inborn traits or life events are more important to

an individual's development — and suggests it is a false dichotomy. As in the *Nemoria darwiniata* with its multiple but limited caterpillar shapes, genes are at the root of both. Yet again, these genes are not inflexible oracles but germs of potential. They build, tear down, and remap based on experience.

The possibility of a spectrum of forms is always there, just like in the beetles that can grow horns, but make bigger eyes instead. An infant up to six months old can distinguish any of the sounds made in any language in the world before he or she largely loses the ability. The genes are present, but the environment of a dinner table where Mandarin is spoken, or Swahili, creates the neural pathways that enable certain linguistic skills. The capacity to make certain German vowels is, for many, a horn that doesn't grow. Other examples further illuminate the complicated dance between environment and gene. Because his ancestors needed to avoid venom to survive, a boy might have a genetic predisposition to be more afraid of snakes than dogs. (And here the genes have responded to the snaky surroundings.) If he never encounters a snake, though, but a vicious dog attacks him as a toddler, then those resources might go into a fear of dogs.

A girl whose father is an artist might be hardwired for accurate hands, but if she didn't have a stepfather to teach her to paint, the neural pathways enabling her to create such a lifelike lantern fly would never develop. Coming to Amsterdam as an adult may have made it more difficult to learn Latin, forcing her to rely on Caspar Commelin's help to translate the Surinam book. A trip to the tropics and a bout of malaria would change the contents of her blood.

And here the metaphorical and the scientific connect. Rather than imagining ourselves as caterpillars awaiting a miraculous transformation at any moment, or as pupae, liquid and tender in a vulnerable stage, we are learning how we are all transforming into something new, moment by moment, cell by cell, every day.

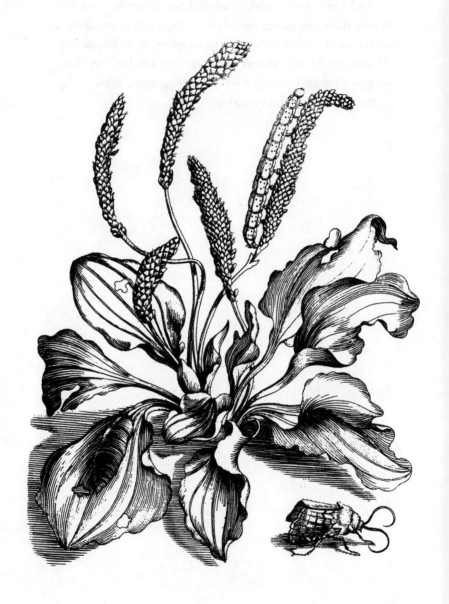

# CONCLUSION

There's no memory you can wrap
in camphor but the moths will get in.
— T. S. Eliot, *The Cocktail Party*

On a rainy day in a recent December, I paged through a 1719 edition of Merian's Surinam book in the library of the American Museum of Natural History, looking at the original image of the brown and lavender moth that I'd stumbled across on a card years before. It was the *Thysania agrippina,* the "white witch," that Merian found at La Providence, the Labadists' plantation. The wings, enlarged for the book that took up almost the whole table, spread like a finely knit shawl. Merian had never leaned over this copy — she died two years before it was published — but the book still felt very close to her. As I traced the curve of the antenna and admired the way the text bit deep into the thick paper of the pages, a head bumped up against the inside of my rib cage.

While working on this book, investigating Merian's biography, picking through studies of butterfly life histories, I was pregnant with and later raising young twins. The two activities, unavoidably, wove together. When my son's broad palm swam into view on the ultrasound, where months before had only been a bright bean of light, all the speculation about how a body is built rushed in. My husband, feeling the two forms wriggle under the surface of my skin, called them "the caterpillars." After they were born, my infant daughter, chasing ants across a stone with predatory fingers,

brought to mind those early notions that a mother's experiences were translated to a child in utero. Was she suffering the effect of hours I spent poring over pictures of beetles? It was, as friends pointed out, an interesting time to be thinking about metamorphosis.

Researching someone who lived so long ago involves a constant sifting for connection. In some ways, with Merian and with metamorphosis, it's not hard to find. All the old theories are still here, not wiped away, but layered one on top of another. Aristotle, with his view of the larva as a "soft egg," prefigures recent ideas about the evolution of metamorphosis. The epigenesists and preformationists each were wrong, yet somehow right. Certainly the embryo is not the figure of the adult writ small, but it does contain the program, the genetic code, that will direct its development. Even ideas like spontaneous generation, when viewed in the light of evolution, have something to offer. Species do alter. The specific questions at the center of Merian's explorations and choices — What are the connections between one life and the next? How do we see ourselves reflected in the natural world? How do we balance personal passion and family commitment? How do we make sense of and order our lives by what we study? — are as vital today as they were in the seventeenth century.

In other ways, though, Merian's strange trajectory remains a mystery, as does the woman at its heart. Her life story inspires debate about whether she was exceptional, without peer, a woman who came out of nowhere or whether she was on a continuum of women who painted flowers, collected insects, asked questions of the world around them. Instead, perhaps, she can be viewed as an exceptional woman among exceptional women. Kaala, leader

of the band of maroons who escaped from La Providence, fighting with Matjaus over land claims, launching a new life for a tribe that persists today; Aphra Behn, with her witty plays; Anna Maria van Schurman, talent so great she mistrusted her pride in it; Rachel Ruysch with her ten children and royal commission. Their desire and necessity built them bigger rooms to act in. Something about the spirit of the seventeenth century, the sense of discovery and possibility, made it impossible to keep these women down. For many (not Kaala, though a vibrant oral tradition gives us her story), publishing allowed them to access ideas that fed their minds and to correspond beyond isolating villages.

Even wild Antoinette Bourignon realized this. In a radical interpretation of God's words to the serpent in Genesis that "I will put enmity between thee and the woman, and between thy seed and her seed: it shall bruise thy head and thou shalt bruise his heel," she wrote, "Sometimes I consider whether the 'seed' may not be the lights which God will give unto women, and which they will sow over the world in writing or print, shining so brightly that the devil will no longer be able to deceive men of good-will."

On the other hand, it's hard to think of anyone in any age who led a life as full as Merian. The willpower needed to forge a path where none existed before must have been overwhelming. She gave a nod to expectations, but then sailed straight through them as though they were ripples and not tidal waves. Although I want her contributions to science to be recognized, sometimes I think her biggest gift was the way that she lived. Any life, of course, is messy, filled with rationalizations, contradictions, episodes best tucked away out of sight. But there is a boldness at the heart that won't be chipped away.

As Natalie Zemon Davis points out in the profile of Merian in her book *Women on the Margins*, Merian underwent her own metamorphosis, emerging from the cocoon of Wiewert, building herself the wings in Amsterdam that let her take flight. But, in some important ways, she didn't change at all from the girl whose pulse quickened as the first wet wing unfurled. Her focus was unwavering and profound. Other natural philosophers of her day studied, over the course of their lives, everything from human anatomy to botany to metallurgy. From the time she was thirteen she examined not just insects, but one biological process within that class. There are few other examples of such a single-minded scientific obsession. And while her religious zeal waxed and waned, her values remained the same. Look after your mother. Plant trees. See for yourself.

Following in her footsteps is one way to search for Merian, to close the gap of time, but three hundred years obscures many details. A fence curves around a rock in a field on the outskirts of Wiewert, the only remnant of Waltha Castle. The dirt road from castle site to village offers a glimpse of the church steeple, a view she may have seen. Stone roses bloom on the roof of an Amsterdam home on Kerkstraat. Could this have been the "rose house" where Merian lived? The Amsterdam botanical garden retains patterns of the intricate seventeenth-century layout. The Paramaribo fort, now a museum with exhibits on Amerindian cultures and present-day maroon tribes, contains some of the original building materials. An old cannon still points out over the Surinam River. But really, so little is left.

Surinam remains, a slumbering fox, nose tucked under tail. In 1975, the country cut its ties with the Dutch and became the Independent Republic of Surinam. A series of military coups in the 1980s and 1990s roiled the parliamentary

democracy and left it still searching for a secure path to the future. The nation's imperial legacy created one of the most culturally diverse countries anywhere, with descendants of African slaves mixing with descendents of contract laborers from Java, India, and China. It is the rare South American country whose official language is Dutch.

Gold once again courses through the fantasy lives of some inhabitants. In the wake of a discovery of a large gold deposit in the Amazon in the early 1980s, small-time miners, working on their own, comb through soil with gold pans, extract gold with mercury, and bring their gleanings to the brokers on the market street in Paramaribo, leaving poisoned streams and toxic fish behind them. More profitable on a large scale, bauxite, ore used to make aluminum, has been a mainstay of the economy through the twentieth century. In the 1960s, Alcoa dammed the river just past the site of La Providence to create energy to process the bauxite, flooding maroon territory and creating a vast lake where, when the water level sinks, the dead trees rise.

But for the most part, unlike Amsterdam, unlike Frankfurt, unlike many South American countries where rain forests are rapidly being logged, much of the landscape of Surinam itself remains similar to that of three centuries ago. Vast tracts of land stretch into the interior, home to Amerindian tribes and bands of maroons. A last outpost of stunning biological diversity, it encompasses 2.5 million acres of pristine tropical rain forest. And the abundance of life forms that awed and intimidated early visitors is now viewed by some as the country's most precious resource. The number of known species is increasing all the time, particularly in the canopy, which Humboldt described as "a forest above a forest." Biologists specializing in these high regions have taken to climbing the branches with tools used

by rock climbers, erecting cranes and building walkways between the trees, and detailing the many unknown creatures found there. In the place of seventeenth-century specimen hunters, bioprospectors have arrived, surveying the plants for the next pharmaceutical breakthrough. It's a different kind of gold.

A new generation of researchers picks its way through the swamps and matted vines. Cheryl White, an archeological graduate student, hitchhikes on canoes going upriver to dig up mound sites built by the first maroons as they carved a home for themselves in the jungle. Kathleen Burke studies the leaf cutter ants that fascinated so many with the neat circles they gnawed out of vegetation and carried away. Merian thought they fed the leaves to their young. Bates concluded they gathered the leaves to shield their offspring from the rain. Scientists now know the ants cultivate a fungus on the collected leaves and use that to nourish the next generation. Burke studies how the leaf cutter ants, persistent crop pests, move into deforested areas, and what chemicals in native plants might be helpful in repelling them.

The questions biologists investigate have changed since Merian's time. Now they not only document life histories and new species, but many are concerned with preserving the vanishing richness they've found. There is an awareness not present in Merian's day of how delicate these complex ecosystems are and how easily they might be lost. The moral issues, while less stark than the question of slavery, are no less pressing. How to compensate Amerindians and maroons for their knowledge, recognize their ownership, make negotiations more like trade and less like theft. How to preserve both plant and animal species of the rain forest and the human cultures that live there.

And still, all these years later, after all this probing, many rain forest insects and their lives remain mysterious, except those near cities or airplane landing strips. Caterpillars, cocoons, life histories are particularly buried, not just in Surinam but in the surrounding areas. So many of the things Merian struggled with, we still don't know. Books that cover butterflies in Central and South America are packed with the phrases: "Hostplant: unreported." "Early stages: unknown." According to Hélène Hiwat, curator of invertebrates at the National Zoological Collection of Surinam, "Large parts of the interior have never been explored, so we have no sense of what is there and what is endangered."

Besides the forests Merian wandered and houses where she may have lived, documents and books also offer the possibility of some throb of life, some whispered secret. Tracing the marks of her hands on her letters in the state library in Nuremberg and in the glint of gold paint on a watercolor at a museum in Frankfurt promises some answers. One key manuscript may open the door to the sound of a laugh or a sigh. Or at least that's the hope. But, then again, perhaps the most vital links aren't either buildings or piles of paper.

While my husband pushed the twins through Amsterdam in the double stroller, I went to the city archives, housed in a stately building along the Amstel River. At long tables, researchers bent intently over the finding aids and computer screens. As I scrolled through the microfilm of Merian's will, written in a cramped seventeenth-century lawyer's hand, almost illegible except for her neat signature at the bottom, a gray moth fluttered up from behind a bank of projectors, a spry and tiny ghost. How did it get in? What was it doing in this stale academic room, darting toward the sunlight leaking through the blinds? She was there.

And in the Surinam airport where, as I waited to get my passport checked in the middle of the humid night, a big moth, shaped like a hummingbird, batted against the caged light bulb. And in Erick Greene's office, where giant photos of a caterpillar that looks exactly like an oak catkin and one that looks exactly like an oak twig hung side by side. And in San Francisco's Conservatory of Flowers, where a freshly hatched white peacock flicked the air with new antennae. She was all these places. And in every start of wonder.

# ACKNOWLEDGMENTS

Writing a book like this involves creating your own Amsterdam, a community of artists and scientists mired in discovery and creation and willing to talk about it. This virtual city was vibrant and invigorating, though perhaps more heavily reliant on e-mail than Merian's.

I am grateful to the MacDowell Colony and the Hedgebrook writers' retreat for space to write and think and attempt to raise caterpillars (and fail); the Environmental Leadership Program, for funding for travel to Surinam, and Renee Hoyos for coming with me; Glenn Kurtz, Jennie Dorman and the ELP writers' group for comments and conversation. Of all those who looked over this manuscript, I would particularly like to thank Erica Olsen, who read many drafts and chapters and never said she didn't have the time, even when she didn't have the time.

Additional thanks: For help with translations, Martina Baum-Acker, Sandra Huettenbuegel, Valerie Hedquist, Jay Stevens, and Sheila Gogol who, with her offer of a place to stay, twins and all, made a trip to the actual Amsterdam possible. For interviews about their work, Erick Greene, Douglas Emlen, Darren Williams, Kathleen Burke, Hélène Hiwat, Robert Michael Pyle, Lynn Riddiford, and Deniz Erezyilmaz. For hints on Surinam travel, Cheryl White, Carolyn Proctor. For encouragement and insightful editing,

Andrea Schulz and Elyse Cheney. For discussions of Merian, Natalie Zemon Davis and the late Sharon Valiant, a Merian true believer who was more than generous with her time, research, and theories.

I owe a particular debt to the historians who have uncovered so much of Merian's buried life, especially those who brought her study book to light in 1976. The painstaking transcription and publishing of her handwritten notes and tracking down of scientific names of species she depicted has made the picture of what Merian thought and saw much clearer.

Finally, I would like to offer heartfelt gratitude to Bill and Jane Stevens, Peter and Gail Todd, and Jay, for the suggestions that made this book far better, and for his grace and patience in this new phase of our lives.

# NOTES

## PROLOGUE

3    *date pits* Graffin (1679), introduction.

3    *Patience is a very* Merian, letter to Johan Georg Volckamer, re-prod. in Wettengl (1998), 267.

7    *bang their head* Merian (1976), entry 22.

7    *they eat so much...* Merian (1976), entry 19.

7    *they became such snow* Merian (1976), entry 17.

8    *I think that* Galileo, qtd. in Mayr (1982), 97.

8    *mechanical arts* Bacon (1960), 277.

8    *most ordinary* Ibid., 279.

8    *mean, illiberal, filthy* Ibid.

8    *trifling and childish* Ibid.

10    The statistic that ninety percent of those living in Surinam at the time of Merian's visit were slaves comes from Price (1976), 8.

14    The estimate of 5 million insects is a conservative one. Some suggest there may be as many as 30 million.

## CHAPTER ONE

18    *The most useful and noble of all the worms* Merian (1976), entry 1.

20–21 The information about de Bry's widow arranging for Matthaus Merian the Elder to take over the business comes

from Michiel van Groesen's Ph.D. dissertation in progress at the University of Amsterdam on the de Bry family.

22 The resemblance between Merian and her father can be clearly seen by comparing two pictures: a family portrait painted by Matthaus Merian the Younger (likely painted in 1641, before Maria Merian was born) and an engraving after a portrait of Maria Merian in old age painted by her son-in-law Georg Gsell. Interestingly, Matthaus Merian the Younger, who criticized his stepmother Johanna Heim in his autobiography, paints himself to look almost exactly like his mother. The family portrait is in the Offentliche Kunstsamm-lung in Basle and the engraving is bound into several copies of Merian's books published after her death.

22 The estimates of deaths during the Thirty Years War come from Blackwell (1990), 23.

22 Those of Frankfurt's population come from Finlay (1981), 170.

22 *It was summer* Petersen (1990), 59.

23 *Here very often* Henri Estienne, qtd. in Jantz (1966), 419.

24 Matthaus Merian the Elder's status as a citizen can be in-ferred from the fact that Maria Merian, his daughter, was a citizen and actively petitioned to give up her Frankfurt citi-zenship in the 1690s, when she decided to settle in Amster-dam. The clearest way for her to have achieved the status as citizen is if her father was one.

26 *Pious diligence wins* Mathaus Merian, publisher's seal, visible in *Theatrum Eurpaeum,* among other places.

27 *summer birds* Graffin (1679), introduction.

28 *an honest matron* Wunder (1998), 217.

28–29 The statistics on who attended school come from Ogilvie (2003), 88.

29 *Go to the ant* Proverbs, 6:6 (New Oxford).

29 *how the world was made* Wisdom of Solomon 7.17 (King James).

30 *I have consequently recorded* Merian (1717), introduction.

30 Frankfurt may have offered more of an opportunity for women to learn skills because the city council, in a bid for ad-

ditional power, abolished the guilds in 1616 and replaced them with looser craft associations overseen by the city council. As aristocrats with little vested interest in maintaining opportunities for masters and journeymen to earn a living, city council members enforced rules more laxly than the heads of guilds. Though printing was governed by a guild before 1616, the reorganization didn't include a printer's association, leaving it a "free" occupation with even fewer regulations. Merian and Marrel family connections with the Netherlands, a country with a greater tradition of letting women work, may also have contributed to Maria Merian's education. For more information, see Soliday (1974).

30–31  A reproduction of this engraving by Abraham von Werdt of a Nuremberg printing press can be found in Moran (1973), 35.

35  *decorated with caterpillars* Graffin (1679), introduction.

36  *Latin Cs and Ms and Bs along the edges* At the start of her study book, Merian notes letters found on the wings, perhaps seeing some significance there, perhaps using them as a descriptive tool. Later on, though, she drops the practice.

38  *this research I started* Merian (1976), entry 1.

38  The recipes listed here are abstracted from a list that Redi took from Athanasius Kircher.

39  *After a long period* Redi, qtd. in Cole (1926), 352.

40  *their Nature, owing* Aristotle (1953), 329.

40  *when I have observed* Pliny (1940), 437.

41  *Look not to what* Babrius and Phaedrus (1965), 415.

41  *Lest in his spear-inflicted* Homer (1873), book xix, lines 25–27.

42  *tried by proof* Ovid (2001), 15: 398.

42  *We see how flesh* Ibid, lines 399–411.

43  *I want to inquire* Fujiwara (1929), 15.

43  *Then she again* Ibid.

44  *In all the world* Ibid., 33.

45  *how many stings* Topsell (1967), 1027.

45  *come from themselves* Ibid., 934.

45  *that are bred* Ibid.

45 *If men should deny* Ibid, preface, Vol. 3.

46 *I have no doubt* Jonston, qtd. in Schierbeek, (1967), 139.

47 *I make mention in the following* Goedaert, qtd. in Wettengl (1998), 159.

48 *great effort* Merian (1679), introduction.

49 *odd Monstrous Calf* Boyle (1665), 10.

## CHAPTER TWO

51 *Godly miracles in a little book* Graffin (1679), introduction.

52–53 *Experimental Philosophy* Spratt (1958), 1.

53 *it will not be absurd* Malpighi, qtd. in Adelmann (1966), 844.

54 *quartan ague* Boerhaave, qtd. in Schierbeek (1967), 16.

54 *the glint of an elegant* Swammerdam, qtd. in Ruestow (1996), 135.

55 *It is certain* Swammerdam, qtd. in Schierbeek (1967), 124.

58 *Because of the heavy demands* Sandrart, qtd. in Hollstein, 1995, 5.

58 It seems likely that both the Merian and Graff households had servants, though Merian doesn't mention them specifically as she does with the servants and slaves in Surinam.

58 *pourtraitures and similitudes* Turnbull (1947), 118.

59 *re-experimented experiments* Ibid.

59 *perfect directions for the timely* Ibid., 119.

59 *Fortification, besieging* Ibid., 118.

59 An in-depth discussion of this midwifery book appears in Tatlock (1992).

60 *When put on the warm* Merian (1976), entry 69.

60 *had been covered by me* Merian (1976), entry 115.

62 *executed with great care* Bier (1972), 153.

63 *then the man's joy* Furst, qtd. in Wiltenburg (1992), 122.

64 The fact of Germany executing more witches than all the rest of Europe is found in Monter (1976), 191.

64 The statistic about one midwife under suspicion of killing two hundred children is found in Wiltenburg (1992), 240.

65  *The trading of good for evil* Hollstein (1995), 253.

65  *I have been suspected* Jezrel Jones, qtd. in Stearns (1952), 263.

65  *It is again instanced* Boguet (1971), 143.

65  *If we but look* Ibid., xxxii–xxxiv.

66  *all kinds of decorations* Sandrart, qtd. in Rucker, 1980a, 2.

67  *works like these* Ibid.

67  *company of maidens* Merian, letter to Clara Regine Imhoff, July 25, 1682, reprod. in Wettengl (1998), 262.

69  *the flowers that had neither* Merian (1999), introduction.

69  *On the other hand* Ibid.

69–70  An interesting interpretation of the story of the beautiful butterfly found on the weed, in which Merian asserts the value of the humble plant and relates it to herself, is given in Kinukawa (2001), 106–109.

70  *since we encountered* Graffin (1683), plate 81.

72  *as if they were mean* Merian (1976), entry 140.

72  *make it something* Merian (1976), entry 140.

74  *a completely new invention* Graffin (1679), title page.

74  *The Caterpillar's Wondrous* Ibid.

75  *It is remarkable* This poem appears bound into the Raupenbuch. The translation is in Merian (1980), 39.

77  *invent* Merian (1976), entry 119.

77  *investigate* Ibid.

77  *leave this to the gentleman scholars* Graffin (1679), plate 22.

77  *like a swaddled child* Ibid., introduction.

77  *summer birds* Ibid.

78  *moth birds* Ibid.

78  *seed* Ibid.

79  *egg* Ibid.

79  *flies* Ibid.

79  *date pits* Ibid.

79  *we also found another one* Merian (1976), entry 130.

80  *very noble* Merian, letter to Clara Regine Imhoff, July 25, 1682, reprod. in Wettengl (1998), 262.

80  *it gives me boundless* Merian, letter to Clara Regine Imhoff, May 24, 1683, reprod. in Wettengl (1998), 263.

## CHAPTER THREE

83 *That which is found in the fens and heath* Merian (1705), introduction.

85 *I felt truly consoled* Petersen (1990), 66.

85 An in-depth discussion of this fascinating female-authored prayerbook appears in Aikin (2003).

86 *We lose ourselves* Jean de Labadie, qtd. in Saxby (1987), 164.

87 *tenth muse* Schurman (1998), 5.

87 *Star of Utrecht* Irwin (1980), 68.

87 *most noble virgin* Rivet, qtd. in Schurman (1998), 48.

87 *narrow limits* Schurman (1998), 45.

87 *thinking it makes little difference* Ibid.

88 *I confess that sometimes* Ibid., 83.

89 *God's will* Merian (1976), entry 132.

91 The statistic about pregnancy rates comes from Blackwell (1990), 22.

92 *I have no news* Merian, letter to Clara Regine Imhoff, June 3, 1685, reprod. in Wettengl (1998), 264.

93 *I ask that if* Ibid.

94 This drawing of Waltha Castle, attributed to Johann Andreas Graff, is located in the Staatsarchiv in Nuremberg.

94 *people of the woods* James (1899), 25.

97 *people of great breeding* Penn (1825), 462.

97 *Certainly, the Lord* Ibid., 464.

98 *doesn't bear little ones* Merian (1976), entry 203.

99 *It was for God alone* Dittlebach, qtd. in James (1899), 19.

99 *If any woman* I Corinthians 7:12 (New Oxford).

99 *the marriage cannot be considered holy* Pierre Yvon cited in James (1899), 13, footnote 1.

101 *to observe this most wonderful happening* Swammerdam, qtd. in Schierbeek (1967), 108.

102 *contract and enlarge her person* Macewen (1910), 202.

103 *power and brightness* Graffin (1679), introduction.

103 *such Godly miracles* Ibid.

103 *I was looking not* Ibid.

103 *Dearest GOD, thus* Arnold, qtd. in Merian (1991), iii.

104 *The observation made in* Swammerdam, qtd. in Schierbeek (1967), 143.

104 *they keep time and order* Graffin (1679), introduction.

104 *where they know* Ibid.

108 *All of which showed* Ibid.

109 *The Discovery of the Manner* Ray (1727), 322.

110 *A fourth and most* Ibid., 310.

112 *He was the enemy* Pistorius, qtd. in Rodway (1917), 73.

115 *community of goods* Saxby (1987), 315.

116 *I cannot persuade myself* Charles Darwin, letter to Asa Gray, May 22, 1860, reprod. in Darwin (1899), 105.

116 *God is receiving* Bustin qtd. in Saxby (1987), 269.

## CHAPTER FOUR

119 *Le grande monde* Saxby (1987), 320.

120 *Why should I long for* Hansen (1996), 671.

120 *What is life* Purcell and Gould (1992), 32.

121 *"knobbed" vs "wrinkled"* Nehemiah Grew, *Musaeum Regalis Societatis* qtd. in Impey and MacGregor (1985), fig. 62.

121 *"the right lip broad" vs "parallel lips"* Ibid.

121 *"smooth" vs "spiked"* Ibid.

121 *"naked wings"; "sheathed wings"; "creeping"* Impey and MacGregor (1985), 186.

122 *foolish company* Schurman (1998), 82.

122 *involvement in the amusements* Ibid.

122 The estimates of Amsterdam's population come from Berardi (1998), 109.

123 *Le grande monde* Saxby (1987), 320.

124 *It has been many years* Merian, letter to Clara Regine Scheurling, August 29, 1697, reprod. Wettengl (1998), 264.

124 *Madame* Ibid.

126 *if anyone is a collector* Merian, letter to Clara Regine Scheurling, August 29, 1697, reprod. in Wettengl (1998), 264.

127 *their Skins being* Warren (1667), 20.

127 *glow worm* Topsell (1967), 978.

127 *the eyes whereof* Ibid.

127 *lantern-bearer* Wettengl (1998), 157.

128 *blew, white, and greene spotted* Thomas Lechford, qtd. in Klauber (1956), 1197.

128 *The mouth of it* Dampier, 1698, 33.

129 *to save her young* Topsell (1967), 511.

129 *wherein she keepeth* Ibid, 16.

129 *In every collection* Merian (1705), introduction.

132 *many of the Antient* Sir Hans Sloane, qtd. in MacGregor, (1994), 12.

132 *I humbly intreat* James Petiver, *Philosophical Transactions*, 1696, qtd. Brooks (1954), 180–181.

133 *You may often find* Petiver (1767), 1.

135 *rose house* Merian, letter to James Petiver, June 4, 1703, reprod. in Wettengl, 266.

138 *The Duchess hath* Pepys (1974), 243.

139 *scissor Minerva* Honig (2001), 34.

139 The selling price of 4,000 florins for one of Johanna Koerten's works comes from Honig (2001), 34.

141 *In Holland more* Merian (1705), introduction.

141 *I removed myself from society* Ibid.

143 *Time flies and cannot* Purcell and Gould (1992), 32.

## CHAPTER FIVE

145 *An awesome and expensive trip*, Merian (1705), introduction.

145–46 The claim that Merian was the first to plan a journey rooted solely in science is based on the fact that virtually everyone who came before conducted investigations as a sideline to some other work: soldier, surgeon, doctor, pirate.

The closest parallel to her trip was that of Edmund Halley, who in 1698 aimed the *Paramour Pink* at the South Atlantic to make observations there, but he returned without completing his project, due to a mutiny. Later voyages would have greater success.

147 *Scorpion's Heart* Colt (2002), 72.

150 *Grones of a Dying* Warren (1667), 22.

150 *Hell-Bred* Ibid., 9.

150 *Of things there Venomous* Ibid., 20.

151 *Guiana is a Contrey* Ralegh, qtd. in Greenblatt (1973), 112.

152 The statistic that thirty of thirty-four Morovian missionaries to the interior of Surinam in the late 1800s became ill and eleven died is from Price (1990), 300.

152 *vigorous investigations* Merian (1705), introduction.

153 *Wild Coast* West India Company, qtd. in Goslinga (1971), 504.

154 *Here the Air* Stedman (1988), 38.

154 *Here I found the Grass* Ibid., 39.

155 *a verry lively place* Ibid., 236.

157 *these caterpillars wrap themselves* Merian (1976), entry 232.

157 *beautiful flies* Ibid.

158 The statistic about the ratio of Europeans to Africans in Surinam at the time of Merian's arrival comes from Price (1976), 8.

158 The statistic about some plantations going through four full staffs in twenty-five years comes from Price (1976), 9.

159 *certainly had his late* Behn (1994), 47.

159 *tiger* Ibid., 49.

159 *how such vast trees* Ibid., 48.

161 *slaves* Merian (1705), plate 36.

161 *my Indian* Ibid.

162 *as easily as weeds* Ibid., plate 2.

162 *then the whole room smells* Ibid.

162 *Surinamese flamingos* The inscription "Surinaamische Flamingo" appears on the ibis watercolor by Merian in the Rijksprentenkabinett in Amsterdam.

## CHAPTER SIX

165 *Far out into the Wilderness* Merian (1705), plate 53.

165–66 The color of a morpho butterfly is actually "impossibly blue" for an artist seeking to capture it with paint. While many scales on a butterfly wing (the small plates that hold the color) get their hue from pigment, the iridescent morpho scales create their shine through light interacting with the complex, multi-layered shape of the scales.

167 *On account of the constant* Vega (1859), 18.

169 *mimicry complex* Papageorgis (1975), 524.

169 *It will convey* Bates (1876), 52–53.

170 The statistic that one tree in Peru can host forty-three ant species comes from Lowman and Rinker (2004), 359.

170 *'tis there eternal spring* Behn (1994), 47.

171 *melt in the mouth* Merian (1705), plate 40.

171 *tastes better than artichoke* Ibid., plate 48.

173 *mocked me for seeking* Ibid., plate 36.

173 *these decorations remain* Ibid., plate 48.

174 *jumped out of bed* Ibid., plate 49.

175 *cryptic, nocturnal, solitary* Costa-Neto and Pacheco (2003), 27.

175 *They make a sound* Merian (1705), plate 49.

175 *mother* Ibid., plate 49.

175 *a fiery flame* Ibid., plate 49.

176 *daughter* Costa-Neto and Pacheco (2003), 38.

177 *This resemblance has attracted* Bates (1892), 94.

179 *Holy Grail* Plotkin (1994), 126.

179 *terminated their pregnancies* de Bry (1976), 131.

179 *peacock flower* Merian (1705), plate 45.

180 *Indeed they even kill* Ibid.

180 A very similar description to this belief in rebirth in the home country appears in Warren (1667), 20.

180 *must be treated benignly* Merian (1705), plate 45.

181 *red bird of Paradise* Schiebinger (2004), 245.

181 *belonging to the Misses Sommelsdyk* Merian (1705), plate 20.

183 *The most burning sunbeams* Johann Riemer, qtd. in Price (1990), 174.

184 *They would give you* "Twentieth-century Saramakas," qtd. in Price (1990), 17.

186 *The forest grew together* Merian (1705), plate 36.

186 *our father* Merian (1976), entry 277.

186 *sweet bean* Merian (1705), plate 51.

186 *marmalade box* Ibid., plate 43.

187 *They are so beautiful* Ibid., plate 6.

187 *they fly very fast* Ibid., plate 29.

188–89 Natalie Zemon Davis points out the uniqueness and centrality of the tarantula picture in plate 18 to Merian's Surinam experience in Davis (1995), 183–184 and 198.

189 *can eat whole trees* Merian (1705), plate 18.

189 *a particular account* Royal Society, qtd. in Allen (1947), 133.

192 *The heat in this country* Merian, letter to Johan Georg Volkammer, October 8, 1702, reprod. in Wettengl (1998), 264.

192 *In this land* Merian (1705), introduction.

193 *The only place* Lansdown Guilding, qtd. in Howard (1985), 110.

194 *without their mother* Merian (1705), plate 23.

## CHAPTER SEVEN

197 *The first and strangest work that had ever been painted in America* Merian (1705), introduction.

198 *many wondrous, rare things* Merian, letter to Johan Georg Volkammer, October 8, 1702, reprod. in Wettengl (1998), 264.

198 *this work is not only rare* Ibid., 265.

202 The information that Ruysch thought his recipe was worth 50,000 guilders comes from Appleby (1982), 385.

203 *so I can have them cheap* James Petiver, qtd. in Stearns (1952), 284.

203–4 *a paragon of learning* Uffenbach (1934), 126–127.

204 *wretched both in looks* Ibid.

204 *very poor and deficient* Ibid.

204 *discovered with love* Merian, letter to James Petiver, June 4, 1703, reprod. in Wettengl (1998), 266.

205 *A woman, I would personally* Merian, letter to James Petiver, April, 1704, reprod. in Wettengl (1998), 267.

205 *in a great hurry* Merian, letter to James Petiver, June 20, 1703, reprod. in Wettengl (1998), 266.

205 *a Curious History* Advertisement found in *Philosophical Transactions of the Royal Society* (1703).

205 *That Curious Person* Ibid.

207 *I inspected many times* Leeuwenhoek, letter to Charles Landgrave of Hesse, Prince of Hirtsvelt, April 20, 1702, reprod. in Leeuwenhoek (1986), 109.

207 *They would then be able* Merian (1705), plate 19.

208 *fish scales with three branches* Ibid., plate 2.

208 *the neck of a goose* Ibid., plate 3.

208 *hair like that* Ibid., plate 6.

208 *lice* Leeuwenhoek (1700), 665.

208 *These Flies, as soon* Ibid.

208 *accidental* Merian (1976), entry 140.

208 *wrong* Ibid.

209 *The crocodile is certainly* Réaumur (1926), 29.

210 *re-creation* Anon. Observation of insect metamorphosis (No date).

211 *pupa* Merian (1705), introduction.

211 *I could probably have made* Ibid.

212 *if I were to sell* Merian, letter to Johan Georg Volkammer, October 8, 1702, reprod. in Wettengl (1998), 265.

212 *for the benefit and pleasure* Ibid.

213 The price of 20 florins for a group of specimens comes from Merian, letter to unnamed person in Nuremberg, October, 1702, reprod. in Wettengl (1998), 265.

213 The price of 4 ducats for her first caterpillar books comes from Merian, letter to James Petiver, October 5, 1703, reprod. in Wettengl (1998), 266.

213 The price of 15 florins for an uncolored Surinam and 45 florins for a colored one come from Merian, letter to Johan Georg Volkammer, April 16, 1705, reprod. in Wettengl (1998), 267.

213–14 *I ask that you extend* Merian, letter to unnamed person in Nuremberg, October, 1702, reprod. in Wettengl (1998), 265.

214 *in a number of weeks* Merian, letter to Johan Georg Volkammer, late July, 1704, reprod. in Wettengl (1998), 267.

214–15 *because this fruit has been* Merian (1705), plate 1.

215 *the most infamous* Ibid.

215 *wilderness* Ibid., plate 60.

216 *the great Atlas* Ibid.

216 *neither the name* Ibid.

216 *great passion for investigation* review in *De Boekzaal* qtd. in Kinukawa (2001), 303.

217 *I am very obliged* Vincent to Petiver, April 26, 1704, qtd. in Kinukawa (2001), 217.

217 *I must give him* Merian, letter to James Petiver, April 1704, reprod. in Wettengl (1998), 267.

218 *animals in liquid* Merian, letter to unnamed person in Nuremberg, October, 1702, reprod. in Wettengl (1998), 265.

218 *1 crocodile* Ibid.

218 *the generation and reproduction* Merian, letter to James Petiver, April 17, 1705, reprod. in Wettengl (1998), 268.

218 *the man who sent them* Ibid.

219 *So I guess* Merian (1976), entry 131.

219–20 *You may easily* Bradley, qtd. in Henrey (1975), 427.

220 *it is especially difficult* Uffenbach (1934), 16.

220 *The book with excellent* Ibid., 187.

220 *"poor" and "joyless"* Uffenbach (1753), 552–553.

221 *"energetic"* and *"busy,"* Ibid.

220–21 Uffenbach, in his report of the conversation, mentions that Merian went to Surinam with her son-in-law and grandchild and that she planned to stay except that the heat made her return home. The fact that she considered relocating permanently is implied in the introduction to her Surinam book as

well. As far as her traveling with her extended family, it's interesting to speculate if this was a story she told, or if he made these assumptions, coming down on the side of propriety.

221 *about 8 or 10 Days* Leeuwenhoek, letter to James Petiver, August 18, 1711, cited in Stearns, 284.

221 *I shall not concern* Ray, qtd. in Raven (1950), 400.

221 *I think that the ichneumon* Ibid., 104.

223 *a flying fish, a spider* Merian, letter to James Petiver, August 29, 1712, reprod. in Wettengl (1998), 269.

223 *miraculous being and beauty* Merian (1717), introduction.

223 *has three times feasted me* Bradley, letter to James Petiver, July 4, 1714, qtd. in Henrey (1975), 426.

225 In her note at the start of Merian's compilation of three caterpillar books, Dorothea mentions that she is including some plates of Surinam insects by her sister, Johanna. But these images do not seem to be part of the book.

225 *her Works are now Complete* Dorothea Maria Henrikje's note in Merian (1717), introduction.

## CHAPTER EIGHT

227 *The modern world is very sensitive* Merian (1705), introduction.

227 Early biographies of Merian mention that she died in poverty, perhaps because the Heiligewegs Kerkof graveyard is listed as one where paupers were buried. It was also, however, close to her house and may have been a logical place for that reason. More recent biographers seem to be turning away from the theory that she ended so poor, but there isn't much concrete information on either possibility. The Surinam book wasn't as much of a success during her lifetime as it would be after her death, so she could very well have been strapped for money.

231 *The painter Gsell arrived* Journal of the St. Petersburg Academy of Sciences, qtd. in Lukin (1974), 126.

231 *To make it easier* Ibid., 128.

232 *Madame Merian* Taylor (1860), 464, among other places.

232 *methodize* Petiver (1767), 22.

233 *single-coloured butterflies* Ibid.

233 *admirals* Ibid.

233 *atlasses* Ibid.

233 *lizards, frogs and serpents* Ibid.

235 The text was corrupted, too, through translations. Both Erasmus Darwin and Kirby and Spence reference a story that she painted her lantern flies by the lantern flies' own light, but that tale doesn't appear in her 1705 Surinam book.

237 *I have not the smallest* Stedman (1988), 223.

239 *God had suffered* Linnaeus, qtd. in Farber (2000), 13.

239 The fact that Linnaeus cited her thirty-seven times is noted in Stearn (1980), 76.

242 *typical* Chambers (1994), 244.

242 *sub-typical* Ibid.

243 *exile* Guilding, qtd. in Howard (1985), 112.

243 *carelessness* Guilding (1834), 361.

244 *worthless* Ibid., 374.

244 *vile and useless* Ibid., 369.

244 *good-tempered* Ibid., 371.

244 *every boy entomologist* Ibid., 369.

244 *Doubtless this species* Ibid., 362.

244 *Mr. MacLeay consequently disbelieves* Ibid., 362, note.

244 *some cunning Negro* Ibid., 371.

244 *on the testimony* Ibid., 365.

244 *used by Creole doctresses* Ibid., 370.

244 *it forms a pretty hedge* Ibid.

245 *to undertake an awesome* Merian (1705), introduction.

245 *That Curious Person* Advertisement found in (1703).

245 *are to a considerable* Duncan (1841), 42.

245 *As she is not always* Kirby and Spence (1846), 381.

245 *Though she suffered* Domestica (1851), 155.

247 *The fact of species* Bates (1876), 83–84.

247 *did not prey* Bates (1855), 4801.

248 *maddening* Bates (1876), 83–84.

248 *One day I saw* Ibid., 84.

248 There is another report of a bird-eating spider falling out of a tree in Essequibo in 1848 in an unsigned article in *Harper's New Monthly Magazine*. This predates Bates and also explicitly presents itself as a defense of Merian, saying of her detractors that "we must conclude [they] had either not the good fortune or the good eyesight to verify her statements by their own experience." (1852).

248 *set down as an arch-heretic* (1865), 185.

248 *who positively assaulted* Taylor (1860), 464.

249 *To all the contention* Dall (1881), 906.

250 *Oecologie* Haeckel, qtd. in Stauffer (1957), 140.

250 *the investigation of the total* Ibid., 141.

250 *A list of the most* Agassiz (1856), 250.

250 *distinguished entomologist* Wallace, qtd. in A. (1887), 227.

253 *he grasped, as no entomologist* Raven (1950), 277.

## CHAPTER NINE

255 *Because of its color so special* Merian (1976), entry 43.

257 *they lay down quietly* Ibid., entry 172.

258 *light sea-green* Merian (1705), plate 45.

259 *It would have been* Swammerdam (1978), 2.

263 The estimate of the number of species that have gone extinct in the Netherlands in the past century comes from Pullin (1995), 243.

264 *I think that they only change their color* Merian (1976), entry 20.

264–66 The details of Poulton's experiment come from Poulton (1903a).

266 *There is quite sufficient* W. C. Hewitson, qtd. in Poulton (1903b), lxxxvii.

269 *The developing organisms* Author's interview with Erick Greene, October 15, 2004.

270 *sneaking* Emlen (1997), 335.

270 *The modern view* Author's interview with Douglas Emlen, January 14, 2005.

## CONCLUSION

276 *soft egg* Aristotle (1953), 329.

277 *I will put enmity* Genesis 3:15 (King James).

277 *Sometimes I consider* Antoinette Bourignon, letter of 1671, qtd. in Macewen (1910), 82.

278 *rose house* Merian, letter to James Petiver, April 1704, reprod. in Wettengl (1998), 267.

279 *forest above a forest* Humboldt, qtd. in Caufield (1985), 45.

281 *Hostplant: unreported* This note is found throughout DeVries (1987).

281 *Early stages: unknown* Ibid.

281 *Large parts of the interior* Author's interview with Hélène Hiwat, December 7, 2004.

# SOURCES

## ORIGINALS OF WORKS BY
## MARIA SIBYLLA MERIAN

Graffin, Maria Sibylla. 1679. *Der Raupen wunderbare Verwandelung.* Nuremberg: Johann Andreas Graff. [Library of the Netherlands Entomological Society].

———. 1683. *Der Raupen wunderbare Verwandelung und sonderbare Blumen-nahrung.* Frankfurt am Mayn: Johann Andreas Graffin. [Library of the Netherlands Entolomological Society].

Merian, Maria Sibylla. 1705. *Metamorphosis Insectorum Surinamensium.* Amsterdam: G. Valck. [American Museum of Natural History].

———. 1717. *Der Rupsen Begin, Voedzel en Wonderbaare Verandering en Gestaltverwiffeling.* Amsterdam: Gerard Valk. [Artis Bibliotek].

———. 1719. *Maria Sybilla Meriaen Over de Voortteeling en Wonderbaerlyke Verandering en der Surinaemsche Insecten.* Amsterdam: Joannes Oosterwyk. [American Museum of Natural History].

———. 1730. *Histoire des Insectes de l'Europe.* Amsterdam: Jean Frederic Bernard. [American Museum of Natural History].

## MARIA SIBYLLA MERIAN'S LETTERS

To Clara Regine Imhoff, July 25, 1682. Germanisches Nationalmuseum Nurnberg, ex Imhoff-Archiv.

To Clara Regine Imhoff, May 24, 1683. Stadtbibliothek Nurnberg, Ms. no. 164.

To Clara Regine Imhoff, December 8, 1684. Stadtbibliothek Nurnberg, Ms. no. 165.

To Clara Regine Imhoff, May 8, 1685. Germanisches Nationalmuseum Nurnberg, ex Imhoff Archiv, Part II.

[No recipient name], June 3, 1685. Stadtbibliothek Nurnberg, Ms. no. 166.

To Clara Regine Scheurling, August 29, 1697. Stadtbibliothek Nurnberg, Ms. no. 167.

To Johan Georg Volkammer, October 8, 1702. Universitatsbibliothek Erlangen, Trew-Bibliothek, Brief-Sammlung Ms. 1834, Merian, no. 1.

[No recipient name], October 1702. Universitatsbibliothek Erlangen, Trew-Bibliothek, Brief-Sammlung Ms. 1834, Merian, no. 2.

To James Petiver, June 4, 1703. British Library, London, Department of Manuscripts, Sloane 4063, Fol. 201.

To James Petiver, June 20, 1703. British Library, London, Department of Manuscripts, Sloane 4063, Fol. 204.

To James Petiver, October 5, 1703. British Library, London, Department of Manuscripts, Sloane 4063, Fol. 214.

To James Petiver, April 1704. British Library, London, Department of Manuscripts, Sloane 4064, Fol. 5.

To Johan Georg Volkammer, late July 1704. Universitatsbibliothek Erlangen, Trew-Bibliothek, Brief-Sammlung Ms. 1834, Merian, no. 3.

To Johan Georg Volkammer, April 16, 1705. Universitatsbibliothek Erlangen, Trew-Bibliothek, Brief-Sammlung Ms. 1834, Merian, no. 4.

To James Petiver, April 27, 1705. British Library, London, Department of Manuscripts, Sloane 4064, Fol. 70.

To James Petiver, March 12, 1707/1708. British Library, London, Department of Manuscripts, Sloane 4064, Fol. 161.

[No recipient name], October 2, 1711. Collection Frits Lugt, Fondation Custodia, Paris, Inv. no. 7578.

To James Petiver, August 29, 1712. British Library, London, Department of Manuscripts, Sloane 4065, Fol. 58.

## MARIA SIBYLLA MERIAN'S WILLS
## AND LEGAL ACTIONS

Gemeentearchif Amsterdam. Notary S. Wijmer, 4864, no. 23, April 23, 1699, 112–114.

Gemeentearchif Amsterdam. Notary S. Wijmer, 4849, no. 42, October 3, 1711, 193–198.

Institut fur Stadtgeschichte Frankfurt am Main. Ratssupplication en 1685, Vol. I, fol. 148r–v.

Institut fur Stadtgeschichte Frankfurt am Main. Ratssupplication en 1690, Vol. II, fol. 78, 81.

## FACSIMILES OF WORKS
## BY MARIA SIBYLLA MERIAN

Merian, Maria Sibylla. 1974. *Leningrad watercolours,* ed. Ersnt Ullmann. New York: Harcourt Brace Jovanovich. [Watercolor paintings in St. Petersburg].

— — —. 1976. *Butterflies, beetles and other insects: the Leningrad book of notes and studies,* ed. Wolf-Dietrich Beer. New York: McGraw-Hill International Book Co. [Studybook].

— — —. 1980. *Metamorphosis Insectorum Surinamensium.* London: Pion Limited.

— — —. 1991. *Flowers, butterflies and insects.* New York: Dover Publications, Inc. [Plates, but not text of the three caterpillar books].

— — —. 1999. *New book of flowers.* New York: Prestel. [The 1680 flower book].

Copyright-free translations of Merian's Surinam and her study book are also available online through the Maryland Institute for Technology in the Humanities at www.mith.umd.edu/flare, the Web site of the documentary, *Out of the Chrysalis: A Portrait of Maria Sibylla Merian.*

## OTHER SOURCES

1703. Advertisement. *Philosophical Transactions of the Royal Society* 23, no. 286 (July/August).

1834. *Transactions of the Zoological Society of London* (Feb. 11).

1852. A bird-hunting spider. *Harper's New Monthly Magazine* IV, (Dec. 1851–May 1852).

1865. Gleanings from the natural history of the tropics. *Catholic World* 2, no. 8 (Nov.).

A. 1887. Living lights. *Science* 10, no. 248. (Nov. 4).

Acuna, Cristoval de. 1641. *A new discovery of the great river of the Amazons.* Madrid: Royal Press.

Adelmann, Howard B. 1966. *Marcello Malpighi and the evolution of embryology.* Ithaca: Cornell University Press.

Agassiz, Louis. 1856. *Principles of zoology.* New York: Gould and Lincoln; Shelton, Blakeman & Co.

Aikin, Judith P. 2003. Gendered theologies of childbirth in early modern Germany and the devotional handbook for pregnant women by Aemilie Juliane, Countess of Schwartzburg-Rudolstadt (1683). *Journal of Women's History* 15, no. 2.

Allen, Phyllis. 1947. The Royal Society and Latin America as Reflected in the Philosophical Transactions, 1665–1730. *Isis* 37, no. 3/4.

Anon. No date. Observation of insect metamorphosis. Artis Bibliotek. M.S. legk. 37:1, no. 03555.

Appleby, John H. 1982. Robert Erskine: Scottish pioneer of Russian natural history. *Archives of Natural History* 10.

Aristotle. 1953. *Generation of animals,* trans. A. L. Peck. Cambridge: Harvard University Press.

— — —. 1910. *Historia animalium,* trans. D'Arcy Wentworth Thompson. Oxford: Clarendon Press.

Babrius and Phaedrus. 1965. *Babrius and Phaedrus,* trans. Ben Edwin Perry. Cambridge: Harvard University Press.

Bacon, Francis. 1960. *The new organon and related writings.* Indianapolis: The Bobbs-Merrill Company, Inc.

Bass, George Fletcher. 1988. *Ships and shipwrecks of the Americas.* New York: Thames and Hudson.

Bates, Henry Walter. 1855. Observations on the habits of two species of Mygale. *The Zoologist* 13.

— — —. 1876. *The naturalist on the River Amazons.* London: John Murray.

— — —. 1892. *The naturalist on the River Amazons.* London: John Murray.

Behn, Aphra. 1994. *Oroonoko and other writings.* Oxford: Oxford University Press.

Berardi, Marianne. 1998. Science into art: Rachel Ruysch's early development as a still-life painter. Ph.D. diss., University of Pittsburgh.

Bier, Justus. 1972. Johann Adam Delsenbach. In *The German baroque: literature, music, art,* ed. George Schulz-Behrend. Austin: University of Texas Press.

Blackwell, Jeannine and Susanne Zantop. 1990. *Bitter healing: German women writers from 1700 to 1830: An anthology.* Lincoln: University of Nebraska Press.

Blunt, Wilfrid and William T. Stearn. 1994. The art of botanical illustration. Woodbridge: Antique Collectors Club, Ltd.

Boguet, Henri. 1971. *An examen of witches.* New York: Barnes and Noble.

Boyle, Robert. 1665. An account of a very odd monstrous calf. *Philosophical Transactions of the Royal Society* 1.

Brooks, E. St. John. 1954. *Sir Hans Sloane: The great collector and his circle.* London: The Batchworth Press.

Caufield, Catherine. 1985. *In the rainforest.* New York: Alfred A. Knopf.

Chambers, Robert. 1994. *Vestiges of the natural history of creation and other evolutionary writings,* ed. James A. Secord. Chicago: The University of Chicago Press.

Clair, Colin. 1976. *A history of European printing.* London: Academic Press.

Cohn, Marjorie B. 1977. *Wash and gouache: A study of the development of the materials of watercolor.* Cambridge: Center for Conservation and Technical Studies, Fogg Art Museum.

Cole, Rufus. 1926. Francesco Redi (1626–1697), physician, naturalist, poet. *Annals of medical history* 8, no. 4.

Colt, Henry. 2002. *The voyage of Sir Henry Colt*. St. Michael, Barbados: Barbados National Trust.

Commelin, Caspar. 1715. *Horti Medici Amstelaedamensis*. Lugduni Batavorum: Apud Joh. du Vivie.

Connor, James. 2004. *Kepler's witch*. New York: HarperCollins.

Costa-Neto, Eraldo Medeiros and Josue Marques Pacheco. 2003. "Head of snake, wings of butterfly, and body of cicada": impressions of the lantern-fly (Hemiptera: Fulgoridae) in the village of Pedra Branca, Bahia State, Brazil. *Journal of Ethnobiology* 23, no. 1 (Spring/Summer).

Dall, Caroline H. 1881. Report made to the Eleventh National Woman's Rights Convention. *History of Woman Suffrage* 2 (1861–1867).

Dampier, William. 1698. *A new voyage round the world*. London: James Knapton.

Dance, S. Peter. 1978. *The art of natural history*. Woodstock: The Overlook Press.

Danckaerts, Jasper. 1913. *Journal of Jasper Danckaerts*, ed. and trans. Bartlett Burleigh James. New York: Charles Scribner's Sons.

Darwin, Charles. 1899. *The life and letters of Charles Darwin*. Vol. 2. New York: Appleton.

Davis, Natalie Zemon. 1995. *Women on the margins: Three seventeenth-century lives*. Cambridge: Harvard University Press.

de Bry, Theodore. 1976. *Discovering the new world*, ed. Michael Alexander. New York: Harper & Row.

Denver, Robert J. 1998. Hormonal correlates of environmentally induced metamorphosis in the western spadefoot toad, Scaphiopus hammondii. *General and Comparative Endocrinology* 110.

DeVries, Philip. J. 1987. *The butterflies of Costa Rica and their natural history*. Princeton: Princeton University Press.

Denton, Michael. 1985. *Evolution: A theory in crisis*. Bethesda: Adler & Adler.

Dittelbach, Petrus. 1692. *Verval en val der Labadisten*. Netherlands.

Domestica, Aceta. 1851. Episodes of insect life. *The Living Age* 30, no. 375 (July 26).

Duncan, James. 1841. Memoir of Maria Sibylla Merian. *The Naturalists' Library* 30.

Eamon, William. 1994. *Science and the secrets of nature, books of secrets in medieval and early modern culture.* Princeton: Princeton University Press.

Ehmer, Adam. 2000. The host associations and developmental plasticity of Nemoria darwiniata. *The University of Montana Biology Undergraduate Journal* 1, no. 2.

Eisenstein, Elizabeth L. 1979. *The printing revolution as an agent of change.* Cambridge: Cambridge University Press.

— — —. 1983. *The printing press in early modern Europe.* Cambridge: Cambridge University Press.

Emlen, Douglas J. and Frederik H. Nijhout. 1999. Hormonal control of male horn length dimorphism in the dung beetle Onthophagus taurus (Coleoptera: Scarabaeidae). *Journal of Insect Physiology* 45, no. 1.

Emlen, D. J., 1994. Environmental control of horn length dimorphism in the beetle Onthophagus acuminatus (Coleoptera: Scarabaeidae). *Proceedings of the Royal Society of London,* Series B, 256.

— — —. 1997. Alternative reproductive tactics and male-dimorphism in the horned beetle Onthophagus acuminatus (Coleoptera: Scarabaeidae). *Behavioral Ecology and Sociobiology* 41.

Farber, Paul Lawrence. 2000. *Finding order in nature, the naturalist tradition from Linnaeus to E. O. Wilson.* Baltimore: The John Hopkins University Press.

Findlen, Paula. 2004. *Athanasius Kircher, the last man who knew everything.* New York: Routledge.

Finlay, Roger. 1981. Natural decrease in early modern cities. *Past and Present,* no. 92.

Fujiwara, Kanesuke. 1929. *The lady who loved insects,* trans. Arthur Waley. London: The Blackamore Press.

Gilbert, Scott. 2001. Ecological developmental biology: Biology meets the real world. *Developmental Biology* 233.

Godfray, H. C. J. 1994. *Parasitoids, behavioral and evolutionary ecology.* Princeton: Princeton University Press.

Goslinga, Cornelis Ch. 1971. *The Dutch in the Caribbean and on the Wild Coast, 1580–1680.* Gainesville: University of Florida Press.

Gottdenker, Paula. 1979. Francesco Redi and the fly experiments. *Bulletin of the History of Medicine* 53, no. 4.

Gould, Stephen Jay and Rosamond Wolff Purcell. 2000. *Crossing over: Where art and science meet.* New York: Three Rivers Press.

Grant, M. H. 1956. *Rachel Ruysch, 1664–1750.* Leigh-On-Sea: F. Lewis, Publishers, Limited.

Greenblatt, Stephen J. 1973. *Sir Walter Raleigh: The Renaissance man and his roles.* New Haven: Yale University Press.

Greene, Erick. 1999. Phenotypic variation in larval development and evolution: polymorphism, polyphenism, and developmental reaction norms. In *The origin and evolution of larval forms,* ed. Brian K. Hall and Marvalee H. Wake. San Diego: Academic Press.

Greenfield, Kent Roberts. 1918. Sumptuary law in Nurnberg, a study in paternal government. *Johns Hopkins University Studies in Historical and Political Science,* Ser. 36, no. 2.

Grimaldi, David and Michael S. Engel. 2005. *Evolution of the insects.* Cambridge: Cambridge University Press.

Guilding, Lansdown. 1834. Observations of the work of Maria Sibylla Merian on the insects, &c., of Surinam. *The Magazine of Natural History and Journal of Zoology, Botany, Mineralogy, Geology, and Meteorology* VII.

Hall, Brian K. and Marvalee H. Wake. 1999. *The origin and evolution of larval forms.* San Diego: Academic Press.

Hansen, Julie V. 1996. Resurrecting death: anatomical art in the cabinet of Dr. Frederik Ruysch. *The Art Bulletin* 78, no. 4.

Heel, S. A. C. Dudok van. 1975. Honderdvijflog advertenties van Kunstverkopingen uit veertig jaargangen van de Amsterdamsche Courant, 1672–1711. *Amstelodamum* 160, no. 52.

Henrey, Blanche. 1975. *British botanical and horticultural literature before 1800.* Vol. II. London: Oxford University Press.

Herman, Mark. 2003. *Searching for El Dorado.* New York: Nan A. Talese/Doubleday.

Hollstein, F. W. H. 1995. *German engravings, etchings, and woodcuts, ca. 1400–1700.* Vol. 41. Rotterdam: Sound & Vision Interactive.

Homer. 1873. *The Iliad of Homer*, trans. Edward, Earl of Dover. Philadelphia: Porter and Coates.

Honig, Elizabeth Alice. 2001. The art of being "artistic": Dutch women's creative practices in the 17th century. *Woman's Art Journal* 22, no. 2.

Howard, Richard A. and Elizabeth. 1985. The Reverend Lansdown Guilding, 1797–1831. *Phytologia* 58, no. 2.

Impey, Oliver and Arthur MacGregor. 1985. *The origins of museums: The cabinet of curiosities in sixteenth and seventeenth century Europe*. Oxford: Clarendon Press.

Irwin, Joyce. 1977. Anna Maria van Schurman: From feminism to pietism. *Church History* 46.

— — —. 1980. Anna Maria van Schurman: the star of Utrecht (1607–1678). In *Female scholars: A tradition of learned women before 1800*. Montreal: Eden Press Women's Publications.

— — —. 1991. Anna Maria van Schurman and Antoinette Bourignon: Contrasting examples of seventeenth-century pietism. *Church History* 60.

James, Bartlett B. 1899. The Labadist colony in Maryland. *Johns Hopkins University Studies in Historical and Political Science*, Ser. 17, no. 6.

Jantz, Harold. 1966. German renaissance literature. *MLN* 81, no. 4.

Kinukawa, Tomomi. 2001. Art competes with nature: Maria Sibylla Merian (1647–1717) and the culture of natural history. PhD diss., University of Wisconsin, Madison.

Kirby, William and William Spence. 1846. *An introduction to entomology*. Philadelphia: Lea and Blanchard.

Kistemaker, Renee E., and others. 2005. *The Paper Museum of the Academy of Sciences, C. 1725–1760, introduction and interpretation*. Amsterdam: Royal Netherlands Academy of Arts and Sciences.

Klauber, Laurence M. 1956. *Rattlesnakes: Their habits, life histories, and influence on mankind*. Berkeley: University of California Press.

Kors, Alan C. and Edward Peters. 1972. *Witchcraft in Europe, 1100–1700: A documentary history*. Philadelphia: University of Pennsylvania Press.

Kupperman, Karen Ordahl. 2004. Natural curiosity: Curious nature in early America. *Common-Place* 4, no. 2 (January).

Leeuwenhoek, Antoni van. 1700. Letter from Mr. Anthony van Leeuwenhoek, F. R. S., concerning some insects observed by him on fruit-trees. *Philosophical Transactions of the Royal Society,* no. 265 (July/August).

— — —. 1986. *The collected letters of Antoni van Leeuwenhoek,* Vol. XIV, ed. L. C. Palm. Lisse: Swets & Zeitlinger.

Lowman, Margaret D. and H. Bruce Rinker. 2004. *Forest canopies.* Burlington: Elsevier Academic Press.

Lukin, Boris Vladimirovic. 1974. On the history of the collection of the Leningrad Merian watercolors. In *Leningrad watercolors.* New York: Harcourt Brace Jovanovich.

Macewen, Alex R. 1910. *Antoinette Bourignon, quietist.* London: Hodder and Stoughton.

MacGregor, Arthur. 1994. *Sir Hans Sloane, collector, scientist, antiquary, founding father of the British Museum.* London: British Museum Press.

Mayr, Ernst. 1982. *The growth of biological thought, diversity, evolution and inheritance.* Cambridge: Belknap Press.

McIntosh, Robert P. 1985. *The background of ecology: Concept and theory.* Cambridge: Cambridge University Press.

Mechaber, W. L. and J. G. Hildebrand. 2000. Novel, non-solanaceous hostplant record for Manduca sexta (Lepidoptera: Sphingidae) in the southwestern United States. In *Annals of the Entomological Society of America* 93, no. 3 (May).

Moffett, Mark W. 1993. *The high frontier: Exploring the tropical rainforest canopy.* Cambridge: Harvard University Press.

Monter, E. William. 1976. *Witchcraft in France and Switzerland.* Ithaca: Cornell University Press.

Moran, James. 1973. *Printing presses: History and development from the fifteenth century to modern times.* Berkeley: University of California Press.

Nijhout, H. Frederik. 1991. *The development and evolution of butterfly wing patterns.* Washington, D.C.: Smithsonian Institution Press.

Ogilvie, Sheilagh. 2003. *A Bitter Living: Women, Markets, and Social Capital in Early Modern Germany.* Oxford: Oxford University Press.

Ovid. 2001. *Metamorphoses*, trans. Arthur Golding. Baltimore: The Johns Hopkins University Press.

Papageorgis, Christine. 1975. Mimicry in neotropical butterflies. *American Scientist* 63 (Sept–Oct).

Parrish, Susan Scott. 1997. The female opossum and the nature of the new world. *William and Mary Quarterly*, 3rd ser. 54, no. 3.

Penn, William. 1825. Travels in Holland and Germany. In *The select works of William Penn*, Vol. II. New York: Kraus Reprint Co.

Pepys, Samuel. 1974. *The diary of Samuel Pepys*. Vol. VIII, 1667, ed. Robert Latham and William Matthews. Berkeley: University of California Press.

Petersen, Johanna Eleanora. 1990. The Life of Johanna Eleanora Petersen. In *Bitter healing: German women writers from 1700 to 1830: An anthology*. Lincoln: University of Nebraska Press.

Petiver, James. 1767. *Opera historiam naturalem spectantia*. London: John Millan.

Pliny the Elder. 1940. *Natural history*. Vol. III, ed. H. Rackham. Cambridge: Harvard University Press.

Plotkin, Mark. 1994. *Tales of a shaman's apprentice*. London: Penguin Books.

Posey, Darrell A. 1981. Wasps, warriors and fearless men: Ethnoentomology of the Kayapo Indians of Central Brazil. *Journal of Ethnobiology* 1, no. 1.

Poulton, Edward B. 1903a. Experiments in 1893, 1894, and 1896 upon the colour-relation between lepidopterous larvae and their surroundings, and especially the effect of lichen-covered bark upon Odontopera bidentata, Gastropacha quercifolia, etc. *Transactions of the Entomological Society of London for 1903*.

— — —. 1903b. President's address. *Transactions of the Entomological Society of London for 1903*.

Price, Richard. 1976. *The Guiana maroons*. Baltimore: The Johns Hopkins University Press.

— — —. 1983. *First-time: The historical vision of an Afro-American people*. Baltimore: The Johns Hopkins University Press.

— — —. 1990. *Alabi's world*. Baltimore: The Johns Hopkins University Press.

Pullin, Andrew S. 1995. *Ecology and conservation of butterflies.* New York: Chapman & Hall.

Purcell, Rosamond Wolff and Stephen Jay Gould. 1992. *Finders, keepers: Eight collectors.* New York: W. W. Norton & Company.

Raven, Charles E. 1950. *John Ray, naturalist: His life and works.* Cambridge: Cambridge University Press.

Ray, John. 1727. *The wisdom of God manifested in the works of the creation.* London: William and John Innys, Printers.

Réaumur, Réne-Antoine Ferchault de. 1926. *Natural history of ants,* trans. William Morton Wheeler. New York: Alfred A. Knopf.

Redi, Francesco. 1909. *Experiments on the generation of insects.* Chicago: The Open Court Publishing Company.

Ridley, Matt. 2003. *Nature via nurture.* New York: HarperCollins.

Rodway, James. 1912. *Guiana: British, Dutch, and French.* London: T. Fisher Unwin.

Ross, Edward S. 1994. Fearsome Fulgora. *Pacific Discovery.* Summer.

Rossiter, Margaret W. 1982. *Women scientists in America: Struggles and strategies to 1940.* Baltimore: The Johns Hopkins University Press.

Rublack, Ulinka. 1996. Pregnancy, childbirth and the female body in early modern Germany. *Past and present,* no. 150 (Feb).

— — —. 1997. The public body: Policing abortion in early modern Germany. In *Gender relations in German history: Power, agency and experience from the sixteenth to the twentieth century,* ed. Lynn Abrams and Elizabeth Harvey. Durham: Duke University Press.

Rucker, Elisabeth. 1980a. The life and personality of Merian Sibylla Merian. *Metamorphosis Insectorum Surinamensium.* London: Pion Limited.

— — —. 1980b. The Surinam work. *Metamorphosis Insectorum Surinamensium.* London: Pion Limited.

Ruestow, Edward G. 1996. *The microscope in the Dutch republic.* Cambridge: Cambridge University Press.

Rumpf, Georg Eberhard. 1999. *The Ambonese curiosity cabinet,* trans. E. M. Beekman. New Haven: Yale University Press.

Saxby, T. J. 1987. *The quest for the new Jerusalem, Jean de Labadie*

*and the Labadists, 1610–1744.* Dordrecht: Martin Nijhoff Publishers.

Schama, Simon. 1997. *The embarrassment of riches: An interpretation of Dutch culture in the golden age.* New York: Vintage.

— — —. 1999. *Rembrandt's Eyes.* New York. Alfred A. Knopf.

Schierbeek, A. 1967. *Jan Swammerdam: His life and works.* Amsterdam: Swets & Zeitlinger.

Schiebinger, Londa. 2004. Feminist history of colonial science. *Hypatia* 19, no. 1.

Schurman, Anna Maria van. 1998. *Whether a Christian woman should be educated and other writings from her intellectual circle,* ed. and trans. Joyce L. Irwin. Chicago: The University of Chicago Press.

Smith, Ray F., and others. 1973. *History of entomology.* Palo Alto: Annual Reviews, Inc.

Soliday, Gerald Lyman. 1974. *A community in conflict: Frankfurt society in the seventeenth and early eighteenth centuries.* Hanover: University Press of New England.

Sprat, Thomas. 1958. *History of the royal society.* St. Louis: Washington University Studies.

Stauffer, Robert C. 1957. Haeckel, Darwin, and Ecology. *The Quarterly Review of Biology* 32, no. 2.

Stearn, William T. 1980. The plants, the insects and other animals of Merian's Metamorphosis Insectorum Surinamensium. In *Metamorphosis Insectorum Surinamensium.* London: Pion Limited.

Stearns, Raymond P. 1952. James Petiver: Promoter of natural science, c. 1663–1718. *Proceedings of the American Antiquarian Society* 62.

Stedman, John Gabriel. 1988. *Narrative of the five years expedition against the revolted Negroes of Surinam.* Baltimore: The Johns Hopkins University Press.

Stoeffler, F. Ernest. 1965. *The rise of evangelical pietism.* Leiden: E. J. Brill.

Stott, Rebecca. 2003. *Darwin and the barnacle.* New York: W. W. Norton and Company.

Swammerdam, John. 1978. *The book of nature, or the history of insects.* New York: Arno Press.

Tatlock, Lynne. 1992. Speculum Feminarum: Gendered perspectives on obstetrics and gynecology in early modern Germany. *Signs* 17 (Summer).

Taylor, Charlotte. 1860. Spiders: Their structure and habits. *Harper's New Monthly Magazine* 21, no. 124 (Sept.).

Thomas, J. A. 1995. The ecology and conservation of Maculinea arion and other European species of large blue butterfly. In *Ecology and conservation of butterflies*, ed. Andrew S. Pullin. New York: Chapman & Hall.

Todd, Janet. 1997. *The secret life of Aphra Behn.* New Brunswick: Rutgers University Press.

Topsell, Edward. 1967. *The history of four-footed beasts and serpents and insects.* New York: Da Capo Press.

Truman, James W. and Lynn M. Riddiford. 1999. The origins of insect metamorphosis. *Nature* 401 (Sept. 30).

Turnbull, G. H. 1947. *Hartlib, Dury and Comenius: Gleanings from Hartlib's papers.* London: Hodder & Stoughton.

Tyson. Edw. 1683. Vipera Caudi-sona Americana, or the anatomy of a rattlesnake. *Philosophical Transactions of the Royal Society,* no. 144 (Feb. 10).

Uffenbach, Zacharias, Conrad von. 1753. *Murkwurdige Reisen durch niedersachsen Holland und Engelland,* Vol. 3. Ulm: Memmingen: auf Kosten Johann Friedrich Gaum.

— — —. 1934. *London in 1710, from the travels of Zacharias Conrad von Uffenbach,* trans. W. H. Quarrell and Margaret Mare. London: Faber and Faber.

Valiant, Sharon. 1993. Maria Sibylla Merian: Recovering an eighteenth-century legend. *Eighteenth-Century Studies* 26, no. 3.

Vega, Garcilaso de la, and others. 1859. *Expeditions into the Valley of the Amazons, 1539, 1540, 1639.* London: Hakluyt Society.

Warren, George. 1667. *An impartial description of Surinam.* London: William Godbid.

Wedgwood, C. V. 1938. *The Thirty Years War.* London: Jonathan Cape.

West-Eberhard, Mary Jane. 2003. *Developmental plasticity and evolution.* Oxford: Oxford University Press.

Wettengl, Kurt. 1998. Maria Sibylla Merian, artist and naturalist. Ostfildern: G. Hatje.

Wiesner-Hanks, Merry. 1993. *Women and gender in early modern Europe.* Cambridge: Cambridge University Press.

Wiesner Wood, Merry. 1981. Paltry peddlers or essential merchants? Women in the distributive trades in early modern Nuremberg. *Sixteenth Century Journal* 12, no. 2.

Wigglesworth, V. B. 1954. *The physiology of insect metamorphosis.* Cambridge Monographs in Experimental Biology, no. 1.

— — —. 1976. *Insects and the life of man.* London: Chapman and Hall.

Wijnands, D. O. 1983. *The botany of the Commelins.* Rotterdam: A. A. Balkema.

Wilbert, Johannes. 1985. The house of the swallow-tailed kite: Warao myth and the art of thinking in images. In *Animal myths and metaphors in South America,* ed. Gary Urton. Salt Lake City: University of Utah Press.

Wilson, David Scofield. 1987. The rattlesnake. In *American wildlife in symbol and story,* ed. Angus K. Gillespie and Jay Mechling. Knoxville: University of Tennessee Press.

Wiltenburg, Joy. 1992. *Disorderly women and female power in the street literature of early modern England and Germany.* Charlottesville: University Press of Virginia.

Wunder, Heide. 1997. Gender norms and their enforcement in early modern Germany. In *Gender relations in German history: Power, agency and experience from the sixteenth to the twentieth century,* ed. Lynn Abrams and Elizabeth Harvey. Durham: Duke University Press.

— — —. 1998. *He is the sun, she is the moon: Women in early modern Germany,* trans. Thomas Dunlap. Cambridge: Harvard University Press.

# INDEX